The Most

Beautiful Woman

in the World

The Most Beautiful Woman in the World

THE OBSESSIONS, PASSIONS,

AND COURAGE OF

Elizabeth Taylor

ELLIS AMBURN

HarperLargePrint
An Imprint of HarperCollinsPublishers

THE MOST BEAUTIFULL WOMAN IN THE WORLD. Copyright © 2000 by Ellis Amburn. All rights reserved. Printed in the United States of America. No part of this book may be used or reproduced in any manner whatsoever without written permission except in the case of brief quotations embodied in critical articles and reviews. For information address HarperCollins Publishers Inc., 10 East 53rd Street, New York, NY 10022.

HarperCollins books may be purchased for educational, business, or sales promotional use. For information please write: Special Markets Department, HarperCollins Publishers Inc., 10 East 53rd Street, New York, NY 10022.

A hardcover edition of this book was published in 2000 by HarperCollins.

FIRST HARPERLARGEPRINT EDITION 2000.

Printed on acid-free paper

Library of Congress Cataloging-in-Publication Data is available upon request.

ISBN 0-06-019719-6

00 01 02 03 04 ❖/RRD 10 9 8 7 6 5 4 3 2 1

This Large Print Book carries the
Seal of Approval of N.A.V.H.

To my sister, Lu Bradbury

A perfect woman, nobly planned,
To warn, to comfort, and command.
And yet a Spirit still, and bright
With something of angelic light.

—WORDSWORTH

Age cannot wither her, nor custom stale
Her infinite variety.

—SHAKESPEARE

Contents

Acknowledgments

I am primarily grateful to my agent, Al Lowman, for helping me with the concept and proposal for this book on Thanksgiving 1997 in Key West, and to Diane Reverand, senior vice president of Harper-Collins and publisher of Cliff Street Books, for commissioning it and later improving the manuscript with her brilliant editing. Diane's assistant Matthew Guma held the package together through the production process, helping me with the photographs, catalog, jacket, and a thousand other details. Eagle-eyed attorney Jim Fox went over every word with me.

Of the more than five hundred people I interviewed, I wish to single out for special thanks the novelist Norman Bogner, who introduced me to Elizabeth's directors, Edward Dmytryk and Brian Hutton. The year following our interview, Eddie Dmytryk died, in his early nineties. This warm and lovable man, who directed Elizabeth and Monty Clift in *Raintree County*, will be missed and long remembered for his powerful films *Crossfire*, *The Caine Mutiny*, and *The Young Lions*.

Hollywood agent Dorris Halsey, who sheltered me when I went to Los Angeles in 1985 to collaborate with Priscilla Presley on *Elvis and Me*, again came to my aid in 1998–1999, putting me in touch with those who worked with Elizabeth, including *Raintree County* scenarist Millard Kaufman, and Ray Stricklyn, who described what it was like to be a gay movie actor in the 1950s.

Jack Larson, a friend of many years, shared his memories of Elizabeth, Monty Clift, Michael Wilding, and Roddy McDowall. Another Hollywood friend of long standing, agent Ron Bernstein, did everything he could to make my trips to the West Coast both pleasurable and profitable, as did Jean Porter, Pat Loud, Julia Winston, director Curtis Harrington, agent Bettye McCart, Felice Bogner, and publicist Dale Olson. Two astute biographers, Elaine Dundy (*Finch, Bloody Finch*) and Steven Gaines (*Simply Halston*), added to the interest of this work.

In Key West, I am indebted to actress Joanne Jacobson; friends of the late Philip Burton and Tennessee Williams, who gave revealing interviews; producer Frank Taylor; publisher Ross Claiborne; and producer and author Ed Ditterline. It was writer Jerry O'Connell who told me about the Marya Mannes–Richard Burton connection and put me in touch with Robert and Jacqueline Burr. Other interviewees I wish to thank by name include Ed Shaw, Barbara Pahlenberg, Gary Graver, Colin

Donnarumma, Joanne V. Cates, and George J. Stauch.

Librarians were unfailingly helpful, preeminently Marianne Duchardt and Anne Layton Rice of the Monroe County Public Library and, in Beverly Hills, the staff of the Margaret Herrick Library of the Academy of Motion Picture Arts and Sciences Center for Motion Picture Study. Oscar librarian Linda Harris Mehr, special collections coordinator Faye Thompson, and research archivist Barbara Hall graciously gave me access to director George Stevens's private papers. At the Betty Ford Center, I am beholden to the friendly staff in the admissions department.

Most of this book was composed in a beautiful homestead near the Suwanee River, in High Springs, Florida, which was entrusted to me for six months in 1999 by my sister-in-law, Joyce Kahlich Amburn, and my brother, Bill Amburn. As I completed each chapter, I sent it to Cy Egan, my closest friend and first reader, who was generous with the skills that made him famous as the best rewrite man in the New York newspaper business. Fannie Mae Gibbons provided loving support (and regular CARE packages).

Many others unknowingly contributed to this biography during my years as a New York book editor from 1960 to 1985, and collaborator on celebrity autobiographies from 1985 to 1990; these include Joan Bennett, June Allyson, Joan Blondell, Orson Welles, Susan Strasberg, George

Cukor, Stewart Granger, Ann Todd, Shelley Winters, Zsa Zsa Gabor, Kim Novak, Debbie Reynolds, John Huston, Olivia de Havilland, Lana Wood, Joshua Logan, Marisa Berenson, Sammy Davis Jr., Arnold Weissberger, Milton Goldman, J. Bryan III, Charles J. V. Murphy, Carlo Fiore, and Swifty Lazar. I made notes of my conversations with some of these extraordinary people, and found them useful while writing this book.

Though I did not interview her, I am especially grateful to *Hollywood Reporter* columnist Radie Harris for taking me to dinner with Elizabeth during John Warner's race for the U.S. Senate. On a subsequent occasion, I escorted Radie to the star-studded *Endless Love* party, where I again encountered Elizabeth.

I am indebted to David Patrick Columbia, biographer (*Debbie*) and magazine editor (*Avenue*), for having introduced me to Edie Goetz, L. B. Mayer's daughter and longtime doyenne of Hollywood society. In the years before her death, Edie shared an insider's knowledge of the movie elite.

The interest of my alma mater, Texas Christian University, in preserving my manuscripts has been heartening. Eugenia Luker Trinkle, tireless TCU booster, and the late Paul Parham were instrumental in establishing my archive at the Mary Couts Burnett Library. The current university librarian, Robert A. Seal, keeps everything related to my books and their production.

Speaking of which, many thanks to Harper-Collins production editor Andrea Molitor and designer Victoria Kuskowski.

Named on the dedication page, my sister Lu Bradbury has been my lodestar since childhood, a bottomless well of love and encouragement.

Preface

I was in Las Vegas around 1959 or 1960, staying at the Desert Inn, and one evening I attended Eddie Fisher's show, which was absolutely first-rate. In those days, he was still a golden-throated head-liner. Later, as I stood watching a poker game in the casino, I suddenly became aware of Elizabeth Taylor standing next to me. "Is the show over?" she asked. It was odd—she wasn't looking at me, but seemed to expect an answer. I told her that Eddie had been terrific, and she said she was always expected to make an appearance and sit ringside, but she hadn't arrived in time. She could have been talking to herself. Everyone else around us in the crowded casino was engrossed in the game and took no notice of her. Rooted to my spot a few inches from her, I couldn't help staring, and she didn't appear to mind. Indeed, she seemed relieved that I was going to let her be, and not ask for an autograph or take a picture.

The first thing you noticed about her when she was still in her twenties was that, despite the beauty she displayed on film, no camera had ever

done her justice. Her skin was unbelievable. She had on a simple sundress, and I remember her shoulders being velvety and iridescent. Her coloring made me think of a rose at dusk. Her manner was appealingly demure—typical 1950s ladylike poise. Being in her presence, at the height of her beauty, was an almost religious experience. She was an example of nature perfecting itself, a once-in-a-generation phenomenon.

We both spotted Eddie at the same time as he entered the casino from the dressing room area. People who'd just seen the show began to recognize him, and their gaze followed him as he approached Elizabeth, whom they still hadn't noticed. Eddie kissed her on the cheek, and they stood smiling at each other, an apparently happy young couple, both dark-haired and both shorter than most of the people around them. The crowd at last realized who she was, and a murmur went through the room, taking only seconds to build into a roar. Suddenly everyone around me went ballistic, charging the startled couple. Even diners who'd been helping themselves at the complimentary buffet threw down their plates and joined the chase. The casino was an extension of the hotel lobby, and fortunately we were standing fairly near the entrance. Eddie and Elizabeth made for the door at a dead run. The last I saw of them, they were sprinting just ahead of the herd.

It was then I first began to think of writing this

book, but a couple of other careers intervened
before I got around to it, first as a New York editor
and later as a collaborator on autobiographies by
Shelley Winters, Kim Novak, Zsa Zsa Gabor, and
Peggy Lee. Through it all my fascination with
Elizabeth never wavered, especially with her emo-
tional life, which in many respects is the most mis-
understood erotic voyage of the twentieth century.

1
Discovering Boys:

One of Elizabeth Taylor's child-star contemporaries at MGM's Little Red Schoolhouse was Jean Porter, who later became famous for a fast-talking comedy routine with Red Skelton in *Thrill of a Romance*. "We had a surrogate mother, Muzzie McPhail, who took care of all of us MGM kids," recalled Porter in 1998. "For Elizabeth, Virginia Wiedler, Roddy McDowall, and me, Muzzie McPhail was someone whose shoulder we could cry on. How we loved Muzzie! She was there every day, morning until evening when everybody went home. Muzzie's son, Doug McPhail, was under contract to Metro [and appeared in minor parts in *Born to Dance*, *Maytime*, and *Sweethearts*]. Elizabeth and all of us knew Doug; they were grooming him in case Nelson Eddy ever faded away, but Nelson kept turning them out, and Doug finally hanged himself."

Metro's Little Red Schoolhouse was a pitiful

excuse for an educational institution. As a result, Elizabeth would never really have a decent education. In 1999 she described it as "a nightmare. No two kids were the same age . . . When you were not shooting, you went to school."

Recalling Elizabeth as a child, Porter said, "Elizabeth and I had the same makeup lady every morning, Violet Downer. Elizabeth's mother was always with her. She was very careful, back of the camera, in the dressing room, or on the set. And always in the makeup room, wherever Elizabeth was. Mrs. Taylor was a very sweet lady. We had lunch together a lot, but when her mother needed to take a breather, Muzzie was there with open arms. Tea was ready in the afternoon, in the commissary, or you could bring it out and have a snack.

"The Little Red Schoolhouse was the domain of Mrs. Mary McDonald, the teacher. She was just murder to everyone. She was a rather stern disciplinarian who always wanted to be sure the kids did their homework. That was good, but she wasn't anything like a mother." Elizabeth recalled that, when she was fourteen or fifteen, Mrs. McDonald rapped her hands with a ruler and ordered her to "stop daydreaming!" Thereafter Elizabeth went to the toilet to enjoy her reverie of being swept away by a prince on a white charger, and when Mrs. McDonald scolded her for an absence of fifteen minutes, Elizabeth said, "Oh, Miss [sic] McDonald, if you don't believe me, I suggest you go in and

smell." Asked to evaluate Elizabeth as a student, Mrs. McDonald called her "[no] Einstein, but she wasn't stupid."

Elizabeth Rosemond Taylor had arrived at Metro's 187-acre Culver City lot just before the outbreak of World War II. She'd been born on February 27, 1932, at 2:30 A.M., in a house called Heathwood, at 8 Wildwood Road, in a semirural section on the northern edge of London. Her mother, Sara, a vivacious beauty who'd briefly been a stage actress, and father, Francis, an elegantly dressed art dealer with sparkling blue eyes, were American by birth and British by choice. Eerily beautiful even as a small girl, Elizabeth looked as if an adult woman's head had been incongruously placed on her child's body. Her rosy skin seemed to glow with its own inner Technicolor, and a double row of long black eyelashes highlighted eyes that were "not violet as publicized," she later stated, but were "different colors" depending on what she wore. The Taylors had one other child, Howard, born in 1929 and blessed with features as well-defined and striking as his sister's.

Both children were sometimes subjected to rough treatment from their father. In 1937, one house guest saw Francis Taylor slap Elizabeth across the face—with too much force and too little provocation—and shove her brother into a broom closet under the stairs. To some observers Francis seemed happier with his male companions, and

they concluded that his marriage was a cover for an active homosexual life. Sara was four years older than Francis and had been thirty and in fear of becoming an old maid at the time of their marriage in 1926. With Sara's quite normal connubial expectations, she unwittingly placed Francis under pressure, and when he exploded, it was the children who suffered.[1]

With war on the horizon, Sara and the children left England and came to L.A. on May 1, 1939, and Francis followed shortly afterward, establishing an art gallery in the Beverly Hills Hotel, where he counted collectors like Edward G. Robinson, Billy Wilder, and George Cukor among his clients. The Taylors lived briefly with Elizabeth's maternal grandfather in Pasadena. The number one topic all over L.A. was *Gone with the Wind*, still in production in Culver City. Sara was advised by almost everyone she met that Elizabeth resembled Vivien Leigh and should try out for the role of Bonnie Blue Butler, Scarlett O'Hara's daughter. For two years her parents refused to let her work, choosing instead to enroll her in school. Her classmates, who included Norma Shearer's children as well as Darryl F. Zanuck's offspring Richard and Darrylin, sometimes poked fun at her British accent, saying, "I cawnt take a bawth on the grawss with the banawnas." Fortunately the Taylors soon moved into their own house in Pacific Palisades, and both children enrolled at Willard Elementary and later

at Hawthorne School at 624 North Rexford Drive. "The children very quickly lost their accents," Sara recalled, but Elizabeth retained the ability to switch back and forth depending on movie requirements. Darryl F. Zanuck, the mogul who'd reigned supreme at 20th Century-Fox since 1935, dandled Elizabeth on his knee when Darrylin brought her home but pooh-poohed his daughter's suggestion that he put Elizabeth under contract. Mischievous young Richard Zanuck's idea of fun was tying Elizabeth up and locking her in the basement.

She first met Louis Burt Mayer, who founded Metro-Goldwyn-Mayer in 1924 and still ruled it like a dictator, during a visit to the studio with her parents. Mayer wanted to sign her, but Sara mistakenly thought Elizabeth would get more attention at a smaller studio and took her to Universal instead. The year was 1941 and, at a salary of $100 per week, Elizabeth played an ear-pulling brat with Alfalfa (*Little Rascals*) Switzer in the B-movie *There's One Born Every Minute*, but the Universal casting director said, "Her eyes are too old. She doesn't have the face of a kid." Universal fired her on March 23, 1942. When asked years later if she'd wanted to be an actress, she replied, "Oh, yes, of course. I did. Because my mother had been an actress. My dad was against it, but Mother and I got together behind his back." The following October she was given a test option for the role of Priscilla in MGM's *Lassie Come Home*. "Elizabeth

and her costar Roddy McDowall [who played Joe Carraclough] bonded for life," recalled Roddy's friend Jerry O'Connell, a writer for *Show* magazine and the *New York Mirror*. Twentieth Century-Fox's leading juvenile player and the star of John Ford's classic *How Green Was My Valley*, Roddy was loaned to Metro for *Lassie*. On weekends Elizabeth attended parties at Roddy's house, sitting beside the pool and eating sandwiches and drinking lemonade with another aspiring child actor, Robert (R. J.) Wagner. "Roddy was a little older than Elizabeth and very protective of her," said O'Connell. "They were two child stars holding on to each other for dear life. With later gay men, Elizabeth would play a mothering role, but with Roddy, he was the one with stability, and she could lean on him."

And Elizabeth desperately needed support. L.A. and moviemaking proved an ordeal, and she would later tell writer Paul Theroux that she felt like the studio owned her. She was to recall in 1987, "Constantly faced with adult situations and denied the companionship of my peers, I stopped being a child the minute I started working in pictures." At home, her alcoholic father was increasingly resentful that his nine-year-old daughter was making more money than he was. "He batted me around a bit," she revealed in 1999. "He was drunk when he did it. He didn't know what he was doing." Nonetheless, the effects on her emotions would be far-reaching, endangering every love relationship of her adult life.

Despite her father's resentment of Elizabeth's superior earning power, he was ready enough to spend the money she earned. Because she was a minor, her finances were handled by her parents, but fortunately the Coogan Act, named after child star Jackie Coogan, stipulated that a percentage of juvenile earnings be placed in trust until she reached the age of twenty-one. The system was far from foolproof. Another Metro child star, Shirley Temple, who moved to the studio from Fox in 1940, later complained that her parents appropriated all of her $3,207,666 gross earnings, leaving her only $89,000. Jackie Cooper, star of *The Champ*, collected only $150,000 of his $1 million earnings. Roddy McDowall once explained, "There are reasons for the money thing with young actors. Number one, one's own sense of guilt coming from making amounts of money that your parents never even made in their lifetime." Elizabeth supported her family from the age of nine.[2]

Though she had only a supporting role in *Lassie*, millions of children and adults fell in love with her on sight. The *Hollywood Reporter* sagely predicted, "Elizabeth Taylor looks like a comer." *Lassie* was the story of a boy and his dog, and the salary of the collie playing Lassie exceeded Elizabeth's by $50 a week. On January 5, 1943, she scored a seven-year MGM contract, beginning at $100 per week and gradually rising to $750 per week.

Her family had moved to a spacious pink stucco

Mediterranean-style house with a red-tiled roof on North Elm Drive, walking distance from her father's gallery in the Beverly Hills Hotel. This would be her home until the day she married.

In March she was loaned out to Fox for a small but highly emotional and visible role as the orphan child Helen Burns in Orson Welles's *Jane Eyre*, stealing several important scenes from established child stars Peggy Ann Garner and Margaret O'Brien. Though the ten-year-old Elizabeth received no billing, the *Hollywood Reporter* noted, "The little girl Jane befriends in school wins a credit which is regrettably omitted." On the set, Elizabeth had caught Orson's eye. "Remind me to be around when she grows up," he said. It was from the grandiose Welles that she first learned that a star can take over an entire production. The first day of shooting, Welles marched in four hours late, trailing an entourage of half a dozen minions including his agent and doctor, and ordered the cast to do a run-through with him, completely ignoring director Robert Stevenson. Watching Welles and other stars she worked with, Elizabeth soon became ambitious for bigger and better roles.

The White Cliffs of Dover was her fourth film for Metro in two years. A romantic epic spanning World Wars I and II, *Dover* starred Irene Dunne, Peter Lawford, Van Johnson, and Roddy. The character Elizabeth played had a crush on young Roddy, but in reality she fell in love with the hand-

some, twenty-two-year-old Peter Lawford. So did the press. When the film was released in 1944 to critical acclaim, much of the praise went to Lawford, whom the *L.A. Times* singled out for "eventual stardom." Lawford was in the middle of an eight-month love affair with Lana Turner and didn't pay much attention to Elizabeth. Neither did the critics.

The star of the picture, forty-three-year-old Irene Dunne, did notice something odd about Elizabeth, whose "eyes seemed to look straight through you," Dunne recalled. Behind the blank stare was a burdened child, preoccupied by tensions at home and batterings by her father, but there was something more. She was developing, even at eleven, into a very determined careerist who had little time for those—like Irene Dunne—who couldn't serve her. Shrewdly plotting her next move at Metro, she saved her charm for her *Dover* director, Clarence Brown, plying him with greeting cards, hoping to win the starring role in his forthcoming picture, *National Velvet*. She also sought out the picture's producer, Pandro Berman, and listed her qualifications: she was the right age for Velvet Brown, "going on twelve," and she loved horses, knew how to ride, and had a British accent. "Sorry, honey, but you're just too short," Berman said. She needed three more inches of height for the scenes in which Velvet masquerades as a jockey. "Well, I'll grow," she said, but the picture was to

start in three months. Stuffing herself on high-protein foods, she showed up in Berman's office three months later and, according to a Metro press release, three inches taller. In actuality, she'd cleverly devised an older look for herself with makeup, hairstyle, and attitude.

Velvet began filming on February 4, 1944. Based on a beautifully written novel by Enid Bagnold, author of *The Chalk Garden*, the story focuses on the close-knit, loving family of young Velvet Brown, who dreams of owning a horse she's seen running wild in the countryside. "The Pirate," or "The Py," as Velvet calls him, is a stubborn chestnut beauty with a white star on his forehead and three white socks. Though Velvet is only twelve, she miraculously manages to acquire the horse, explaining, "I arranged it with God." Mickey Rooney, who turned twenty-three during the shoot, plays a young gypsy jockey con man who wanders into the Brown family's life, and teaches Velvet how to ride like a professional jockey. This leads to her competing in the legendary Grand National Steeplechase, attended by the Queen.

Elizabeth and Mickey had several intimate scenes together in his bedroom in the Browns' stable, and some members of the crew noted an almost sexual chemistry between them. Though Elizabeth's costumes were designed to minimize her formidable chest development, her physical assets were already evident to her coworkers. Metro

executive Frank Taylor, interviewed in 1999, said, "Around the time of *Velvet* she began sitting at a table next to mine in the studio commissary. Though still a child she already was a major beauty with those spectacular eyes." A source close to Rooney said that Taylor and Rooney were involved during *Velvet*, but Elizabeth herself has said that she was a virgin until her marriage six years later. Mickey, though short in stature, was one of Hollywood's most prized lovers and was being pursued at the time by the sultry Ava Gardner. Wrote gossip columnist Sheilah Graham, "Like several other young actresses in Hollywood who would be fascinated by Mickey—Elizabeth Taylor and Judy Garland, to name two—Ava was in love with him."[3] And Ava won him, at age twenty.

Clarence Brown insisted that Elizabeth cut her long dark hair to impersonate a male jockey during the horse-race finale. She went crying to hairdresser Sydney Guilaroff, the crotchety, queenly Metro makeover genie, who'd come to the studio in 1934, giving Greta Garbo, Greer Garson, Joan Crawford, and Norma Shearer their distinctive looks and serving as their father-confessor. Touched by Elizabeth's tears, he made her a wig, attaching it to her jockey cap so she could save her natural hair. Clarence Brown was completely fooled and even warned Guilaroff not to cut Elizabeth's hair another inch. She threw her arms around Guilaroff, thanking him, and the actress

and hairdresser became friends for life. The only acting Oscar in *Velvet* was awarded to Anne Revere, but it was—and remains half a century later—Elizabeth who was responsible for the film's magic. Years later she revealed the secret of her acting: "I sweat real sweat and I shake real shakes." A celestial intensity dances out of her strange azure eyes in the film, almost in mischievous defiance of the executives at Universal who decided to fire her for having a grown-up's face in a child's body. Clarence Brown, who'd guided Garbo through seven films to a mythic status beyond stardom, and his cinematographer Leonard Smith knew exactly how to photograph Elizabeth. "There's something behind her eyes that you can't quite fathom," said Brown. "Something Garbo had."

From the moment *Velvet* opened at New York's Radio City Music Hall for Christmas 1944, it catapulted Elizabeth into juvenile stardom. Her performance—more natural and relaxed than anything she would subsequently do before the camera or on stage—is one of her two favorites, the other being *Who's Afraid of Virginia Woolf?* Clark Gable, king of MGM, pronounced that she had achieved the best juvenile work in movie history. The *New York Times*'s Bosley Crowther wrote, "Her face is alive with youthful spirit, her voice has the softness of sweet song and her whole manner is one of refreshing grace." L. B. Mayer raised her to $30,000 per year. She became the idol and role

model of millions of girls, including future columnist and TV personality Rona Barrett, who recalled, "God, she was gorgeous. Those purple velvet eyes. The first time I saw the film, I spent every waking moment staring into the mirror in our apartment wondering if there would ever be a way *I* could look like that."

To capitalize on the box-office success of *Velvet,* Elizabeth was shoved into another animal opus, *Courage of Lassie,* in which the popular canine, cast as an Allied combatant in WWII, regularly outsmarts the Nazis, with Elizabeth going through another outdoorsy role. Working almost constantly, she had no opportunity to develop real boyfriends, but that didn't stop her from having imaginary ones. After work at Metro each day, she'd go home around 3 P.M. and play make-believe games with two girlfriends who lived on her block. "We'd make up plays . . . and of course I was really *in*, because I could say, 'Well, I know Van Johnson, so Van Johnson is going to be *my* boyfriend today. But I'll let *you* have him tomorrow.'" She and her chums christened themselves "The Three Musketeers."

Each morning Sara roused Elizabeth from bed in time to go horseback riding at the Riviera Country Club for an hour before reporting to makeup at nine. Natalie Wood was another typically overprotected, isolated child actress, and her mother was perhaps Hollywood's most dedicated stage mother,

"rivaled in protective ferocity only by Elizabeth Taylor's," wrote Natalie's biographer Warren G. Harris.[4] Sara Taylor was at once the unsung heroine of Elizabeth's career and a deceptively soft-spoken adventuress who, still trim and attractive in her late forties, was out for all the power and pleasure she could get. "Sara Taylor had a tremendous crush on L. B. Mayer," wrote Ava Gardner in her memoir. "Elizabeth must have been aware of it, because her mother never stopped talking about Mayer. I think it's the reason Elizabeth hated him so much."[5] According to Shirley Temple, L. B. tried to seduce her thirty-seven-year-old mother, Gertrude, while, in an adjoining office, *Wizard of Oz* producer Arthur Freed exposed his genitals to eleven-year-old Shirley. Compared with Sara Taylor, Gertrude Temple was a plain, matronly woman, but no female was safe from the randy execs at MGM. A shocked Shirley giggled at Freed's exposure, and Gertrude fled L. B.'s office, walking backward. Metro, Shirley concluded, had "more than its quota of lecherous older men."[6] Unlike Gertrude Temple, Sara Taylor had found her element and embraced it wholeheartedly.

Once Sara had penetrated the inner sanctum of Hollywood studios via Elizabeth, she left Francis Taylor for Michael Curtiz, who directed Elizabeth at Warner Bros. in *Life with Father* in 1946. Francis began a gay affair with costume designer Adrian, another closet homosexual, who was married to Janet Gaynor. When her parents separated, Eliza-

beth said, "It was no special loss. I had felt father-
less for years anyway."[7] According to Guilaroff,
"Most difficult of all for Elizabeth was her parents'
separation, which began in the autumn of 1946."[8]
By the following summer, Elizabeth and Sara were
living in a beach house in Malibu, while her father
and brother remained in Beverly Hills. After Sara's
affair with Curtiz ended, she persuaded Francis to
return, and gossip columnist Hedda Hopper head-
lined, "Elizabeth Taylor's Parents Reunited." Four-
teen-year-old Elizabeth would remain estranged
from her father for another six years. "I looked
upon my agent, Jules Goldstone, and Benny Thau
of MGM as my two fathers," she recalled. "I went
to them for help and advice." It is doubtful that
Francis was still battering her, since she was now
the family's primary means of support.

She once said she loved her brother, Howard, "as
much as any man I've ever known." Howard had
grown into a handsome lad, with eyes as uniquely
distinctive as her own. The grasping Sara set up a
meeting for him with a studio executive, but
Howard had already seen that fame didn't make
Elizabeth happy and sheared off all his hair so he
wouldn't have to audition. It was Howard who
dubbed Elizabeth "Lizzie the Lizard," which
explains why she came to hate the name Liz.

The Taylors' beach house in Malibu was an ideal
setting for teenage socializing and dates for Eliza-
beth, but apart from the Three Musketeers, she had

few friends and was shunned as an oddball by her peers, who made her feel paranoid. There were no dates, no proms, no football games. Howard, who attended Beverly Hills High, said, "Get your own dates. You got to take chances like other girls. Call up a boy, get turned down, maybe, like any other girl," but she demurred, knowing that nice girls in the 1940s waited for boys to make the first move. Finally Sara prevailed upon Howard to invite forty friends to a Saturday cookout, but Elizabeth found herself marooned on the beach as the guests flirted and drifted off two by two. She felt "completely lost," she recalled.

Ironically, there were disturbing parallels in the films she was making. In *Cynthia*, a surprise hit, she played a sickly, neurotic teenager who finally rebelled against her domineering parents, portrayed by Mary Astor and George Murphy, and found acceptance among her high school contemporaries. Adolescent moviegoers identified and instantly embraced Elizabeth as America's Teen Queen. Costar Jimmy Lydon gave Elizabeth her first screen kiss—"politely pecked, like a handshake," she commented, dismissing it as a child's kiss. It was "humiliating," she added, "being kissed on the screen first before real life." According to Lydon, she was distracted over having been trapped into being her family's breadwinner. Costar Mary Astor also noted her agitated state, which Elizabeth had already begun sedating with

mild sedatives "to calm her nerves," Astor said.[9]

It became evident between Elizabeth's fourteenth and fifteenth birthdays that she was blossoming into a major sex object, boasting a thirty-five-inch bust, thirty-four-inch hips, and a twenty-two-inch waist. Metro hastily drew up yet another contract on January 18, 1946, giving her $750 per week and her mother $250 per week plus a bonus of $1,500. When Elizabeth was loaned to Warner Bros. for *Life with Father*, Metro charged Warner $3,500 a week for her services but pocketed everything over $750, thanks to the patently corrupt studio system. In her role as Mary Skinner, she played the girl who wins the family's eldest son, Clarence, portrayed by Jimmy Lydon. Her performance—one of her least effective—suffered because of her mother's affair with Curtiz.

Sara took Elizabeth for a vacation in England after the wrap, and Howard stayed behind with his father. On Elizabeth's return, she resumed a crushing workload. When she at last objected to the exploitive drudgery of her childhood and adolescence, Sara shamed her for not being grateful. Elizabeth began to fall into fits of depression and call in sick, missing work. Her mother actually encouraged this behavior after discovering that Irene Dunne had "menstruation privileges"—days off during her period, provided by contract. Sara demanded the same rights for her daughter, though she never blamed Elizabeth's absences from

work on menstruation but rather on colds or sinus infections. On subsequent pictures, Sara always demanded the "Irene Dunne" clause.

Elizabeth became known as a nervous, somewhat difficult girl who might or might not show up for work. Alarmed, L. B. ordered a close watch kept on her by the studio doctors, fearing he'd lose her as Metro's top potential money earner. "She could play Dracula's daughter and draw crowds," he commented. "If the moviegoers are married, they want exactly that kind of daughter. If the moviegoer is a single girl, she wants to be just like Elizabeth. And if it's a single man, then he wants to meet Elizabeth." Innately shrewd, Elizabeth knew her value. She immediately snapped back whenever Mayer insulted her or her mother. When it was rumored she was to appear in a musical, Sara took her to L. B.'s office to inquire if Elizabeth should begin taking singing and dancing lessons. The touchy, hot-tempered executive felt that the mother was being pushy. "You're so goddamned stupid you wouldn't even know what day of the week it is," he yelled. "Don't try to meddle into my affairs. Don't try to tell me how to make motion pictures. I took you out of the gutter."

"Don't you dare to speak to my mother like that," Elizabeth said, standing up and facing the CEO. "You and your studio can both go to hell." Mayer, who had destroyed two-time Oscar winner Luise Rainer for much less, blanched and broke

into a sweat. He was stunned not only by the adolescent's anger but by her precociously foul mouth. He wisely said nothing, knowing that every studio in Los Angeles wanted her and would shell out more for her than the $30,000 he was paying. Terrified by what she'd done, Elizabeth burst into tears and ran out of the office. She collided with L. B.'s gay secretary, Richard Hanley, who let her weep on his shoulder. Sara remained in Mayer's office, doing whatever she could to pacify the Big Daddy. A message was relayed that Elizabeth should march back in and apologize, but she refused, saying, "He was wrong."

During two years of romantic misery, as Jane Powell and other teenage stars fell in love and became engaged, Elizabeth remained a wallflower. Intimidated by her lush beauty, boys didn't want to risk rejection by asking her out. She had to rely on Bill Lyon of MGM's publicity department to take her to Roddy's eighteenth birthday party in September 1946. Even there, boys shunned her. Bill noticed that she "danced constantly, but with older men."[10] Ironically, when still fifteen, she was among the top three winners as "America's Girl Friend" in a 1947 national poll, coming in behind Shirley Temple and June Allyson. A beaming L. B. announced, "Our child star has suddenly developed an elegant bosom and become a fully formed lady." Her jutting breasts caused censors to insist an orange be placed in the gap between them, and if

the cameraman could see the orange, he had to move the camera back. Studio "B.I.'s," bust inspectors, regularly patrolled her sets, ordering a higher-cut dress when too much bosom was visible, but as soon as they left, she bared as much as the law allowed, loving to exhibit her assets. Metro gave her an $18,000 raise. She posed for her first cheesecake photo at fifteen, revealing her ripening figure. "As a child I had been dying to get my period because it meant I was growing up," she recalled. "I loved every second of puberty."

As a moneymaker she was pampered shamelessly by Metro. When she sprouted a perfectly ordinary adolescent pimple, the studio rushed her to a dermatologist. When she stepped on a nail and punctured her foot, an ambulance was summoned to take her to the studio hospital, sirens blaring. Every time she developed a common cough, a full thoracic examination was ordered. Even on trips to the bathroom, someone always accompanied her out of fear she'd be raped. She quickly came to expect this kind of attention and demand it. Despite her own salty language, if anyone cursed on one of her sets, he was immediately fired.

One morning the young star sat in the makeup and hairstyling department at MGM along with Turner, Gardner, Garland, Zsa Zsa Gabor, Greer Garson, and Nancy Davis (the latter would one day wed Ronald Reagan and become First Lady of the

United States). They were all waiting for Guilaroff, and when he arrived Elizabeth told him, "My eye is bloodshot. Look. Won't it show up in close-ups?" He told her to call the studio doctor and moved on to Ava Gardner. Dr. Blanc, a studio physician, gave Elizabeth an eyewash and told her director it was okay for her to work that day. On another occasion, she complained of a nose irritation. Again Dr. Blanc was summoned, and again he said there was nothing to worry about—she could be made up and go before the cameras. Foot-dragging is a distinctive trait of troubled children, and Elizabeth, beginning in adolescence, would be late for virtually every significant occasion of her life. Lacking self-esteem, she used unpunctuality as a means of bullying others into admitting their need of her.

Once the camera was rolling, she was a consummate pro who got it right on the first take, and around Metro she became known as "One-Shot Liz," the ideal movie actress. Off-camera, however, she didn't know what to do with herself, years of child labor having robbed her of a chance to develop a life. Richard Burton, a later husband, said she was "naturally somewhat indolent, not the kind of girl one finds rushing off to play golf and tennis. She can barely move one foot in front of the other. God forbid. She just seems to find everything just too much trouble." Gorgeous on the outside, Elizabeth felt awkward and ugly on the

inside. As a result, she would always have a special affinity with anyone "who has ever felt unloved, unwanted, and ineffectual," she said.

There was never any letup in her workload. On January 16, 1948, she started filming *Julia Misbehaves* with Peter Lawford and Greer Garson, known as "The First Lady of Metro." During the shoot Elizabeth was instrumental in the meeting of Garson and her future husband, Texas oil tycoon Colonel Elijah E. "Buddy" Fogelson, whose adopted son, Gayle, had become a friend of Elizabeth's. She still had "a tremendous crush" on Lawford, now twenty-five.[11] When she turned sixteen in February 1948, Lawford and other cast members threw a birthday party on the set, giving her jade earrings and a silver choker. Metro gave her a complete new wardrobe. Though she didn't know how to drive, her parents gave her a Cadillac convertible with a set of gold keys and a miniature steering wheel on the passenger side for her to use as Sara taught her to drive. When she got her license Elizabeth gave a new meaning to the phrase "hell on wheels," driv-ing like she owned the road and sometimes, when parking, hitting the car in front of her and then backing into the one behind, walking off as if it were the other person's fault.

In her sixteenth year she reached her full growth—"five feet four and a half in my bare feet"—and her ideal weight, between "120 and

122 pounds, no more and, certainly, no less."[12] Her infatuation with Lawford was not re-ciprocated, partly because L. B. warned him of dire consequences should he involve the underage starlet in scandal. Nonetheless, their scenes together in *Julia* were so romantic that the studio decided to continue casting her in mature roles. As a result, she succeeded in bridging a crucial point, adolescence, when most juveniles—Claude Jarman Jr., Butch Jenkins, Jane Withers, Peggy Ann Garner, Margaret O'Brien—stumbled and disappeared from the screen. Unfortunately, Guilaroff tried to make Elizabeth look too mature, slathering on makeup and fussing with her hair. *Time*'s critic complained that although she was "one of the loveliest girls in movies, here she is made-up and hair-done and directed into tired, tiresome conventional prettiness."[13] Shooting on *Julia* was completed on April 9, 1948, and it was an instant hit after opening the following October at the Radio City Music Hall. Otis L. Guernsey Jr., the *New York Herald Tribune* reviewer, called Elizabeth "one of the cinema's reigning queens of beauty and talent."

Despite professional success, she remained lonely, isolated, and restricted at home. Her brother's friends still referred to her as "Howard's kid sister who is in films." According to Debbie Reynolds, whom she met that year, Elizabeth wanted simple things like drive-in dates "that would never happen in her life." Mary Astor

blamed Elizabeth's "cool and slightly superior" demeanor. Again playing Elizabeth's mother in *Little Women*, Astor found her to be "smug" and unlikable.[14]

In lieu of beaux, Elizabeth practiced kissing every night after she went to bed, hugging and smooching a smooth satin pillow, pretending it was Gable, Lawford, Robert Stack, or Marshall Thompson. Years later Elizabeth said her first *mature* screen kiss, apart from Lassie's licks, Py's nuzzles, and Jimmy Lydon's childish peck, came from Stack, her *Date with Judy* costar, in October 1947. Though she found the blond, well-built, socially prominent actor to be "occasionally patronizing," she added, "I was kissing Bob Stack and I loved it."[15] Jane Powell was the star of the picture, but Elizabeth walked off with it, playing a snooty, man-stealing teenage minx with such sexy insouciance that the *Herald Tribune*'s Guernsey saw in her "a real, 14-carat, 100-proof siren with a whole new career opening in front of her." Fan clubs sprang up. Between June and November she received 1,065 invitations to college proms—but still no dates.

At last, lanky, likable, curly-haired Marshall Thompson, in his own low-key way as sexy as Stack, asked her out. Born in 1925, Thompson began his career playing juveniles in *Gallant Bess* and *The Romance of Rosy Ridge* in 1945 before graduating to more serious roles in *Battleground* and the

TV series *Daktari*. Chaperoned by her mother, Elizabeth went with him to the premiere of *The Yearling*, MGM's major film of the year. Later he visited the Taylor home, and Elizabeth tried to vamp him by dressing up like Jennifer Jones in *Duel in the Sun*, wearing hoop earrings, a peasant blouse, and a full skirt with a cinched waist. It worked. Thompson held her hand, gazed into her eyes, serenaded her with Frankie Laine's hit "Golden Earrings," and then gave her a probing kiss she wouldn't forget. Janet Leigh, one of Elizabeth's *Little Women* costars, remembered going to a weekend beach party at the Taylors' Malibu rental along with Thompson, Roddy, Lawford, Van Johnson, June Allyson, and Dick Powell, and described Thompson as "gentle and sensitive and nice." At a Christmas dance, Thompson kissed Elizabeth under the mistletoe. When she later described the memorable buss to Richard Burton, he flew into a jealous rage and subsequently confronted Thompson, mistakenly accusing him of giving Elizabeth her first screen kiss. "No, darling," Elizabeth said, explaining that Thompson's kiss was *"real"* and decidedly "offscreen." Burton said, "Well, that makes it even worse."[16]

Marshall Thompson remembered Elizabeth as being "shy and quiet" with a "fully developed female body." They went dancing at the Coconut Grove and the Trocadero, and on Sundays they went to brunch at Roddy's house. Inspired, Eliza-

beth turned her daydreams into poetry, writing a verse called "My First Kiss." "Heavenly bliss," she wrote, would come "if only you'd love me . . . Our hearts would tenderly kiss, I would know how happy I would be."[17] Metro toyed with the idea of costarring her and Thompson as a romantic duo but finally decided that, though Thompson was seven years her senior, he wasn't sufficiently mature to be a leading man. The studio eventually dropped his contract. He and Elizabeth drifted apart, and he married a girl named Barbara Long. Elizabeth remained friends with both of them. Janet Leigh, who was having an affair with Barry Nelson, recalls double dating with Elizabeth and Tommy Breen, son of the chief Hollywood film censor, and later with Elizabeth and Arthur Loew Jr., a rich playboy whose grandfathers, Marcus Loew and Adolph Zukor, had founded MGM and Paramount, respectively. Resembling James Woods and Peter Weller—blond, lean actors of a later generation—Arthur Jr. produced Paul Newman's *The Rack* and dabbled in writing at Metro. Janet Leigh described him during his dates with Elizabeth as "natural, easygoing . . . comfortable in all situations, and blessed with a superior sense of humor," but Joan Collins, a later girlfriend, left him because she found their relationship too platonic. In 1948, Arthur owned one of the few TV sets in L.A., and on Tuesday nights Elizabeth came to his apartment to watch "Uncle Miltie" on *The*

Texaco Star Theater, often joined by Shelley Winters and Farley Granger. Elizabeth never regarded the young Loew heir as a steady date. She found herself more intrigued with older men. Metro promised to team her with such established stars as Robert Taylor and Clark Gable once she successfully negotiated the chasm between juvenile roles and adult stardom.

Though she had long been hailed as a world-class sex kitten, she wouldn't begin to go steady until summer 1948. Former West Point football star and Heisman Trophy winner Glenn Davis, now an army lieutenant, was brought to dinner at the Taylor home by Hubie Kearns, the husband of Metro publicist Doris Kearns. A USC track star, Hubie had appeared as an extra in Davis's low-budget film debut, *The Spirit of West Point*. Everyone was agog to be this close to the legendary all-American halfback, who was known as "Mr. Outside" and was handsome and built like a god. Davis had distinguished himself on the same army team with "Doc" Blanchard, the equally legendary fullback known as "Mr. Inside." They'd both appeared in the West Point film, but it brought movie stardom to neither.[18]

"I don't remember much about that night," recalled Davis, who was in L.A. on leave and to play exhibition football with the Rams before being shipped to Korea for two years. "I just stared at Elizabeth," he added, "and I think she stared

back."[19] There was plenty for both to take in: Elizabeth looked ripe and curvy in her jeans during a game of touch football on Malibu Beach, and the twenty-three-year-old Davis was tall, with reddish-brown hair and a winning smile. Soon he was a regular at the beach house. "He was so wonderful—ye gods!" Elizabeth said.[20] As they strolled in Los Angeles one day, she paused at a jewelry store window to admire a necklace of sixty-nine graduated pearls. Davis bought it for her. Later, at Davis's exhibition football games, while other fans chanted, "We want Davis! We want Davis!" Elizabeth stood in the stands in his letter sweater yelling, "I want Davis!" Turning to her startled mother, she added, "And don't think I don't I mean it."[21]

Janet Leigh, who was now seeing Arthur Loew Jr., double dated with Elizabeth and Davis and later said that Elizabeth had been so starved for romance that she mistook Davis's moderate interest in her for undying love. Some observers felt Davis wasn't aggressive enough, that Elizabeth was ready for him to become "Mr. Inside" instead of "Mr. Outside." "I should have fallen for a busboy," she said, sounding testy and impatient when a reporter quizzed her about Davis. All too soon, the army shipped him off to the Korean front, but they wrote to each other, and she wore his gold football around her neck for seven months.[22]

During his absence, *Little Women* began production in June 1948 with Elizabeth playing the role that Joan Bennett, her future film mother in *Father of the Bride*, played in a 1933 David O. Selznick production of the sentimental Louisa May Alcott classic. Selznick had changed his mind about remaking the film with Jennifer Jones and Shirley Temple. One day, Elizabeth announced her engagement to Davis without even consulting him, telling a reporter they were "engaged to be engaged." Years later, Davis issued an amazing denial, stating, "That wasn't at all the case. We were neither engaged nor 'engaged to be engaged.'" Elizabeth bored her costars by reading Davis's love letters aloud on the set and confessed, "I liked playing the role of a young woman in love."[23] The husky-voiced, thirty-one-year-old June Allyson, who was married to Dick Powell and expecting a baby, played Elizabeth's teenage sister Jo March, and later recalled that Elizabeth was "crazy" about Davis and intended to marry him as soon as he returned from the Korean War. "There wasn't anything about being married that she didn't want to find out," said June.

Two months later, in October 1948, Elizabeth sailed aboard the *Queen Mary* for England and her first adult role in *Conspirator*. Though still only sixteen, she played a twenty-one-year-old American debutante in London who unknowingly marries a communist spy, played by thirty-eight-year-old

Robert Taylor. When she arrived at Claridge's she found a bouquet of red roses from Davis, who was still writing her from Korea. Though now earning $4,000 a month, she was chaperoned by both her mother and Mrs. Birdina (Andy) Anderson, her Metro tutor, who continued to coach Elizabeth in her worst subjects, English, algebra, and history. Weary of being watched and supervised, Elizabeth said her parents loved her "too much. They had no lives of their own, especially my mother." How could she focus on school, Elizabeth wanted to know, "when Robert Taylor keeps sticking his tongue down my throat?" In their clinches Elizabeth fantasized that Taylor was Davis, while Taylor worried about how to conceal his erections, later instructing cameraman Freddie Young to shoot him from the waist up. Patricia Neal, who was in London filming *The Hasty Heart* with Ronald Reagan, overheard Robert Taylor tell Elizabeth, "If you don't shave those legs, I'm going to shave them for you."[24]

The public wasn't yet ready to accept her as an adult. When released in 1950 *Conspirator* bombed at the box office, but *Variety* applauded her first effort in a romantic lead, writing, "Elizabeth Taylor comes out with flying colors." Metro was ecstatic, especially when her bathrobe fell open during a scene with Robert Taylor and the full extent of her breast development became apparent. Viewing the rushes, rutting studio executives rejoiced at the

evidence of a full-blown love goddess and the promise of a string of box-office bonanzas. Executive Ben Goetz thought her "so beautiful and so capable there's no doubt she will develop into one of the greatest stars the screen has known." Since it was still the post-Victorian, pre–1960s era of timidity, prudishness, and censorship, MGM reluctantly decided to scrap the scene and have it reshot. The original negative was destroyed.

One day she met British matinee idol Michael Wilding, who was filming at the same studio and had eyes that were aqua-blue, her favorite color. Until then, she'd been writing Davis nightly, but soon she was haunting Wilding's set. Though smitten by her beauty, he remained somewhat aloof, mindful that he was thirty-six and she was sixteen. Estranged from his wife, actress Kay Young, Wilding was dating the bisexual Marlene Dietrich, and he'd been emotionally attached to Stewart Granger since they'd first met in 1930. Wilding had every reason not to complicate his life even further, and noted that Elizabeth "was writing to her soldier boy and among other things she was going to balls. Lord Mountbatten gave one for his daughter Pamela, and on that occasion I was very aware of young Miss Taylor dancing with Prince Philip."[25] Earlier, at a command performance of Metro's *That Forsythe Woman*, Elizabeth had been presented to the Prince; his new wife, Princess Elizabeth, the future Queen of England;

and her parents, the reigning monarchs. Standing in the reception line next to Myrna Loy, Elizabeth said she was sick from food poisoning and afraid of throwing up on the King. As Their Majesties approached, Myrna reassured Elizabeth by saying she felt a little queasy herself, and the introductions went off without a hitch.

On leaving for America, she stood on tiptoe to kiss Wilding goodbye. "I kissed her very thoroughly," he recalled. Back in the United States, she celebrated her seventeenth birthday on February 27, 1949, at a party at her great-uncle Howard Young's home on Star Island, near Miami Beach. A well-known and very successful art dealer, Young had long been a mentor of Elizabeth's father, Francis, and had helped him get established in the art world. Though Elizabeth's parents had always benefited from Young's largesse, Francis had never duplicated Young's success, and at present was almost entirely dependent on Elizabeth for money.

At Young's lavish resort home, Elizabeth met William D. Pawley Jr., who was twenty-eight, rich, socially prominent, and more attractive than most movie stars. With her mother's full approval, she began to date Pawley though still supposedly engaged to Davis. When the latter arrived in Miami on furlough, she met his plane at Miami airport and secretly proceeded to see both Pawley and Davis in Florida, at the same time giving an occasional thought to Wilding. Pawley threw her and Davis a

lavish dinner party. "The guy was real slick," Davis said. "He showed her a better time than I did . . . I had no civilian clothes with me, and not very much money." Davis was worth $20,000 at the time, certainly no pauper but hardly in the same league with a millionaire. He had brought along a ruby-and-diamond engagement ring that was a miniature of his class ring at West Point, but when he realized the game Elizabeth was playing, he said, "Screw it." Clutching the spurned engagement ring, he left Miami in a huff. Elizabeth subsequently rang him and said, "Please do me one last favor and take me to the Academy Awards."[26] Having announced their engagement to the world, she was reluctant to face the press at the Oscars without him. On Oscar night he wore his army uniform, and she was resplendent in a beaded gown designed by MGM's Helen Rose, who'd created her clothes for *Judy*.

They were among the most photographed and cheered couples arriving at the Academy Award Theater on March 24, 1949, for the twenty-first annual Oscar ceremony, emceed by Robert Montgomery. Lieutenant Davis looked uncomfortable when a photographer told him, "Give her a big smooch," but he complied, blushing in embarrassment and vexation. During the program in the Academy's 950-seat screening room, Elizabeth glided on stage to present the Oscar for best costume design for a black-and-white picture, and the orchestra struck up "Did You Ever See a Dream

Walking?" For a moment Hollywood, troubled over a U.S. Supreme Court ruling divesting the studios of the theater chains that accounted for fifty percent of their profit, was again the carefree capital of glamour. Elizabeth returned to her seat next to Davis but ignored him and turned to gossip with Ronald Colman, who was seated behind her. Davis looked thoroughly bored. At the end of the evening they said goodbye for the last time. Years later, Elizabeth told her stepson, Mike Todd Jr., "It had all been arranged by Metro for publicity purposes."[27]

A *Time* cover girl in 1949, Elizabeth was on a roll and could have had any man she wanted, including notorious playboy, industrialist, and test pilot Howard Hughes. Tall, dark-haired, and handsome, the forty-five-year-old Hughes had recently acquired a film studio, RKO, and already owned Hughes Aircraft Company in Glendale, California; Hughes Electronics, the largest supplier of weapons systems to the air force and navy in WWII; Hughes Helicopters; and a substantial chunk of TWA. He was equally well-known for his ubiquitous conquests of Terry Moore, Joan Crawford, Bette Davis, Olivia de Havilland, Katharine Hepburn, Marilyn Monroe, Jane Russell, and Gene Tierney. Indefatigable, he now went after Elizabeth, flying her and Sara to Lake Tahoe for the weekend, and offering a six-figure dowry if Elizabeth would marry him. He also bought expensive

works from her father's art gallery. Though Hughes had Sara on his side, Elizabeth brushed him off as an obvious weirdo. "He needed a bath," she recalled. "I always knew what I wanted and what I didn't want. Somebody hitting on me made no difference to me. Unless I was interested in them, they could go take a Flying F. I'm not one to be pushed around." Nevertheless she attended a party Hughes gave for Jean Simmons at the Beverly Hills Hotel at which Elizabeth and Jean, who looked like twins, formed a fast friendship; neither saw Hughes all evening.[28]

Not long after Elizabeth's romance with Glenn Davis, and the truncated one with Hughes, Sara began promoting Elizabeth's old suitor Pawley as a potential husband, calling him "brilliant, understanding, strong, poised . . . and full of fun." In May mother and daughter went to Florida to visit the Pawleys at their Sunset Island home. Elizabeth accepted an engagement ring from Pawley the day after they arrived. The $16,000 ring had a 3.5-carat emerald-cut solitaire diamond flanked by two half-carat diamonds. Sara did all the talking at the forty-five-minute press conference she called on June 5, 1949. Bill Pawley sat in stony silence as Elizabeth flashed her diamond for reporters, calling it a "nice piece of ice." According to one of the Florida reporters present, Pawley cringed. His family had already objected to Elizabeth as vulgar.

Mesmerized by Pawley's dark, hirsute sensual-

ity, Elizabeth appeared to agree when he insisted she give up Hollywood, telling reporters she was bored with making movies and would rather "make babies" with Bill. It sounded fine in theory, but when Metro sent emissaries to lure her back, she chose career over Pawley. Sara convinced her future son-in-law to be patient until Elizabeth finished two more film commitments. The first, *The Big Hangover*, was undistinguished, but Elizabeth liked her new salary, $2,000 per week, and her costar Van Johnson. *Father of the Bride*, her second commitment, was one of Metro's most valuable properties, scheduled to start filming January 1950. A third offer turned up unexpectedly, and it was too good to resist. George Stevens, one of the best directors in the world, wanted to cast her in *A Place in the Sun* opposite the number one male star in Hollywood, Montgomery Clift. Paramount arranged to borrow her from Metro. It meant losing Pawley, who walked out on her after they attended Jane Powell and Geary Steffen Jr.'s wedding on September 17, 1949. Elizabeth caught the bridal bouquet and went nightclubbing at the Mocambo with the wedding party.

Nicky Hilton, heir to the hotel fortune, saw her at the Mocambo and found that he couldn't get her out of his mind. He began plotting ways to meet her, trying to use some of his father's influential friends to arrange it. For a while, Elizabeth remained completely unaware of his interest. She

blew off her Pawley fling with the flip remark, "We went well together under the palm trees."[29]

And then she met Montgomery Clift. Though Nicky wanted to marry her, it was Monty who touched her heart.

2

Montgomery Clift:

She'd been in a hurry to get married, partly due to lack of self-esteem, and partly to get away from an oppressive atmosphere at home. Of all the men she'd known so far, the one Elizabeth was most serious about was Monty Clift, an intense, brooding, and startlingly good-looking actor who in the 1940s was the forerunner of a new breed of giants who'd ultimately dominate the industry and change the art of movie acting. Monty pioneered a style that was edgy, intense, mutely eloquent, and bristling with a sense of barely contained violence, and in his wake would come Marlon Brando, James Dean, Dustin Hoffman, Robert De Niro, and Al Pacino. Professionally Monty seemed like a god to Elizabeth, and personally he was the kind of sensitive man she'd been looking for without even realizing it.

Discussing their relationship in 1997, she said,

simply, "I loved him," quickly adding, "but I knew from *A Place in the Sun* that he was gay—probably even more than he did. And I helped him with it. Which is extraordinary because I was only about sixteen, and I didn't really know anything about it. I turned seventeen during the filming of that movie." The charismatic twenty-nine-year-old Monty was described in January 1999 by his close friend Jack Larson, a Hollywood contemporary who played Superman's friend Jimmy Olsen in the popular TV series, and who for many years was the companion of the late James Bridges, director of *Urban Cowboy* and *The China Syndrome*. Interviewed in his vintage Frank Lloyd Wright house perched on a cliffside in Brentwood while he petted and attempted to train his romping, high-spirited, eighteen-month-old dog Dewey, Larson asked rhetorically, "What was Monty like when he first knew Elizabeth? Exuberant. But he was in no sense effeminate. He wasn't worried about being gay. He was bisexual. Monty had an affair for years with Libby Holman [the Broadway torch singer, accused husband-killer, and Camel cigarette heiress]." When asked if Monty was bisexual with Elizabeth, Larson replied, "No, he liked older women. He had a relationship with Myrna Loy. Elizabeth was in love with him and a wonderful friend to him—always. He loved her and called her Bessie."

Another friend of Monty's, Frank Taylor, who produced Monty's 1961 film *The Misfits*, insisted in

a 1999 interview in Key West, "Monty was gay, not bisexual. He was obviously very much in love with his best friend, Kevin McCarthy, something that's always been denied. They weren't lovers, but Monty wanted him very much. Monty also loved Kevin's lovely wife, Augusta Dabney, but as family. Kevin and Augusta had children together and later divorced, and she married [actor] William Prince. During location filming of *The Misfits* in Dayton, Nevada, Monty became close to John Huston's stepmother Nan Huston, but I never saw any sign of bisexuality. Nan was in her seventies, and had been married to Walter Huston, John's father."

Even before Elizabeth and Monty started filming *A Place in the Sun*, Paramount was determined to build the two beautiful young stars into a romantic legend, ordering the reluctant Monty to escort Elizabeth to the world premiere of his latest film, *The Heiress*, in which he costarred with Oscar winner Olivia de Havilland. Monty was so terrified of the prospect of his studio-enforced date that he made his drama coach, the dour Mira Rostova, tag along as a chaperone. Hoping to impress Monty, Elizabeth went to Helen Rose for something "sexy and sophisticated," and Helen gave her a strapless net gown and a snowy fur cape. When Monty came to pick her up that night, Sara greeted him at the door and was so overwhelmed by Hollywood's hottest property that she began gushing.

"Sorry about mother," Elizabeth said later in the limo. "She can be a real pain in the ass." Press agent Harvey Zim, who accompanied them along with Rostova, later explained, "She looked ravishing, and she was so foul-mouthed and unconcerned about going to this premiere that everybody else relaxed in the limousine too." Zim and Rostova got out two blocks before they arrived at Grauman's Chinese Theater (later renamed Mann's), and Elizabeth and Monty then made a romantic entrance on their own. An Associated Press photographer caught her adjusting Monty's tie after they stepped out of the limo onto Hollywood Boulevard. Their legions of fans erupted into a near-riot, and Elizabeth and Monty smiled into a hail of flashbulbs as they made their way up the red carpet laid over the hand- and footprints of generations of movie stars in the courtyard of Grauman's. Waving to the hysterical crowd, they finally disappeared into the zany, pagoda-like theater.

Already a veteran of countless premieres and screenings, Elizabeth had learned from Gable and Spencer Tracy to assume an expression of bland nonchalance while watching herself on screen, but Monty started writhing in horror as soon as the picture began, scrunching down in his seat until he was reclining on his coccyx. Trembling, he grabbed her hand, surprising her, but she immediately intuited his need and leaned over and whispered, "You're great. You really are." He groaned,

"Oh, God, it's awful, Bessie Mae." When she asked later why he called her "Bessie Mae," he replied, "The whole world calls you Elizabeth Taylor. Only I can call you Bessie Mae." The movie ended with its startling *in medias res* shot of Monty pounding on Olivia's bolted door in Washington Square, and the audience burst into applause and bravos. When an enthusiastic crowd gathered around Elizabeth and Monty, he sprang from his seat and said, "Let's get out of here, Bessie Mae!" He was glowing with elation.

They went on to a party at director William Wyler's Hollywood mansion, which was bedecked with fresh flowers and aglow with hundreds of candles. As they chatted with Gary Cooper, David Niven, and Selznick, a guest who observed them from the patio later recalled, "Together they were a blinding flash of gorgeousness. Elizabeth's perfect features were almost freakish—until you were sucked into them like a black hole. Lavender eyes with double lashes—glamorous, mysterious, enigmatic. And Monty! That long ecstatic El Greco face—Prince Myshkin in Dostoyevsky. She was the goddess of creation and destruction, he could have been the messiah or a serial killer."

Elizabeth asked Monty to dance and was dismayed when he refused, pleading he didn't know how. Later, when they danced so gracefully together in *A Place in the Sun*, he explained that he could only dance when acting. Her beauty aston-

ished him, and he later told photographer Blaine Waller, "Her tits! They are the most fantastic." Elizabeth and Monty, with their dark hair and stunning eyes, looked like twins, and indeed he was her counterpart in profound ways: they'd both been child actors who'd rarely if ever played games with other children, and both felt emotionally lost and disenfranchised, but at the same time enormously enthusiastic about life and hungry for experience. Jack Larson observed in 1999 that Monty's *joie de vivre* had been downplayed in previous biographies in favor of a dark, morose portrait. According to Larson:

"Monty Clift in life was more like Jerry Lewis than Monty's screen persona, which was introverted and serious. Libby Holman often referred to his 'divine madness.' He was a very serious actor though he always looked for the comedy in parts. His nature was essentially comic, always joking and having fun and doing wildly comedic things. The best example was when he and Libby Holman went to Europe with Kevin McCarthy and his wife, Augusta [shortly after *Sun*]. Monty usually didn't sail first-class because he liked to mingle with people, but Libby always traveled first-class. Since they were having their great affair, they went first-class on the *Queen Elizabeth*. They sailed to Europe, but Monty didn't enjoy the trip. When they were sailing back, he disappeared for several days. They'd see him at meals, but he wasn't spending

time with them. They were out on the first-class deck sunning in their chaise longues, and one day Monty suddenly reappeared. Libby said to him, 'What's the matter, Monty, does our company bore you?' Monty said, 'Yes I'm so fucking bored with this trip that I decided to walk home.' He jumped overboard. They ran to the rail. What he'd been doing the days he was incognito was preparing his joke, his divine madness. He'd been practicing in the ship's gym to be able to do this stunt and grab the rail. Kevin McCarthy had a camera and Kevin got the picture which Libby had framed in a beautiful silver frame of Monty 'walking' home. He was hanging from the rail and 'walking.' He was always doing something like that. He was more fun, and he was brilliant. Elizabeth Taylor found him generous and warm, an overwhelmingly affectionate friend who would always be there for you."

She was drawn to him not only spiritually and intellectually but professionally. A budding rebel herself, she venerated him as the first Hollywood figure to defy the powerful studio system and win. Having resisted studio pressure to play conventional romantic heroes, he was at the zenith of his career as a loner and renegade, playing such complex offbeat characters as Steve, the idealistic GI who befriends little Karel, an orphaned survivor of the Holocaust, in Fred Zimmerman's *The Search*, and Private Robert E. Lee Prewitt, the ultimate 1950s outsider, in *From Here to Eternity*.

Elizabeth had been an instinctive child star, an innocent who acted straight from the heart, and later a pretty starlet in lightweight films who never thought much about her dramatic potential. Her part in *A Place in the Sun*, drawn from Dreiser's novel *An American Tragedy*, was a challenge—that of Angela Vickers, a rich girl who comes between George Eastman, played by Monty, and Alice Tripp, a poor factory girl he's gotten pregnant, played by Shelley Winters. It was acting for which Elizabeth had no proper training or experience. When shooting commenced at Lake Tahoe in October 1949, Stevens ridiculed her timid efforts, pointing out that this was not *Lassie Comes Home to a Place in the Sun*. He made her leap into the icy lake for a scene with Monty, take after take, until Sara screamed that Elizabeth would never be able to have babies. "As far as I know," Shelley Winters later commented, "Elizabeth never stopped having babies." Under Stevens's relentlessly exacting direction, Elizabeth finally started sobbing and ran from the set. Monty rushed to her rescue. In the following days, he began to teach her how to project an air of mystery and fascination in her role. He told her to hold back some of her energy and power, sharing his theatrical training with her. Jack Larson explained in 1999 what that training consisted of:

"He was very knowledgeable. He had been given an education from great people; he learned

from Thornton Wilder, in whose *Skin of Our Teeth* Monty appeared on Broadway. He'd played Henry, Mr. Antrobus's son [he also appeared as George Gibbs in Wilder's *Our Town* on Broadway in 1944], and Wilder adored him obviously and shared anything he knew with Monty. And then he worked with Alfred Lunt in *There Shall Be No Night*. All that he knew from Lunt about acting he was very generous with; also he was an instinctual actor." Though Monty was never a member of the Actors Studio, he was directed by Elia Kazan, one of the pioneers of Method acting, in *The Skin of Our Teeth* in 1942, and would be the first of his generation of actors to popularize the moody, self-conscious style later exemplified by Brando, Dean, Kim Stanley, Shelley Winters, Ben Gazzara, Paul Newman, and Geraldine Page. In Monty, Elizabeth had found a master teacher.

"It was my first real chance to probe myself," she recalled, "and Monty helped me . . . It was tricky because the girl is so rich and so spoiled it would have been easy to play her as absolutely vacuous, but I think she is a girl who cares a great deal." She began to study Monty, noting that the key to his acting was "concentration." During a scene, he'd become so emotional that he'd lose control of himself physically, and she found this to be contagious. When he would start to shake, she would start to shake. "Monty is the most emotional actor I have ever worked with," she said.

Sexually, she was intrigued and mystified, but some instinct told her to go slowly. "I really didn't know then what being a homosexual was," she recalled in 1997. "But I just knew . . . well, I don't know how I knew." She probably sensed it the first time Monty told her he could mimic the Angela Vickers part for her, showing her exactly how to deliver her lines, as well as demonstrating all her expressions and gestures, including her behavior in their love scenes together. While enacting her role in private sessions, he became the essence of alluring femininity, telling her that Angela possessed a great and unshakable inner conviction that she was going to succeed in winning George Eastman.

Elizabeth was equally sure that one day she'd win Monty himself, despite her intuitive awareness of his homosexuality and other difficulties he was struggling with, including his repressive Presbyterian background and Sunny, his anxious, over-controlling mother. Even when Elizabeth was exhausted after an arduous day's filming, she would make Monty a cup of tea and take it to his room. Apprehensive but flattered that a lovely woman desired him, he told her, "I've found my other half!" She begged him to rehearse her for the next day. As he acted out a love scene that was to be shot in close-up, he again took the part of Angela, and she fed George Eastman's lines to him. He did everything for her but get in drag. She gradually absorbed his interpretation of her role by osmosis, transforming

Angela from a shallow ingenue into a fascinating creature of smoldering, eternal womanliness. As Elizabeth blossomed into an actress of depth and sensitivity, she sparked Monty's best performance to date. His passive intensity, in contrast to her subtle feminine aggression, was the apotheosis of fifties alienation, setting a standard of contained, explosive energy that would galvanize American acting for decades to come. "Bisexuality . . . underpins great acting," wrote Michael Billings in his book, *The Modern Actor.* Clearly it underlay Elizabeth's emergence as an actress under Monty's aegis.

In one of the film's best-known scenes, Elizabeth appeared in a billowing white strapless tulle evening gown, one of the costumes for which Edith Head would shortly win an Oscar. Unable to contain himself, Monty breathed in her ear, "Your tits are fantastic, Bessie Mae, just fantastic." After that, she found it impossible to repress her own sexual yearnings for him. She invited him into the bathroom with her when she took one of her three daily baths, supposedly to calm her nerves. At first they just talked as he sat beside the tub. "I'm too old for you," he muttered. "I'm an old man." He gave her some Benzedrine, and soon she perked up. She felt incredibly close to him, as if she were inside him, looking out at herself. "I told him everything—even the things I'm most ashamed of," she recalled. She knew he wanted to be mothered, and she knew she could give

him that, but she could also give him much more if he'd let her.

Stevens seemed to grasp the evolving nature of their relationship and used it to good effect in their scenes together. He wrote some new lines and gave them to Elizabeth and Monty. She accepted some of the dialogue without question, for example Angela's observation to George, "You seem so strange, so deep, so far away, as though you were holding something back." She balked at "Tell Mama. Tell Mama all," which Stevens expected her to deliver at a crucial moment—just before she and Monty went into a clinch. "Forgive me," Elizabeth said, confronting the director, "but what the hell is this?" Later, Stevens recalled, "Elizabeth dissolved when she had to say 'Tell Mama.' She thought it was outrageous she had to say that—she was jumping into a sophistication beyond her time." But Stevens remained adamant, and the result was a uniquely compelling love scene that was both carnal and transcendentally lyrical. In Elizabeth's arms, Monty was enveloped by "the mothering tentacles of the world," as the film's associate producer, Ivan Moffatt, son of poet Iris Tree, aptly put it. For the Silent Generation of the 1950s, who still thought that personal transformation could be effected through romantic love, it was the most electrifying love scene of the decade, rivaled only by Burt Lancaster and Deborah Kerr's roll in the

Hawaiian surf in *From Here to Eternity*. Monty and Elizabeth lit up the screen like heat lightning. Their intimate "Tell Mama" scene became the picture's trademark and assured Stevens the directing Oscar for 1951.

Monty loved her so much that he tried to go straight for her. "For three days Monty played the ardent male with me, and we became so close," she recalled. "But just as he'd overcome all of his inhibitions about making love, he would suddenly turn up on the set with some obvious young man that he had picked up . . . I thought he wanted me to play *Tea and Sympathy* with him." In Robert Anderson's *Tea and Sympathy*, a hit play and movie of the 1950s, a headmaster's wife at a boys' prep school helps an insecure adolescent, who's been accused of being gay by his classmates, lay claim to his heterosexuality by having sex with him. According to a chauffeur who drove Elizabeth and Monty to the Paramount lot on Melrose Avenue, they made out in the back of his limo. "It was the one time Mrs. Taylor and that Russian lady [Mira Rostova, Monty's drama coach] didn't go along," the driver recalled.

They had other dates, attending a noisy Christmas party thrown by Norman Mailer, who'd rushed to Hollywood the minute his novel, *The Naked and the Dead*, had become an international best-seller. "Monty and Elizabeth Taylor and Marlon [Brando] were very uncomfortable," said Shel-

ley Winters, who explained that the party turned into a fiasco because Mailer, a newcomer to the Hollywood scene, invited too many incompatible guests, such as Humphrey Bogart and Ginger Rogers, who despised each other. No one could escape the miserable party because actor Mickey Knox's car was blocking the driveway. Monty got into a fight, and Elizabeth started to leave, only to discover that Shelley had taken her beaver coat by mistake.

Elizabeth and Monty continued to see each other. When they finally tried to have sex, he couldn't "rise to the occasion," he told one of his boyfriends. Elizabeth sensed Monty's discomfort and said, "Look, Monty, I'm always here for you— for whatever you want." Though he knew he would never find another soul mate like Elizabeth, he also knew that he couldn't stand the pressure of Elizabeth or any woman who expected him to make love to her every night. After Elizabeth he became more "campy" and "nelly," his failure with her propelling him into a fully gay life.

After *A Place in the Sun* wrapped, Elizabeth was hurt when Monty flew to New York to be with Shelley Winters and take in some Broadway plays. Years later, I asked Shelley to tell me about filming *Sun*. "You must have been very lonely making that film, with Elizabeth and Monty so close," I suggested. "Lonely!" Shelley scoffed. "I was making love with Burt Lancaster and Marlon Brando. If

anyone was lonely, it was Monty—the loneliest man I've ever known and the best actor."

After going to the theater in New York with Shelley, Monty visited Libby Holman, who thrived on the confessions of young men like Monty with sexual hang-ups. Between her torrid lesbian relationships with Du Pont heiress Louisa Carpenter Jenny and Tallulah Bankhead, Libby became Monty's new obsession.[1] He stayed with her for a while at Treetops, her lavish estate in Stamford, Connecticut, and then went on to Acapulco with Mira Rostova.

Elizabeth loved Monty so much that she later tried to help him find a stable identity as a gay. "I was eighteen or nineteen when I helped him realize that he was a homosexual," she recalled, "and I barely knew what I was talking about. I was a virgin when I was married . . . I knew that he was meant to be with a man and not a woman, and I discussed it with him . . . I tried to explain to him that it wasn't awful. It was the way that nature had made him . . . I introduced him to some really nice young gays."[2] In 1999 she added that she found him his first real lover.[3] With unwitting irony, Andrew Sarris wrote when *A Place in the Sun* was released in 1951, "Clift and Taylor were the most beautiful couple in the history of cinema. It was a sensuous experience to watch them respond to each other. Those gigantic close-ups of them kissing

were unnerving—sybaritic—like gorging on chocolate sundaes."

The film became the pivotal performance of Elizabeth's career as critics acclaimed it a classic, a reputation it sustained throughout the next fifty years of changing cinema fashions. The *New York Times*'s A. H. Weiler wrote, "Elizabeth Taylor's delineation of the rich and beauteous Angela is the top effort of her career," and the *Boxoffice* reviewer unequivocally stated, "Miss Taylor deserves an Academy Award." When Oscar nominations were announced for 1951, Monty and Elizabeth, who'd carried the picture, were both snubbed, and in 1999 she bitterly reflected, "If you were considered pretty, you might as well have been a waitress trying to act—you were treated with no respect at all." Shelley Winters was nominated in the best actress category for her starkly moving performance as the drab factory girl Monty murders in order to marry Elizabeth, but she lost the Oscar to Vivien Leigh for *A Streetcar Named Desire*. George Stevens won the Oscar for best directing.

When Elizabeth returned to Metro after her Paramount loan-out, the studio compounded the Academy's oversight by refusing to give her the more substantial roles that *A Place in the Sun* proved she could handle. She fought hard for the part of the Spanish peasant girl who could devastate men with a sultry look in *The Barefoot Contessa*. So did Jen-

nifer Jones, who went directly to director-pro-
ducer Joseph L. Mankiewicz. In the end neither won
the role, which went to Ava Gardner, who was hav-
ing an affair with Joseph Schenck, CEO of United
Artists, the studio financing the picture. Observing
industry protocol, MGM didn't dare rock the UA
boat by putting Elizabeth up for the role.

She also badgered Metro to acquire *I'll Cry
Tomorrow*, nightclub singer Lillian Roth's best-sell-
ing memoir about her struggle with alcoholism,
but the studio continued to restrict Elizabeth to
mindless, forgettable dross such as *Callaway Went
Thataway*, *Love Is Better Than Ever*, *Ivanhoe*, *The
Girl Who Had Everything*, *Rhapsody*, *Beau Brummel*,
and *The Last Time I Saw Paris*. She was a money-
maker as always, but rarely had a good actress been
so totally wasted. The acting muscle she'd devel-
oped with Monty atrophied as she meandered
through a series of mediocre films, usually playing
a cool, rich femme fatale who destroys men or
interferes with their fulfillment. She once com-
pared herself to her friend Natalie Wood, observ-
ing, "Our technique was just to know your lines,
hit your marks, and get out there and do it."[4]
There was a vast discrepancy between Elizabeth's
onscreen image and the woman she grew into. On
camera she projected an almost regal poise, estab-
lishing the classy high-fifties style later epitomized
by Grace Kelly and Audrey Hepburn. Offscreen
she was a party girl who could outdrink and out-

cuss most men, and her personal idol was the earthy queen of Italian neo-realism, Anna Magnani.

Tragically, it was the image, and not the woman, that Nicky Hilton fell in love with when they finally met in October 1949.

3

Sexual, A-loving Husbands:

NICKY HILTON AND MICHAEL WILDING

Tall, broad-shouldered, dark eyes flashing mischief and desire, twenty-three-year-old Nicky Hilton was the son of hotel magnate Conrad Hilton. From the instant he laid eyes on Elizabeth at the Mocambo the night of Jane Powell's wedding, he knew he had to have her. As vice president of the Hilton Corporation and manager of the haughty Bel Air Hotel, Nicky not only had money but powerful connections. When he found out that Elizabeth was working on a film at Paramount, he asked Pete Freeman, son of Paramount chief Y. Frank Freeman, to help him meet her. Pete later ran into Elizabeth and suggested a luncheon with Nicky. "Love it," she said, aware of Nicky's reputation as one of the world's most eligible bachelors.[1] They met at Lucy's, a Mexican restaurant across Melrose Avenue from the studio. She wore a simple violet sheath dress with a round white collar. "Miss

Taylor," said Freeman, "may I present Nicky Hilton."[2]

A *Place in the Sun* had wrapped that day, and she was feeling a bit teary, explaining, "Excuse the way I look—we just finished Monty's death scene," but Nicky's wild eyes, which were burning holes through her, lifted her mood even as they made her blush.[3] With his clean-cut looks and masculine magnetism, he was easy to like after only a few minutes, during which they discovered a common passion for hamburgers with onions, outsize sweaters, and Ezio Pinza, the *basso profundo* who'd come to Metro from his Broadway smash *South Pacific*. "I thought he was a nice, pure, all-American boy," she recalled, but something deeper in her, something torn and twisted, responded to Nicky's essential helplessness and lostness, a dark side that would eventually all but swallow her up. The product of a broken home, he'd grown up since his eighth year without his mother, Mary Barron Hilton. Nicky later became the family's black sheep—a secret heroin addict, compulsive gambler, and woman-beater. His younger brother Barron was already married. Though Conrad Hilton preferred Nicky's company—both father and son were playboys—he'd been bugging Nicky for months to get married and to start raising a family. Referring to Nicky's brother, he'd said, "Barron did it—it's the only way to succeed."[4]

At the end of their first date, Nicky asked Eliza-

beth in his beguiling Texas drawl, "May I call you, Elizabeth?" Charmed by the unfamiliar formality, she replied, "I'd like you to."[5] At home that afternoon, she tore open a florist's transparent box containing three dozen long-stemmed yellow roses and pressed her face into the fragrant petals, wondering how he'd known her favorite flower. Hovering over her, Sara read the card, "To bring back the Sun—Nick,"[6] and screamed, like someone who'd just won the lottery, "Nicky Hilton! Nicky Hilton! Oh, Elizabeth."[7]

Nicky told his father that he'd met the most beautiful girl in the world and was going to marry her, convert her to Catholicism, and sire a dozen kids with her. Conrad Hilton, who'd recently survived marriage to Zsa Zsa Gabor, greeted the news with mixed emotions. In his fifties, old enough to be her father, he'd married Zsa Zsa on April 10, 1942, expecting to get a beautiful simpleton who'd follow his orders. "Got Zsa Zsa and the Town House the same day," he crowed. Instead, he got a complex, exuberant, and mercurial woman who would spend time in a sanitarium, "a world of straitjackets, insulin shock treatments, endless injections," Zsa Zsa recalled. Being married to Zsa Zsa, Conrad once said, was "expensive," a "joke," and "like holding onto a Roman candle, beautiful, exciting, but . . . it is surprisingly hard to live the Fourth of July every day . . . Our marriage was doomed before it started." Intrigued by her virile

stepsons, Zsa Zsa later wrote cryptically, "Nicky, the eldest, was nearly seventeen, only a little younger than myself . . . I did my best to be a companion to the . . . boys."[8] When Nicky provocatively hinted he'd like Zsa Zsa to kiss him the same way she kissed his father, Conrad backhanded him across his face so hard that Nicky went staggering backward.[9] In 1944, Conrad and Zsa Zsa went their separate ways and were finally divorced in 1946. That was not the last Nicky saw of his stepmother. Zsa Zsa told me, over a meal of "Dracula Goulash" she cooked for us in her Bel Air kitchen, that she was going out with Nicky after he met Elizabeth.

After Zsa Zsa, Conrad became involved with actresses Jeanne Crain and Denise Darcel and socialites Hope Hampton and Kay Spreckles. Both Conrad and Nicky loved glamour, but the father knew from experience it was a trap. His first instinct was to spare his son the agony of a bad marriage.

Nicky was drawn to Elizabeth for the same reason his father had sought out Zsa Zsa. He wanted an ego crutch in the form of a beautiful woman on his arm to confirm his masculinity. Conrad, as Zsa Zsa discovered, had sexual problems stemming from Catholic guilt.[10] Nicky's problems stemmed from a shattered ego. Dominated all his life by his father, he'd been convinced from childhood that he'd never be a great businessman like Conrad.

"The trouble with me is that I have a millionaire dad," he said.[11] As the elder son he was the titular heir apparent to the Hilton empire, but it was his younger brother Barron who demonstrated ability to run the international hotel chain, while Nicky spent his time drinking, shooting heroin, and gambling.

Two days after they met, Nicky called on Elizabeth at home, and Sara invited him to stay for a dinner of beef and kidney pie. During the meal, Elizabeth pushed the kidneys aside, trying to find the beef. Nicky saw what she was doing, followed suit, and they both started laughing. When Sara wanted to know if he drank and smoked, he lied, saying he did a little of both. Two days later, he invited the Taylors to dinner at the Hiltons' sixty-four-room Bel Air mansion, Casa Encantada, which was located on eight-and-one-half acres off Bellagio Road. Barron and Marylin Hilton were visiting from Chicago with their two small children, and the other guest was MGM dancer Ann Miller, Conrad's current girlfriend. Elizabeth's father admired the Ming vases from China in the foyer, and Sara was agog over the fourteen-karat-gold fixtures in the mansion's twenty-six bathrooms, five kitchens, and five wet bars. When reporters later asked Sara what she thought of Nicky, she said, "He couldn't have been nicer or more charming. We couldn't have liked Nick more."[12]

After dinner, they all went out to the Mocambo

for drinks and dancing. In the following days, Elizabeth and Nicky dated constantly—going to the theater with the Geary Steffens, to a football game with Marshall and Barbara Thompson, and to dinner with Howard Taylor and his steady girl, Mara. Gossip columnist Louella O. Parsons rang Elizabeth to inquire about her relationship with Nicky. "Nothing comes off until the ring goes on," Elizabeth snapped.[13] After she'd broken up with Davis and left Pawley just short of the altar, columnists had dubbed her "Liz the Jilt." She was determined to keep the lid on her relationship with Nicky for as long as she could, hoping to avoid a backlash of bitchy publicity if this romance aborted like the others.

An incorrigible youth-seeker who couldn't get along with his wives and used his oldest son as a drinking buddy, Conrad Hilton wasn't sure he was ready to give up Nicky to Elizabeth. He complained, "Nick was suddenly incapable of good times that didn't center around his startlingly lovely, young star." Conrad had risen from humble beginnings as the son of a New Mexico merchant to found a hotel empire so vast and illustrious that by 1949 it included the Waldorf-Astoria, New York's flagship hotel. Zsa Zsa once described Nicky as "a young Conrad, proud, stubborn, hard to control."[14] Shortly after Elizabeth and Nicky met, Conrad insisted that Nicky, always his favorite son, accompany him to a party marking the opening of

the first of his international hotels, the Caribe Hilton, in San Juan, Puerto Rico. Nicky wanted to stay in L.A. with Elizabeth, but Conrad warned him that he'd fallen in love with a "photograph" rather than a woman and was moving too fast.

The domineering Conrad finally coaxed Nicky into coming with him to San Juan but soon realized his mistake. Obsessed by Elizabeth, Nicky no longer was an amusing sidekick for Conrad, who began to spend more time with Ann Miller. After hearing reports of Nicky's playboy proclivities, Francis Taylor urged Elizabeth not to rush into an engagement. At Christmas, the Taylor and Hilton families flew together to Arrowhead Springs, where Conrad owned a luxurious hotel. There, Nicky and Elizabeth were inseparable. He took her down the toboggan run, holding her closely, and later everyone went sailing on the big lake. Conrad put up a majestic Christmas tree in the lobby and another in his suite. On Christmas morning, Nicky gave Elizabeth dangling diamond earrings set in clusters of pearls, and she gave him a gold ID bracelet. Taking Francis aside, Nicky asked permission to marry Elizabeth. Francis gave his blessing, though Elizabeth was not yet eighteen and still hadn't graduated from high school. The Little Red Schoolhouse solved that problem by arranging for Elizabeth to acquire a legitimate high school diploma. At University High in West L.A., she was abruptly planted in a midterm graduating

class. In white cap and gown she was graduated the final week of January 1950. "She wasn't one of the class, really," recalled Debbie Reynolds. "It was more like making a personal appearance."[15]

Nicky attended the graduation ceremony, but Elizabeth still felt like an outsider, a total stranger to the other graduates, who were laughing and chatting and hugging one another. Her haphazard education would hound her throughout her life, especially in the sixties when she would find herself among the intellectuals of the British stage.[16] After graduation, Nicky took her to the Mocambo and told her, "What I want to be is your *husband*. Will you marry me, Elizabeth?" Remembering her conflict with Pawley, she brought up the matter of her movie commitments, but Nicky told her, "I like your career." Guessing, correctly, that Francis had already told her of his intentions, Nicky called her a "little ham, acting so surprised," and insisted they set a date. As they swayed in each other's arms on the Mocambo's postage-size dance floor, Elizabeth said, "In May. In May. Early in May. Say the fifth. Is that okay?" Nicky agreed, exclaiming, "I get the most wonderful girl in the world. You know, when you marry a Catholic, it's forever, Elizabeth."[17] She said she was ready to begin her instruction in the church immediately. As he gave her a lingering kiss, everyone in the nightclub burst into applause. The next day, Sara started drilling her in the catechism.[18]

As rumors of Elizabeth's engagement circulated in the press, business picked up at Hilton hotels all over the world, and Conrad Hilton let his desire for free publicity override his better judgment. He came to believe Metro's publicity leaks about the movie princess's fairy-tale romance. One evening, he invited Elizabeth and Nicky to dinner at Casa Encantada, hosting a five-course meal served on solid gold plates by waiters in tuxedos. She was grateful to have his blessing. Indeed Conrad seemed almost unduly eager to have Elizabeth in the family. "He was probably a little jealous," said Ann Miller, who added, "he'd like to be in his son's shoes." At Nicky's urging, Conrad broke the news of the wedding date in the press, blurting to an inquisitive reporter who'd asked him if the couple were serious, "Serious? Of course they're serious. They're going to get married on May 5." Elizabeth was furious, and Louella O. Parsons apologized to her, whining that Conrad himself had given her the scoop.[19]

Yet Elizabeth also had a premonition of disaster, confiding to columnist Olive Wakeman, "Everything is against us." Though she knew Nicky was eager to get her pregnant, she defiantly announced, "We don't want children for two years yet. Nick and I want to have fun." Unimpressed, Esther Williams predicted that Elizabeth would have a baby between every two pictures, but Elizabeth said, "Esther, that's enough . . . I've never been

talked to like this in my life."[20] During an interview with Jean Porter in 1998, I asked, "Why on earth did she marry Nicky?" Jean said, "She wanted to get off on her own. She liked her parents but wanted some independence." Elizabeth herself later admitted that she'd at last surrendered to lust, "driven by feelings that could not be indulged outside marriage."[21]

On February 20, 1950, Nicky gave her a five-carat diamond engagement ring and diamond-and-emerald teardrop earrings. Seven days later, she turned eighteen and invited Monty to her wedding, which was timed to coincide as nearly as possible with MGM's June 6 release of *Father of the Bride*. Aggressively macho as well as a racist and a male chauvinist, Nicky had alienated Monty, who said, "Bessie Mae, I don't think dear Nicky is my kind of guy."

"When I'm married, will you come to see us?" she asked.

"I don't think so, Bessie Mae," he replied.

"I thought you were always going to be my friend, my good, good friend," she said, slamming down the receiver.[22] When she kept calling Monty in New York, describing the thrill of being courted by a robust and dashing fiancé, Monty, loving her but knowing he could never satisfy her, was rattled and shakily downed big highball glasses full of Jack Daniels after each call.

On February 21, the Taylors gave a formal tea at

home to announce their daughter's engagement. Elizabeth still had misgivings. Ironically, she shared them with Spencer Tracy and Joan Bennett, her screen parents in *Bride*, instead of her real parents. "I felt sorry for Elizabeth," Joan told me. "I played her mother in *Bride* and *Father's Little Dividend* because our coloring was the same. Nicky was nuts. Spence knew it but didn't have the nerve to warn her off. Who did? She was bent on matrimony at any cost—on the rebound from Montgomery Clift and upset that Jane Powell had beat her to the altar. Nicky had no interest in her work, which is very important to Elizabeth. When she offered to introduce Nicky to Spence and me, he said, 'Skip it.'"

Elizabeth's leading man in *Bride* was thirty-year-old Don Taylor, a former drama major at Penn State who'd hitchhiked to L.A. and then left to serve in WWII, appearing in *Winged Victory*. On screen, he and Elizabeth were made for each other. Metro decided after *Bride* to team them in a series of newlywed films.

Francis Taylor didn't approve of Elizabeth's proposed conversion to the Catholic faith. In April Elizabeth, too, had second thoughts, after learning that she'd have to sign an oath promising to bring her children up in the church. At Metro, which was performing corporate somersaults to support her wedding because of all the free publicity for

Bride, Pandro Berman predicted a flare-up of what he called Elizabeth's "crazy defiance."[23] The couple reached a compromise, and on April 15 an announcement appeared in newspapers stating that though the wedding ceremony would be Roman Catholic, Elizabeth would remain Protestant. Journalists warned Sara that Nicky was a drunk, but she continued to give her blessing to the marriage, as did Metro. "Mr. Mayer liked to make big publicity splashes out of marriages," recalled Hedy Lamarr, who'd defied L. B. when she'd eloped to marry scenarist Gene Markey.

When L. B. was ousted as chief of Metro, the effects were felt on the set of *Bride*. Mayer's successor, Dore Schary, foolishly insisted on Jack Benny for the role of Elizabeth's father, but fortunately director Vincente Minnelli fought for Tracy and saved the picture. Tracy, like Elizabeth, was one of the industry's rare one-take wonders, according to Eddie Dmytryk, who directed Tracy in *The Mountain*. "Tracy got nasty when he got drunk, like Richard [Burton], but Spence only drank once in a while—a periodic drinker—and most of the time, he was perfectly fine on the set, spoke his lines, never had a drop, the kind of a guy you didn't have to check on pace. He understood pace, which a lot of actors don't." Francis Taylor said he envied Spence, because all the actor had to do was pretend to be the father of the bride. Being the real thing

was enough to bankrupt a man. To help with expenses, Metro office workers chipped in and paid for the cost of the bridesmaids' dresses.

The Taylor-Hilton wedding was the great celebrity event of 1950, held at 5 P.M. on Saturday, May 6, at the Church of the Good Shepherd in Beverly Hills—"Our Lady of the Cadillacs," as it was known, because of the richness of the parishioners. Stalled traffic clogged Santa Monica Boulevard for miles. "The whole more-stars-than-there-are-in-the-heavens crowd was out," recalled Joan Bennett, "the whole Metro gang, everybody from Gene Kelly to me and Spence, L. B. himself, Fred Astaire, June Allyson, Van Johnson, Debbie Reynolds, Esther Williams, George Murphy, the lot. Gals like Shearer, Garbo, and Greer Garson had always been the queens of Metro, but Elizabeth was the princess, and you'd jolly well better show up, because the studio sent out the invitations, promoting *Father of the Bride*." The town's gossip mavens were naturally in attendance, including Radie Harris, Hedda Hopper, Louella O. Parsons, and Sheilah Graham.

Sweating in 104-degree temperature, two hundred studio police held back ten thousand fans, who began cheering when Elizabeth's limo arrived with six motorcycle policemen. There was an awkward moment when she caught her dress on the door handle as she tried to exit the car. She had to duck back in and start all over. Finally the driver

unsnagged her and she emerged into the sunlight, a vision in white satin, ten yards of veiling floating around her. Helen Rose and fifteen MGM seamstresses had spent two months embroidering the gown with beige beads and seed pearls, and a cream-tinted tiara and satin slippers completed the bride's ensemble. Guilaroff had styled her hair, and MGM set decorators had laid a white runner down the center aisle, tying white silk bows to the pillars and placing bouquets of white carnations and lilies throughout the church. Six hundred invited guests watched her walk down the aisle to Wagner's "Wedding March."

Dressed in saffron yellow, the bridesmaids included Jane Powell, Marjorie Dillon, Mrs. Barron Hilton, Mrs. Marshall Thompson, Betty Sullivan Precht, Mara Regan, and Anne Westmore, a friend and neighbor since childhood, whose family founded the well-known Hollywood cosmetics firm. Elizabeth's family, Conrad, and Zsa Zsa sat in the front pews. After a Catholic Mass, Nicky slipped a $10,000 platinum-and-diamond wedding band on Elizabeth's finger, and they kissed so long that Monsignor Patrick J. Concannon told Elizabeth, "I think that's long enough, dear." Later, as Conrad stood with Mrs. Mary Saxon, his former wife and Nicky's mother, in the receiving line at the Spanish-style Bel Air Country Club, Mary said, "They have too much. I don't think it's going to be easy for them." Edith Head had

designed Elizabeth's going-away outfit, a blue silk suit with matching linen shoes and bag, and a white-on-white embroidered blouse and gloves. She carried a blue-gray mink stole. It was much too hot for fur, but she knew her fans expected to see her in mink.

Leaving on their honeymoon, they drove up the California coast to the Monterey Peninsula, where they stayed at a sumptuous private resort overlooking the Pacific Ocean. One of the bellboys immediately annoyed Nicky by calling him Mr. Taylor, an ominous omen that was followed by one far more alarming. The groom spent his wedding night in the bar, getting drunk. Elizabeth later complained that he ignored her, "told me to go to hell."[24] When I asked Edward Dmytryk in 1998 what went wrong with the marriage, he said, "On their honeymoon, she was in her room waiting for him and he was down in the bar drinking and came in very very late and they got into a fight. He was not a gentleman at all." Nicky had learned about women from his father, a man who pursued glamour gals but couldn't live with them.

The second night, Nicky stayed in the bar again, drinking himself into a stupor, but on the third, Elizabeth finally got him into bed, and evidently it was well worth the wait.[25] Nicky had tremendous stamina as a lover, said two of his later sex partners, Joan Collins and Terry Moore, both of whom were awestruck by his manliness and gym-

nastics.[26] On subsequent nights, eager to please, Elizabeth joined him in the bar and drank herself sick. When she went to bed, Nicky remained in the bar flirting with other women. The hellish honeymoon came to an end after ten days. Elizabeth returned to Elm Drive on Mother's Day, and when a reporter asked Sara why Nicky wasn't present, she said, "Elizabeth and I have never been apart on Mother's Day."

Bringing the newlyweds back together, Conrad staked them to a three-month European vacation with stops in France, Italy, and England. They departed from New York on the *Queen Mary* on May 23. Nicky promptly dropped $100,000 in the casino and took out his rage on Elizabeth. Passengers saw him shove her up against a bulkhead after she'd walked away from him in anger. Shaking his finger in her face, he snarled, "Don't you ever do that to me—*I'm talking to you*!" The Duke and Duchess of Windsor were on board and became lifelong friends of Elizabeth, later hosting a supper party for the Hiltons in Paris. The Duchess told Elsa Maxwell, "You'd have thought at times they were a couple reaching the end of their marriage, rather than beginning one."[27] Interviewed in 1998 in Key West, Joanne Jacobson, wife of the then-owner of Pocket Books, said, "My friends Sylvia and Ed Sullivan were on the Riviera when Nicky and Elizabeth honeymooned in Cap Ferrat in 1950. Nicky was an alcoholic. He and Elizabeth visited

the Ed Sullivans, and Sylvia told me, 'Nicky paid far too much attention to me and completely ignored his beautiful bride.' Elizabeth was desperate for Nicky's attention and affection, and he ignored her, but would stay up drinking with Sylvia."

Refusing to adjust to being a working woman's husband, Nicky rebelled when she asked him to wait for two hours while she signed fans' autograph books. Although glamour at Elizabeth's level meant never being seen in the same dress twice, Nicky was a pinch-penny like his father and groused when she spent the 1990s equivalent of $50,000 for a Balmain gown to wear to a Paris ball. Later, boarding the *Queen Elizabeth* at Cherbourg in September 1950, she showed reporters her new French poodle and said, "His name is Bianco, and I bought him in Paris *with–my–own–money*." On the transatlantic crossing she ran into Elsa Maxwell, who later reported that Elizabeth was twelve pounds lighter and had taken up smoking. Her new figure was not becoming; she looked haggard and unhealthy.

In New York, Nicky split for California. She checked into the Plaza and called MGM, gasping, "Send someone to bring me home. I can't take any more of this."[28] Metro promised to dispatch a representative to meet her during her Chicago stopover. Instead, she remained in New York, staying with Sondra Voluck, a young woman her age she'd met in Cannes, who lived with her family at

927 Fifth Avenue. Both Sara and Nicky were on the phone to her constantly, urging a reconciliation. Nicky drove to Chicago in his car to meet her, and the couple returned to the Coast together.

They moved into a luxurious two-bedroom suite at the Bel Air Hotel, in which Nicky owned a forty-one percent interest. Patricia Schmidlapp, mother of Nicky's second wife Trish McClintock, said, "Regarding Elizabeth Taylor, Nicky didn't care for her from the beginning."[29] He complained that the cozy welcome-home party Jane Powell gave them was a bore, though the guests included most of Elizabeth's favorite people: Betty Precht, Anne Westmore, Marshall and Barbara Thompson, and Mara Regan, who'd become engaged to Howard Taylor. Nicky preferred the high life of Rome and Paris and thought it corny of Jane to serve a buffet supper and expect her guests to sit on the floor. Elizabeth loved the informality and the chance it gave her to relax and have fun. Later, when Anne Westmore invited them, Nicky absolutely refused to go, saying he was through with "kids' games." He flew to Las Vegas, and Elizabeth went to Palm Springs, checking into the Miramar Hotel. Before she'd spent five minutes alone, she burst into tears, realizing how much she missed him. Suddenly, Nicky appeared at the door and took her in his arms, explaining that he couldn't stand Vegas without her. They had several passionate days together, but within a month their volatile

tempers flared again, and they were at each other tooth and nail.[30]

When she began filming *Father's Little Dividend*, a sequel to *Father of the Bride* depicting the normal experiences of early marriage—spats, reconciliations, conceiving a baby—she wished she could apply some of the wisdom in the movie to her own marriage and was sad she didn't. In October 1999 she revealed for the first time that Nicky had kicked her in the stomach, causing a miscarriage. "He was drunk . . . I didn't know that I was pregnant, so it wasn't a malicious or on-purpose kind of act . . . I had terrible pains. This is not why I was put on earth. God did not put me here to have a baby kicked out of my stomach . . . I saw the baby in the toilet." While she was in bed recovering from the assault, he blithely announced that he was going deep-sea fishing and advised her to spend the night with Marjorie Dillon, her stand-in. On December 6, 1950, they had a brawl that ended in his calling her "a fucking bore" and telling her to "get the hell out." Fleeing in the middle of the night to Marjorie Dillon, she told *Life*'s Brad Darrah many years later, "You can't allow yourself to be killed."[31]

The marriage was over, having lasted less than a year. "I left him after nine months of marriage after having a baby kicked out of my stomach," she said in 1999. She was afraid to return to her parents because she couldn't admit what a mess she'd made

of her life after having told Sara at the wedding, "Oh Mother! Nick and I are one now, for ever and ever." Getting a divorce was still a disgrace in 1950, but she began discussing it when she moved in with her agent-lawyer, Jules Goldstone, and his wife. Exhausted and moody, she was chain-smoking and suffering from colitis and an ulcer.

In early December, Metro issued a statement that clearly indicated the studio was on her side and would do anything to defend her: "It's doubtful they'll get together again . . . They always fight about the same thing, his gambling and playing around and ignoring her as a wife. They both have a temper." This was followed on December 17, 1950, by a Metro release containing Elizabeth's formal statement: "Nick and I . . . have come to a final parting of the ways . . . There is no possibility of a reconciliation."[32]

She started a film, *Love Is Better Than Ever*, the same month and became enamored of her director, Stanley Donen, though Donen was still married to dancer Jean Coyne. A twenty-seven-year-old *wunderkind*, Donen had just codirected *Singin' in the Rain*, Metro's definitive musical. Though she and Stanley worked at the studio all day and spent their nights together, the sexual pull wasn't strong enough to hold her. She still spent hours fantasizing about Nicky and how good their love life had been. On occasion, she and Nicky met and made frantic love, and afterward he begged her to give

up her career. She refused, though she couldn't forget his power as a lover. At a Sunday brunch with Janet Leigh and Tony Curtis, Elizabeth and Stanley Donen had a disagreement that ended with Elizabeth pushing a whipped-cream-covered pie in the director's face.

On January 26, 1951, in a Los Angeles courtroom, she collapsed on the stand after saying she'd been "a virgin not only physically but mentally" before marrying Nicky. Eighteen years old and close to a crackup, she charged "extreme mental cruelty." Murmuring, "I don't want a prize for failing," she did not ask for alimony, but successfully fought for a private property settlement, receiving one hundred shares of Hilton Hotel stock and all her wedding presents. Though busy filming, she checked into Cedars-Sinai Medical Center in L.A. on February 2, 1951, for nervous exhaustion, ulcers, and colitis, and commuted to MGM until her doctors forbade her to. After recovering, she rented a five-room apartment at 10600 Wilshire Boulevard, a two-story ivy-covered building, and shared her upstairs quarters with a secretary-companion, Peggy Rutledge, who'd formerly worked for Bob Hope's wife and was recommended by Jules Goldstone as "a nice dame, kind of a society girl."[33] Newlyweds Janet Leigh and Tony Curtis moved in downstairs and Elizabeth attended the bridal shower along with Ava Gardner, Helen Rose, and Shelley Winters. As a young divorcee,

Elizabeth was sought by some of the world's most desirable bachelors, including Orson Welles, Betty Hutton's ex-husband Ted Briskin, associate producer Ivan Moffat, millionaire's son Lin Howard Jr., George Stevens Jr., and Merv Griffin, in addition to Stanley Donen, Warner publicist Leo Guild, and former beaux Tommy Breen and Arthur Loew Jr.

"A lot of people wanted to marry Elizabeth," Dmytryk recalled in 1998. "Greg Bautzer [the well-known Hollywood divorce lawyer and man-about-town] called Elizabeth and said, 'Look, you shouldn't be alone. Come on out to Palm Springs. We have a house out there, and you can have a little time, meet people.' She said, 'Fine,' and they flew out there in a private plane. She went to this house with Greg and then he went off some place and left her alone. In a few minutes there was a knock on the door. She opened it, and there was Howard Hughes. 'I want to show you something,' he said, and took her out to this old Chevrolet which he used to drive in those days. He opened a handkerchief or a bandana and it was full of jewels. 'This is all yours,' he said, 'if you'll come with me.' She went in the house and called a taxi and had the taxi take her back to Hollywood."

Nicky spitefully said, "Every man should have the opportunity of sleeping with Elizabeth Taylor, and at the rate she's going every man will."[34] In fact, she spurned all her pursuers, choosing

instead to go on the town with gay friends in New York. "Okay," Monty said, "now what's with you and Stanley Donen?" They were "just friends," she replied, adding a little wearily, "Does that sound familiar to you, my dear, dear friend?"[35] They partied nonstop, usually with Roddy at Monty's favorite bar, Gregory's, on Lexington Avenue and Fifty-fourth Street. Often joined by a nineteen-year-old, whom Monty was trying to seduce, and Kevin McCarthy, they always huddled in a wooden booth to the right of the bar, chain-smoking and drinking. None of the other customers—pimps, winos, a few undergraduates, and middle-aged women nodding over their drinks—bothered them or even recognized them. One night Monty flaunted a cute chorus boy in front of her, and the next night he came in with a well-bred young woman. He seemed to be saying, "Look Ma—I can—and I must—do both," Elizabeth confided to *Life*'s entertainment reporter Tommy Thompson, who later wrote the novel *Celebrity* and other books. Monty often hung out at Bickford's, the all-night gay cafeteria on Fifty-first Street and Lexington Avenue, where he went to get picked up. But he would never find in any man the spiritual twin he'd found in Elizabeth. Finally, he consulted Dr. William Silverberg, a gay analyst, but therapists in the 1950s—even gay ones—didn't yet know whether

homosexuality was a problem or a solution. The more Monty was analyzed, the more he drank.

He was already an alcoholic, and Elizabeth was well on her way to becoming one. In 1998, Cy Egan, a former assistant city editor of the *New York Journal American,* recalled, "She often showed up drunk at nightclubs around Manhattan. She was loud and boisterous." In the later parlance of alcoholism and recovery, Elizabeth qualified as an adult child of an alcoholic, a victim of her father's abuse. She later told Barbara Walters, "When I was twenty-one, I called him and asked him to the house. I sat on his lap and buried my head in his neck and we both sobbed and bonded for the first time since I was nine." Still, husbands and fathers were forever branded in her mind as threatening figures. Only by drinking could she dispel the painful ambivalence she felt toward straight men.

The vagaries of Elizabeth's life sprang from the compulsions and passions that were driving her. One of them involved a vicious cycle of pain and addiction to painkillers, whether in alcohol or drug form. The never-ending cycle of sickness and recovery explains much of her life in and out of hospitals and between marriages. Every time there was a crisis, there was a medical emergency. Feeding into this pattern was her conflicted history with men, stemming from her father's brutality. Her loving relationships were asexual and with

such gay men as Roddy, Monty, and, later on, Rock Hudson, James Dean, Tennessee Williams, Truman Capote, Halston, Andy Warhol, and Steve Rubell, as well as her secretaries Richard Hanley and Roger Wall. Her sexual relationships were "a-loving"—in the sense that any relationship based primarily on sex is a *using* one rather than a loving one—and were with such straight men as Nicky Hilton and, later, Mike Todd, Eddie Fisher, John Warner, and Larry Fortensky or bisexuals like Michael Wilding and Richard Burton. Her inner conflict created its own state of pain, which added to the vicious cycle and blocked her from working out the balance of love and sex that characterizes any healthy erotic relationship.

At the Oscar ceremony on March 29, 1951, at RKO Pantages Theater, *Father of the Bride* was up for best picture, best actor, and best screenplay, but Elizabeth, who was largely responsible for the charm that made it one of the year's most popular films, was again ignored by the Academy. On April 5, Metro premiered the sequel, *Father's Little Dividend,* at the Egyptian Theater on Hollywood Boulevard, hoping to capitalize on the success of *Father of the Bride* and the notoriety over the Elizabeth Taylor–Nicky Hilton breakup, and starring the same winning team—Elizabeth, Joan, Spence, and Don Taylor. Joan Bennett later recalled that she was looking forward to doing a long string of sequels with Elizabeth and Spence when a tragedy

struck in 1951 that ended both the *Father of the Bride* series and Bennett's career. By late 1950, Joan's husband, Walter Wanger, was aware that her feelings for Jennings Lang, her agent since 1948, "went beyond our business relationship," Joan recalled. Typical of the double standard of the era, the fifty-seven-year-old Wanger had pursued his own infidelities since marrying Joan in 1949, but he warned in 1951 that he'd kill any man who "tried to break up my home."[36] On Friday, December 13, Wanger shot Jennings Lang in the groin and later served a four-month sentence at Castaic Honor Farm north of Los Angeles. In a 1999 interview in Key West, Frank Taylor recalled, "I had lunch with Jennings Lang the day that Walter Wanger shot him. He was in fine spirits as we lunched at Twentieth Century-Fox, and then he went to meet Joan. Walter shot him between the nuts, so his virility was not diminished. That evening I went to dinner at the Walt Disneys. Walt was not usually a humorous man, but that evening was an exception. The whole room was abuzz with news of the shooting, and Walt said, "That's the first hit Walter has had in ten years." According to L.A. *Times* writer Paul Rosenfield, Lang "lost one ball (as in testicle)" but capitalized on the publicity, moving from the Jaffee Agency to mammoth MCA. The only one who suffered professionally from the fracas was Joan Bennett.

"That Walter was really something," Joan told

me one night in the 1970s. "He went back to work at Monogram the same day he was indicted, but I never again got a decent role in films. The wonderful series with Elizabeth and Spence, which would have been another Hardy Family—a real annuity for me—was canceled. Walter, being a man, got all the sympathy, and went on to make *I Want to Live!* with Susan Hayward and *Cleopatra* with Elizabeth. I was branded as the vixen who drove men crazy, like the characters I'd played earlier on in the forties, in *The Woman in the Window* and *Scarlet Street*. I had kids to raise, so I went on the stage, replacing Roz [Russell] in *Bell, Book and Candle*."

In the spring of 1951, Elizabeth touched off a mini-scandal by appearing frequently in public with Stanley Donen, who was still very married. Guarding her as their most valuable commodity, Metro took decisive action to extricate her from Donen's marital difficulties, in effect banishing her to England to play the role of Rebecca in Sir Walter Scott's *Ivanhoe*, which was to be filmed near London over the summer. She warned Metro that she'd just recovered from a "nervous breakdown" and was in no condition to make a film, but the studio remained adamant.[37]

She saw Monty again in New York before leaving for London. They both attended a party Roddy gave at the apartment he and Merv Griffin shared in the Dakota. Eddie Fisher was there and recalled that Elizabeth spent most of the evening

sitting in a corner with Monty. Elizabeth and Eddie were introduced but she scarcely noticed him. "I fell in love with her that night," recalled Eddie, "but she was out of my league."[38] After she went abroad, she and Monty continued to exchange letters and long-distance telephone calls. He urged her to take bold chances with her career, to be daring as an actress and stretch her talent. Monty's lover, a youthful Hollywood actor, moved to New York to be closer to him, though Monty remained guilty about his homosexuality. "He had the ugliest cock I'd ever seen," recalled Frank Taylor, who had sex with Monty in New York after producing *The Misfits*. "This beautiful face, you know, but there was no cock really; it was all foreskin."

In consigning Elizabeth to the fusty costume drama *Ivanhoe*, which she dismissed as "a big medieval Western," MGM again mismanaged her career, costarring her with the wooden Robert Taylor for the second time with predictably mundane results. The London scene she discovered that summer was recalled by novelist Elaine Dundy, who was married to Britain's leading theatrical critic, Kenneth Tynan. "In the early 1950s, Elizabeth Taylor, John Huston, everyone turned up there because that's where their frozen assets were," said Dundy. Working abroad was a legal way of evading heavy U.S. taxes. Since British law required that money earned there must be spent there, Elizabeth

checked into the opulent Savoy and pampered herself.

Each day she left the hotel at 5:15 A.M. for the long drive to Metro's 120-acre Borehamwood studio outside London. Michael Wilding was filming at the same studio, starring in *Trent's Last Case* with Orson Welles. Though only nineteen, Elizabeth told the thirty-nine-year-old Wilding, "I wish you'd stop treating me as if I had a child's mind inside a woman's body . . . Why don't you invite me out to dinner tonight?"[39]

Wilding was known to be a vigorous lover, but he tended to lose interest in female conquests rather quickly. Apart from Elizabeth, he currently had two women on the string—his wife, actress Kay Young, and the bisexual Dietrich, who was eight years Wilding's senior. Dietrich "preferred fellation," according to her daughter, Maria Riva, who added, "It put into her hand the power to direct the scene." But Dietrich herself confided in her diary that Wilding was so "inventive" at coitus that she was "staining [bleeding]" as a result of his "steeple chasing," and she always had to insert a "firecracker [Tampax]" the minute he dismounted. The two stars accepted each other's homoeroticism. When Dietrich was involved with women, she gravitated to the petite chanteuse Edith Piaf or the severe-looking Spanish screenwriter Mercedes de Acosta. Michael Wilding was a relief for Dietrich from standard Hollywood hunks: she preferred the

knightly British type to Americans with whom she'd had sex, including Frank Sinatra, General James Gavin, Adlai Stevenson, William Saroyan, and Edward R. Murrow. Wilding had been Marlene's leading man in Hitchcock's 1950 thriller *Stage Fright*. "A British version of [James] Stewart," Dietrich called him. "He mumbles, is ever so shy, and being English, gets through the film on charm."

Elizabeth saw Wilding as a strong father figure who'd give her children and make her feel like a woman. Again she was going for the wrong man. Wilding always required a woman to be "the dominant partner," he wrote. They were both looking for a strong person, and both would be disappointed. The determined Elizabeth hooked him that first date, though he tried to resist her, mindful of their absurd age difference. He later wrote: "Secondly, I dreaded hurting Marlene."[40] He took Elizabeth to see Dietrich's cabaret act at the Café de Paris. From the stage Dietrich immediately spotted them in the audience and later wrote to Yul Brynner, "Michael was there last night with Liz, sitting rather stiffly in a corner and looking at me quite steadily and sadly, and I thought that that could happen to me, seeing you with another woman and I felt quite sick." To Maria Riva, Dietrich complained, "He says he cannot live without me and then—goes and fucks Taylor!"[41] Dietrich was also involved with Kenneth Tynan, and

according to Riva, they'd become "inseparable." The secret of Dietrich's mysterious appeal, Tynan wrote, was that "she has sex without gender."[42]

As a heterosexual, Elizabeth lacked, for Wilding, the necessary ambivalence, ambiguity, and AC/DC latitude afforded by Dietrich—to whom he'd one day return. He knew from the start that they were mismatched. As he continued to waffle, Elizabeth grew impatient and started dating Tab Hunter, an athletic young leading man who was quickly becoming the teenage rave of the early 1950s. He was in England at the time, filming *Island of Desire* with Linda Darnell, but he would make a stronger impression a few years later, playing a U.S. marine in Leon Uris's *Battle Cry*. Ironically, like many other macho heartthrobs who carried the burden of public sex fantasies in the fifties, Hunter was one of the targets of a "confidential" exposé of Hollywood gays.[43] He had a close relationship with Anthony Perkins and appeared frequently on the set of Perkins's movie *Fear Strikes Out*.[44]

Aware she was seeing Tab, Wilding at last asked Kay Young for a divorce. He didn't love Elizabeth, but her sensational performance in *A Place in the Sun* convinced him she was a beauty who surprisingly could act. It also convinced him he could use her to boost himself into major stardom. For the second time, Elizabeth was headed to the altar with a man who didn't love her. Wilding confessed

as much to his frequent costar Anna Neagle, who was married to his agent, Herbert Wilcox. "He told us that, as Elizabeth's husband, he would have a bigger career in Hollywood than Herbert could give him here," Neagle recalled. "He wanted to be a truly international star . . . He saw himself starring with this girl who had the most wonderful success in *A Place in the Sun*."[45] Elizabeth's motives were equally self-seeking. She was convinced she could cannibalize what she called Wilding's "abundance of tranquility, security and maturity—all of which I desperately need."[46] Both were looking outside themselves for strengths that could come only from within, and such spiritual vampirism did not bode well for their relationship.

Before Elizabeth, he'd attracted other glamour girls such as Rita Hayworth and Paulette Goddard, as well as male admirers. In London during the first phase of WWII, Wilding and Stewart Granger, Elizabeth's costar in *Beau Brummell*, shared a flat and had sex one night during an air blitz. Granger recalled their liaison at dinner one evening in the early 1980s. "People will say we were both queer, and we weren't. It was just the kind of thing that happened during the war." According to Boze Hadleigh, author of *Hollywood Gays*, Granger was bisexual. Wilding served as best man at the Texas wedding of Granger and Jean Simmons in 1950. Later, when Granger caught Howard Hughes simultaneously ogling Jean and

Elizabeth, he said, "Well, Howard, which one would you like? Take your pick."[47]

Though Wilding was aware that his marriage to his first wife had failed because he'd been unable to give of himself, he was drawn to Elizabeth as though by an undertow. He took her to the Savoy Grill and to the Mirabelle, the Ivy, and the Caprice. As a lover he had stamina to spare. According to Alexander Walker, author of *The Shattered Silents* and film critic of the *London Evening Standard*, "He gave tireless satisfaction in bed."[48] Soon she began to forget about Nicky—and about Donen—and she no longer complained of colitis. Her zest for living returned in full force. She wanted Michael Wilding and was determined to have him. Elaine Dundy in a 1998 interview unwittingly shed light on how Elizabeth could have fallen in love with a bisexual who later drove her to distraction, describing her as a sweet but shallow young woman whose conversations were restricted to hairdressers.

When Wilding arrived at the Savoy to take Elizabeth to dinner one night, she wasn't yet ready, and he later wrote, "Unpunctuality is a sort of disease with Liz." She invited him into her bedroom, where she was still making up. When he complained that she used too much makeup, she burst into tears. "It's to make me look older," she said. "If only I was older, you would ask me to marry you." When he again mentioned their age difference, pointing out that she might later feel she'd made a mistake, she

snapped, "Tomorrow I'm flying to California. When I'm gone you'll see who's making the mistake."[49] At the airport, she told him, "Goodbye, Mr. Shilly-Shally. Let's forget we ever met."

Upon arriving in New York, she checked into the Plaza, which was now a Hilton hotel, and later had a reunion with Monty at Voisin, flashing a sapphire ring on the fourth finger of her left hand. She explained she'd become engaged to Wilding, but Monty was skeptical. Elizabeth had bought the ring herself and was using it as a ploy to lure Monty into marriage, or so he suspected. She checked out of the Plaza and moved into Monty's duplex, though nightly he brought home tricks he'd picked up on upper Third Avenue. In a quandary, he shouted at Elizabeth during a drunken evening on the West Side, "You are the only woman I will ever love." Slouching in a chair, she stared at him and crooned, repeatedly, "Baby, oh baby."[50]

In London, fearing his last chance for international stardom was slipping from his grasp, Wilding cabled Elizabeth that he was taking the next plane to the United States. He signed the cable "Mr. Shilly-Shally." In December 1951, she met Wilding at the Burbank airport, accompanied by Stewart Granger and Jean Simmons. By now Granger was succeeding as a romantic lead at Metro in films with Elizabeth, Ava Gardner, and Deborah Kerr. Elizabeth and Wilding stayed with

the Grangers in their Hollywood Hills home, and Granger advised Wilding, "Forget you're forty. I have, and look how happy I am." Jean Simmons was twenty-two. In the following days, the two couples became indivisible, showing up regularly at Romanoff's, Chasen's, and the Mocambo. Granger later said he hated Elizabeth for keeping Howard Hughes on the string so long, teasing and taunting him, and she treated Wilding "shabbily from the beginning," he alleged.[51]

Though rumors of a Taylor-Wilding marriage were rampant, Wilding still showed no inclination to propose. Gossip columnists were often useful to Elizabeth as catalysts or hit men, none more so than the ruthless Hedda Hopper. One day, Elizabeth took Mr. Shilly-Shally to Hopper's home. As they sat in the living room Hopper said, in Wilding's presence, "Did you know Michael Wilding's homosexual, Elizabeth?" Mortified, Wilding sat in abashed silence instead of proposing to Elizabeth, as Hopper had hoped to intimidate him into doing. Later, Elizabeth and Wilding related the story to Stewart Granger. When Wilding became agitated, Elizabeth said, "Oh, Mikey, don't worry about it." Granger glared at her and started cursing. "Look, you silly bitch," he snarled, "what the fuck are you talking about? Why didn't you say anything?"[52] Granger then called Hopper and cussed her out, which would shortly bring a terrible retribution down on all of them.

Quite early one morning, Wilding received an ominous telephone call from Humphrey Bogart. "Have you seen Hedda's column?" Bogey asked.

"No," Wilding said. "I was still asleep."

Bogey said, "Then nip downstairs and you'll get a rude awakening." In her column and later in a book, Hedda implied strongly that Wilding and Granger were lovers. Wilding later wrote, "Under a photo of Stewart Granger and me larking about on his boat, she had written the caption 'More than just friends?'" Wilding immediately went to Granger and said he was instigating a libel suit in their joint names, but Granger turned him down flat. "Count me out, pal," he said. "You might as well sue God. Anyway, the studio wouldn't permit it. Just remind me, next time we are photographed together in public, not to hold your hand."[53]

The threat of scandal horrified MGM. Granger was under contract to the studio and Wilding soon would be when Elizabeth married him and pressured MGM into giving him a job. Metro's London office was contacted and the head man, Paul Mills, was asked to make discreet inquiries. When Metro demanded, "Are you able to prove that they are *not* homosexuals?" Mills replied, "As far as we know, they are both sleeping with ladies." Sheilah Graham later reported that Hedda was "anguished . . . going all over town asking known homosexuals to back her up. A gay producer friend of mine gleefully told her to go to hell."[54] Hedda's son,

William Hopper, best known as Paul Drake on television's *Perry Mason*, was gay, though Hedda could not accept it. While Granger offered no help for the beleaguered Wilding, David Niven rushed to his defense, ridiculing Hopper's suggestion that Granger and Wilding had a homosexual relationship. Hopper had written, "One doesn't like to imagine what went on when this pair were living it up together on a yachting trip to the Riviera," and Niven quipped, "I can well imagine what was going on all right," suggesting that Wilding and Granger nailed so many coquettes that "the population of the South of France doubled overnight."[55]

Risking exposure of his bisexuality, Wilding sued and won, receiving $100,000 in an out-of-court settlement, an apology, and an admission from Hopper that she had made her charge "in a malicious and wanton fashion with complete disregard of the plaintiff's feelings."[56] Her book publisher deleted the gay passages. Reassured, Elizabeth looked at Wilding over dinner one night at Romanoff's and said, "Will you marry me?" Wilding later revealed that his first wife, Kay Young, had also taken the initiative. "I was terrified of my own emotions," he wrote. "It was Kay who finally proposed."[57] At Romanoff's, without waiting for a reply, Elizabeth asked him to help her decide between two sapphire rings she was considering. Wilding was down to his last $20, his recent divorce having exhausted his meager savings, but

he reluctantly helped her select a ring. Later, when he started to slip it on her finger, she stopped him and said, "I think that's the finger it should go on, Michael, the engagement ring one." In her usual impetuous, take-charge manner, she announced their engagement at a press conference around New Year's. "That makes it official, doesn't it?" she said. "It's leap year, isn't it? Well, I leaped."[58]

Wilding's agent, Herbert Wilcox, ruefully reflected, "All my future plans for Michael would be nullified by the whim and passions of a mere eighteen-year-old girl [sic]." On February 14, 1952, Wilcox lunched with Dietrich and they discussed the upcoming Taylor-Wilding nuptials. "What's Liz Taylor got that I haven't got?" Dietrich wanted to know. "She was very sad," Wilcox later wrote. "I didn't have the heart to give her the obvious answer, namely youth."[59] Dietrich was forty-seven; Elizabeth, nineteen, but age was hardly the issue. Wilding was drawn to dominant women and saw in Elizabeth the ultimate dominatrix. Moreover, he intended to exploit her power and connections to blast his career out of its U.K. confines. Elizabeth was on the rise, while Dietrich was past her prime as an international sex goddess. As Anna Neagle put it, "Michael thought Elizabeth's stardom would rub off on him somehow."[60]

He left for London on February 17, Elizabeth planning to follow him in a week. He had to inform Herbert Wilcox that their twenty-year-con-

tract was no longer viable since he would be moving to California, where, he assumed, he'd immediately become a Hollywood star. "If you'll forgive me saying so," Wilcox remarked, "I don't think Hollywood will understand you, or vice versa." Elizabeth arrived in London on February 21, 1952, checking into the Berkeley Hotel. Metro's Helen Rose again designed her bridal outfit: an anthracite-gray wool suit with a full skirt and a three-tiered organdy collar and cuffs and a hat of small white flowers. Three thousand onlookers swarmed around London's Caxton Registry Hall, Westminster, for the ten-minute ceremony on February 27 attended by Wilding's parents and Anna Neagle and Herbert Wilcox. A reception at Claridge's was followed by a smaller gathering at 2 Bruton Street, Wilding's maisonette in Mayfair. Afterward, the newlyweds repaired to Elizabeth's suite at the Berkeley, where room service brought them a meal of bacon and eggs, soup, and champagne. Subsequently they honeymooned in France and Switzerland, returning to Mayfair on March 2.

When Dietrich heard of the marriage, she called Elizabeth "that English tart," and conjectured, "It must be those huge breasts of hers—he likes them to dangle in his face." In New York, Monty gave up all hope of having a wife and family. He increased his intake of Nembutals and Scotch, and got into a brawl at Gregory's, where another man broke his nose and dislocated his shoulder. Libby

Holman, whom critic Brooks Atkinson once described as a "dark purple menace" after hearing her sing "Body and Soul," replaced Elizabeth as the most important woman in his life.

In London, Elizabeth settled into Wilding's flat, and they appeared to enjoy quiet evenings, reading the theatrical biography *We Barrymores* aloud to each other. Her public statements could not have been more at variance with reality: though she was busily plotting how to support an indigent husband, she told the press, "I just want to be with Michael and be his wife. He enjoys sitting home, smoking his pipe, reading, painting. And that's what I intend doing—all except smoking a pipe."[61] In fact, she was trying to form her own production company in England, so that her husband could continue his career there. He was still a top box-office star, much loved by the British, whose leading men do not have to be flawlessly beautiful as long as they're intelligent and charming, like Trevor Howard, John Mills, and James Mason. But MGM persuaded Elizabeth to return to Hollywood by promising to upgrade her contract.

When they arrived in L.A. in mid-March 1952, they stayed at first in Elizabeth's absent parents' home on Elm Drive. Though Metro had no interest in Wilding, the studio soon realized the only way to lure Elizabeth, now their most valuable star, into resigning was to stake her husband to a fat contract.

MGM hired him for $3,000 a week, with a $2,000 weekly raise after two years. Elizabeth's contract was about to expire, and she kept Metro waiting until she'd extracted numerous concessions, finally accepting a deal that paid her $5,500 per week. In the interim, she and Wilding were broke, and she was forced to ask MGM to lend her $50,000 to buy a house at 1771 Summitridge in Beverly Hills. She also strong-armed Metro into paying her mother $300 a week as her chaperone, despite the fact that Elizabeth was now twice-married.

The spring of 1952 represented the happiest time of the Wildings' relationship. In June, they moved into their new home, which consisted of three units connected by roofed walks, high over L.A. All Elizabeth knew of domesticity was how to cook bacon, eggs, toast, and coffee, so Wilding prepared most of their meals and cleaned the house. Granger and Simmons were frequent dinner guests, and the Wildings were often at the Grangers' Hollywood Hills home, which had become the most popular meeting place for British actors working in California. On June 21, Elizabeth announced she was pregnant. Dr. Aaberg, the obstetrician, told the Wildings to anticipate delivery in January 1953. Metro added two hours to her usual day's work, hoping to get her next film, *The Girl Who Had Everything*, in the can before her pregnancy began to show. On reading Art Cohn's script, a rehash of *A Free Soul*, the old Clark

Gable–Norma Shearer movie about a lawyer's daughter who falls for a gangster, Elizabeth pronounced it "crap," but agreed to film it, later explaining, "I needed the dough."[62]

There was an emotional reunion with Monty when he came to the West Coast to film Hitchcock's *I Confess* at Warner in 1952. "Elizabeth was wonderful to him, always," Jack Larson recalled. "Monty adored Michael Wilding." On August 1, 1952, after completing *The Girl*, Metro placed her on suspension because of her pregnancy instead of wishing her well and expressing their appreciation to her for the prosperity she'd brought to the studio ever since childhood. "Those shitassed motherfucking faggot cocksuckers," she said, according to Truman Capote. Metro also placed Wilding on suspension for turning down a costarring role with Lana Turner in *Latin Lover*, and his career further plummeted after his lifeless performance in *Torch Song* with Joan Crawford. With neither of the expectant parents on salary, they soon fell into debt. Broke, Elizabeth finally cashed in bonds—amounting to fifteen percent of her childhood salary—that her parents had been required by law to purchase and put in escrow for her. The resulting $47,000 enabled her to pay the mortgage and pediatrician's bills.

Named after her husband and her brother, Michael Howard Wilding Jr. was born by cesarean section on January 6, 1953. Dr. Aaberg hospital-

ized Elizabeth for five weeks, but she was at last able to get up on February 27, her twenty-first birthday. The joy of motherhood was diminished by financial difficulties, studio sanctions, and a husband who was "flat broke," she recalled. She sometimes ditched Wilding to slip off to Oscar Levant's Beverly Hills house with Monty, where the pianist serenaded them with Gershwin tunes as they whiled away afternoons and early evenings. When Monty left for Rome to film *Indiscretion of an American Wife* with Jennifer Jones, Elizabeth grew increasingly restive, unhappy with mediocre roles at Metro, tired of being her family's breadwinner, and terrified at the prospect of another failed marriage. "The happiest years . . . were when you were so dependent on me," said the hapless Wilding. "I hate it now. Now I follow *you* around. Now I'm left in a corner."

Elizabeth had been forced by her pregnancy to turn down *Elephant Walk*, though the role had been designed for her. Vivien Leigh, to whom Elizabeth bore a striking resemblance, got the part and went to Ceylon to shoot on location. Leigh had a nervous breakdown during filming, distraught over her husband Laurence Olivier's sexual relationship with Danny Kaye and embroiled in a dalliance of her own with costar Peter Finch. Elizabeth finally reclaimed the role on March 19, 1953. While filming in Hollywood she became fond of Finch, whose drinking and hell-raising rebelliousness appealed

to her. Eventually he decided to forgo further film-
making in the United States. Insulted by Para-
mount's offer to costar him with Jane Russell in
The French Line, he returned to England.

In October 1953 Michael Jr. was christened in
Grosvenor Chapel, Mayfair, and then left with his
British grandparents while the Wildings went on a
second European honeymoon they could ill afford.
The following year Elizabeth again became preg-
nant. Despite her unrelenting workload, Wilding
again went on suspension, turning down the role
of a pharaoh in *The Egyp-tian*. Elizabeth reminded
him of his domestic obligations, including medical
expenses, taxes, the upkeep of six cars, a mortgage
to pay off, interest on their MGM house loan, and a
weekly payroll for a household staff of five. Wild-
ing finally agreed to do *The Egyptian*, and when the
film premiered in London, *Daily Express* critic
Leonard Mosley sadly asked, "What is Hollywood
doing to our poor Mike? They have blacked his
face, dressed him in a nightshirt and provided him
with unspeakable dialogue. What a waste of a
great talent!"[63]

Though pale, overworked, and afraid of miscar-
rying, Elizabeth filmed *The Last Time I Saw Paris* in
1954, her fourth movie in twelve months. She
clashed with director Richard Brooks, who
screamed and cursed at her for wearing full makeup
for her death scene. "You look like you're ready for
a fucking premiere," he said. "Your mouth looks

like a bloody cunt." Jack Larson was with her later that day, at a dinner party in the home of Roland Petit, who was filming *Glass Slipper* with Michael Wilding and Leslie Caron. "Roland lived on Beverly Estates near Tower Road and Elizabeth and Montgomery Clift came down," Larson recalled. "Roland had been on the set and commented how good Elizabeth looked even without makeup." Despite her altercation with the director, the film—based on F. Scott Fitzgerald's story "Babylon Revisited"—was the only one she'd made since *A Place in the Sun* that she wasn't ashamed of. "*The Last Time I Saw Paris* first convinced me I wanted to be an actress, instead of yawning my way through parts," she said, and her happiness showed at the November 1954 premiere, which she attended with Monty, both of them laughing as they posed for photographers. *Variety* thought her performance "her best work to date."[64]

On her twenty-third birthday in February 1955, Elizabeth's second child, blue-eyed Christopher Edward Wilding, was delivered by cesarean section at Santa Monica Hospital. Dr. Aaberg advised that she should never attempt motherhood again. She immediately went on a crash diet of ice water and fruit juice, losing thirty-five pounds for her appearance at the Oscar ceremonies on March 30. As one of the presenters Elizabeth made the audience gasp when she came on stage at the RKO

Pantages looking almost inhumanly gorgeous in a white silk, organza, and satin gown and a white fur stole. She had a poufy brunette hairdo, stiletto heels, and a constellation of diamonds around her neck and on her earlobes. Though she sometimes feigned a distaste for Hollywood, she was its unofficial spokesperson and trademark, and the industry would flaunt her at every opportunity for the next twenty years.

By the mid–1950s, she'd lost all interest in Wilding and said, "I am afraid that after five years my marriage to Michael Wilding has become the relationship for which we were much more suited—brother and sister." Monty—still the most sought-after male lead in Hollywood—was a frequent house guest at the Wildings' and on one occasion brought along Rock Hudson. Monty was so attentive to baby Britches, as the older Wilding boy, Michael, was nicknamed, that friends began to whisper the child was Monty's son. "I wish he were," Monty said.

There were times during this period when Elizabeth was with the present, past, and future men in her life at the same time. At the Grangers' home one day, the guests included Richard Burton, Monty, and Wilding.[65]

A renowned stage actor in London's West End, the thirty-year-old Richard had so far failed in Hollywood to match his theatrical success, appear-

ing in forgettable fare such as *The Robe* and *My Cousin Rachel*. When Elizabeth first became aware of him, she was sitting on the far side of the Grangers' pool, reading a book. Richard was regaling guests with quaint stories from his Welsh past, tipsy and talking a little too loudly. Lowering her book, Elizabeth removed her sunglasses, decided he was a conceited ass, and gave him the "cold fish-eye," she recalled. He was disappointed when she turned away and began talking with another woman. He'd been eyeing Elizabeth's breasts, which he'd later panegyrize as "apocalyptic—they would topple empires before they withered."

When Richard approached her, Elizabeth was delivering a tirade about how much she loathed a certain Metro producer, and she noticed that Richard was startled by her language. "Don't they use words like that at the Old Vic?" she teased.[66] He flirted with her "like mad," she remembered, but he was also making passes at every other pretty girl around the pool. "Ohhh boy," she thought, "I'm not gonna become a notch on *his* belt." Richard was "frustrated almost to screaming," he later wrote, adding that she was "the most self-contained, pulchritudinous, remote, removed, inaccessible woman I had ever seen." Shortly after that he left Hollywood and returned to stage acting.

In the summer of 1954, the Wildings moved to a new house at 1375 Beverly Estate Drive, high above Benedict Canyon Drive in Beverly Hills.

"She and Wilding had built what was at that time a high-tech house," Jack Larson said. "Sliding windows would move, and it had high-tech lighting." Designed by L.A. architect George McLean and built of steel and adobe, it was aggressively, almost arrogantly modern. From the living room, a glass wall looked out over the valley below. Another glass wall afforded a view of the swimming pool, while a third wall was made of tree bark, decorated with orchids. The fourth wall, forty-five feet in length, was made of fieldstone and had an open fireplace and a bar. The ceiling seemed to be supported by an elaborate driftwood tree. The tone was casual, with cats and dogs scampering about. "Our home is like an animal shelter," Wilding complained. He felt like a servant when Elizabeth ordered him around over the intercom. When Joan Bennett came to visit one day, she said, "Tell her to go fuck herself." Wilding tried to correct Elizabeth's manners, but she informed him, "I'm your wife, not your daughter." She had radically altered her appearance, getting the short "Italian boy" haircut, a style that made her facial features stand out even more exquisitely.

She visited Roland Petit's house one afternoon when Jack Larson was there. "She was looking very beautiful," he reminisced. "She came down for the afternoon with Michael Wilding for a late lunch around the swimming pool. She had on a one-piece leopard-print bathing suit, which showed off her

great figure, but she didn't go in swimming. She was a lovely mother to this one particular little boy, the younger one. 'You're extraordinarily beautiful in this sunlight,' I said. 'Yes,' Michael said, 'it's so amazing. When she sits down to make up in front of her modern makeup table, everything's always in place, so neat, completely organized by servants. And when she finishes making up or whatever she's doing—she doesn't have to do much—there's this disaster area of turned-over bottles, everything lying around among discarded Kleenex. From this disaster rises Liz Taylor, looking so beautiful.' He of course adored her."

The feeling was not mutual. "I'm fed up with working so hard and having to live like this," Elizabeth told actress Carroll Baker, who came to dinner with her husband, director Jack Garfein. The Wildings employed a live-in nanny for sons Mike and Chris, but there were no nighttime servants. As Elizabeth put out a cold buffet, she explained to her guests, "I can't afford servants who stay after five o'clock. God, how I hate being poor!"[67] The Garfeins complimented their hosts on their "dream house," but Elizabeth considered it a hovel. "I do believe MGM might give Elizabeth a bonus soon," said Wilding, "and if they do, we simply must get a better house."

Unemployed, Wilding hung out at Barney's Beanery on Santa Monica Boulevard while Eliza-

beth was at work. Like George Hurstwood, the debonair saloonkeeper who destroys himself over an ambitious actress in Dreiser's *Sister Carrie*, Wilding's downfall coincided with Elizabeth's rise to superstardom, which began in the mid–1950s with *Giant*.

4

Loving, A-sexual Partners:

JAMES DEAN AND ROCK HUDSON

In 1955, a changing of the guard was about to take place among Hollywood actresses as a younger generation attempted to supplant long-established stars. Elizabeth's struggle for the juicy role of Leslie Lynnton Benedict in Edna Ferber's Texas generational saga *Giant* pitted her against her old role model, Jennifer Jones, who was thirteen years her senior, and had won an Oscar more than a decade previously in *The Song of Bernadette*. Jennifer was so determined to win the *Giant* lead that she personally called George Stevens, who was to direct the film for Warner Bros. Studios, but Stevens didn't cast her. Nor did it occur to him, at first, to cast Elizabeth.

As early as July 2, 1954, Stevens was trying to sign Audrey Hepburn as Leslie Benedict, but at the time she was appearing on stage in New York in *Ondine*. Referring to a Monday visit, Stevens

wrote her at the 46th Street Theater that he was "hopeful" their talks would eventuate in a mutually agreeable "visualization of *Giant* as a film."[1] On July 9, after *Ondine* closed, he wrote Hepburn again, this time addressing her at 35 East Sixty-seventh Street. The letter clearly indicates that the director and the actress were at loggerheads over their interpretation of the Edna Ferber story. Though their visit was "very pleasant," Stevens wrote, they were "not always" of one mind about the character of Leslie. "I respect your views on our story," Stevens added.

With Hepburn no longer in the running, the director turned to Eva Marie Saint, but a Warner interoffice memo dated January 25, 1955, advised Stevens and Henry Ginsberg, Stevens's coproducer, that Saint was pregnant, and the baby was due in late April. On January 28, Ginsberg was informed in a letter he received at the Bel Air Hotel that Grace Kelly was "very anxious" to be cast as Leslie, but MGM had earmarked her for a Spencer Tracy film, though she definitely did not want to do it. Meanwhile, Stevens had also been attempting to cast the lead male role of Jordan "Bick" Benedict, Leslie's husband. The current box-office kings of Hollywood, Clark Gable, Gary Cooper, and William Holden, were all vying for the part since *Giant* promised to be the most distinguished film of the year. Then Ross Hunter, producer of Universal's *Magnificent Obsession*, insisted that Warner

screen the film to see the performance of the up-and-coming Rock Hudson.

On viewing the movie, Stevens immediately realized that Rock's scenes with Jane Wyman were going to make him the biggest romantic lead since Gable.[2] He screened an earlier Hudson film, *The Lawless Breed*, in which the actor played a gunslinger who ages several decades, just as Bick ages from youth to midlife in *Giant*. Stevens alerted Warner to start negotiations for borrowing Hudson from his home studio, Universal. A copy of the script was sent to Universal's Edward Muhl on October 23, 1954. The studio was reluctant to lose the services of its hottest new star, even for a short period, and decided to rush Hudson into another Jane Wyman tearjerker, *All That Heaven Allows*. Eager for the plum *Giant* lead, Hudson was convinced his studio would never loan him out. However, on November 4, Louella O. Parsons wrote in the *L.A. Examiner*, "Rock begged so hard he finally won over."[3] On the same day, Hudson cabled Stevens from Evanston, Illinois, that he'd been apprised of the "wonderful news" and was "walking in clouds."[4] He was returning to L.A. immediately, hoping to call on Stevens. The director replied on November 6, agreeing to Hudson's request for a meeting. Universal notified Warner that Hudson was available beginning May 17, 1955, and a deal was made with his agent Henry Willson.

At their first conference, Stevens asked Hudson whom he'd like for his leading lady, "Grace Kelly or Elizabeth Taylor?"[5] Having met Elizabeth through Monty and knowing she was simpatico with gays, he replied, "Elizabeth Taylor," and Stevens said, "Fine. We'll get Elizabeth." Hudson later recalled, "If I had said Grace Kelly, he would have found a way to make me think that Elizabeth would be better. That was the wonderful way of his direction, of making me think that it was my idea." At first Metro refused to lend Elizabeth to Warner. "I had to go almost on a sitdown strike," she recalled. "MGM wanted me for some other film—like a sequel to Lassie's mother."[6] Fortunately, on May 4, 1955, Metro finally consented to release her until August 21, 1955. "Those bastards at MGM make me do five pictures a year for my hundred thousand," she complained, "and on this *Giant* loan-out alone they are collecting two hundred and fifty thousand from Warner Brothers."[7]

She was now at a key turning point in her career as an actress rather than a Hollywood personality. Warner Bros. planned the film as an ambitious three-hour-and-eighteen-minute epic, not only a portrait of modern Texans grappling with social and economic change, but of an independent woman surviving in a male-dominated society. A Warner interoffice memo about the character of Leslie Benedict demonstrated that a new wind was blowing through the studios, wiping out old

stereotypes and hinting at the advent of women's lib in the following decade. "There was in her the elements of romantic rebellion against the Virginia social world," wrote the Warner profiler. "Leslie romanticized truth, without necessarily under-standing it . . . A ride on a clear morning, a mountain view, a child in need, a calf being branded—these made her blood quicken and demanded her intense participation . . . She rejoiced in a kind of noble dilettantism." Elizabeth would bring Leslie alive in all her dimensions, inhabiting the role with an authority that would make it impossible to imagine any other actress in the part.

In another casting anomaly, Stevens at first envisaged Richard Burton in the role of Jett Rink, the oil wildcatter who secretly loves Leslie Bene-dict. To avoid stereotypes, he was determined to cast actors who'd never appeared in a Western before. That he contemplated casting Burton, a British subject whose voice had the music of Wales in it, shows the extent to which he was willing to go to make *Giant* a film free from clichés. Stevens reconsidered and offered the role to Alan Ladd, but Ladd turned it down and the part went to James Dean, who'd achieved overnight stardom in his first film, *East of Eden*.[8]

With the cast in place, a press conference was held in the Warner commissary to announce the start of principal photography, and Elizabeth sat on the dais with Stevens, Dean, Hudson, Mercedes

McCambridge, and Chill Wills. At first, she wasn't sure what to make of the peculiar, introverted Dean. To everyone's astonishment, he appeared in blue jeans, a threadbare red flannel shirt, a sweat-stained Western hat, tattered boots, and an aged cowboy belt with a silver buckle, a cigarette droop-ing from his lips. Photographers asked him to remove his sunglasses for a group photo but he refused. Though his costars stood up as they were introduced, he remained in his chair, staring at his boots. Hudson rolled his eyes. To all appearances, he was as straitlaced as Dean was quirky, and of the two men, Elizabeth at first preferred Hudson.

Though her box-office power was well-known, Elizabeth was not, prior to *Giant*, regarded as a heavyweight actress or megastar. The billing file in Stevens's private papers indicates that the original pecking order was Hudson, Dean, Elizabeth, Jane Withers, and Wills, in that order. Not until the following year, 1956, as Stevens laboriously edited thousands of feet of footage, did Metro, Elizabeth's home studio, nail down the exact billing in negoti-ations with Warner. A memo from Marvin H. Schenck, vice president of Loew's Inc., specified that Elizabeth was to be "first of the names of the members of the cast."[9] Hudson followed Elizabeth on the bill, and Dean received third billing.

On April 28, 1955, a few days before Elizabeth's loan-out agreement went into effect, she reported to Warner's Burbank lot for fittings for her six cos-

tumes. Having heard from their friends at Metro that she was a problem but such a moneymaker that she was worth it, Warner executives nervously quizzed wardrobe about her behavior. In an interoffice memo to Stevens, Russ Llewellyn wrote that while the star was "very cooperative," it would be advisable—"less tiring" for Elizabeth—if they brought her in for one hour a day three days a week. Almost immediately she quarreled with Stevens over costumes. He put her in brogue shoes, a long skirt, and a man's slouch hat, appropriate attire for the wilds of West Texas, but she complained that she felt like "a lesbian in drag."[10] The director ridiculed her in front of the entire company as just another pretty face who'd never make it as a serious actress. Though she eventually got rid of the slouch hat, she appeared in the rest of the outfit in one of the Reata ranch scenes, and Stevens's judgment was borne out. The costume contributed to her credibility as a working ranch woman and enhanced her overall performance. Though she resisted Stevens, he was, apart from Monty, the best thing that had ever happened to her, tapping emotions and deep, rich vocal tones that no one else could elicit from her. Apart from Angela Vickers, Elizabeth's Leslie Benedict is perhaps her most appealing role—warm, lovable, and intelligent—and one of the first of the screen's new breed of liberated women.

 Giant brought her two of her most important

loving, a-sexual relationships. Rock Hudson and James Dean both became influential in her life and career in that watershed year of 1955. For decades thereafter, she scrupulously guarded the secret of Hollywood's foremost masculine role model, Hudson, a closet queen for whom the love that dare not speak its name was anathema. Even after his death from AIDS in 1985 she declined to discuss his sexuality. Finally, in 1997, she told interviewer Kevin Sessums, "I knew he was gay." She also revealed to Sessums that Dean was homoerotically inclined, something that had been rumored for years but never confirmed by a primary source. "The men that I knew—Monty and Jimmy and Rock—if anything, I helped them get out of the closet," she said.

Had she not been such an earnest and resourceful actress, Hudson's and Dean's homoeroticism would have made her work quite difficult in *Giant* as the lovely Leslie Benedict, supposedly desired by both men. Instead, it was Hudson and Dean who experienced difficulty, not because they were gay, but because her appearance was somewhat daunting to all males. Both actors were petrified at the prospect of making love to the world's reigning glamour girl, and it showed in their work as they began filming in Burbank in early 1955.

The Wildings invited the twenty-nine-year-old Hudson to their home one night, and Hudson brought along a woman named Phyllis Gates. According to actor Ray Stricklyn, Phyllis was a

farm girl from Minnesota who'd been an airline stewardess.[11] Later Phyllis moved to the West Coast and met Rock when she went to work for his gay agent Henry Willson, who'd changed Rock's name from Roy Fitzgerald to Rock Hudson and launched him on a movie career. When Ray Stricklyn moved to Hollywood and looked up his old friend Phyllis Gates, he met Henry Willson, who had a reputation for trying to seduce young actors.[12] Willson attempted to have sex with Stricklyn, and one night hosted a gang bang at his house, inviting Rock and other young studs. One of the boys squealed to *Confidential* magazine, which threatened to expose Rock as a homosexual. According to Stricklyn, Willson managed to "dissuade" the magazine with the help of hired gangsters, and then advised Rock to get married for at least two years to squelch the rumors. Rock ended his affair with a blond, blue-eyed, twenty-two-year-old man and started living with Phyllis Gates. When it appeared that *Confidential* was going to expose Rock as gay after all, studio executives gave the scandal sheet a big story on the prison record of another, lesser star, Rory Calhoun. Calhoun's career was sacrificed, and Rock was off the hook.

At the Wildings, that night, Rock asked Elizabeth, "How can you stand being so beautiful?" She replied, "Beautiful? Beautiful! I'm Minnie Mouse." Going into another room, she changed into a red

skirt and black pumps, pinned her hair back, and then came back looking exactly like Minnie Mouse. The campy, relaxed nature of their relationship was firmly established. They partied until four in the morning and then went to the studio at six to shoot one of *Giant*'s most important scenes, the wedding of Leslie Benedict's sister in Virginia, during which Bick Benedict comes from Texas to retrieve the independent, self-willed Leslie.

Hung over, Elizabeth sat in her dressing room wondering when she'd be called to the set. After an hour, she walked out and found Stevens and the entire company waiting for her. "What's going on? What happened?" she asked. The director bawled her out for being late. She tried to explain that no one had paged her, as was customary. Stevens tongue-lashed her until he'd reduced her to tears. When they started filming, she continued to weep throughout the scene. As played by Elizabeth and Rock, it was one of the most moving sequences in the film, despite the fact that between takes, both stars ran off the set to vomit. "We were both so hung over we couldn't speak," Rock said. "That's what made the scene."[13] Elizabeth suspected that Stevens had attacked her for being late to prepare her emotionally for this pivotal turn in the love story. Years later, in the early 1960s, when Stevens asked her to play Mary Magdalene in *The Greatest Story Ever Told*, she reminded him of their fight

and expressed surprise that he would want her. Astounded, Stevens said, "I always thought we got along very well together."[14]

As Elizabeth's marriage to Wilding deteriorated during the shoot, Rock offered a convenient shoulder on which to cry. She was frantic over how she'd raise two children alone if the marriage ended. "I felt sorry for her and the kids," Hudson said. "She loves them, but she never seems to know what she wants or where to go."

After location filming in Virginia, the company moved to Marfa, Texas, in the sweltering summer of 1955, traveling by Southern Pacific railway for six more weeks of location work. It was here that Elizabeth's relationship with Dean began to develop an erotic edge. He had a love-hate relationship with women. Born on February 8, 1931, in Fairmount, Indiana, he adored his mother, Mildred, who pampered him and gave him music and acting lessons as a child. She died at twenty-nine from cancer of the uterus when Jimmy was nine, and he grew up to become a basketball star, also lettering in track at Fairmount High. "If my mother hadn't died when she did, I would have been queer," he told Arthur Loew Jr.[15] Like many gay and bisexual males in the homophobic 1950s, when everything was explained in psychological rather than genetic terms, Dean blamed his homoeroticism on his mother's influence, refusing to accept that his sexual makeup was part of his basic

nature. If his mother had indulged him, it was because he charmed and captivated her, just as in adulthood he'd lure women into the same kind of relationship. Some nights he'd talk to Elizabeth until three or four in the morning, revealing intimacies, but the next day he'd snub her, ashamed of his confessions.

Like Rock, Dean owed his career to gay admirers, having gotten his start in 1949 by having an affair with a powerful advertising executive who landed Dean several radio and television shows in Los Angeles. He hustled while looking for acting jobs, rooming with Nick Adams, a short blond actor of whom it was said, "Big things come in small packages." Later the star of the TV series *The Rebel*, Nick "publicly opened his fly . . . to prove he was a manly man," according to Rona Barrett.[16] When Dean left California to try his luck on Broadway, he made friends with other young hopefuls, including Betsy Palmer and Ray Stricklyn. James Dean "kissed me firmly on the lips," said Stricklyn, describing a romantic encounter in a meadow in Central Park.[17] Dean also developed a crush on actor Jonathan Gilmore. Dean asked Jonathan, "Can you be fucked?" and Jonathan answered, "Jesus, I don't think so."[18] Dean was "multisexual," recalled Gilmore, who added that Dean once told him, "I'm certainly not going to go through life with one arm tied behind my back."

Returning to L.A. after Elia Kazan cast him in

East of Eden, Dean fell in love with actress Pier Angeli, a green-eyed, Madonna-like beauty, though he also dated Terry Moore and Vampira (Maila Nurmi) and bragged that he'd escaped the draft during the Korean War thanks to "flat feet, bad eyes, butt-fucking." Monty Roberts, the rodeo rider who'd performed Elizabeth's stunt work in *National Velvet*, taught Dean how to act like a masculine Salinas farmer for *Eden*. "Get some teeth in your ass," Roberts told him, "bite the saddle, and don't just sit there."[19] In *Eden* Dean had emerged as the most compelling actor since Clift and Brando. Elizabeth's 1954 pregnancy with her second child, Christopher Wilding, had been responsible for schedule shifts that enabled Dean to accept the lead in *Rebel Without a Cause*, which later became known in the industry as the movie that would never have been made except for Elizabeth's "act of God." In *Giant*, Dean was again being butched up for his Western role by Monty Roberts.

In Marfa to begin location filming, Elizabeth and Rock formed their own exclusive clique, eating together and watching daily rushes in the local movie house, while Dean always sat with Actors Studio–trained Carroll Baker, who played Elizabeth's daughter Luz Benedict II and who, in her next picture, as Tennessee Williams's thumb-sucking "Baby Doll" Meighan, would outrage the Catholic Legion of Decency. Carroll found Dean to be "asexual," and rumors of his homoeroticism cir-

culated after it was noticed that he spent all his spare time with stuntmen and cowboys. Conflict developed on the set after Dean used his Actors Studio know-how to steal scenes from every performer he worked with. In retaliation, Elizabeth and Rock ingratiated Carroll Baker with the aim of getting her to sabotage Dean's scenes. Infatuated with Elizabeth, Carroll immediately became a part of the Taylor-Hudson clique, and Dean, who felt betrayed, stopped speaking to her. Another switch occurred in the social dynamics of the cast when both Elizabeth and Rock fell in love with the charismatic Dean. "My heart was broken," Carroll later wrote, not because she'd lost Dean but because "I hardly ever saw [Elizabeth] any more." She tried to turn Elizabeth against Dean by telling her, "Dean's publicity seems to be only at your expense." During a photo op, Dean had grabbed Elizabeth and held her upside down, exposing her to the photographers from her feet to her waist. Stevens sternly reprimanded Elizabeth, and for a while she stopped speaking to Dean.

She lived in a rented house for the duration of the shoot with her sons Britches and Chris. When she'd first arrived in Marfa with her children, Stevens glared at her and asked, "Do you have to do this?" Glaring right back, she asserted, "Yes, I do have to do this. I know how hard you are to work for. Michael is being sent abroad to make a film with Anita Ekberg. I'm not going to have my

boys left just with servants. You see, dear George, I know that I won't always be camera-beautiful or camera-young, and I am not going to lose my hold on things that are real." Stevens later confessed, "Elizabeth probably knew a lot more about how to live her life than people with less courage did, in which group I might include myself."[20]

Dean and Rock shared a house with Chill Wills. Rock couldn't resist hitting on Dean, but he proved not to be sexually appealing to Dean, who moved out of the house.[21] Thereafter, a spiteful Rock scorned Dean as unprofessional and selfish. Elizabeth, fascinated by Dean's acting skills and personal magnetism, forgave him for having embarrassed her and became attached to him, sitting with him in the theater balcony to view daily rushes. Abandoned by Elizabeth, Rock was consoled by Carroll, Jane Withers, and Phyllis Gates, who joined him briefly in Marfa but left after a fight. Elizabeth began to spend more time with Rock again, comforting him during private talks about Phyllis. Now Carroll felt excluded, but Earl Holliman, who played another of Elizabeth's sons in the film, rushed into the vacuum and became Carroll's constant companion.

On June 3, 1955, Elizabeth shot her first scene with Dean on an open set at the Worth Evans Ranch. Dean was supposed to hoist a rifle over his shoulder and ask Elizabeth in for tea, but he froze. "Jimmy was really fuckin' nervous," recalled Den-

nis Hopper, who played Elizabeth's son. "At that time, there wasn't anybody who didn't think she was queen of the movies." They filmed numerous takes, but nothing worked. "He was really getting fucked up," Hopper continued. Then, suddenly calling on his Method training, Dean unzipped his Levi's and rolled out his penis. He urinated in full view of twenty-five hundred onlookers, then told Stevens, "Okay, shoot." They got the scene in one take, and later Dean told Hopper, "I'm a Method actor. I figured if I could piss in front of those 2,000 [sic] people, man, and I could be cool, I could do just anything, anything at all."[22] And indeed he could, recalled costars Carroll Baker and Hopper, both of whom assumed that Elizabeth and Jimmy had an affair. Her sons were sent back to Los Angeles, where they were looked after by their father.

Discussing Dean in November 1997, Elizabeth said Dean hadn't made his mind up whether to live his life as straight or gay. "He was only twenty-four," she explained, "but he was certainly fascinated by women. I loved Jimmy. He and I . . . 'twinkled.'" Kevin Sessums, the interviewer, warned Elizabeth that people would think she and Dean had played water sports in bed. "Oh God!" she said. "We had a . . . well . . . a little 'twinkle' for each other."

When Wilding visited Marfa, Dean told him, "You'd better know right away, Mike, that I have

fallen madly in love with your wife."[23] During Wilding's stay, Sara and Francis Taylor kept the children and their nanny in Beverly Hills. Elizabeth's quarrels with Wilding became so violent that he left Marfa after a week and returned to L.A., where he drank away his days with other unemployed actors at Barney's Beanery. Elizabeth confided to Jean Dmytryk that she and Wilding "had problems. He has minor seizures. And he's the most terribly British character that we've ever had on screen; simply can't speak American."

While in Texas, Elizabeth and Rock drank heavily. "We were really just kids," he said, "and we could eat and drink anything and we never needed sleep."[24] Stevens's private papers tell another story altogether. In July 1955, Elizabeth was calling in sick, alarming the entire studio. Warner executives began to exchange frantic memos about a succession of ailments, including a throat infection that went to her bladder and thrombophlebitis, a blood clot in a deep leg vein, for which Dr. John Davis treated her from July 30 to August 26. In a letter to Elizabeth's accountant, A. Morgan Maree, Dr. Davis wrote that she had to wear "some very tight breeches" which caused great pressure behind her knee, causing "impaired circulation."[25] In another letter Dr. Davis revealed that she suffered from "a congenital anomaly of the spine."[26]

After a scene in which she was required "to do a lot of jumping and twisting on a bed," Dr. Paul

McMasters diagnosed "severe low back strain and possibly a ruptured intervertebral disc." When she attempted to get Warner Bros. to absorb her doctor bills, Dr. Davis concurred that Elizabeth's back condition had not been hurting her until the wild bed scene, citing "a definite connection" between her pain and work conditions. When location filming was completed, Elizabeth returned to Los Angeles and finished the film in Burbank. According to a Warner memo, she requested two days of rest on Saturday and Sunday. "I questioned her husband Michael Wilding," unit manager Tommy Andre told Stevens, adding that Wilding assured him Elizabeth's physician, Dr. Robert Buckley, had ordered the rest. Andre went directly to Dr. Buckley, who confirmed that he was coming into the studio to examine Elizabeth. The doctor warned that the studio "might lose her in the picture for two or three weeks later on" if they didn't let her have two days' rest now.

Her medical complaints continued to hound the production staff. According to Dr. Nathan Hiatt, Warner's insurance doctor, she was suffering from "a slight case" of sore throat and cystitis, but might be able to report to work on Monday "unless something *unusual or dramatic* happens." On July 29, she told Andre that she needed half a day to one day off for the dentist. During her absence two production units remained idle. She was by no means the only cast member experiencing health

issues. Rock complained of a painful hip and received treatments from an orthopedic specialist at the studio every morning, later going to Vineland Hospital for X-rays.[27]

As costs mounted, Warner's patience ran out. Due to an infection in her left leg, Elizabeth didn't come to work on July 31, checking into St. John's Hospital in Santa Monica. Warner's immediately alerted Dr. Nathan Hiatt to absolve the studio of any responsibility for the star's behavior. On August 2, she said she couldn't return to work until Friday, August 5, and Warner executives bemoaned the "loss of a whole day on our schedule."[28] The first and second unit directors and crews hastily made plans to shoot around her, but on August 6 the company was forced to shut down, according to Andre, who added, "Our understanding is that we are covered by insurance."[29]

Though she returned to the set, she was still complaining of pain in her leg on August 10, 1955. A summit conference of physicians was held, and Drs. Davis, Hiatt, and Paul McMasters agreed that she had sciatica. She left the set and went home. Stevens rehearsed her double for the sequence they'd been shooting, but because of close-ups they were unable to make it work. Instead, Stevens completed a second-unit shot of Rock in the Reata Thanksgiving scene. Dr. McMasters taped Elizabeth's back to relieve her pain. On August 11, she missed work because of a

medical examination. She also went to Dr. McMasters's office for an injection of Novocain to numb her sciatic nerve. Warner's insurance doctors met to decide whether to put her in traction for several days in the hospital. When Stevens heard this, he hit the ceiling. Elizabeth later wrote, "George was quite convinced it was all psychosomatic. But it is a characteristic of sciatica that it's crippling one moment and disappears the next." For a big scene to be shot at the Lockheed Air Terminal, the company considered using Elizabeth's double, but on August 12 the star arrived on the set on crutches, saying she was ready to work. Dr. McMasters warned everyone to keep her off her feet as much as possible.[30]

Because of the delays it was necessary on August 12 for *Giant* producer Ginsberg to write MGM's legal department for permission to use Elizabeth for another four weeks beyond August 21, when her loan-out period expired. At 7:30 A.M. on August 31, Elizabeth called Stevens complaining of a "bad headache" and asking "did she have to come in so early," according to Tom Andre. When she arrived an hour late for filming, Stevens, Ginsberg, and Tom Andre met to consider asking "Miss Taylor if she would care to move on the lot until the picture is finished," Andre wrote. Predictably, Ginsberg had to ask MGM for another extension on her loan-out to September 30, 1955. Metro's Marvin Schenck granted the extension. Warner Bros. then had to

persuade Universal to extend Rock's expiration date of August 23 to September 30.[31]

James Dean also caused delays by arriving late on the set or failing to show up at all. One occasion was on August 23, when he completed a move into a log house he'd leased for $250 a month on Sutton Street in Sherman Oaks. When Dean showed up late, the outraged Stevens upbraided him in front of the company, pointing out that Mercedes McCambridge had reported to work despite a broken arm. Dean took it in silence. One evening after work, Elizabeth and her husband joined Dean, Ginsberg, Arthur Loew Jr., and Joan Collins for dinner at a restaurant, where Dean picked up several girls. Later they all went to Oscar Levant's Beverly Hills home. Oscar and June Levant's fifteen-year-old daughter Marcia, who was already in bed asleep, was an ardent fan of Dean's. Elizabeth, June, and Joan decided to lead Dean up the stairs to Marcia's bedroom, where he woke her by placing his finger lightly on her nose. When she awoke and recognized him, she screamed and pulled the covers over her head. Finally, he convinced Marcia to put on her bathrobe and come downstairs, where he spent half an hour quizzing her about her life and advising her about school, friendship, and life in general. Then he told her to go to bed as it was quite late. After Elizabeth and the others left, Dean stayed and talked with Levant about Bach, Mozart, Arthur Honegger, Charles Ives, and Stan

Getz. Then Levant played the piano for him, and he finally went home at 4 A.M. "He knows so much about music," Levant said.[32]

Dean's prime passion was racing his silver Porsche 550 Spyder. Just before he drove off to Salinas on Friday, September 30, 1955, for a road race, Elizabeth gave him a beige-and-brown Siamese cat named Marcus, but he passed it along to a friend, explaining, "You know what a crazy life I lead. What if I went away and never came back?"[33] At 5:45 P.M., one mile east of Cholame in San Luis Obispo County, at the intersection of highways 466 and 41, Dean saw a two-tone black-and-white Ford sedan making a left turn onto the highway just ahead of him. At 115 mph, Dean was going too fast to avoid a collision. The other driver, Donald Gene Turnupseed, a student at California Polytechnic, walked away with a bruised nose,[34] but Dean's head was almost severed from his body. He was dead on arrival at Paso Robles War Memorial Hospital, and a doctor there rang the Warner studio in Burbank.

A guard answered the phone and relayed the news to the projection room, where Elizabeth was watching rushes with Stevens, Rock, and Carroll Baker. Stevens took the call and told the others that Dean had been killed. Elizabeth collapsed across the chair in front of her, then jumped up and ran from the room. Locating Dean's friend, dialogue coach Bob Hinkle, she stayed on studio

phones until 9 P.M., calling police, hospitals, morgues, and the press, trying to disprove the report, but getting nothing but confirmations. When she saw Stevens later, she said, "I can't believe it, George, I can't believe it." Stevens replied, "I believe it. He had it coming to him." She asked Stevens what he meant, and the director said, "The way he drove, he had it coming." In a blind rage Elizabeth drove home at 100 mph, over canyons and around S curves, plotting how to get even with the director.[35]

Later that night, she rang him and said, "I can't work tomorrow. I've been crying for hours. You can't photograph me tomorrow." He asked, "What's the matter with you?" She replied that she "loved that boy. Don't you understand?" Sternly, he told her, "That's no reason. You be on that set at nine o'clock tomorrow morning, ready to shoot."[36] She was there as ordered, but no sooner had she started to rehearse than she went into hysterics, complaining of abdominal pains. She was punishing Stevens, whom she called a "callous bastard."

On Saturday, October 1, as *Rebel Without a Cause* went into release across the nation, garnering rave reviews and enormous popularity, Dean's father, Winton, arranged for his casket to be transported from the Kuehl Funeral Home in Paso Robles to Los Angeles. The same morning, Elizabeth showed up late for work at Warner Bros., "upset," according to an October 4, 1955, memo from Tom

Andre. She threw up her breakfast in the makeup department, and first aid was summoned to give her medicine to settle her stomach. Finally, at 11:45 A.M., she reported to the set to finish the final sequence in the Reata ranch house. "We felt she was upset over James Dean's death," Andre continued. She finished her long shot scenes, but later that afternoon, she again felt nauseated when she attempted to perform close-ups. "We shot a close-up of the final scene in the hope that if it were OK we could finish the picture," Andre memoed, but when Stevens printed the scene, he found it unsatisfactory. By then Elizabeth was so ill Stevens sent her home, and Andre noted that her indisposition resulted in the loss of a "whole day's work, roughly 3/4th of a day."[37]

There is no evidence among the voluminous *Giant* documents in the Stevens archive, which includes Warner memos and physicians' reports, that Elizabeth had anyone on her side during this crisis. Where, one wonders, were her parents as she struggled through the arduous shoot, taking care of her children, supporting a helpless husband, anxious over a terrible tax situation that ate up eighty percent of her $180,000 annual income, and wondering how she was going to get out of debt.[38] No one seems to have supported her as she slowly came apart at the seams. Occasionally Sara called when she read newspaper hints of a nervous breakdown.[39]

Doctors warned Stevens that she would be out for at least two days, but promised the studio that no exploratory operation would be performed on her until they got her "back in shape" to finish the picture. Due to the uncertainty of her health, Stevens, Ginsberg, and Andre decided to close down the first unit and lay off all personnel. Dr. Davis later stated that she was ill "due to extreme nervous tension from the fact that one of her co-actors was killed in an automobile accident, but more important, the extreme mental duress she was put under by the director at this time." As the crisis worsened at Warner, Ginsberg tried to get some idea of when Elizabeth would return to work on the picture, which was one of the longest and most anticipated films since *Gone with the Wind*, but she said "the date when she would be able to return to work was up to her doctor." Eager to cover the expenses of this further delay, Ginsberg immediately told Warner's insurance doctor to get in touch with Dr. Buckley. He also requested that Elizabeth be given an examination the following day. Using a double for Elizabeth, Stevens was able to get at least a few shots of the film's coda scene involving Rock, Chill Wills, Tina Menard, and two infants.[40]

As Elizabeth's sitdown strike continued, Dean's remains were flown to Indianapolis. A Hunt Funeral Home hearse carried the coffin to Vernon Hunt's store in Fairmount, which also served as the

town's mortuary. Later, there was a viewing at the Winslow farm where Dean had grown up. In Los Angeles, Warner was in turmoil as doctors hovered over Elizabeth, trying to diagnose a lump in her side but unable to agree whether it was appendicitis, a broken cyst in her ovary, or adhesions from her cesarean section. Elizabeth told Warner she was "terribly anxious" to complete *Giant*, but her doctors could not state a definite date on which she could return to work. The studio instructed its insurance adjuster, Mr. Eggenberger of Toplis & Harding, to start an investigation into her condition.[41]

On October 8 in Fairmount, three thousand mourners jammed the Black Creek Friends Church for Jimmy's funeral, the largest in the town's history. Not one Hollywood celebrity showed up, though Henry Ginsberg, representing *Giant*, did attend. Elizabeth sent flowers, as did Edna Ferber. His estate, inherited by his father, amounted to $96,438.44 after taxes, but by the 1990s, Dean's trademarked image was earning $6 million a year from items ranging from T-shirts and posters to sunglasses and Converse sneakers. Dean, Elvis Presley, and Marilyn Monroe became the biggest cult figures of the twentieth century.

Elizabeth was hospitalized at the University of California Center on October 2. According to Drs. John H. Davis and Robert Buckley, she "presented a diagnostic problem with a major differential

between a volvulus [a loop twisted in her small intestine] versus a Mittelsmertz syndrome [a dull pain during ovulation] . . . The former is the most likely diagnosis and it resulted secondary to prolonged retching and vomiting and to a marked visceroptosis [a downward shift of viscera]." The following diagnosis was made: "1. Volvulus self reduced. 2. Acute tracheobronchitis."[42] She was released from the hospital on October 10. By May of the following year, Elizabeth and Warner were still arguing over who should pay her doctor bills.

When *Giant* was released in 1956, it was the hit of the year, establishing Elizabeth as one of the leading movie actresses of her generation, along with Marilyn Monroe, Audrey Hepburn, and Kim Novak. The consequences for Rock were even more momentous: he immediately shot to superstardom, the Film Buyers of the Motion Picture Industry voting him the number one box-office attraction in America. Under pressure from *Life* to prove he wasn't gay, he married Phyllis Gates but continued sleeping with boys. The marriage ended after two years.[43]

Jack Larson recalled how Monty came back into Elizabeth's life in 1956. "I was in New York with him, and then I came back to L.A. to shoot a season of *Superman*. He had been offered *Raintree County* and offered every script in town. I was very surprised when he called me and said, 'I'm coming out there, I've decided to make *Raintree*.' I said, 'Is

it good?' 'No, it isn't good,' he said, 'but it's good enough that I'd be a coward not to do it, and it means working with Bessie. I love her.' Lew Wasserman, his agent, found Monty a house that didn't work out because neighbors kept coming over on the pretext of needing a cup of sugar but really wanting to see Montgomery Clift, the mysterious movie star. Monty then got another house. He'd run his car off the road while making *From Here to Eternity*, so he hired Florian, a Filipino, as combination house boy/driver. When Monty moved from the first house, the one Wasserman had helped him get, he found a small place with a pool on Canter, and spent much of his time either with Elizabeth and Michael or with me."

In the cluttered and unhappy Wilding household, Monty became an interpreter between Elizabeth and Wilding, who barely spoke to each other. Wilding was always drowsy and confused from his constant drinking and the Seconals he took for his epilepsy. Taking a separate room in the house, he virtually disappeared from Elizabeth's life. Besides Monty, she entertained regular guests like Rock, the Grangers, Kevin McCarthy, and Humphrey Bogart, who brought around his entourage, known as "The Holmby Hills Rat Pack." Elizabeth started an affair with Frank Sinatra, according to restaurateur Jilly Rizzo, a close friend of Sinatra's.[44] Eddie Fisher later added that Sinatra's manager picked her up in a limousine and drove her to "some dirty

place in Mexico—where she had an abortion."[45] When a Sinatra biographer reported these allegations, Elizabeth issued an emphatic repudiation of them through columnist Liz Smith.[46]

Wilding had an affair with Marie "The Body" McDonald, a minor actress who'd appeared in forties fluff like *Getting Gertie's Garter*, and Elizabeth had a fling with Victor Mature, whose lovemaking was described as "a force of nature" by Esther Williams. According to one of her many biographers, Wilding caught Elizabeth in bed with Mature, his costar in *Zarak Khan*.[47] Wilding then became a ghostly presence in his own home, where Elizabeth and Monty seemed more like the married couple and Wilding the house guest. "I just can't get over it—Liz is the only woman I have ever met who turns me on," Monty told Wilding. "She feels like the other half of me."

Eddie Dmytryk began filming *Raintree* in April 1956 following his directorial triumph in *The Caine Mutiny*. Metro paid Elizabeth $125,000, and Monty, still a bigger star than she, received $300,000. He played John Wickliff Shawnessy, an idealistic schoolteacher and Union soldier during the Civil War, and Elizabeth portrayed Susanna Drake, the deranged Southern belle who loves him. It was a hexed picture from the start. "The author was Ross Lockridge, whose widow told me he was struggling with some sort of psychotic problem— depression, I imagine," said Dmytryk. "He wanted

to go to a psychiatrist and his family said no, it would be a blot on the name. Imagine—his family wouldn't let him go to a psychiatrist. He committed suicide."

Explaining the casting of *Raintree*, Dmytryk added, "As the director, I cast my films, but in this case, MGM already had Monty and Elizabeth, and who would say no to Monty and Elizabeth. Making that (or any) picture was a twenty-four-hour-a-day job. You couldn't cut it off and go home at five o'clock. I always knew exactly what I wanted to do the first thing in the morning, because the previous day I'd quit early, at 4:30 P.M. or so, and rehearse the next day's shot with the actors so they would know exactly what they were going to be doing. I'd tell the actors, 'Okay, go home, see you in the morning,' but the lighters, electricians, and crew would stay on and get ready for the next morning. I'd arrive early the next day, the actors would be ready, and they'd get the shot in the can by nine o'clock. A director's biggest job is getting the pace out of people, making it lifelike. Elizabeth was a natural at that, and so was Monty. They both needed just a little bit of goosing." She also needed help with her Southern accent. Marguerite Lamkin, a stylish young woman from Monroe, Louisiana, took Elizabeth in hand and turned her into a passable Southern belle.

On the evening of May 12, 1956, Elizabeth invited Monty to a small dinner party at her home

on Beverly Estate Drive. "It was a going-away party because we were going on location," Dmytryk recalled. Monty had spent the day with Jack Larson, who left Monty at 5 P.M. to go to his mother's house to see a TV show starring his favorite actor, Claude Rains. Neither Monty nor Jack owned a television set. "Monty told Florian to go home as it was getting late in the afternoon," Larson recalled in 1999. "He told me, 'I'm not going out.' After I left, Monty talked to Elizabeth and said, 'I'm exhausted and not coming.'"

Elizabeth persisted, explaining that she wanted to fix Monty up with a hip young priest who was a fan of his. "He says 'fuck,' but I don't care what he says, I want to stay home," Monty said, feeling drained from listening to the Wildings' problems. Elizabeth called back numerous times, and finally he consented, driving his car up what Jack Larson describes as a "winding, peculiar road." After turning from Benedict Canyon Drive, Monty started driving up the frightening, almost vertical ascent to Elizabeth's house at 1375 Beverly Estate Drive, negotiating several treacherous curves, including one sharp right angle that seemed to lead directly into the front door of a house. Teetering on the brink of a yawning gorge, the deadly little street is a death trap just waiting to snap shut on drunk drivers.

Elizabeth's dinner party had already dragged on for four hours when Monty arrived around mid-

night. A heavily sedated Wilding lay on the couch as Elizabeth listened to Sinatra records on the hi-fi, which Wilding thought "unbearably indiscreet" of her.[48] Rock Hudson was visibly bored with Phyllis Gates, and Kevin McCarthy was reluctantly sipping the Wildings' lukewarm rosé. "Monty had one glass of sherry and no drugs," Jack Larson said, but according to other accounts, he consumed several glasses of wine, later slipping into the bathroom to drop two downers. When Wilding saw him swaying, he said, "Monty, how are you?" Monty replied, "None too gorgeous," using a phrase that customarily signaled a bout of depression. Elizabeth pressed a drink on him and begged, "Don't look so sad . . . I want everyone, most of all you, to be happy with me." According to Wilding, "Monty brushed her aside and got unsteadily to his feet, saying, 'You'll have to excuse me, sweetie. Not feeling too gorgeous, you understand.'" Rock noticed his stupefied condition, took his arm, and said, "Time for me to pull the blinds down, too." Elizabeth and Michael stood in the doorway, waving goodbye, and then went inside and rejoined the others.

It was a little after midnight. "Monty wasn't sure if he knew the way out and asked Kevin to lead him down," Larson said. "Kevin drove in front of Monty to lead him back to Benedict Canyon. After that, Monty could find his own way to Canter. Going down the hill, Monty fell asleep at the

wheel. He was prone to fall asleep. That's when he hit a post." Kevin stopped and walked back to the wreck. Monty was crouched under the dashboard, blood spurting from his head. "Kevin went back to the house to call an ambulance," Larson continued. "Then they all rushed down the road to the crash site, and Elizabeth saved Monty's life. His top front teeth were lodged in his throat." Telling him, "You're going to be all right, Monty darling, you're going to be all right," she rammed her hand into his mouth.[49] "She got the teeth out from his throat," Larson said. "He was a total mess, cheek-bones fractured, jaw broken on both sides, nose broken. Rock Hudson and the priest were there. Michael Wilding was—well, confused."

Finally, Monty's doctor, Rex Kennamer, arrived. Monty said, "Dr. Kennamer, meet Elizabeth Taylor." Kennamer and Rock managed to pull Monty from the wreck. "The film," he gasped. "I've got to be at the studio." Elizabeth was holding his head in her lap. "Don't worry about the studio," she said. "We'll shoot something else." She accompanied him in the ambulance to Cedars of Lebanon Hospital, where she and Monty received intravenous sedative injections. "His head was so swollen that it was almost as wide as his shoulders," she recalled. After Kennamer told her it was "a miracle" he'd survived, she went home and collapsed in a state of "shock, anxiety, worry, depression," Wilding said. Apart from facial injuries,

Monty had suffered a cerebral concussion. He would be nine weeks recuperating, spending part of the time in traction to correct severe whiplash. His jaw been set sloppily and had to be rebroken.

"Those of us close to him had always been surprised by his public image, and often talked about it and said we would never put up with the kind of person described in the press, this creature they write about—a drab, introverted, tortured person, which he was not in any way, shape, or form," said Jack Larson. "The comedian Nancy Walker was close to him, I was, Libby, who was tons of fun, was, and Roddy McDowall, who was also great fun, was a good friend, and Elizabeth loved him. Then came the accident and things changed totally. His face was destroyed. It made a difference in his relationships to people and how he thought about himself. I know that. His feeling about himself changed. He always tried to spare people as much as he could any unhappiness. After the accident, Monty stayed with me and I saw him through as much as I could . . . A lot of people behaved very badly—they just wanted him to finish that film *Raintree County* which he shouldn't have done.

"At the time of the accident, Libby came out to be with Monty. She told him he needed to come back and spend several years recovering with the very best doctors back east and not Hollywood doctors, and slowly get plastic surgery. Instead,

they had shot him full of things, and he developed a scar tissue he shouldn't have had. Elizabeth was wonderful, visiting him almost daily in the hospital."

One day she walked in his room and discovered him with Libby, who glared at Elizabeth and blamed her for letting Monty drive his car alone. "Screw off," Elizabeth said. Nurses at Cedars gossiped about how the movie star and the Broadway diva nearly came to blows over the actor's bandaged and trussed body. Libby called Elizabeth "sensual and silly . . . a heifer in heat." Later, as Monty lay in traction at his rented home, McCarthy was shocked to find him sipping martinis through a straw after Libby restocked his bar. When he recovered, he was scarcely recognizable as Montgomery Clift, appearing pinched and withered. The famous gullwing eyebrows were now shaggy thickets, the left side of his face was almost paralyzed, the once heroic jawline was soft and mushy. His eyes looked dead, no doubt due to pain, bewilderment, and massive dosages of barbiturates.

The film was temporarily shut down, but "insurance covered it," Dmytryk said in 1998. "We waited; Van Johnson had been hurt during the 1940s, and Metro waited until he'd healed up and finished the picture. We did the same thing. Accidents happen to movie stars too." Scenarist Millard Kaufman and his wife Lorry spent many evenings

looking after Monty during his convalescence. "He had more guts than any hero he ever portrayed," Kaufman said in 1999. "He was in constant pain. He came for dinner. Lorry had made him some very nourishing thin liquid soup, and she had a very wide straw for him to drink it through. He looked like he'd had bad cosmetic surgery. The studio's attitude was: 'Let's get him back on the stage and get the picture out fast.' Monty was exhausted. When he came back to work, we shot all day on a Saturday. I called Dore [Schary] and said, 'Give us Saturday off or Monty's going to die.' Elizabeth was also having a bad time—trouble with Michael Wilding."

Though Dmytryk never entertained the thought of replacing Monty, some of Metro's executives wanted to dump him, since he now looked more like a scarecrow than a movie star. Elizabeth warned Schary that Monty would kill himself if the studio fired him. Monty was reinstated in his role when the filming resumed after a nine-week suspension. Dmytryk was impressed with Monty's valor and recalled, "He remained a very funny, amusing personality. No matter how hurt he was he wouldn't complain. He was in great pain, so he went back to drugs and liquor, and that shows in the film, but not much. You can't tell what was shot before the accident and after it. We made absolutely no attempt to photograph him any differently, except that once he returned to work, we rarely shot in the afternoon because the sun was

out and it was hot. I love Monty, I thought he was a great great guy, but I swore I'd never work with him again because it was just too difficult. It took 125 days. It was too much responsibility—he was too much trouble, but I'll say this: almost everyone else I know who gets drunk becomes nasty. The only one who didn't get nasty was Monty Clift. He just fell apart."[50]

During the production's hiatus, Elizabeth had exploded at Wilding and he'd walked out. He'd turned down the stage role of Henry Higgins in the U.S. touring company of *My Fair Lady*—the same role that made Rex Harrison one of the biggest stars in the world. Aside from not having appeared on a stage in twelve years, Wilding quite logically feared having one of his epileptic seizures during a live performance. "You're nothing but a coward," Elizabeth told him. "To think that the man I once loved turns out to be nothing but a coward." It was more than even the masochistic Wilding could take. When they separated on July 19, 1956, Elizabeth explained, "It wasn't that we had anything to fight over. We were just not happy, and I think it was showing in the two boys." Wilding resumed his affair with Dietrich, who told Maria Riva, "He is a new man, now that that awful woman that made his life so miserable is gone. Now, we have to get his children away from her." Riva immediately went to Wilding and warned him, "For God's sake, don't ever let her

near your boys." Meanwhile, Dietrich and Wilding were making love "so energetically," according to Riva, "that they broke the double bed in the guest-room."

Elizabeth felt "dead, old at twenty-four, with no reason for living out the day," she recalled. All that would soon change when she met dashing, able-bodied Kevin McClory, an employee of flamboyant producer Mike Todd.

5

Mike Todd:

It was on *Raintree County* that she met Mike Todd," said Millard Kaufman. "It was very difficult for her." One of the difficulties was that Elizabeth was already involved with Todd's assistant director, Kevin McClory, who later coproduced the James Bond thriller *Thunderball*. McClory was a dark-haired, blue-eyed Irish screenwriter and cinematographer who was working on Todd's all-star movie *Around the World in 80 Days*. After beginning as a production assistant, he was put in charge of the second unit, eventually becoming Todd's number one sidekick. According to Todd's son Michael Jr., his father was taken with McClory's "wit and Gaelic charm." Perhaps because of McClory's speech impediment—a stutter—Todd referred to him as "Klevin."[1]

As a lover, McClory was as lusty as Elizabeth, exhibiting the same confidence and go-for-broke

drive that had made him a WWII hero. "He's campy," she said, using a favorite gay term for her latest sex partner, and McClory described her as "totally pornographic." One day she phoned him at the studio, and Mike Todd somehow got wind of it. A few days later Todd told him, "Everybody knows who you're seeing, and I don't think it's right."[2]

The clever, underhanded Todd hatched a plan to steal Elizabeth from McClory, inviting her aboard his rented 117-foot yacht *Hyding*. "As his invitation coincided with the day of my visit to the boys," Wilding recalled, "Liz asked if she might bring us along too." Elizabeth had already caught sight of the forty-nine-year-old Todd in the MGM commissary and thought, "Oh, he's quite good-looking for a producer. He glanced at me a few times and I thought he had very pretty eyes."[3] A native of Minneapolis, Todd had kicked around Broadway for years as a Times Square high roller in the tradition of Sky Masterson in *Guys and Dolls.* After producing Broadway spectacles like Gypsy Rose Lee's *Star and Garter* and Mae West's *Catherine Was Great*, he teamed up with Orson Welles to bring Jules Verne's *Around the World in 80 Days* to Broadway in the 1940s, but left Welles stranded on the road, craftily retaining the film rights. His current mistress, the witty, intellectual Evelyn Keyes, a blond dazzler with elegant cheekbones, had appeared in one of the most popular postwar

films, *The Jolson Story*, but remained a second-rank star. The title of her autobiography, *Scarlett O'Hara's Younger Sister*, alluded to her turn as the fretful spinster Suellen in *Gone with the Wind*. A dishy account of her marriages with superior men like John Huston and Artie Shaw, Keyes's memoir revealed her to be anything but a wallflower.

Aboard the *Hyding* that summer day in 1956, even a sophisticated paramour like Keyes was no match for Elizabeth in her form-fitting flamingo pants and a violet cashmere sweater that brought out the glory of her eyes. "Todd fell for Liz the moment he set eyes on her," Michael Wilding recalled. "After a few minutes in his company she was at her sparkling best, her mood matching Todd's wit and overflowing exuberance."[4] As the Wildings drove home later, Elizabeth told her husband that Todd was a man who could get anything he wanted once he'd set his heart on it.

The Wildings saw Todd again that summer at a small barbecue given by Todd and Evelyn Keyes in their Hollywood Hills home. In full view of Wilding, who'd been introduced to everyone as Elizabeth's husband, Elizabeth proceeded to flirt with Todd as they floated in the pool, sitting back-to-back on a large air mattress. "Our backs were about three inches apart," she recalled. "It was as though my spine were tingling." The other guests included Eddie Fisher and his wife Debbie Reynolds. Later that night Eddie told Debbie that he was not

impressed by Elizabeth. "She has skinny legs," he said. "I could never go for someone like that." Years later, Debbie reflected, "When your husband says that about a woman, she's the one to watch out for."

Elizabeth was on the threshold of two of her strangest sexual, a-loving relationships—Mike Todd and Eddie Fisher. Born in 1928 in Philadelphia, Eddie was a child of the Depression whose Russian Jewish family, originally named Fisch, moved twenty times during his boyhood, and whose father he described in 1999 as "a nasty, abusive man, a tyrant." Eddie's unresolved issues with his father underlay his dependence on such older men as Mike Todd and mobster Sam Giancana. "I just like hanging around with tough guys," Eddie said, adding that he loved Giancana "like a brother." Spoiled as a child by his mother, Katie Fisher, who called him "Sonny Boy," Eddie seemed never to appreciate fully how hard his father worked to support seven growing children. Joe Fisher slaved in a leather factory and a delicatessen and finally peddled fruits and vegetables from the back of his car, but Eddie was still kvetching in 1999 that Joe did nothing to help his career. What Eddie really resented was that he could never earn his father's respect even after stardom.[5]

If Eddie had a redeeming feature, it was his smooth, clean, lyric baritone voice. By the early 1950s, he'd scored twenty-two consecutive hit recordings, notably "Anytime" and "I'm Walking

Behind You." While playing the Paramount in Times Square for $7,500 a week, exhausted from performing five shows daily, he became a patient of Dr. Max Jacobson, a "feelgood" doctor catering to Broadway and Hollywood stars. Max gave him intravenous shots of a "vitamin cocktail," one in his arm and one in his buttocks. Eddie didn't know that the shot included methamphetamine, only that "a wave of sunlight passed through my body." The date was April 17, 1953, and he remained an addict for the next thirty-seven years.[6]

His loveless 1955 marriage to Debbie followed a studio-arranged meeting at Metro, where she was filming *Athena*. Sexually they could not have been less compatible, as both would later reveal in their respective memoirs. She was virginal, and he was like a sexual pirate, taking all and giving nothing, according to Debbie, who tolerated him because he was useful to her socially. The daughter of a mechanic and a washerwoman, she'd grown up behind a gas station in El Paso, Texas. After proving her versatility in films as a comedian, dancer, singer, and actress, she hungered for respectability. As the "hot young couple," she and Eddie were taken up by "a society unlike anything either of us had ever known," she wrote. "They loved having us. The Goetzes, the Goldwyns, the Warners, the Mervyn LeRoys." Eddie spent his time with his male cronies, who resented Debbie and excluded her from their card games, which lasted till dawn.

"Only guys with guys," she mused. To rumors that he was gay, Eddie once yelled, "I am not a homosexual!"[7]

Compared with the youthful, glossy-haired Eddie, middle-aged Mike Todd was hardly a sex object, but Elizabeth thought Todd the more attractive of the two men. Though short, he was powerfully built, virtually steaming with energy. What he lacked in youth and stereotypical male beauty, he more than made up for in his bristling virility and Machiavellian tactics. At twenty-four, Elizabeth was half his age. Kevin McClory remained a formidable competitor for Elizabeth's affections. Though still married to Wilding, she seriously contemplated marrying Kevin, though he warned her that on his "meager finances" he could not give her a lavish Beverly Hills home with a pool. An even bigger mistake was telling her that he'd expect her to wash and iron his shirts. He was about to give her a twenty-dollar gold locket as an engagement present when a coworker, Don Tomlinson, saw it and warned, "That's not enough."[8] As Mike Todd began to move in on Elizabeth, he treated McClory brutally. Todd invited Elizabeth, Wilding, and McClory to a party he threw for Edward R. Murrow, who was filming the prologue to *Around the World in 80 Days*. When Todd spotted McClory helping himself to a huge mound of caviar, he told him to go easy on the beluga or there wouldn't be any left for the "real" guests.

Wilding left the party early, but Elizabeth stayed on until 2 A.M. In white satin and diamonds, she again eclipsed Evelyn Keyes, who wore a Mexican skirt and blouse.[9]

The day following another of Elizabeth's separations from Wilding, Todd cornered her at Metro and proposed. Startled and overwhelmed, she "ran away from Mike, a couple of thousand miles away," she recalled. "I left immediately for Danville, Kentucky, to do *Raintree County*." In her absence, the ruthless Todd banished McClory to Mexico City, presumably to work on a bullfighting scene for *Around the World in 80 Days*. Todd also got rid of Evelyn Keyes, sending her to Mexico with McClory and later to Caracas on a trumped-up mission to "look at some theaters to select one for Todd-AO [his wide-screen system]." The way was now clear to woo Elizabeth without interference. "He behaved like a shit," said Keyes, who'd helped finance Todd's film.[10]

"The real love of Elizabeth's life was Mike Todd," Jean Porter Dmytryk recalled during our 1998 interview. "If he was alive they'd be together today." When informed that Todd beat Joan Blondell, his former wife, to a pulp, Mrs. Dmytryk said, "Maybe he did. Elizabeth and Mike Todd had fights but they made it up. They loved each other." When Elizabeth was given a two-week vacation, Todd sent a chartered plane to fly her to New York. At the airport, she ran down the steps into his arms

and they kissed for the first time. From that moment on, they both knew that they were getting married. When she returned to Kentucky for some retakes, she proudly showed off the ring he'd given her. "Don't you think you should get divorced before you think about getting married again?" Eddie Dmytryk asked. It stopped her in her tracks. She still hadn't made any firm plans to seek a divorce from Michael Wilding. Perhaps because of the two children they shared, they kept trying to recapture their early passion. But with Elizabeth running around outrageously and Wilding sleeping with Marie McDonald, Dietrich, Montgomery Clift, Stewart Granger, and an assortment of strippers from a Hollywood burlesque house, their efforts to restore their family life were halfhearted at best.[11] "It just isn't ring-a-ding-ding any more," she told Wilding.

In a 1999 interview *Raintree County* scenarist Millard Kaufman recalled that the steamy summertime location shoots took place in Danville; Natchez, Mississippi; and northern Louisiana. "Elizabeth and Monty went through a lot of very bad heat down in the South," Jean Porter added. "She had corsets, slips and petticoats on. They would keep cool washcloths on their heads to get through their outdoors scenes until they were ready to shoot. It was hard on them, and yet the minute the camera was rolling, you'd never know it." Kaufman found her to be the fastest study he'd

ever known: "Though she would start the day bored, saying, 'Another day of this hell,' she'd ask the first assistant, 'What are we doing today?' He'd give her five or six pages. She'd look them over and shoot the scene without blowing a single line. What a decent, thoughtful woman; she was so compassionate with Monty, being his mother at her age. She took care of him more than anyone else."

When the company flew from Kentucky to Mississippi for shots of antebellum ruins, Elizabeth was late, and Kaufman remembered that they had to hold up the plane for her on the runway. "Finally someone brought her out to the plane in a jeep," he said. Later, she arrived at the Natchez airport in front of hundreds of spectators, one of whom remembered, "Elizabeth apparently had so much to drink aboard the flight that she had to be carried off the airliner into a waiting limousine. Her feet never touched the ground."[12]

Eddie Dmytryk took his cast "outside of Natchez a few miles, a wonderful old ruin, with the big pillars, just a natural for the set, a natural metaphor for the South," he recalled. "Elizabeth had a long scene there, a number of pages, in that heat—and finally she collapsed." Jean Porter explained, "She was hyperventilating in those corsets," but Dmytryk said, "Elizabeth could drink pretty well." When her doctor prescribed forty chloral hydrates for sleep, Monty told her, "Chloral hydrates are a fantastically strong mickey finn." By

the next evening, he had reduced her drug supply by half and was found comatose in his room, a cigarette having burned his finger to the bone.

Elizabeth and Monty dined together nightly in their hotel rooms in Natchez, avoiding the crowds that gathered outside to catch a glimpse of them. The crew was under the impression that Elizabeth was sleeping with Monty, since they often saw him at her door, completely nude. Elizabeth would take him in, give him a shower, dry him off, and tuck him in. Constantly on amphetamines, barbiturates, and tranquilizers, he was no longer able to help her with her acting, as he'd done before his accident. That left her without coaching of any kind.

Eddie Dmytryk believed in leaving the interpretation of a role entirely up to the actor. "I did not give a concept to an actor," he said in 1998. "Show me a script that an actor with an IQ of 100 cannot understand—show me one. You don't have to explain a script to an actor; most actors I work with are very bright. I never in my life have had to tell an actor what something means. They understand it. I want them to make their own characters. I don't want my characters on the screen; I want their characters, that's why I cast them. And it's easier that way."

His hands-off technique worked with many of the stars he directed over the years—Bogart, Tracy, Brando, Deborah Kerr, Jose Ferrer, Eva Marie Saint, Ginger Rogers, Van Johnson, Dorothy

McGuire, Fred MacMurray, Robert Ryan, Dean Martin, Clint Eastwood—but not with Elizabeth. Playing a madwoman in *Raintree*, she grossly overacted. Had Monty been able to, he would have restrained her and coached her in his interior style of projecting a part, but he no longer had the will or perhaps even the desire to control her. As a result, she came off as overconfident and garish instead of laying bare her vulnerability and showing her character's gradual mental and moral collapse. It was one of her least affecting performances. Ironically, it was also the first for which she'd be nominated for an Academy Award.

After Raintree, Elizabeth and Monty drifted apart. She was replaced in his circle by a new platonic buddy, Nancy Walker, the lovable, horse-faced comedienne. In Mike Todd, Elizabeth at last met her match—a man who wouldn't let her humiliate him as she was driven to do with heterosexual men. He'd had plenty of experience in taming shrews before he met the ultimate one in Elizabeth. He understood that she liked to be mistreated and that she regarded fights as foreplay. Though she would not live with him long enough to feel the full force of his violence, other women had.

At a publication party for Joan Blondell's *Center Door Fancy* in the 1970s at Delacorte Press editorial director Ross Claiborne's East Side apartment in Manhattan, Joan said she felt lucky to have survived her marriage to Todd with nothing worse

than a broken arm and a nervous breakdown.[13] She also discussed the weird circumstances surrounding the death of Todd's first wife, Bertha Freshman Todd, who died of anesthesia poisoning prior to surgery for self-inflicted wounds incurred while chasing Mike around the house with a steak knife in 1947. Todd lied to the press, claiming Bertha had cut her hand while slicing an orange. He came under further suspicion when it was discovered that Bertha's $80,000 collection of jewels and furs was missing. Mike and Bertha's son, Mike Todd Jr., concluded, "Mother's chance-in-a-million fatal reaction to the anesthetic would not by itself have implicated him in her death, but the phony story he used to explain her knife injury did."[14]

Though Todd never achieved true distinction on Broadway and was still an unknown quantity in Hollywood, his genius was at last about to flower in several ways in the mid–1950s. A trio of singular triumphs was before him: his manipulation of and marriage to Elizabeth; his promotion of a gimmicky, revue-type movie, *Around the World in 80 Days*, into an Oscar-winning blockbuster; and his revolutionary experiments with Cinerama and Todd-AO that widened and deepened the motion-picture screen and made movies more competitive with television at a crucial juncture when the future of the industry was in question. Of the three achievements, his winning of Elizabeth was the one that made him a household name.

Realizing how demanding Elizabeth was, Todd immediately enlisted Eddie Fisher to help him keep her satisfied. "Elizabeth was incapable of being alone," Eddie recalled. "When Mike was busy, I became her second choice." One night, Todd was involved in a high-stakes card game at the home of producer Harold Mirisch. Bored, Elizabeth kept asking when the game would be over. Todd telephoned Fisher, who'd had a fight with Debbie and was staying at the Beverly Hills Hotel. "Come over and talk to her," Todd said. "Tell her how great I am." Eddie rushed to the Mirisch residence, later explaining, "When Mike told me to do something, I did it."[15]

Eddie and Elizabeth played gin and popped a bottle of champagne while the card game went on in another room. Occasionally, Todd looked in on them, and at midnight he told Eddie to take Elizabeth home to pack for a trip to Palm Springs later that morning. They drove to Benedict Canyon, where she and Eddie drank two bottles of brandy and talked until 3:30 A.M. Michael Wilding was still living there, but off in a small room where he subsisted like a hermit. "It was as if he didn't exist," Eddie remembered. "Nobody ever mentioned his name . . . His kids even pretty much ignored him." Finally, Eddie tried to call Todd, but he'd already left Mirisch's house for home.

Todd was fuming when Elizabeth finally got him on the phone. She'd caused him to lose face

among his poker buddies, and he screamed, "You're not gonna fucking step all over me like you stepped on everybody else in your whole life." As he cursed, she held the receiver up to Eddie, and for a while they listened together, cheek to cheek. Eddie's feelings were "jumbled up"; he was aware that her hair felt "kinky," but he was also "overwhelmed by the scent of her . . . Breathing in her essence . . . was heaven." When Todd hung up on her, Eddie called him back. Todd warned him to stay out of it, adding, "I just hope you had a good time."

Though Elizabeth and Eddie were drunk, he drove her to Todd's house, where Todd came to the door in white silk pajamas. Eddie later wrote, "Bam! he smacked her. 'What'd I tell you—' he yelled at her. Bam! All I saw was the bare bottoms of her feet as he dragged her into his bedroom." The next morning, she rang Eddie and said that Todd had hit her, and asked about sleeping pills, since she was having trouble dozing off. Eddie concluded that "she tolerated being hit, maybe she even needed it to respect a man."[16]

Through her attorney, she at last informed Wilding she was filing divorce papers, citing mutual incompatibility. Wilding would be allowed reasonable access to their sons, and Elizabeth expected no alimony, which was only sensible, since Wilding was broke. She gave him their house, and Todd later gave him $200,000. The

minute MGM heard that Elizabeth had washed her hands of Wilding, the studio fired him, and he moved to a two-room apartment on Sunset Boulevard, "a bottle of vodka my only companion," he recalled. For a while, he became a recluse.

In October 1956, in conjunction with the opening of *Around the World in 80 Days* on the 17th at the Rivoli on Broadway, Elizabeth flew to New York, leaving her small children with a nurse. Todd gave her the $92,000, 29.4-carat emerald-cut diamond engagement ring he'd stealthily retrieved from the jilted Keyes. "I had a huge rock on my finger," she recalled. "It was all mad and marvelous."[17] On network television, Todd introduced her, telling reporters, "I see you're curious about my friend. Meet Miss Lizzie Schwartzkopf." Though the timing, which coincided with the opening of his film, suggested cynical self-promotion on Todd's part, Elizabeth said in 1997, "Mike Todd gave me the tools to understand love." He did at times seem like the fulfillment of her life-long expectation that life should have some great romantic outcome; at other times, he was like a bomb about to explode in her face. Their love affair was one of the most open and unashamed reporters had ever witnessed. When a magazine photographer arrived one afternoon to film Todd in his swimming pool, Elizabeth leaned from a balcony in her nightgown and ordered Todd to come back to bed. He said he'd join her directly, but she

yelled, "You come right now. I want to fuck you this minute."[18]

On the night before Todd's film opened, he told Elizabeth he was broke and couldn't meet the rent at the Rivoli. Eddie Fisher gave him a certified check for $25,000, and the doors opened on schedule. Meanwhile Otis Chandler of the L.A. Times Corporation offered Todd $25 million for the picture or fifty percent of the gross for $15 million. Fisher and Todd's son, Mike Todd Jr., urged him to take it, but Elizabeth told him to hold out. He listened to her.[19] The film was a smash hit by the standards of the time, bringing in $29,600,000 on a $6.3 million investment. "All this and Elizabeth Taylor too," Todd said. "How's that for lucky?" His luck would soon run out, but for the brief time he had left, he seemed happy with her despite the dangerous game she played with her husbands. "I will get away with murder if I can," she confessed. "I used to try, out of my perversity, sometimes to drive Mike mad. I'd be late, deliberately just fiddle around and be late, and I loved it when he would lose his temper and dominate me. I would start to purr because he had won. Mike was strong, which was very good for me." Yet their relationship was beset with disaster from the start.

It began with an accident aboard Lord Beaverbrook's yacht that felled Elizabeth in November 1956. Her footing on board what she called "this huge, cumbersome sailing houseboat" as they

returned from Nassau to the United States was probably not the steadiest. "The boat lurched and I went flying out into the air, feet out, and landed straight on my tail about six steps below," she said.[20] In excruciating pain, she flew with Todd to New York's Columbia-Presbyterian Hospital, where she was diagnosed at Harkness Pavilion with three crushed spinal discs. Todd took her to Dr. Dana Atchley, one of the best internists on the East Coast, and Dr. Atchley turned her over to Dr. John Lattimer, a top orthopedic specialist. The ruined discs were removed by surgery, and replacements were made from bone in her pelvis and hip.

While she was being examined, doctors discovered she was pregnant.[21] She remained in the hospital for two months, finally emerging on January 21, 1957, in a wheelchair. Elizabeth and Todd went to Acapulco because Elizabeth needed a quickie Mexican divorce from Wilding. After it was granted, they were married on February 2, with Eddie serving as Todd's best man and Debbie as Elizabeth's matron of honor. The Acapulco setting was breathtaking—a hacienda overlooking a bay in an unspoiled, undeveloped peninsula. Among the thirty-four wedding guests were Todd's son, Mike Todd Jr.; Sara and Francis; Elizabeth's brother Howard and his wife, Mara; Todd's cabdriver brother; Mario Morena (the Mexican comedian known as Cantinflas, star of *Around the World in 80 Days*); and Metro's Helen Rose.[22] The

terrace was decorated with fifteen thousand cut
flowers.

Just before the ceremony, Debbie helped Eliza-
beth, who'd been drinking champagne all day,
wash and set her hair. She wore a back brace under-
neath the cocktail-length, hydrangea-blue wed-
ding dress Helen Rose had designed for her. Canti-
nflas and Todd carried her down to the terrace as
she clutched a bouquet of white orchids. The
mayor of Acapulco officiated at the civil service,
and Eddie sang "The Mexican Wedding Song."
Then Todd and Cantinflas picked her up again and
carried her to the reception, where Todd presented
her with her wedding gift, an $80,000 diamond
bracelet. Strolling violinists in gaucho costumes
serenaded guests as they feasted on baby lobsters,
suckling pigs, cracked crabs, tacos, hot tamales,
enchiladas, tortillas, guacamole, greenboned fish,
ham, caviar, and lemon-and-peach chiffon pie,
washing it down with twenty-five cases of cham-
pagne. The party was supposed to go on all night
but ended abruptly when Todd noticed Elizabeth
wincing from pain. "I just had to lie down as soon
as the show was over," she remembered. "Poor
Mike had to cater to his crippled old lady."

The next morning, Todd summoned Eddie to
the bridal suite. The groom wanted his best man to
look at Elizabeth, who lay seminude on their nup-
tial bed. Though she had on a short nightgown,
Eddie could clearly see every detail of her anatomy.

Completely relaxed, Elizabeth accepted Eddie's presence as if he were part of a ménage à trois, which in a profound sense he was. "This was Mike's way of bonding with me," Eddie thought, "his way of proving how close we were."[23] The keener-minded Debbie knew better; Eddie "enjoyed watching all of it," she revealed. "It was what he wanted that he didn't have with me."

On the Todds' sixth-month anniversary, Mike had a furrier bring two coats for Elizabeth to choose from—a diamond mink and a diadem mink. After studying each, Elizabeth said, "I'll take both"—and got them.[24] He wasn't always so agreeable. They started fighting in the middle of a dinner party one night, falling to the floor and clawing and pummeling each other. Suddenly they stopped, got up, and went into another room and had sex. When they returned to the dinner table, they acted as if nothing had happened and enjoyed their coffee and dessert.

She finally announced her pregnancy on March 26, 1957. Doctors warned her that the embryo's pressure on her back, which had been "whittled away and replaced with little matchsticks," could leave her with permanent curvature of her spine, but she was determined to have Mike's baby.[25] In the following months, she almost lost the baby three times.

On March 27, *Around the World in 80 Days* won the best picture Oscar at Hollywood's RKO Pan-

tages Theater. Todd bolted from his seat, raced down the aisle, and then, suddenly remembering Elizabeth, ran back and kissed her before going to the stage to accept the award. "The Academy was really choosing one mammoth advertising binge over another," wrote Anthony Holden in *Behind the Oscars*, explaining that both *Around the World in 80 Days* and its main rival for the Oscar, Cecil B. DeMille's *The Ten Commandments,* had spent millions lobbying for votes in industry trade-paper ads and throwing lavish parties. Radiant in the $25,000 diamond tiara Todd had given her, Elizabeth accepted Victor Young's posthumous award for the scoring of *Around the World in 80 Days* after emcee Jack Lemmon introduced her as "the most beautiful thing Mike Todd left out of *Around the World in 80 Days.*" The day Todd had given her the diamond tiara, she'd taken it into the bathroom to try it on. Later, emerging in nothing but the tiara, she'd jumped on him in bed to show her thanks.[26] "Lemme tell ya," he said. "Any minute this little dame spends out of bed is wasted, totally wasted."

To promote Todd's film overseas, they made a transatlantic crossing in April on the *Queen Elizabeth* with Elizabeth's sons, Michael and Christopher. Every time the fetus kicked against Elizabeth's reconstructed spine, she cried out in agony. Todd leased Lady Kenmore's villa, La Fiorentina, near St. Jean-Cap Ferrat for $20,000 a month (Bill Gates reportedly bought the house in 1999 for

$100 million). The Todds' guests at La Fiorentina, long considered one of the most beautiful houses on the Riviera, included Wilding Sr., William Holden, Gary Cooper, David Niven, and Eddie and Debbie. Eddie poked fun at his wife for her supposedly "righteous attitudes," and Elizabeth kidded him, saying, "Where's Debala? You lucky stiff."

One day, Todd and Eddie wanted to go to Monte Carlo without her, but she pointed out that she was pregnant and didn't like being left alone. "You go," she warned, "and if you're not back in an hour the bedroom door'll be locked."[27] Under Todd's influence Eddie had become a heavy gambler at the crap tables, betting the limit, $7,000 a roll. They didn't return to the villa for several hours. Todd pounded on her door, but found himself out in the cold that night.

The Todds attended the Cannes Film Festival on May 2, 1957, for the European premiere of Mike's film. By now Elizabeth had seen it twenty-five times and was complaining that being Todd's wife "took fifty hours a day." She got drunk in a bar one night and threw an ashtray at a stereo speaker blaring the French version of the song "Around the World." She told British journalist Leonard Mosley that he ought to write her biography. "Start it this way," she suggested. "'It was 4 o'clock in the morning in a very crummy bar on the French Riviera. The radio was playing '80 Days.' And sud-

denly Elizabeth Taylor felt sick of everything—of films, of people, above all things, of herself.' . . . Call it *I Am Twenty-five Years Old and I Do Not Want to Live*."[28]

They went on to Paris for yet another premiere, and Elizabeth was taken up by the Parisian *haut monde*, who made a cult of her. The Todds stayed in the honeymoon suite at the Ritz, overlooking the Place Vendôme, and Todd persuaded the legendary coiffeur Alexandre de Paris to give him a crewcut. Later, Elizabeth had Alexandre cut her hair and they became lifelong friends. Visiting the Right Bank fashion houses, Elizabeth met famous couturiers Givenchy, Balenciaga, Yves St. Laurent, and Marc Bohan of Christian Dior. Todd accompanied her to Dior, where Bohan and Simone Noir fashioned a ruby-colored chiffon dress for her to wear to the premiere of Mike's film with her ruby earrings and a matching tiara. After the opening, a reception was held for three hundred guests at a Chinese restaurant that seated only one hundred. When the chef walked out in protest, Todd ordered fifty pizza pies from a nearby pizzeria.

In London for the British premiere, they stayed at the Mayfair Hotel and had such a loud set-to that they attracted the attention of the press. "Sure, we had a hell of a fight," Todd told a reporter in Elizabeth's presence. "This gal's been looking for trouble all her life . . . She's been on a milk-toast diet . . . with men; but me, I'm red meat."

Annoyed, Elizabeth snapped, "Tell Ol' Flannel-mouth there to stuff it."

On June 21, en route to Nice, they missed their plane and fought again in front of reporters. "It's your fault," she said at the London Airport. "*Now* what shall we do?"

Taunting her, he said, "For a change it was *my* fault that we were late here."

She whirled on him, hissing, "I'm getting fed up with that line. I am always blamed for the delays. I could hate you for saying that." Turning to his secretary, he asked for a plane to be chartered to Nice with a two-hour stop in Paris. "I don't want to go to Paris," Elizabeth said. "Paris bores me! I will *not* go to Paris." The plane cost $5,000, and Todd told the pilot to fly them straight to Nice.

As long as Elizabeth watched her figure and stayed lean and shapely for him, Todd indulged her, but his patience had its limits. During the course of their marriage she had to call Eddie Fisher more than once and ask him to go find Todd, who'd stormed out of the house after one of their fights.[29] Submerging his own identity, Eddie let himself become a proxy Mike Todd in Elizabeth's marriage, and Debbie resented it.

Back in London the Todds threw a sixth-wedding-anniversary party for Janet Leigh and Tony Curtis, inviting Noel Coward, Debbie and Eddie, Michael Wilding Sr., Louis Jourdan and his wife

Quique, and Ann and Kirk Douglas. Bearded for his role in *The Vikings*, Tony was embraced by Coward, who said, "Hello, you bearded beauty!" The Todds later attended a party given by Coward, who described it in his diary on June 23, 1957, as "a free for all at the Dorchester which was a terrific success." In the same month Coward noted that he caught Eddie's opening at the Palladium and was rehearsing Michael Wilding in the West End production of *Nude with Violin*. "He stumbles and stammers and gets into an increasing frizz at each rehearsal," Coward wrote. "I shall beat the fuck out of him."[30] Elizabeth and Mike fixed Wilding up with a millionairess, but she put him to work as the maître d'hotel of a restaurant she owned in Brighton, which promptly flopped, as did Wilding's marriage to the heiress.

"Elizabeth told me that in England Todd used to play poker with the guys," Eddie Dmytryk recalled. "He wanted her there, but she would be asleep someplace or sit outside, and he'd be inside with the guys. Every once in a while he'd come outside and give her a kiss and go back in and play, and she had to stay there and wait for him. Bette Davis once said, 'It took me three husbands to find out that the kind of a guy I would marry is the kind of a cad I'd learn to hate.' Bette's spouses were all weak sissies who couldn't handle her, and she wanted to be handled. I think Elizabeth needed to be handled, needed a strong man."

It was certainly what she wanted, but probably the last thing she needed. She once told Monty, "I yearn for a big strong guy to look after me, to buy me lots of jewelry and to pay my bills,"[31] but her greatest need, of course, was to develop her own strengths and take charge of her life. Todd had bankrupted his second wife, Joan Blondell, taking her for $3 million, and he was already into Elizabeth for $100,000 to cover gambling debts. If he were really the strong character she thought him to be, he'd never have exposed her, while pregnant, to so many dangers. She was still recuperating from back surgery when he involved her in extensive travel and drum-beating for his movie, which made her pregnancy life-threatening for herself and the child she was carrying. After a final party in their Dorchester penthouse suite on July 4, attended by Wilding Sr., who laughed when Elizabeth said she'd lost their passports, the Todds rushed off to catch the boat train to Southampton, where the U.S. consul issued temporary passports. Crossing the Atlantic aboard the *Liberté*, Elizabeth went into labor, but the shipboard doctor didn't know how to perform a cesarean. Todd called her New York gynecologist, yelling that she was having pains every five minutes. Finally the doctors decided to knock her out with drugs, and fortunately the contractions stopped.

Eddie and Debbie returned on the *Queen Elizabeth*, as did Noel Coward, who noted in his diary

that he won $1,000 in joint gambling on board with Eddie. When Eddie went to the ship's steam room and stripped for his daily massage, Coward inevitably showed up and tried to hit on him. "Just let me pat you once, dear boy, just let me touch it a little," Coward said, but Eddie turned him down. On the Fishers' return to Hollywood Eddie decided to get a divorce, but just as he was preparing to move out, Debbie told him, "I'm with child."

Back in the United States, the Todds moved into a twenty-three-room Westport estate leased for the summer. Truman Capote, whom Elizabeth met at a Manhattan dinner party, came up for the weekend and found Elizabeth at her happiest and most jovial. She and Todd were lying on the grass with "clouds of golden retriever puppies," and later Capote and Elizabeth had long conversations about fiction. "She was a connoisseur of obscure novels by great writers and introduced me to P. G. Wodehouse," Capote said. They also discussed Monty, and Truman realized she "was in love with him . . . but Monty at this time was going crazy on pills, making scenes, and letting cheap tricks rip him off. As for Mike Todd, he was the only man Elizabeth married who had the balls to tell her to go fuck herself when she got out of hand."

Elizabeth spent most of her time that summer on her back in bed, wearing a metal back brace that helped her carry the baby high, near her rib cage, to prevent pressure on her spine. The baby's

unusual position affected Elizabeth's heart and she had to be given digitalis, but the drug jeopardized the fetus's heart. In danger of a ruptured uterus, she was rushed to Columbia-Presbyterian Hospital in premature labor on July 28, almost losing the baby for the third time. Todd moved into the hospital and prayed by her bedside in Hebrew. Her doctors advised an abortion but she said, "Not on your nelly."[32] She spent two weeks in an oxygen tent, and her doctors recommended a premature delivery before Elizabeth reached term, but she told them, "She's not cooked yet." The baby was due October 15. Todd told reporters she was in terrible pain and added, "If she can hold out for two and a half weeks, it'll be seven months and that could do it . . . She's crying all the time." She insisted on being taken off digitalis despite doctors' warnings that she'd become comatose. "If I had not gotten off the digitalis," she said, "our child wouldn't have had a chance to survive."

A cesarean was performed on August 6, 1957. Elizabeth was attended by a team of eight that had been assembled by Dr. Dana Atchley. They included an obstetrician, a pediatrician, a diagnostician, two neurologists, a resuscitationist, and two other physicians. Born at 12:03 P.M., Elizabeth Frances "Liza" Todd appeared to be stillborn but rallied after Dr. Virginia Apgar, the resuscitationist, worked on her for fourteen minutes and thirty seconds. "It was a miracle," Todd told reporters.

Near death, the frail, motionless, four-pound, four-teen-ounce infant remained in an oxygen tent for two months, and Elizabeth had to undergo tubular surgery to prevent further pregnancies. "It was the worst shock of my life," she said, "like being killed."

Returning to California in September, they moved into a temporary home, a twelve-room white-stucco villa at 1330 Schuyler Road in Cold-water Canyon, up behind the Beverly Hills Hotel. There seemed to be no escaping Todd's movie; their next-door neighbor played "Around the World" on his piano every day at the cocktail hour. Elizabeth didn't particularly like her new home, calling it a "big, dark, Mediterranean-type house." There was a circular staircase, a fortresslike living room they seldom used which was "arched and sin-gularly gloomy," and a large sunken tub in which Todd and the Wilding boys ducked one another, splashing and squirting water pistols, "just having a marvelous time horsing around," she recalled. In the master bedroom, French doors opened onto a balcony overlooking the stone terraces below. The Todds luxuriated in an enormous powder-blue-and-gold rococo bed that came with the house. To defray his gambling expenses and the cost of the gifts he lavished on her, including the Cartier tiara that required armed security guards to transport it from place to place, Todd was eager for her to get back to work.

"You had to go to Mike if you wanted any-thing," said Metro producer Pandro Berman. "She was plastic in his hands. She had no thoughts of her own in those days." Though Elizabeth was con-tent to let her career languish, Todd announced he was putting her in Cervantes's *Don Quixote* as the scruffy, shrewish Dulcinea, with Cantinflas playing Sancho Panza and Fernandel in the title role. Later, Todd decided to use Mickey Rooney as Sancho Panza and John Huston as Quixote, and he put his son and Art Cohn to work developing a script. Mike Jr.'s heart was broken when his father rejected the script and decided to shoot the film with nothing more than art director Vincent Korda's production sketches. Nothing came of the project.[33]

In the fall of 1957, Todd hosted a $250,000 party at Madison Square Garden in New York to celebrate the first anniversary of *Around the World in 80 Days*. He made the mistake of letting a buddy of Eddie Fisher's handle all arrangements, and it turned into a debacle. The theme was sup-posedly America as a melting pot, but when Sena-tor Hubert H. Humphrey tried to rehearse his speech shortly before the party, Elizabeth told the future U.S. presidential candidate, "You can't say anything like that—it's too corny." To shut her up, Todd's son, Mike Todd Jr., kicked her in the shin. When she asked him later why he'd kicked her, he said it was imprudent to insult a prominent mem-

ber of the U.S. Senate Foreign Relations Committee. "Well, nobody told me who he was," Elizabeth said, "and besides, it *is* a corny speech." The party disintegrated into a near riot when eighteen thousand guests scrambled for food and house prizes. Standing next to Eddie, who thought the fiasco "incredible fun," Todd and Elizabeth were both drunk and Elizabeth was crying. Embarrassed and humiliated, they made a hasty exit, but Eddie was happy as long as he could be with them, later writing, "We were a great team, Mike and I and Elizabeth."[34]

The Todds resumed their globe-trotting on November 1, Todd promoting his movie by flaunting Elizabeth at openings in the Far East and elsewhere. The Wilding boys and Liza Todd were left in Todd's spacious rented house in Palm Springs with Art Cohn and his wife and Mike Todd Jr., his wife Sarah, and their two children. Despite taking her away, Todd was critical of Elizabeth's role as a mother, saying, "She has let it become a contest between herself and the nurse." He said he often wanted to tell her, "Don't compete with the nurse. You're the mother. Let the children know you're the mother."[35]

Tense and angry after his movie flopped in Japan, Todd was disinclined to indulge Elizabeth's temper and tardiness. Their public fights were a running joke in the media. In the presence of an Associated Press reporter, she flew at Todd in a

rage, complaining that he'd put her nemesis, Dietrich, in *Around the World in 80 Days*. Despite Todd's denials, she suspected that he and Dietrich had been lovers.[36] At the airport, nose-to-nose with Todd, Elizabeth screamed, "Fuck you" over and over. Signs of marital wear and tear continued to surface after they returned to Palm Springs. Elizabeth checked into the hospital on December 17, 1957, to have her appendix taken out. Todd stayed with her for a week, taking a connecting suite, but he was fed up with playing nursemaid and told reporters, "No more hospitals."[37] He was having trouble mounting a worthy successor to *Around the World in 80 Days*, his grand schemes for filming classics by Cervantes and Tolstoy coming to naught, despite a trip he and Elizabeth made to Moscow in early 1958 to hammer out a coproduction deal for *War and Peace*.

After their return to L.A. in March 1958, director Joshua Logan put Elizabeth up for the role of Nellie Forbush in the film version of the Broadway musical *South Pacific*. "She was freckle-faced and young and very ambitious," Logan recalled. The film used the Todd-AO sound department, and Todd was keen to see Elizabeth in the lead. Composer Richard Rodgers insisted on auditioning her, and "she was so scared she croaked," Logan added. Afterward, the director accompanied her downstairs, and when she saw Todd coming, she broke into "I'm in Love with a Wonderful Guy." Logan

told her she sounded like a seasoned Broadway belter, "quite good, loud," and asked her why she hadn't sung that way for Rodgers. "She was just too nervous," Logan concluded.[38] Doris Day, Jane Powell, and Janet Blair also tried out for the part, which eventually went to Mitzi Gaynor.

Though Elizabeth said, "I'm thinking of retiring the commodity known as Elizabeth Taylor, Movie Star," Todd wouldn't hear of it. When a production associate asked him how much of *Around the World in 80 Days*'s earnings of $29,600,000 he'd spent, he said, "$29,599,999.99." One of his expenditures was a $3,000-a-month, long-term lease on a twin-engine Lockheed Lodestar, the same type of plane that Howard Hughes had flown around the world in 1939. Todd named it *The Lucky Liz*. Though he blew a fortune on frills for the plane, he was miserly when it came to important safety equipment. He spent $25,000 to install a new bedroom for Elizabeth, but just $2,000 to update the anti-icing system. Said Todd Jr., "I unsuccessfully prodded him to get rid of the plane in late 1957, when a survey indicated that because of its age—even with the thorough maintenance it received that kept it up to F.A.A. standards—its safety was questionable."[39] The Todds invited the Fishers to fly with them to Palm Springs for Christmas and New Year's 1957, but as they began to descend for a landing, the pilots informed them that they were arriving in Las Vegas. "Las Vegas?"

Todd said. "But we wanted to go to Palm Springs." They spent the night in the casino, and Eddie noticed that the pilots drank brandy steadily until they all took off at 9 A.M. He tried to persuade Todd to hire a pilot he knew, but Todd, perhaps remembering the mess that Eddie's friend had made of the Madison Square Garden affair, decided to keep the pilots he had.[40]

To replenish his depleted coffers, Todd arranged with MGM for Elizabeth to finish her contract by appearing in the film version of Tennessee Williams's Pulitzer Prize–winning play *Cat on a Hot Tin Roof*. Again, voice coach Marguerite Lamkin taught Elizabeth how to talk like a Southerner. Eventually Lamkin, a witty clothes horse, married Queen Elizabeth II's barrister and became a celebrated London hostess and intimate of Princess Diana.

Elizabeth went back to work in February 1958 and soon discovered that the role of Maggie the Cat, who marries a closet homosexual jock but can't get him to impregnate her, was one she could easily relate to. Her personal experience of homosexual ambivalence in relationships with Roddy, Monty, Rock, and James Dean gave her tremendous insight into the part. "I love Elizabeth," said the gay Tennessee Williams, whose play was essentially a tragedy about the "mendacity" of families that refuse to accept their gay offspring, and of the gays who then force themselves into sham mar-

riages to conceal their true nature. Costar Paul Newman didn't like Elizabeth at first, resenting her inertia at rehearsals, but when he saw the torrents of emotion she unleashed the minute a camera was pointed in her direction, he changed his mind, lauding the "ferocity" of her "instinctive" acting. She was paid $125,000, and Newman, who'd recently made his film debut in the role Dean was to have played in *Somebody Up There Likes Me*, received $25,000.

Shortly after her twenty-sixth birthday, Todd moved his offices to Metro to be near her. Principal photography on *Cat* began on March 12, and the Todds watched the daily rushes together in the projection room. They lunched together every day, and were joined on one occasion by Mickey Rooney; Eddie's boyhood friend Joey Foreman, who was now working as a comedian; and Art Cohn, who was writing the script for *Don Quixote* and also completing his biography, *The Nine Lives of Mike Todd*. The Todds were planning to fly to New York, where Mike was to be roasted by the Friars Club as Showman of the Year, but Elizabeth contracted pneumonia in late March and was confined to her bed with a 102-degree temperature. "I made him realize he had to go without me," she recalled. Three thousand people were expecting to see him at the Waldorf-Astoria on Sunday evening, March 24, 1958, including Governor Averill Harriman, Laurence Olivier, Attorney General Her-

bert Brownell Jr., and baseball player Jackie Robinson. Todd didn't want to disappoint them. In Elizabeth's absence he intended to fly a whole party with him on *The Lucky Liz*, but everyone turned him down, including Richard Brooks; Eddie Fisher, who was filming a Chesterfield commercial in Greensboro, North Carolina; Kirk Douglas; Joe E. Lewis; Joseph L. Mankiewicz, whom Todd had been trying to sign as director of *Don Quixote*; entertainment reporter Vernon Scott; publicist Warren Cowan; and Kurt Frings. AP reporter James Bacon accepted but later canceled, terrified by "the worst night I ever remember in Southern California—thunder, lightning, and torrential rain." Finally Todd dragooned two of his employees, Art Cohn and Dick Hanley, into accompanying him.

On Friday, March 21, after playing with Michael and Christopher Wilding in the big sunken tub on Schuyler Road, Todd kissed Elizabeth goodbye, and then kept coming back to kiss her again and again. "We had never been apart overnight before," recalled Elizabeth, who'd once told him, "Whither thou goest, I will go too, buster." Despite her fever, she tried to get up and make the flight, but Dr. Kennamer absolutely forbade it. "I'm so afraid something's going to happen," Todd said. "I'm too happy." They both cried, and she closed her eyes as he picked up his fried-chicken box lunch and left for the Burbank airport in pouring rain. "I knew I

shouldn't have let him go," she said later. "I don't think he really wanted to go."

At the airport, he went to the plane with Cohn, Hanley, pilot Bill Verner, and copilot Tom Barclay, but at the last minute he turned to Hanley and said, "Go back to the little broad. She might need you." After Hanley left, Verner gunned *The Lucky Liz*, and Todd rang Elizabeth on his air-to-ground phone, saying he'd call again from their first fuel stop, Albuquerque, New Mexico, and again from Kansas City, where he was picking up Jack Benny following his benefit performance there. Finally he told her, "We're off, beautiful. Get a good sleep now. I love ya." At 10:11 P.M., a ton overweight, the old plane lumbered off into a stormy sky exploding with thunder, lightning, rain, and sleet.

Back at Schuyler Road, Elizabeth worried that he'd left without a coat. As the storm continued to rage, she looked in on Liza, who was fast asleep, and then went into Chris and Mike's room. "Tell us a story, Mommy," one of the boys said. Plopping onto Mike's bed, she drew them close on either side of her and related the tale of Little Goody Two-Shoes, changing Goody's gender to a boy. Then she told them to go to sleep, turned off the light, and went into her bedroom to await word from Todd. At 2 A.M., Saturday, March 22, she awoke with a start, wondering if she'd slept through his call. After restlessly rolling around their big double bed, she drifted into an uneasy sleep.[41]

At roughly the same time, *The Lucky Liz* was running into trouble over New Mexico. Pilot Bill Verner radioed air traffic control in Winslow, Arizona, that the wings were icing over and received permission to take the plane from eleven thousand to thirteen thousand feet. At the higher altitude the ice accretion only worsened, and the plane headed into an intense storm front. At 2:40 A.M., *The Lucky Liz* was about twelve miles southwest of Grants, New Mexico, over the Zuni Mountains. Below the mountains lay what the Indians call "malpais"—badlands. Suddenly, the right engine stopped, the master engine rod having failed. "The right propeller was feathered," according to the Civil Aeronautics Board report. At their cruising altitude, the plane could not stay airborne on a single engine. It spiraled completely out of control, plummeting through thick fog to the floor of the valley at a steep angle of descent, then crashed and burst into flames. There were no survivors; Mike Todd was dead at age fifty. Wreckage and bodies were scattered over the two-hundred-yard, snow-covered crash site, situated between two mountains at an elevation of approximately seven thousand feet. When a search party arrived at dawn, they found bodies burned beyond recognition. Twisted by the impact of the crash, Todd's gold wedding ring was recovered from the wreck.

In Beverly Hills, Elizabeth's fever had kept her from sleeping well. At 5 A.M. the children's maid,

Bea, came upstairs to massage her back with rubbing alcohol. She stared at the phone, waiting for Mike's promised call from Albuquerque at 6 A.M. When the hour came and passed, she rang Dick Hanley and remarked, "It's the first time since we were married that he hasn't sent word to me in some way." At 7:30 A.M., an overwhelming premonition of death swept over her. "*I knew*," she later wrote. Calling Kurt Frings, she said, "I ought never to have let him fly without me," but Frings said Todd could take care of himself. "I'm not so sure," she said.[42]

Across town Jim Bacon received a call from the AP bureau in Albuquerque telling him that his name had shown up on the passenger manifest of the downed plane. Bacon assured the caller that he was still alive, thanks to having dropped out of Todd's party. At around 8 A.M. the coroner's office in New Mexico rang the Los Angeles Police Department requesting dental records to identify the charred cadavers, and the police contacted MGM security. Metro in turn called Dick Hanley, who gasped, "Oh, my God," and then, collecting himself, rang Schuyler Road and learned from the governess that Elizabeth had not yet been informed. Hanley called Kennamer, Guilaroff, Debbie, and Eddie, but Eddie had already departed for New York to join Todd at the Friars banquet. Debbie reached him on the phone at Manhattan's Essex House, telling him that she was on her way

to visit Elizabeth. "I told her to stay away," Eddie remembered. "I didn't want to share anything with her, even a tragedy." But Debbie proceeded to Schuyler Road anyway, joining Michael Wilding Sr., Kurt and Ketti Frings, and Sydney Guilaroff in Elizabeth's living room.

Hanley and Dr. Kennamer had started upstairs to break the news to Elizabeth. At 8:30 A.M. she looked up as they entered her room and assumed the doctor was making a routine house call. "Hi, Rex," she said, "how are you?" When he said nothing, and both men just stared at her, she screamed, "No, he's *not!*" She put her hands to her ears and kept screaming, unable to believe that the 414-day joyride of her marriage to Todd was over. Wearing nothing but a sheer white nightgown, she ran to the staircase and screamed, "No, no, it's not true! It's not true!" Downstairs, Debbie looked up and saw Elizabeth at the landing, her face "ashen, her violet eyes desperately sad, hair askew and wild— yet still incredibly beautiful, even in tragedy." Shouting Mike's name repeatedly, Elizabeth ran downstairs in hysterics, and Debbie stepped back as she darted past her, heading for the door. The small hillside street was jammed with reporters, photographers, television and newsreel crews, and assorted onlookers. Fortunately, Hanley and Kennamer caught her before she got outside and Kennamer knocked her out with a sedative. The two men carried her back to the bedroom as she

sobbed, "Why Mike? Why did it have to happen?" Downstairs, Debbie pulled herself together and took charge of Elizabeth's boys, aged three and five years old, bringing them home with her.

Though woozy from massive doses of morphine and phenobarbitol, Elizabeth paced her bedroom like an animal, periodically calling out Mike's name as if he were in the next room. "When her screaming finally stopped, Elizabeth retreated into stony silence," recalled Guilaroff. "She sat for hours without moving a muscle, staring straight ahead, her lovely face absolutely devoid of expression." By now, the crowd downstairs included Edith Head, Helen Rose, Irene Sharaff, and, amazingly, Greta Garbo, who emerged from seclusion long enough to tell Elizabeth, "Be brave."

Samuel Goldwyn arrived and told Elizabeth the afternoon papers were full of tributes. Elizabeth asked to see them, and he went outside and brought the papers back from his car. The most moving tribute was from Hollywood's preeminent showman, Selznick, producer of *Gone with the Wind*, who said, "Todd was a great showman, one of the greatest of our times. His courage and magnificent gambling spirit did much to revitalize the motion picture industry. The sympathy of the entire world will be extended to his wife and family in their great loss." When Goldwyn left the house, he told reporters, "I am comforted with the thought she is going to come out of this all right.

She has a great future ahead of her for she is the dominating actress in our business.[43]

Elizabeth's greatest mistake in her marriage to Todd had been subjugating herself to the point that she disappeared as a person, and when he died, nothing was left of her. That was what her grief was really about—not losing him, but losing herself. He had been her refuge, but she had paid a terrible price. Having let Todd solve all her problems, Elizabeth "felt cold and trapped by circumstances and without any of my own resources to find a way out," she wrote. All she could do was let doctors drug her into insensibility. The irony was that the strong person she always sought was already present in her own being, but undermined by self-loathing and drugs. As Mary Martin once needlepointed on a pillow for Joshua Logan, "If the sun should doubt, it would immediately go out."[44]

The Wilding boys stayed with Debbie for the next two weeks. Elizabeth clasped Liza Todd to her bosom, but later on, both Liza and her half-brothers were entrusted to Arthur Loew Jr., who was renouncing his playboy existence for marriage and ranch life in Arizona. Eddie flew back to L.A. and went straight to Schuyler Road. "People I'd never seen before in my life were walking in and out of the house as if they owned it," he recalled. Elizabeth suddenly appeared in a transparent negligee and drifted through the crowd, a look of total distraction on her face. Finally recognizing Eddie, she

told him to come back the following day "so we can talk."[45] In the meantime, Guilaroff kept watch on a couch in her bedroom, "rising to kiss her and trying to comfort her whenever things were at their worst."[46] Elizabeth couldn't hold down food for three days and, according to Richard Brooks, she threatened to kill herself.[47] Guilaroff, Fisher, Helen Rose, and Wilding Sr. managed, in shifts, never to let her spend a moment alone.

Todd's son, Mike Todd Jr., said she was in "a largely incoherent state" when he rang from New York. The funeral was held on March 25, at the Jewish Waldheim Cemetery in Zurich, Illinois, near Todd's hometown of Chicago. The young widow wore a black velvet cloche, a small black veil, a black broadtail fur suit, black leather gloves, a mink wrap, and dangling diamond earrings. Attracting a crowd of sightseers estimated at 21,600, the funeral quickly degenerated into a compendium of every movie Hollywood ever made about itself, from *A Star Is Born* to *The Loved One*. Elizabeth ordered a nine-foot, two-ton marble replica of the Oscar statuette to be installed at the grave, but Todd Jr. called it vulgar. It couldn't be done in any case, after the Academy of Motion Picture Arts and Sciences threatened to sue over copyright infringement. The funeral was set for 2 P.M., but when thousands of onlookers started lining the streets of Forest Park, it was moved back to noon.

At the cemetery, ten thousand intrepid fans had

managed to push their way inside. Stepping from her car in a howling March wind, Elizabeth saw the mob munching potato chips and slurping Cokes, many of them perched on tombstones and crypts to get a better look, and moaned, "Oh, God. Oh, God." When they saw her, they jumped up from their picnics and started screaming and lunging at her. Howard Taylor and Kennamer half-carried her to the grave, traversing a burlap carpet covered with petals from one thousand white roses. The open grave was under a tent, where chairs had been placed for approximately thirty mourners. When she saw the bronze coffin, she murmured, "I love you, Mike. I love you, Mike." According to Eddie, she tried to embrace the casket, and others present said Howard restrained her by grabbing her shoulders.

Two shocking altercations broke out before the service began. One of Todd's brothers, a cabdriver from Long Beach, California, named Carl Golden-borgen, hollered that Dick Hanley had barred him from Todd's residence in Beverly Hills after the plane crash and should now be expelled from the funeral. When another of Todd's brothers, David, attempted to reason with him, Carl yelled, "I dare you to throw me out. I will not be here while Hanley is here." Finally, he was calmed down by yet another brother named Frank. The second altercation concerned where the photographers should stand. It erupted in an unseemly pushing-and-shoving match.

Throughout the half-hour service, the crowd out-
side kept yelling, "Liz, Liz. Come on out, Liz. Let's
have a look." Todd Jr., who shared his father's pen-
chant for hyperbole, rose to speak a few words and
called him "the greatest human being who ever
lived." Pale and withdrawn, Elizabeth sat like a robot
until attendants started to lower the casket into the
ground. "Oh, no, no, no," she cried. "Mike, Mike,
you cannot leave me here alone." At the end of the
service, she asked everyone to leave the tent so she
could kneel and pray beside the grave. After a few
minutes, she walked out by herself. The woefully
inadequate police guard was unable to control the
ten thousand onlookers, who stormed at her with a
savage roar straight out of Nathanael West's *Day of
the Locust*. As her brother tried to protect her, sou-
venir hunters ripped the black veil from her face and
then jerked whole strands of hair from her scalp.
Todd Jr., Eddie, and Kennamer surrounded her, and
she began to sag like Vicki Lester at Norman Maine's
funeral in *A Star Is Born*. Somehow she rallied and
made her way to the limo, with Howard and the oth-
ers doing their best to clear a path through what
looked to her like a flock of "black gray birds."[48]

Todd Jr. returned to L.A. with Elizabeth, and she
took to her bed again. In constant attendance,
Guilaroff bunked on her bedroom couch. His
motives were highly suspect. He used Elizabeth to
impress his friends, sometimes dragging them along
to Schuyler Road. Another visitor to Elizabeth's bed-

room whose motives were less than pure was Eddie Fisher, who was determined to play "an important role in her recovery," he wrote. He was jealous when he realized that she'd begun to see Arthur Loew Jr. and urged her to spend more time with her stepson, Mike Todd Jr., but what he really wanted was to spend more time with her himself. He was in love with her but not yet ready to admit it.[49]

Before Mike's death, Elizabeth had agreed to present the best short subjects and documentary awards at the Oscar telecast on March 26 at the RKO Pantages Theater. Helen Rose called her that morning and said, "Elizabeth, about that white dress you meant to wear tonight?" "Forget it," Elizabeth said. Jennifer Jones went on in her place, also agreeing to accept Elizabeth's Oscar should she win for *Raintree*. Bill Lyon and Howard and Mara Taylor arrived and tried to persuade Elizabeth to come downstairs to watch the telecast. She finally appeared in the living room in her housecoat, without makeup, and her only jewelry was Todd's twisted gold wedding ring, which had been returned to her. One of the first Oscars of the evening, for scientific and technical innovation, went to Todd-AO, the precursor of the wide-screen systems in use today. Elizabeth would have been by Todd's side had he lived to accept it. She said nothing, but tears streamed down her cheeks. As the end of the show approached—the announcement of the best actor and actress Oscars—she said, "I am

not going to win. Joanne Woodward is going to win. Nothing is going to go right for me now. Nothing will go right for me from now on, because Mike is gone." Ironically, Woodward was certain that Elizabeth was a shoo-in, but it was Woodward, the wife of her *Cat* costar Paul Newman, who took home the prize, for *The Three Faces of Eve*. Elizabeth turned from the TV set and told Lyon, "Order a corsage of white orchids right away. Have them sent to the Beverly Hilton before the Academy party, and Bill, tell the florist to have the card read: 'I am so happy for you. Elizabeth Taylor Todd and Mike, too.'" Then she broke down and had to be carried upstairs by Lyon and Howard Taylor. Later, she told Eddie Fisher, "I only care what Mike would have thought had I won."[50]

Mike Todd Jr. remained closeted with Elizabeth. His father's estate was split between them. After the debts were paid off, Elizabeth received $13,000. Of necessity, she returned to work at Metro on April 14, less than a month after Mike's death. She had lost twelve pounds and looked stunning in Helen Rose's short white chiffon dress with a low neckline and a waist nipped in by a two-inch satin belt. The cast showered her with red roses, and the crew, some of whom had worked on her pictures for nearly twenty years, brought her bunches of violets. Her grief lent a new intensity to her acting. She delivered a moving, superbly controlled performance that delighted Tennessee

Williams, who said, "I loved her in *Cat.* She was the best in the film. I think she is—can be—a great actress." Burl Ives agreed, calling her "the best of the bunch."[51]

At home, Elizabeth would call Mike Todd Jr. to her room several times every night, saying, "Mike can't be dead. I don't believe it." Her stepson was three years her junior, and as he later diplomatically put it, he was "very uncomfortable" at Schuyler Road. Trying to deal with his own grief, he found her sorrow damaging to his "state of mind." Nonetheless he established a company, Todd and Todd, with her, and she played a bit part in his gimmicky movie *Scent of Mystery*, featuring a new process called "Smell-o-Vision." His close involvement with Elizabeth ended when he rang his wife and told her to join them, and Sarah Todd wasted no time in whisking her husband away.

For Elizabeth, closure proved impossible as she continued to seek a Mike Todd surrogate. Vacating the Schuyler Road house, she moved into a bungalow at the Beverly Hills Hotel. Carroll Baker, the actress who played Elizabeth's daughter in *Giant*, was the next tenant at 1330 Schuyler Road, and she found herself "listening to ghosts." At twilight, the lilting, waltz-time strains of "Around the World" still wafted from the next-door neighbor's piano. At bedtime, a huge owl swooped in through the French doors on the upstairs balcony and perched at the foot of Carroll's bed, hooting at

her like the bird of doom in Edgar Allan Poe's "Quoth the raven, 'Nevermore.'" Lying in the same powder-blue-and-gold rococo bed the Todds had used, Carroll couldn't stop thinking of Elizabeth and how she'd writhed in shock and grief on hearing of Mike's death. Soon, Carroll moved to a house on Maple Drive, leaving the shadows of Schuyler Road for a sunnier part of Beverly Hills.

Making her first public appearance since widowhood, Elizabeth visited Eddie backstage at the Tropicana Hotel in Vegas on his opening night in June 1958. Her presence at ringside caused a sensation, and later she joined Eddie and Dr. Max Jacobson in the Tropicana lounge. Elizabeth said she was having trouble falling asleep. Eddie took Max up to her suite, where the infamous "Dr. Feelgood" gave her an intravenous shot, a mild sedative. When she still couldn't sleep, Eddie skipped his opening night party to sit up with her till dawn. "Your graciousness in coming to my opening," he telegraphed her later, "is only exceeded by my gratitude."[52]

By his own admission, the right woman for him was always the next one.

6

Eddie Fisher:

CLOSURE BY INJECTION

On August 10, 1958, Eddie turned thirty, and Elizabeth asked him to visit her alone, explaining that she wanted to give him something that had belonged to Todd. She'd missed his birthday party at Romanoff's, explaining, "I have my period, and I just feel awful." He could tell from her slurry voice that what she really had was a hangover. When he arrived, she was sitting by the swimming pool in a flesh-colored bathing suit, a glass of wine at her side and Liza Todd playing between her legs. She gave him Todd's gold money clip, and later they held hands in the car as Eddie drove them to the beach at Malibu. Displaying some of the late Mike Todd's chutzpah, Eddie told Elizabeth he was going to marry her. "When?" she asked. Liza continued to play in the sand near them as they kissed.

After that, they were inseparable, going for long

walks and dining at La Scala and the Polo Lounge. Often they brought the unsuspecting Debbie along and held hands under the table. If Debbie was sitting on the other side of him, Elizabeth would take his hand and place it inside her dress. One evening ended with Eddie driving Elizabeth home and Debbie riding with Guilaroff in ominous silence. At a party, Elizabeth followed Eddie from room to room until they found themselves alone; then she threw herself at him. When Van Cliburn told Eddie that one of his dreams was to meet Elizabeth, Eddie arranged for him to play a private concert for her in the Fisher living room. It was a coup worthy of Mike Todd.

In late August, Elizabeth deposited her children with Arthur Loew Jr. and flew to New York, checking in at the Plaza. Eddie followed, checking in at the Essex House, having lied to Debbie, claiming his TV sponsor, Chesterfield, needed him in Manhattan for a meeting. When he called on Elizabeth at the Plaza, she dismissed her secretary for the night, and Eddie took her in his arms. "When are we going to make love?" she asked. "Tonight," he said, and immediately she was off on another a-loving, sexual relationship. "Maybe with Eddie I was trying to see if I was alive or dead," she wrote five years later. At NBC, publicist Jane Ellen Wayne remembered that starlets who dated Eddie dwelled on "how well endowed he happened to be, and how adept at lovemaking, supposedly

among the best in show business—in a class with Frank Sinatra and Gary Cooper."[1]

Nobody's fool, Debbie caught them red-handed at the Plaza, ringing Elizabeth's suite and getting Eddie on the phone. "Oh, shit," he said, and Debbie could hear a drowsy Elizabeth in the background asking, "Who is it, darling?" Debbie told him off and hung up. As Eddie remembers it, he was the one who called Debbie, telling her he was with Elizabeth "and we're in love." Debbie said, "We'll talk about it when you get home."[2] Either way, when the *New York Daily News* rang to confirm the rumor, Debbie said, "I've never heard of such a thing," hoping somehow to salvage her marriage. She had daughter Carrie Fisher—future Princess Leia of *Star Wars* and best-selling author of *Postcards from the Edge*—to think of, as well as baby Todd Emmanuel, born on February 24, 1958, and named after Mike Todd.

Eddie was not the only man pursuing Elizabeth. Cary Grant called her at the Plaza and invited her to go on an LSD trip with him. She turned him down for Eddie. They went up to Grossinger's for Labor Day weekend, staying in Jennie Grossinger's home. Elizabeth rang Mike Todd Jr. and asked him to join her and Eddie for dinner. That night, at the end of the meal, Eddie excused himself, and Elizabeth said, "I have to tell you about Eddie." Her stepson assumed that Eddie was "being a nuisance and making passes," but she told him, "No! No! You don't

understand. We're in love and we want to get married. We'd like your approval." Todd Jr. still shared business interests with her.

"Of course," he said, "I'm delighted," but later he admitted, "I didn't think he had a lot upstairs." Eddie's gifts lay much further to the south, and he helped the grieving widow to achieve closure through injection.

According to her later lover Max Lerner, "They spent four days and nights mostly in bed together. She said that was how Eddie got her out of her grief." In a public statement she said, "I've felt happier and more like a human being for the past two weeks than I have since Mike died."[3]

Back in Manhattan, they took in Broadway plays and went nightclubbing at Quo Vadis, the Harwyn, the Blue Angel, the Embers, and the Colony. New Yorkers paid the lovers little mind, even when they stopped to kiss on Fifth Avenue in broad daylight. But *Life* got a shot of them leaving the Harwyn, and Leonard Lyons and Walter Winchell reported their affair. In the midst of a brewing scandal, they returned to L.A. and moved into the Beverly Hills home of her agent, Kurt Frings, hiding out in a small upstairs room where his wife, Ketti, Pulitzer Prize-winning author of the Broadway hit based on Thomas Wolfe's *Look Homeward, Angel*, did her writing. They called it their "love nest," or sometimes their "womb with a view." In time, Debbie filed for divorce, later writ-

ing, "You can actually feel the pressure when Elizabeth Taylor tells the world that you're depriving her of a lover." Elizabeth found herself in complete control of a fairly handsome sex machine who wasn't costing her any money, who wasn't beating her up, and who never said no.

"I never challenged her," admitted Eddie. "I didn't care—I was getting what I wanted . . . We'd make love three, four, five times a day." His only complaint was having to catch Elizabeth when she passed out from liquor and drugs. Sometimes she blacked out in the middle of a sentence and collapsed without warning. "It was like catching a dead person," he said.

Eddie went to Dr. Kennamer with his concerns, and Kennamer told him to get Elizabeth to a psychiatrist. Eddie decided to wait for a propitious moment to spring Kennamer's suggestion on Elizabeth. One night, they made love in Ketti's room, had a glass of wine, and Eddie read a love poem aloud to her. It seemed the perfect time to tell her she ought to see a shrink, but he was in for a shock. Elizabeth started throwing things at him, ran stark naked into the street, jumped into her Cadillac, and started the engine. As the car moved down the street, Eddie ran alongside it, screaming at the nude lady behind the wheel, "It's not you, it's me. I'll go to the psychiatrist." Mollified, she returned to the love nest, and they made up by having sex again.[4]

Said actress Joanne Jacobson in 1999, "Ketti Frings told me that when Elizabeth left, she had to paint the room black." Elizabeth obviously needed more space for her children and pets, especially her Yorkshire terrier, Theresa, who slept with her.

To escape the fifties stigma of "shacking up," Eddie took an apartment on Sunset Boulevard but left it in the middle of a housewarming party and never came back. Elizabeth leased Linda Christian's Spanish-style stucco house on Copa de Oro Road in secluded Bel Air, where Eddie could come and go unnoticed.

He paid dearly for his carnal holiday. The ratings for his Chesterfield show plummeted. Oddly enough, he was still expressing surprise forty-two years later that the world disapproved of his sleeping with his best friend's widow less than six months after his death. Elizabeth could be equally naive. In an interview with Hedda Hopper, she committed a monumental gaffe. The columnist asked her why she and Eddie couldn't have waited a decent interval before falling in bed together. According to Hopper, Elizabeth snapped, "Mike's dead and I'm alive. What do you expect me to do, sleep alone?" In the movie colony and throughout the Western world, she soon came to be regarded as a dark vamp and home wrecker—quite justifiably so. It was not the first or last family she'd torpedo. Carrie Fisher was so devastated that she remarked years later, "I've always said that if I was-

n't Debbie Reynolds' daughter, I'd make fun of whoever was."5

On January 8, 1959, rumors circulated that Elizabeth had cracked up and was in the Menninger Clinic in Topeka, Kansas. "I'm going with Eddie to Chasen's so that everyone can see me and know I am not a mental patient," she said, but photographs of her at the time show dark circles under her eyes, and she was putting on weight at a rate no movie star could afford. In Beverly Hills and even on the freeways, people blocked Elizabeth and Eddie in traffic and hurled insults. Elizabeth went to Guilaroff in tears and said she couldn't understand why everyone was turning against her. Writer Joe Hyams observed, "She can't believe that someone else's husband is a luxury that even she will have to pay for."

Most of their old L.A. friends snubbed them. "I'd just been a very bad girl and broken up a marriage," Elizabeth recalled. "Natalie [Wood] and R. J. [Robert Wagner] were about the only people in the industry who'd talk to me." Monty was another. Having forgiven him for his dislike of Todd, Elizabeth went out with him and Eddie one night, taking along a priest who was the cousin of one of her friends. "By dessert, the priest was playing with Monty under the table," Eddie related. "Elizabeth didn't care what Monty did, because she was crazy about him." At another club one evening, Elizabeth spotted Rock Hudson holding

hands with one of the top pop singers of the day. Shaking her head she whispered to Eddie, "To think that I had . . ." Eddie assumed she'd once been in love with Rock.[6]

Elizabeth's pal Oscar Levant, commenting on Eddie's leaving Debbie for Elizabeth, quipped, "How high can you stoop?" Eddie's fans continued to turn on him. His million-dollar career as a popular recording artist vanished. In the following decade, former First Lady Jacqueline Kennedy remarked during her feud with *Look* over a book about JFK's assassination, "Anyone who is against me will look like a rat—unless I run off with Eddie Fisher." On NBC's *Dateline* in 1999, reporter Keith Morrison recalled that Elizabeth and Eddie had been "two of the most hated people in America." There were of course exceptions, such as Rona Barrett, who admitted she fantasized nightly that she was Elizabeth, and "Eddie [was] smothering me with kisses." When Rona became a gossip columnist and met Eddie, he told her, "I wouldn't date a Jewish broad if my life depended on it. They think they're doing you a big favor when it comes to sex . . . The *goyishe* dames are different. They're always happy to do it." Ironically enough, Elizabeth, a *shiksa* (non-Jewish girl), was studying to convert to Judaism, influenced by Mike Todd's rabbi, Max Nussbaum, who helped her cope with her grief.

Despite Elizabeth's bad press, her career continued to flourish as Eddie's declined. Studio chiefs

knew she was the industry's hottest feminine star, ranking as its current number two money-maker, just below Glenn Ford. *Cat* was a box-office bonanza, the most profitable movie in Metro history. Even *Time*, a frequent detractor, had to admit, "Elizabeth Taylor plays with surprising sureness." She continued to have her pick of the best scripts, including *Two for the Seesaw* and *Irma La Douce*, but daringly chose Tennessee Williams's controversial *Suddenly Last Summer*, which dealt with the heretofore taboo subjects of homosexuality, cannibalism, and mental illness. Joseph L. Mankiewicz, one of the best directors in the business, announced the film would be shot in England the following year.

In early 1959, Elizabeth converted to Reform Judaism at Temple Israel in Hollywood and was given the Hebrew name of Elisheba Rachel. Her Christian parents looked on with the same horror they'd have displayed at a witches' sabbath. Elizabeth insisted "it had absolutely nothing to do with my upcoming marriage to Eddie Fisher." No doubt she was telling the truth; Eddie told Rona Barrett, "Jewish girls [are] no good for fucking." Perhaps fortunately for the sake of her conjugal life with Eddie, Elizabeth's passion for Judaism quickly waned—she and Eddie never went to synagogue, only once observed the high holidays, and she never gave up wearing her cross.

Rabbi Nussbaum officiated at her marriage to

Eddie on May 12, 1959, at Temple Beth Shalom in
Las Vegas. The bride wore a Jean Louis moss-green
chiffon with a hood, high neckline, and long
sleeves. Eddie sported a yarmulke and a blue busi-
ness suit. Sara Taylor wore beige lace, and Katie
Fisher wore navy lace. Mike Todd Jr. was best man,
and Elizabeth's sister-in-law Mara was maid-of-
honor. A traditional Jewish wedding, it included
the *chuppah* (a canopy), the groom stomping on a
wineglass, and the signing of the marriage con-
tract. Among the guests were Hanley, Guilaroff,
the Fringses, Milton Blackstone, the Eddie Can-
tors, Dr. Kennamer, and Benny Thau. Robert
Evans, the actor and future Paramount president
who'd once run a sportswear company, sent Eliza-
beth one hundred pairs of slacks. Within a few
years Evans and Eddie would be competing for a
girl named Renata Boeck, "the most beautiful of
them all," according to Eddie.[7]

At a reception at Hidden Well Ranch, Elizabeth
spotted Vernon Scott and told him to "screw off."
He was the UPI reporter who'd refused a ride on
the doomed *Lucky Liz*, and recently he'd been criti-
cizing Elizabeth and Eddie in print. On their hon-
eymoon, Elizabeth wanted sex on demand and got
it. "I was always happy to play my role," Eddie
confessed. "We'd make love in the swimming pool,
on Mexican beaches, under waterfalls, in the back
seat of a limousine on the way home from a party.

There is nothing more erotic than a moonlit beach and Elizabeth Taylor. We fit together . . . perfect sexually."[8]

Cruising the Mediterranean on producer Sam Spiegel's 120-foot yacht *Orinoco*, the newlyweds sailed from Barcelona to Cannes, enjoying the services of the yacht's captain, chef, steward, chambermaid, three sailors, three engineers, and a bilingual assistant. Unfortunately their bedroom, a replica of Columbus's cabin on the *Santa Maria*, was in the prow, and every pitch of the vessel tossed them about. "We had a hard time making love," Eddie complained. In Torremolinos, Spain, Elizabeth collected her children, who'd been flown in to meet her. Eddie took them all to a bullfight. At one point during the corrida, volunteers were invited to participate. Eager to impress her children, Eddie started for the ring, but Elizabeth said, "You do that, I'll break your fucking head."[9] Nevertheless, he accepted a red cape and challenged a young bull. To his surprise, the beast ignored the cape and charged him. "Elizabeth saw her entire sex life about to disappear," he recalled. The bull pinned him to a barricade, but fortunately the family jewels remained intact. As Eddie tried, without success, to ingratiate himself with her children, he shamefully neglected his own. He had to learn from Louella Parsons that his son Todd was in the hospital. Thanks to Debbie's watchful care, baby Todd soon recovered from his hernia operation.[10]

Though Eddie was now unemployable, both Elizabeth and Debbie found themselves at new peaks of earning power as a result of the scandal. Within a year Debbie's annual income rose from $75,000 to nearly $1 million. Elizabeth's salary quintupled. She'd received $125,000 for *Cat*. For *Suddenly Last Summer*, her first independent venture following the termination of her despised MGM contract, she received $500,000. Typical Hollywood salaries at the time ran to Robert Mitchum's $75,000 for *The List of Adrian Messenger*; Anthony Perkins's $40,000 for *Psycho;* and Marilyn Monroe's $100,000 for *Something's Got to Give*. With major bucks came major power. In *Suddenly Last Summer* Elizabeth saw an opportunity to help Monty, who appeared dazed and drugged in recent flops like *Lonelyhearts*. Pitying him, she talked Sam Spiegel into casting him in *Suddenly*, which she began filming after her honeymoon. She also arranged for Eddie to appear in a scene as a peasant begging her for a scrap of bread. It was an apt symbol of what their relationship became after he failed the test to which she subjected straight men. "Elizabeth's tough and I'm a softie," he admitted. She had effectively emasculated him. "To Eddie I was ninety percent mother," she told reporter Ruth Waterbury. Eddie later confided to Rona Barrett that Connie Stevens, whom he married after divorcing Elizabeth, was "the best fuck I ever had," causing Rona

to speculate, "Liz's conversion to Judaism must have ruined everything."[11]

On May 25, 1959, Elizabeth reported to work at Shepperton Studios near London, leaving the children with Eddie. They regarded him "as a friend," she said. Certainly they never mistook him for a parent. The children were "remarkable," she added, in how they survived her serial marriages and constant travel. "My life should have been murder for them. We've lived like gypsies." After a surfeit of sordid headlines in British tabloids, the Fishers found themselves ostracized in conservative Englefield Green, near Great Windsor. Despite their fifteen-room mansion, Crown House, which included a housekeeper, a chef, a valet, three gardeners, three housemaids, and a nanny for the children, they were "snubbed," Eddie complained. Though the press made their presence well-known, they received no calls or invitations. When they asked their neighbors to drinks or dinner, no one accepted. Finally, they quit the English countryside and checked into London's Dorchester, famous for its partiality to show folk. The staff knew Elizabeth to be a great tipper, and according to Sheilah Graham, "The hotel maid received a hundred dollars [$500 by today's standards] every time she unpacked for Elizabeth, and another hundred when she repacked." Monty visited them at the Dorch and alarmed Eddie by perching on a ledge of the terrace while drunk and stoned, "wobbling a few inches from death."

In *Suddenly Last Summer*, Elizabeth played Catherine Holly, a young woman used as bait by her gay cousin, Sebastian, to draw boys to him. Cathy is with Sebastian when he's assaulted on a beach in Spain by a gang of street boys whose sexual favors he'd sought. As she looks on in horror, they tear his body to pieces and eat it. Later Sebastian's mother, Violet Venable, played by Katharine Hepburn, tries to stop Cathy from revealing the truth about her son's demise, and Cathy ends up in an insane asylum. Monty played Dr. Cukrowicz, the psychiatrist who saves Cathy from a prefrontal lobotomy. The character of Violet Venable was based on Tennessee's mother, Edwina, who permitted doctors to perform a lobotomy on Tennessee's sexually frustrated sister, Rose Isabel. In the movie, Violet attempts to bribe Dr. Cukrowicz into performing the same operation on Catherine. Like "Desire and the Black Masseur," Williams's earlier tale of cannibalism, *Suddenly Last Summer* was perhaps the ultimate S&M fantasy of guilty homoeroticism and pleasurable punishment. It struck responsive chords in Elizabeth, for emotional cannibalism typified her straight relationships. Eddie Fisher, who was now seeking a niche for himself in the movie industry as Elizabeth's producer, was feeding on her fame, and Elizabeth was using him for sex. His usefulness in that respect was quickly coming to an end. Columnist Janet Charlton revealed in 1999 that Elizabeth was contemplating

writing a book about Eddie titled *Louse,* in which "she may even claim that he was impotent." That same year, Tony Bennett's ex-wife Sandra revealed that she had a two-month affair with Fisher immediately following his split from Elizabeth. "Eddie was a so-so lover," she said.[12]

Elizabeth and Tennessee grew ever closer during the production. She taught him how to negotiate for a percentage of the gross and burnish his deals like a Hollywood pro. Before that, he'd been getting five percent of the net profits, and he'd never collected anything beyond his original fees. She told the gay playwright that he was "hopelessly naive" and had "no sense of business." "I stepped in and tried to act as his agent," she later said. "I took him in hand! I loved him dearly." Tennessee followed her advice to the letter, improving all his future deals. In gratitude he wrote a new play for her, *Sweet Bird of Youth,* about an aging movie star and a gigolo, but Geraldine Page landed the role on Broadway and in the film years before Elizabeth finally starred in a television version at the age of fifty-seven.

Her marriage with Eddie had been "a mistake," she told Joe Mankiewicz, her director. Years later, Mankiewicz's sons speculated about a relationship between their father and Elizabeth Taylor. Trying to persuade her to lose weight, he said her upper arms resembled "a bag of dead mice." After a crash diet, she was in peak physical form, looking more

like seventeen instead of twenty-seven. She was late for shooting due to an impacted wisdom tooth, and Katharine Hepburn, a meticulous pro, was furious. Hepburn was even angrier when she realized that Mankiewicz was going to favor Elizabeth over her throughout the shoot.

Monty showed Elizabeth how to put over her long monologue about homosexuality and cannibalism. Full of Clift touches such as pointed hesitations for emphasis, violence held in check, and "Method" displacement of her grief over Todd, the monologue became one of her signature pieces. Monty's health was rapidly deteriorating, and the entire production would have been canceled had Elizabeth not pulled rank on Mankiewicz, who wanted to shut it down after Monty fell ill as a result of washing down too many codeine pills with brandy in Tennessee's Savoy suite one night. Having hitched his wagon to Elizabeth's star, the director now meekly deferred to her—the first of many who would. As she took over, British laborers on the crew were rattled by her language. When she wanted a grip's attention, she thought nothing of yelling across the set, "Hey, shmuck!" or "Hey, asshole!" Finally someone complained to Eddie, and thereafter she toned down her expletives.[13]

When *Suddenly Last Summer* opened in December 1959 it was an immediate hit. For the third year in a row, Elizabeth was nominated for an

Academy Award. For the annual ceremony at the Pantages, Helen Rose unpacked the white Grecian gown that Mike Todd had designed for her to wear the year she was nominated for *Raintree*. Unfortunately Elizabeth and Katharine Hepburn, both nominated for *Suddenly*, canceled each other out, and a dark horse, Simone Signoret, won by default for *Room at the Top*. Sitting in the audience, Elizabeth felt cheated but smiled into an explosion of flashbulbs and forced herself to applaud as Signoret, a middle-aged Frenchwoman, ran huffing up the aisle to the stage. Eddie gasped, "God, no! Oh, no!" Elizabeth blamed her loss on him. "I should've won for *Suddenly*," she said, "but I was a bad girl then."[14]

At the studios, she found herself in greater demand than ever before. The film she chose to do was the highly touted 20th Century–Fox epic, *Cleopatra*. Metro insisted she owed them one more picture, despite a waiver Todd had secured but failed to get in writing. Metro threatened a lawsuit unless she agreed to star in John O'Hara's *Butterfield 8*. She hated the role of Gloria Wandrous, a prostitute, but had no choice—she needed the money—and she agreed to shoot the film after Eddie's two-week engagement at the Desert Inn in Las Vegas.

In his nightly act, Eddie shamelessly exploited Elizabeth. Her presence, or even the expectation of it, assured a capacity crowd. She usually arrived at

11:48 P.M., two minutes before curtain. He always sang to her, and she'd blow him a kiss, to the delight of the audience. One evening in Vegas, they went to the Sands Hotel to celebrate Kirk and Ann Douglas's seventh wedding anniversary, sitting at a table with Dean and Jeanie Martin. Frank Sinatra was there with Marilyn Monroe, and Marilyn had mixed so many pills with liquor that she was drooling. Eddie sang a Sammy Cahn parody, and then Sinatra took the stage. Suddenly, Marilyn reached up and started pounding on the stage floor, disrupting the show. Sinatra made a barely perceptible gesture toward her, and goons appeared out of nowhere and dragged her from the room.[15]

On October 19, 1959, the Fishers entrained on the Super Chief for New York, where Elizabeth was to film *Butterfield 8*. Still furious at Metro, she tried to sabotage the film, beginning with her insistence that Eddie replace David Janssen in the role of Steve Carpenter, Gloria's platonic buddy. She wanted Eddie to be paid $100,000 for a single week's work, though his acting could not have been more amateurish or embarrassing. The script was an excellent one, but the Fishers went to great lengths to beef up Eddie's part. Elizabeth called in all her favorite writers—Tennessee Williams, Truman Capote, Paddy Chayefsky, Joe Mankiewicz, and Daniel Taradash—and had a sexy new scene crafted for her and Eddie. "We actually made love on the set," Eddie recalled. "I didn't have an

orgasm, but we did everything else. Knowing the camera was filming was a tremendous turn-on."

Eddie was alone in his enthusiasm. The scene ended up on the cutting-room floor, and all the new rewrites were thrown out. Elizabeth advised Eddie to go to Monty for acting lessons. Eddie arrived at the session wired on speed, and Monty was drunk. Eddie gave him the script and went into the bathroom. When he came out, Monty was asleep with a lighted cigarette in his hand, the script in flames. The acting lessons were abandoned, and Eddie went back to doing what he liked best. "Eddie's favorite time to fuck is the morning," Elizabeth told their hotel manager, alerting him to keep the maids out of their suite until afternoon.[16] At the Park Lane Hotel, they spent three consecutive days in bed. Complaining of back pains and headaches, she took three to four baths a day. "She also liked to make love in the tub," Eddie recalled. "It alleviated her aches and pains." Eddie also had other distractions, among them drinking with his cronies and gambling away sizable amounts of cash. Alone at the hotel, Elizabeth had time to reflect that Eddie was Mike Todd's "ghost [and] boy, did I realize how sick it was."

She was often three hours late getting to the set. Fighting all the way, she denounced the film to the press, chastising Metro for paying her $375,000 less than she'd received for *Suddenly Last Summer* and $875,000 less than she was demanding for

Cleopatra. "I was very self-destructive," she admitted. According to some reports, she came down with a case of double pneumonia, but according to others she took too many pills. Eddie's Dr. Feelgood, Max Jacobson, sent her to Columbia-Presbyterian Hospital. She did not appear sick to Eddie, who noted that she applied lip gloss and powder in the ambulance just before arriving at the hospital. He questioned the accuracy of her diagnosis and decided "she enjoyed playing the invalid. It was a way of testing the devotion of those around her."[17]

Ironically, though Elizabeth despised *Butterfield 8*, she played the hooker to perfection, sultry without being cheap, powerful in a sinewy understated way, and finally touching and vulnerable without being maudlin. When nominated for an Oscar for the fourth time, she held out no hope of winning, still feeling the vehicle unworthy and telling the press: "It's the most pornographic script I've ever read, and . . . I don't think the studio is treating me fairly."[18] She reserved all her enthusiasm for her next picture, *Cleopatra*, though it would represent the artistic nadir of her career.

The *Cleopatra* saga had begun in September 1958 when dapper, sixty-nine-year-old Walter Wanger—Joan Bennett's ex and Jennings Lang's would-be assassin—conferred with Fox president Spyros P. Skouras about remaking the 1917 Theda Bara silent *Cleopatra* for Elizabeth. Wanger's fascination with the subject harked back to his begin-

nings in the movie business. In the 1920s, as Paramount's general manager of production, he'd presided over an era of exotic mideastern orientalist spectacles, providing post-Victorian audiences with titillating visions of freedom and ravishment. This lurid genre, epitomized by Valentino's *The Sheik*, would culminate in 1963 with Elizabeth's *Cleopatra*.[19]

Though Wanger had his heart set on casting her, Skouras feared Elizabeth, warning Wanger that she was trouble.[20] Skouras preferred almost any other pretty actress for the role and suggested everyone from Susan Hayward to Millie Perkins. Wanger never gave up hope of getting Elizabeth. A brave, bright, semi-independent producer who'd worked both in and outside the studio system, putting together memorable films such as Garbo's *Queen Christina* and John Wayne's *Stagecoach*, Wanger served as president of the Academy of Motion Picture Arts and Sciences in 1945. Physically resembling matinee idol Paul Muni, he was a "smiling Casanova," in Selznick's description. He'd romanced both Louise Brooks and Tallulah Bankhead. "Wanger had a good cock," Tallulah said, but added, "he didn't know how to use it."[21] As a producer he was noted for giving his artists maximum freedom, an asset that would work against him in *Cleopatra*, because his principal artists—Elizabeth, Richard Burton, Joseph L. Mankiewicz, and Rex Harrison—were all undergo-

ing varying degrees of nervous collapse. So was 20th Century–Fox, which was having the corporate equivalent of an epileptic seizure after the departure of Darryl F. Zanuck and a succession of inept production chiefs, including Buddy Adler and Skouras.

Wanger had been hired as a line producer at $2,000 a week with fifteen percent of his films' profits, but Fox had turned down most of his ideas, finally accepting his proposal to film Carlo Franzero's book, *The Life and Times of Cleopatra*. Despite Franzero's anachronistic dialogue—the seed of all the problems that would plague *Cleopatra*—Wanger was convinced that with Elizabeth as its star, he could score a hit. Director Rouben Mamoulian also wanted Elizabeth, and finally her agent, Kurt Frings, was contacted. Everyone from Guilaroff to Eddie Fisher has tried to take credit for suggesting Elizabeth's historic fee for *Cleopatra*, but it was Elizabeth herself who, as a kind of joke, told Frings, "I'll do it for $1 million against ten percent of the gross." She was astonished when Wanger took her proposal seriously. As they dined at the Colony in Manhattan, she added that Eddie was to receive $150,000 as "some kind of production assistant."

Securing Elizabeth was Wanger's decisive move in making Fox see *Cleopatra* as a big-budget film, but unfortunately the fusty Franzero material did not justify "A" treatment. Elizabeth's *Cleopatra* was a

"B" movie from the start, despite its $3 million budget. She signed a somewhat hokey $1 million contract, becoming, at least according to Fox, the highest paid movie star in history. The actual document wouldn't be ready for months—as Hedy Lamarr once pointed out, "It is not unusual for an actress to finish a picture before receiving her contracts." At the much-photographed signing ceremony, Elizabeth wore a black dress, long black gloves, and seven strands of pearls. Unwittingly, she ushered in a new era of filmmaking, in which actors would call more of the shots and be paid upward of $50 million a picture. Since Elizabeth provided reporters with good copy, they ignored the fact that William Holden and Susan Hayward had preceded her as million-dollar stars.

When Elizabeth arrived in London to begin filming *Cleopatra* on September 15 at Pinewood Studios, she looked up her old flame, Peter Finch. Leaving Eddie and the children behind at the Dorchester, she went to his flat in Sydney Street. Over dinner that night, Finch was torn between Elizabeth, who sat on one side of the table imploring him to play Julius Caesar to her Cleopatra, and poet Christopher Logue, who sat on the other, pressing him to play King Creon in his new verse play *Antigone*. George Devine, who was producing the Logue play at the Royal Court Theatre, was also present. Though outnumbered, Elizabeth won, and Finch signed for $150,000, hoping she'd

turn him into an international star. Stephen Boyd was cast as her Marc Antony.

Unfortunately the production was in complete disarray at Pinewood. No one at Fox knew how to produce an epic film. Unlike the superb professionals at Metro, who solved all of *Ben-Hur*'s problems in preproduction before going to Rome on location, Fox assembled a cast and crew in London without even having a shootable script, which is essential not only for the actors but for planning operations, budgets, and controls. Moreover, nervous Fox executives shut Walter Wanger out of their deliberations, urging the producer to remain in Hollywood to develop Elaine Dundy's novel *The Dud Avocado*. Dundy herself was in London, where she and her husband Kenneth Tynan ran an influential leftist political and literary salon in their Mount Street flat. Shelley Winters was also in London, filming *Lolita* with Stanley Kubrick. At a dinner one night with the Fishers, Finch, and Albert Finney, Shelley noticed that Eddie was miserable over Elizabeth's obvious intimacy with Finch. Elaine Dundy later wrote Finch's biography, and when quizzed in 1997 about the actor's relationship with Elizabeth, she commented, "Does lovemaking on location count as adultery?"

Despite costly sets of ancient Alexandria covering twenty acres at Pinewood, there was still no finished scenario. Elizabeth somehow convinced herself that Paddy Chayefsky, author of *Marty*, a

modern Bronx love story, could solve their script problems. Fox disagreed, trying out several writers, including Lawrence Durrell, Dale Wasserman, and Nunnally Johnson, none of whom produced an acceptable script. When Wanger finally arrived in London, he was of little help; he'd always been a hands-off producer, and his behavior on the *Cleopatra* set, following a second heart attack, was almost aloof. He wasn't doing any better with *Avocado*. Though he took Elaine Dundy and Blake Edwards to lunch at the Caprice, Edwards later decided to direct *Breakfast at Tiffany's* instead.

Then, as unlikely as an ant upsetting an applecart, Elizabeth's pretentious hairdresser, Sydney Guilaroff, temporarily shut down production at Pinewood. A relatively minor functionary who received $1,000 a week in salary plus $600 in expenses, he cost *Cleopatra* hundreds of thousands of dollars in delays. Guilaroff—who by his own admission couldn't get along with the British hairdressers' union—manipulated Elizabeth into insisting that he remain on the picture. The *London Times* ran a photo of the gigantic $600,000 set at Pinewood with the caption: "This is the set that Mr. Guilaroff closed down." Guilaroff's value to Elizabeth was as an incorrigible snoop who repeated every snippet of gossip he heard on the set. As a result, she always knew exactly what was going on. She also needed Guilaroff for moral support. Though still a young woman, she was near

the end of her rope. Pills, cigarettes, and alcohol undoubtedly had decimated her immune system and left her open to opportunistic infections.

Years later, Eddie explained, "The real cause of her illness was her desire for painkilling pills. She'd be popping pills and drinking most of the day."[22] She also smoked like a chimney, despite a lifetime of respiratory ailments. Shirley MacLaine recalled, "Sydney would light her cigarette and she would draw the smoke long and deep into her lungs with . . . low-down basic oral gratification." According to Guilaroff, her health was undermined by Eddie and Dr. Max Jacobson, whom Eddie brought to London as his drug supplier.[23] *Cleopatra*'s major troubles began the day that Elizabeth filmed a nude scene in forty-degree weather at Pinewood Studios and came down with a cold. Walter Wanger's hope of finishing the film by February 14, 1961, was dashed. On November 13, 1960, Lord Evans, physician to Queen Elizabeth II, was called to Elizabeth's suite at the Dorchester Hotel, where he told her that she had been poisoned by an abscessed tooth. Other doctors arrived, and she was given an anesthetic. The tooth was extracted as she lay on the floor of the suite. She continued to complain of various maladies, but some of her symptoms were faked, according to Eddie, to get drugs from doctors. She knew how to induce a respiratory attack if that was what it took to get a fix. Some of her doctors were in league

with her and made up diseases to justify her pre-scriptions.[24] In the end, the Fishers were no better than two junkies, browbeating their doctors into giving them drugs. Eddie was on Librium, and Elizabeth sometimes passed out from a combina-tion of pills and booze. When they ran out of drugs one day, they called one of their doctors to the suite. He produced a bottle of pills, but Elizabeth yelled, "That's the wrong one, you cocksucker. Don't try to give me that fucking shit. Give me the right one."[25] Eddie, who'd been taught how to give intravenous injections by Dr. Jacobson, finally started injecting Elizabeth with morphine, some-times giving her two shots a night. In addition, "she was eating Demerol like candy," Eddie alleged.[26]

When her fever soared one day to 103 degrees, she was rushed to the London Clinic by ambulance. Dr. Carl Goldman and his medical team thought she might have meningism, an inflammation of the three membranes that cover the brain and spinal cord. Acute fever is a frequent symptom of this ill-ness, which is sometimes associated with binge drinking, smoking, and stress.[27] Doctors insisted she quit working for a period of months. After a week in the hospital, she returned to the United States with Eddie. Her illness cost Fox $2 million. Although Lloyds of London footed the bill, the insurer demanded that Fox fire Elizabeth and hire Marilyn Monroe, Kim Novak, or Shirley MacLaine

in her place. "No Liz, no Cleo," said Wanger. Both
she and the production were eventually reinsured.

The turning point in the Fisher marriage
occurred when the couple stopped in Munich on
their way back to London. At 4 A.M., Eddie threat-
ened to leave Elizabeth by dawn if she didn't stop
passing out on him. Snatching a bottle of Seconal
from her night table, she said, "Oh yeah, you're
leaving in the morning? Well, I'm leaving right
now," and swallowed a handful of pills.

"Are you crazy?" he screamed. "What about the
children?"

She replied, "You'll take care of the children."
She was buckling at the knees and foaming at the
mouth. In the next suite, Kurt Frings heard the
commotion and called a ninety-year-old doctor
who could be trusted not to snitch to the press. He
injected her with an antidote, and Eddie gave him
$1,000 to keep his mouth shut.

When Elizabeth revived the next day, they
started fighting again. He was no longer equal to
the challenge and stress of their relationship, later
explaining that she was abusing him, hitting him
six or seven times in the face, trying to goad him
into beating her. "I'm not gonna hit you," he
said.[28] She kept pummeling him until he was
forced to overpower her and hold her down on the
bed. "Inevitably that led to sex," he said. Cracking
up under the pressure, he persuaded doctors at the
London Clinic to give him a completely unneces-

sary appendectomy just to escape her—surely one of the high points in the unwritten history of human masochism.[29] He also faked other ailments, but Elizabeth's physician, Rex Kennamer, was wise to his stunts and told Elizabeth nothing was wrong with him. She demanded he return to the Dorchester where, according to Eddie, she was overmedicating herself for her back pain. "She needed more and more painkillers just to counter the effects of the painkillers," he wrote.[30]

Fox planned to resume filming in April 1961, but in early March, Elizabeth experienced difficulty breathing and broke out in a cold sweat. Dr. J. Middleton Price jammed a plastic tube down her throat and into her trachea, so air could be pumped directly into her lungs from a portable oxygen tank. Rushed to the London Clinic, she was diagnosed with double pneumonia, but one doctor privately told Eddie that her respiratory failure was the result of depressant drugs.[31] Dr. Terence Cawthorne performed a tracheotomy, cutting a hole in her air passage above her breastbone and inserting a silver tube connected to a respirator. "She was the most lifeless individual I've ever seen," nurse Catherine Morgan recalled.

Four years later, Elizabeth finally admitted that she'd been trying to kill herself to escape her grief over Todd and the emptiness of her life with Eddie. "My subconscious . . . let me become so seriously ill," she wrote. "I just let the disease take me. I had

been hoping to be happy, pretending to be happy . . . My despair became so black that I just couldn't face waking up any more, couldn't face another divorce. My dream world which was Mike was much more satisfactory and much more real."[32] In other words, what came to be known as her heroic "near-death" experience—in which Mike Todd appeared in a vision and wrested her from the clutches of the grim reaper—was nothing but another occasion of too many pills, no better or worse than other celebrities'. Eddie Fisher was with Elizabeth throughout her health crisis and later stated, "Elizabeth's problems in 1960 were basically the same as they were in 1990. She had become addicted to every pill on the market."[33]

In West Hollywood, Joan Collins's telephone rang in her apartment on Sunset Plaza Drive, where she was with Warren Beatty. Her agent told her to get ready to go abroad—Elizabeth wasn't expected to live, and Joan was at last going to play Cleopatra, a role she'd lost the previous year. "God, I hope she doesn't die," Joan said.

"She won't," Warren assured her. "She's got nine lives, that woman. Don't worry about it, Butterfly. All you have to worry about is making break-fast."[34]

In London, Eddie thought it odd that Elizabeth's doctors continued to give her depressant drugs when her crisis had been brought on by the same "pills."[35] Interestingly, he did nothing to

stop them, though he took credit for saving her life several times. At one point he appeared outside the London Clinic and told reporters, "I'm going to lose my girl."[36] Though Elizabeth was still critical, she used what little breath she had left to beg Eddie, "Make them give me something stronger to sleep. Not like before."[37]

On March 10, 1961, doctors announced she'd made a "very rare recovery."[38] By the 12th she was sitting up in bed, entertaining John Wayne and Tennessee Williams and drinking Dom Perignon, even squirting a stream of champagne out of the hole in her throat to amuse Truman Capote.[39] On March 27, swathed in sable, a white scarf covering her incision, she emerged from the clinic in a wheelchair. At London airport, she was mobbed by fans and paparazzi, and additional police were mobilized to control the crowd. Finally, she was raised on a canvas blanket to the plane and flown back to America.

There can be no question that Elizabeth was ill, but in retrospect it seems unlikely that she was as ill as the world was led to believe. She seemed to have been determined to extricate herself at any cost from a picture that was shaping up as the worst turkey of all time. The London shoot, which came to be known as *Cleopatra I*, was shut down permanently. Peter Finch had a nervous breakdown and disappeared into a nursing home. According to Elaine Dundy, Finch "just wanted to lie in the sun and drink," but he posthumously won the coveted

best actor Oscar for *Network*. Stephen Boyd went on to other commitments. *Cleopatra I* was history, an aborted film that had been in production sixteen months, cost $7 million, and amounted to only twelve minutes of usable footage. Facing possible bankruptcy, Fox sold off the 260-acre L.A. lot to cover expenses. The Aluminum Company of America snapped it up for $43 million, the biggest real-estate steal since Peter Minuit snatched Manhattan from the Indians for $24. Quickly developed into Century City, the old Fox lot became a bustling office, hotel, and shopping center complex just south of Beverly Hills. Fox had to lease back some of it to continue in the picture business.

In Los Angeles, Elizabeth—her beauty miraculously unaffected by her recent ordeal—attended the annual Oscar ceremony with Eddie. She was one of the five nominees in the best actress category for *Butterfield 8*. As she left for the Santa Monica Civic Auditorium on April 17, she turned her seven-year-old son, Chris, over to his father, Wilding Sr. Pretending to weep, Chris used a Coke bottle as a microphone and said, "I'm Mummy collecting her Oscar, and I have to look like I'm crying." Later, millions watched on television as Yul Brynner announced Elizabeth's victory. Seated far back in the middle of the auditorium, she screamed, kissed Eddie, and told him, "Take me down the aisle." She hobbled along on crutches, favoring an ankle still bandaged from an IV tube. Her left foot

was so inflamed she needed a size seven shoe on it instead of the usual size four. The long skirt of her evening gown covered her swollen left leg as she and Eddie paused at the steps to the stage. "Walk me to the podium," she said, but Eddie refused. "No, kid," he said, "this one you go alone."

Bob Hope and Burt Lancaster, the year's best actor winner for *Elmer Gantry*, helped her across the stage, both men looking very concerned. As she delivered a modest acceptance speech, Lancaster reached out at one point to steady her. The tracheotomy scar was clearly visible on her bare throat, and she whispered hoarsely, "I don't really know how to express my gratitude. All I can say is thank you." Later, she held court at their bungalow at the Beverly Hills Hotel, receiving the industry's top actors and directors one at a time. When she was told Sinatra was waiting outside, Eddie braced himself for a vengeful scene, but instead Elizabeth was gracious, spending more time with Sinatra than with John Wayne, whom she liked. Eddie thought her "a hypocrite."[40] Dr. Kennamer told her that she belonged at home in bed, but she insisted on attending the 10 P.M. Oscar party at the Beverly Hilton. Posing for fifty photographers, she said, "I always recover, and now I shall live to be 110."

Her unexpected appearance on Oscar night, looking gloriously healthy despite her scar and crutches, raised eyebrows. "Liz Taylor in 1960 remains the only example of someone voted an

Oscar because the electorate thought she was at death's door—and then recovering in time to pick it up," wrote Academy historian Anthony Holden. Critic Peter H. Brown preferred any of the other four nominees—Deborah Kerr, Shirley MacLaine, Greer Garson, and Melina Mercouri—and wrote, "Liz was the sole nominee who obviously did *not* deserve the Oscar." Huffed MacLaine, "I lost to a tracheotomy," but for once the jaded MacLaine was being naive. She'd lost to a drug OD.

Still angry at Metro for forcing her into *Butterfield 8*, Elizabeth dismissed her Oscar as "a sympathy award." But she obviously relished the role of plucky survivor and milked her death-defying London crisis for all it was worth, describing her illness in the most melodramatic terms in a speech at an L.A. Medical Fund dinner. The phony spiel had been ghosted for her by Joseph L. Mankiewicz, whom she'd chosen to replace Mamoulian as director of the revived production of *Cleopatra*.[41] Still facing bankruptcy, Fox executives had decided to salvage the picture after realizing that Elizabeth's renewed popularity might well save the studio from ruin. Shrewdly aware that each increment of fame had its cash value, Elizabeth charged Fox another $1 million to restart production in Rome the following fall. With percentages and overages, she'd eventually realize $7 million.[42]

During the summer of 1961, she learned that her friends Natalie and R. J. Wagner had sepa-

rated. Wagner had been inconsolable when he'd burst into Eddie's bungalow, hysterical over his discovery of Natalie's affair with Warren Beatty.[43] Saddened that the "perfect" Hollywood marriage was over, Elizabeth took to her bed with two tranquilizers. "Why does *she* need sedating?" Natalie asked. "It's *my* marriage that just collapsed."[44] The real reason for Elizabeth's depression was the state of her own marriage and the inevitability of yet another divorce. Meanwhile, Eddie was content to be called "Mr. Taylor," flattered to be her "chosen companion," and he even deluded himself into thinking he was a big-time producer. Though Warner Bros. gave him office space and a four-picture deal—contingent upon Elizabeth's appearing in two of them—he got nothing in the can, and the studio later billed him $60,000 for the office.

Cleopatra II started filming at two locations in Italy in the autumn of 1961. The Roman forum set occupied twelve acres at Cinecittà Studios outside Rome, and the Alexandria set was built at Anzio on Prince Borghese's private beach. Edward Dmytryk, who was in Rome to film *The Reluctant Saint,* recalled, "We were at the Excelsior, Elizabeth was at the Grand, and one day Jeanie [his wife, Jean Porter] and I went over to visit her. She was being made up, and guess who was holding the mirror? The husband: Eddie Fisher. When we left, we said, 'That's the end of *that*.' When a husband has to hold the mirror for Elizabeth, he's

finished. That's the kind of thing that she really doesn't want."

Moving out of the hotel, the Fishers took over the fourteen-room walled Villa Papa on the Via Appia Piatello, which was only ten minutes from Cinecittà. Michael Jr., Christopher, and Liza joined them. Whenever one of the children fell ill, Elizabeth would dash to the telephone between every take, like any other working mom. As she filmed at Cinecitta, Eddie discovered *la dolce vita* on the Via Veneto and soon acquired a following of Hollywood and New York expatriates, mostly music business dropouts, often inviting ten or twenty to dinner. When Elizabeth came home from work, she would have preferred to unwind by making love, but Eddie was smoking cigars and holding forth throughout dinner, often to the accompaniment of his outmoded, pre-rock-era top forty hits. "What is this," she finally asked, "a home for displaced Americans?" Her own group included Dr. Kennamer, hired by Fox to keep an eye on her for six weeks. Eddie was paid $1,500 a week to get her to work on time and keep her away from the bottle.

Soon she was chafing under too many watchful eyes and later complained, "I had gone out maybe four times during six or seven months. Eddie didn't like me to have more than one glass of wine." Cut off from booze and drugs, she fell into a strange kind of limbo, withdrawing into herself and even shutting out the children. It occurred to

Eddie that what they needed was a child "by us. . . . Much as I love them, your children aren't my children," he nagged. "My own children are now Debbie's . . . If only you and I could have a child." Through Maximilian Schell's sister, Maria Schell, they adopted a nine-month-old baby from a Munich orphanage. The infant was sickly and deformed, but Elizabeth said, "I want her all the more because she's ill. Maybe I can do something to help." They named her after Maria Schell, whom stardom had eluded even though she'd won the role that Marilyn Monroe had desired above all others—Grushenka in Dostoyevsky's *The Brothers Karamazov*, filmed by Metro in 1958. Elizabeth's new daughter had saucer-shaped eyes and curly hair. "I just loved her," she said, but nothing could save the Fishers' marriage or assuage her demoralization and ennui.[45]

At Cinecittà, her "dressing room" took up the entirety of a small building and was aptly nicknamed "Casa Taylor." It included an office and dressing room for Eddie, whose presence at Cinecittà soon became a nuisance. Mankiewicz urged him to work harder at becoming a producer, hoping to get him out of everyone's way. As *Cleopatra I* had in London, *Cleopatra II* got off to a shaky start in Rome. The temperamental, imperious Rex Harrison, who won the role of Julius Caesar only because Olivier and Trevor Howard turned it down, arrived in Rome and announced,

"Mankiewicz is not right for this movie." A later director of Elizabeth's, Brian Hutton, observed in 1998, "What Harrison meant was that Mankiewicz hadn't called Rex soon enough for the part." The production's new Marc Antony was Richard Burton, who, according to Guilaroff, won the role after Elizabeth saw him on Broadway as King Arthur in *Camelot* and told Fox to give him the part. The studio paid him $250,000 plus $50,000 to buy him out of *Camelot*. Before leaving for Rome, he announced at a backstage farewell party that within two days Elizabeth would be on her knees giving him oral sex, and Guilaroff later confirmed that Richard said he was determined to get a "blowjob" from "Miss Tits." Most of Elizabeth's work that fall was with Rex; Richard worked only one of his first seventeen weeks in Rome. Elizabeth's memory of her first meeting with Richard at Granger's house years ago was not a particularly pleasant one.

Though depressed over her dismal marriage, she made an awesome entrance her first day on the set. Having applied her makeup at the villa, she stepped onto the sound stage in black mink, looking as magisterial as the monarch she was about to portray. As cast and crew watched in awe, she slowly proceeded to the center of the set through parallel rows of small electric heaters that had been strategically placed every two feet to keep her from catching pneumonia. Trailing her came the

entourage—hairdresser, dresser, maid, and seamstress. As she passed Rex and Richard they stood up and smiled, but she ignored them and kept walking until she reached Mankiewicz. Stopping in front of the director, she winked at him, and he bowed in mock deference. "Ready, Madame Queen?" he asked, kissing her hand. She replied, "I was born ready, dear sir," and dropped her mink to the floor, where it was quickly retrieved by one of her maids, by prior arrangement. Mankiewicz gasped when he saw how ravishing Elizabeth looked in her revealing Cleopatra costume.

At last, she turned to greet her costars.

7

Cleopatra:

THE QUEEN OF THE WORLD

The first thing she noticed about Richard Burton was that he was either drunk or terribly hung over, "quivering from head to foot," she recalled, "and there were grog blossoms . . . from booze all over his face." When he asked her, "Has anybody told you what a pretty girl you are?" she thought, "*Oy gevaldt.*" She couldn't wait to get back to Casa Taylor and gossip about him with the only friends she had, the hairdressers, costumers, and other assistants who worked for her

They tried to do the scene, but Richard kept blowing his lines. "If it had been a planned strategic campaign, Caesar couldn't have planned it better," she reflected. "My heart just went out to him." Richard's rich, pliable voice melted her; his wide-set eyes penetrated, almost intimidated her; and his face and head, in Alec Guinness's description, had the grandeur of a Roman emperor's bust. To Richard, Elizabeth was walking "pornography."

Eddie was standing in back of the set with makeup and costume personnel. When Elizabeth came out dressed in a golden gown as Cleopatra, he had a premonition that made him feel "very sad," he recalled. "I had lost her . . . and she no longer needed me . . . I cried."[1]

On January 22, 1962, she worked with Richard for the first time, filming a love scene. Eddie was not on the set that day. After Mankiewicz called, "Action," Elizabeth looked at Richard and said, "To have waited so long . . ." Richard replied that she was "everything that I want to hold or love or have." Their lips came together, locking in a deep, wet kiss. Mankiewicz had them shoot the scene four times. Watching from the sidelines, Wanger could feel the stars' passion for each other. It was frightening, like a hurricane sweeping all control of the production out of his hands. They were still embracing when Mankiewicz said, "Would you two mind if I say *cut*? Does it interest you that it is time for lunch?"[2] Elizabeth huddled with her maid, hairdresser, and dresser, while Richard gathered his pals and headed for his dressing room. "Liz, come join us," he said. "We'll have some laughs." She'd already started for Casa Taylor with her retinue, and she turned, intending to refuse the invitation. "Come on, Pudgy," he said, "it will be fun." Instead of being insulted, she was reminded of Mike Todd's insolent banter and said, "Why, thank you, Grandpa, I accept."

He made her laugh all through a two-hour lunch, calling her too "homely" to have an affair with. When they returned to the sound stage for more scenes, he lured her from her thronelike chair among the VIPs to his humbler spot on the set, telling her, "If you'd like to hear a story that must be whispered, come over here." He cracked a blue joke, and her laughter resounded around the stage for the first time. She was having fun again, at long last. After work, she invited him to Casa Taylor for a drink. Afterward, he drove her home and then returned to his villa on the Via Appia Antica, only a mile away. On January 26, Wanger warned Mankiewicz they were "sitting on a volcano."[3]

She was now on the verge of her most bombastic, ecstatic a-loving, sexual relationship, complicated even further by the fact that Richard was not entirely, by his own admission, a heterosexual. While not an international name like Elizabeth, Richard at thirty-seven was one of the most dynamic figures in show business. The son of an impoverished coal miner, speaking nothing but Welsh until he was ten, he had risen from an oppressed and ignored underclass to become one of the leading Shakespearean actors of his time. He was born Richard Walter Jenkins in the bleak village of Pontrhydyfen (bridge over the ford across two rivers) in South Wales on November 10, 1925. His early mentors were all gay, including schoolmaster Philip Burton, who took Richard into his

home when he was seventeen, keeping him and giving him his surname. Recalled publisher and movie producer Frank Taylor, who knew Philip throughout his later years in Key West, Florida, "He loved Richard, but it was unrequited. Philip didn't have sex of any kind, he told me." Emlyn Williams, Welsh author of *The Corn Is Green*, was another early gay admirer, handing Richard his first breaks in the theater and movies in 1944 and 1947 respectively. Biographer Melvyn Bragg speculated that Richard had sex with other servicemen when he was in the RAF during WWII, "when hundreds of thousands of men . . . fumbled for comfort and release in the male warrior bondings of war."[4]

It was not Philip or Emlyn or horny warriors, but the celebrated leading actor of his generation who became Richard's lover. "Richard's gay relationship was with Laurence Olivier, but it didn't last because they had the same problem," Frank Taylor, who produced Montgomery Clift's *The Misfits*, added in 1999. He explained that both Richard and Olivier were married to highly visible and attractive women—Vivien Leigh and Sybil Williams—because living openly as gays would have destroyed their careers. In 1948, Emlyn introduced Richard to the petite, nineteen-year-old, prematurely silver-haired Sybil, a Welsh actress working as an extra in Richard's first film, *The Last Days of Dolwyn*. They were married in February

1949. When Sybil learned not long afterward that he was having an affair with an actress in a drama he was appearing in, she wrote it off as a run-of-the-play dalliance. Then came a string of affairs— Claire Bloom, Susan Strasberg, Jean Simmons— and Sybil allegedly said, "The first week I say don't hurt her: the second, don't hurt me." According to Bragg, the Burtons' marriage evolved into a "brother-sister" relationship.[5]

Driven by emotional conflict into a kind of compulsive heterosexuality, Richard once pursued two of his leading ladies simultaneously. When Bloom walked in on Richard and Strasberg having sex, Bloom said, "Fuck off, the pair of you," and slammed out.[6] Bloom, like many of the women in his life, tolerated Richard because he made her believe in herself as an actress. Joan Collins, his *Seawife* costar in 1956, was turned off by his back and shoulders, "deeply pitted and rutted with pimples, blackheads, and what looked like small craters," but she found his greenish-blue eyes to be "piercingly hypnotic."

None of his liaisons ever lasted because of the sexual torment he was in. "I was a homosexual once," he explained, "but not for long. But I tried it. It didn't work, so I gave it up. Perhaps most actors are latent homosexuals. So you drink to overcome the shame." His alcoholism and homosexuality fed into each other and drove him to seek out women and then abuse them. In 1969, when

he played Rex Harrison's lover in *Staircase*, he candidly confessed, "The most difficult and unnerving aspect of this part is to convincingly overcome one's primitive, atavistic fear of becoming one [a homosexual]." Gay actor James Coco, who costarred with Elizabeth in *The Blue Bird*, observed, "Burton said something like, I used to be a homosexual but it didn't work out. Do you believe that? The *guts* . . . I guess he made it with the wrong guy . . . Bisexuality's more common in Europe." Laurence Olivier was indeed the wrong guy, as unwilling as Richard to sacrifice fame for love.

Elizabeth would soon learn that Burton's sexuality was not the only complex thing about him. At Cinecittà, they began to lunch together every day, usually in a group, and they sat together on the set, side by side, whispering and pouring out their hearts to each other. Everything in his soul was at sixes and sevens. A writer and creator at heart, he wanted to be a scholar and a man of letters and was perpetually anguished over what he did for a living, convinced that acting was not serious enough and appealed to the homosexual strain in his nature. Since including Sybil was the only way they could get together off the set, Elizabeth hosted a dinner party at Villa Papa, inviting the Burtons; Robert Wagner; Kurt Frings; and Bob Abrams, an old army friend of Eddie's, now in public relations.

The liquor flowed that evening, gradually becoming a torrent—vodka before dinner, champagne with the meal, followed by "Ivan the Terribles"—a blend of vodka, grappa, and ouzo—in the living room. Richard launched into an anecdote, drawing it out with baroque flourishes as Elizabeth listened in obvious rapture. Then they went over to a small couch for a tête-à-tête, whispering and laughing. Eddie had seen her huddle intimately with gay friends like Roddy, Monty, Tennessee, and Truman, but he felt a *frisson* as he watched her and Richard. "I felt excluded," he recalled. Trying to draw them back into the party, he went to the piano and started performing. "Shut up," Elizabeth said, "we can't talk." Slamming the lid, Eddie went to the hi-fi and played one of his records at high volume. Elizabeth stuck her fingers in her ears. "All right, Elizabeth, we'll go now," said Frings. She ignored Eddie the next day, remaining in her bedroom, but by evening, according to Eddie, she was again "sexy [and] flirtatious."[7] Mike Todd had always been able to charm her with a present, but when Eddie bought her a $50,000 diamond necklace, she looked at it and told him he'd been swindled—there wasn't a decent stone in the lot.[8] Eddie once told Rona Barrett that he hated giving women presents, feeling that he was entitled to "a piece of ass" without having to pay for it.

Roddy was staying with Richard and Sybil. One

evening, he asked Elizabeth and Eddie to join them for dinner. After the meal, at about 9:30 P.M., Eddie started nudging Elizabeth to leave, but she was keyed up and having a good time. Sensing their conflict, Richard slyly exchanged her empty wineglass for his full one, and he kept doing it until she was tipsy. "I absolutely adore this man," she thought. She also liked his wife, later writing, "I admired Sybil tremendously and loved being around her. And Richard and I really fought and hurt each other to keep it from happening." Circumstances seemed to conspire to make their affair not only inevitable but convenient. Sybil divided her time between Rome and London, and Eddie went to Switzerland, purchasing a chalet for them in Gstaad. He was getting fed up with their marriage and later wrote, "She needed a lot of nursing, mollycoddling, support and attention. I couldn't keep on giving that."

At a party hosted by Sybil, Elizabeth and Richard retired to a corner and smooched, apparently not caring who saw them. When Eddie tried to drag her home, she became cantankerous. In the third week of January 1962, Richard walked into the men's makeup trailer at Cinecittà and announced, "Gentlemen, I've just fucked Elizabeth Taylor in the back of my Cadillac." Many coworkers were aware that the lovers were trysting regularly in Dick Hanley's apartment. In Hollywood, Louella O. Parsons reported in a front-page article

that Elizabeth's marriage was in jeopardy. One thousand journalists immediately descended on Cinecittà to confirm the story but Mankiewicz quipped, "Actually, Richard Burton and I are having a fling." Nevertheless Mankiewicz went to Wanger in alarm and told the producer, "Liz and Burton are not just 'playing' Antony and Cleopatra." Wanger's only concern was whether the affair would "help the movie," but he later confronted Richard, who attempted to appease him, saying, "It might just be a once-over-lightly."[9]

At Villa Papa, the Fishers were in bed when Eddie took a telephone call from Bob Abrams. After hanging up, Eddie said, "Tell me the truth. Is there something going on between you and Burton?" Elizabeth softly replied, "Yes." Eddie left the villa and spent the rest of the night with Abrams.

The following day Mankiewicz, fearing that Elizabeth's distraught condition would jeopardize the production, ordered Eddie "to get the hell back" or be "charged with desertion." More than anything else, Eddie's pride was hurt. The womanizer had become a cuckold, and the only way he could stand himself was to raid Elizabeth's Percodan stash. After he swallowed two pills, Elizabeth said, "Eddie, you look like you have a face full of shit."[10]

Richard assured his wife that the affair was over and then went to Wanger and offered to drop out of the picture. The studio could never decide

whether "*le scandale*," as it came to be known, was helping or hurting *Cleopatra*, so Wanger simply advised him to try to be more discreet. Richard then told Sybil that he didn't love Elizabeth, but explained that he had to "play along" with her until Fox had the picture in the can. He complained to his brother Graham Jenkins that he and Elizabeth were being "thrown together." All Elizabeth knew was that Richard represented a way out of the tomb of a dead marriage. Later, she tried to explain in her memoir, "I didn't feel immoral then, though I knew what I was doing, loving Richard, was wrong. I never felt dirty . . . I felt terrible heartache because so many innocent people were involved."[11]

If she was using Richard, he was also using her. Truman Capote observed them at close range and concluded, "She loved him, but he didn't love her. He married her because he wanted to be a movie star. That was the career he wanted—money, money, money." According to Elizabeth, they became obsessive joined-at-the-hip lovers: "We can't bear to be apart, even for a matter of hours. When I'm alone, I can't concentrate on anything." For all his ambivalence, he could be an effective sex partner when reasonably sober and with the right person. Said Sybil, "He gave a lot of pleasure to a lot of people, but couldn't find any for himself." After becoming Elizabeth's lover, he reflected,

"The woman who brings out the best in a man—
who is good in bed—is very rare. In my entire life I
have known only three. The qualities they pos-
sessed were a responding passion and a responding
love."12

Not since Mike Todd had Elizabeth been so
physically and emotionally satisfied. Richard once
explained his technique with women, also reveal-
ing how he tricked himself into the role of great
lover: "You must first love, or *think* you love the
woman . . . the only one you *think* there is for that
moment—you must love her and know her body as
you would think a great musician would orches-
trate a divine theme. You must use everything you
possess—your hands, your fingers, your speech:
seductively, poetically, sometimes brutally, but
always with a demoniacal passion." Obviously he
was as good an actor in bed as on stage, but in both
cases it was acting ("You must first love, or *think*
you love . . . ").13

Eddie, having totally submerged his identity in
Elizabeth, didn't know what to do. As an
appendage that had been severed from the host
body, he could no longer survive on his own. "I put
up with it, because I had no choice," he recalled.
He hung on in the hope that she'd have a brief
fling and come back to him, but she tortured him
daily with accounts of her affair. "She was . . . a bit
of a sadist," he realized. He was a bit of one too: he

started carrying a loaded pistol[14] after friends assured him that the Italian authorities went easy on crimes of passion.[15]

At the same time, he continued to cooperate with Elizabeth in maintaining a semblance of married life. When her old Metro friend Cyd Charisse arrived in Rome to film *Two Weeks in Another Town* with Kirk Douglas, the Fishers went to dinner with Cyd, her husband, Tony Martin; Audrey Hepburn; and Mel Ferrer. At one point Eddie and Tony sang a duet, and someone passed a plate around and gave them a stack of lira. Later they all went to a party given in honor of Kirk and his wife, Ann. Richard and Sybil were there, as was Guilaroff. When Elizabeth and Richard left their spouses to dance together, the excitement in the room was almost palpable. Cyd and Tony glided by them on the dance floor, and Cyd gave Elizabeth "a soft, knowing smile," Guilaroff recalled. Everyone seemed to know what was going on.

Scattered from Wales to Rome, the large, close Jenkins clan had been scolding Richard for endangering his life with Sybil and their daughters. Richard's brother, Ifor, who was hired to be his bodyguard, "beat the living shit out of Burton for what he was doing to Sybil," said a member of the crew, "beat him up so that Richard couldn't work the next day. He had a black eye and a cut cheek." A few nights later Elizabeth brought Richard to

the Villa Papa. They were both drunk, and Eddie sat down with them and started drinking brandy until he was as drunk as they were. Richard spilled his guts, admitting that Elizabeth was of interest to him only as a stepping stone to stardom. She burst into tears and ran from the villa. Suddenly, Eddie realized he didn't care where she was going or what happened to her. Neither did Richard, who decided he wanted to have sex with Eddie.[16]

Having gone to Dick Hanley's apartment, Elizabeth called the villa and Richard answered the phone. "I'm going to fuck him," Richard said. If Eddie raised any objection to being a potential bottom man, he failed to mention it in his detailed account of the episode in his memoir *Been There, Done That*. To Eddie it all seemed "perfectly normal." Eddie does not say that Richard made good on his promise, only that he continued drinking "brandy with her lover" until Roddy and his partner John Valva arrived at 2 A.M. and hauled a reluctant Richard from the villa. Breaking away from them, Burton went to Hanley's apartment and kicked the door in. He called Elizabeth a "cunt," which only made her desire him all the more, but he stormed out and refused to take her calls the next day. Meanwhile, the film's budget shot sky-high, to something like $100 million in 1990s dollars.

Wanger had been pressuring Eddie to leave Rome. Finally fed up, Eddie packed and prepared

to leave, but first he tried to get even with Richard. He paid a visit to Sybil Burton, blowing everybody's cover. "You don't know Elizabeth," he warned Richard's wife. "This time, he's not coming back." Sybil started sobbing and ran from the room, and Eddie beat it out of town, speeding to Milan in the green Rolls-Royce Elizabeth had given him. In Rome, Sybil forced a showdown at Cinecittà, bringing the production to a standstill at a cost of $500,000 to Fox (in inflation-adjusted dollars) and completely freaking out Elizabeth and Richard, both caught totally by surprise. For a moment, it seemed that Eddie's vengeance could not have been sweeter. But then, from Florence, he started calling around Rome trying to find Elizabeth, finally locating her at Hanley's apartment. She bawled Eddie out for snitching to Sybil, and before he could reply Richard grabbed the receiver and said, "You cocksucker, I'm going to come up there and kill you." Eddie was carrying his gun and said, "Stay right there. I'm going to kill you."[17] After hanging up, Richard told Elizabeth that he'd decided he didn't want to destroy his marriage after all. He ended their affair. Running after him, she almost crashed through a glass door.

Richard left for Paris to reshoot his cameo in *The Longest Day* for Darryl F. Zanuck. Sybil joined him. When they dined at Maxim's, Richard reminded a reporter who'd inquired if he was going to marry Elizabeth, "Sybil is my wife, you know.

I'm already married." In Rome, Hanley notified Wanger that Elizabeth wouldn't be reporting for work the next morning, and Wanger noted in his diary, "She's hysterical. Total rejection came sooner than expected."[18] Having been deserted by two men in as many days, she overdosed on Seconals, a prescription sedative, on February 17, 1962, and her stomach was pumped at the Salvator Mundi International Hospital in Rome. Fox publicists devised a food-poisoning story for the press, and the physician in charge, Dr. Pennington, blamed bad oysters. Years later, Elizabeth joined the chorus of denial, trying to explain that "it was more hysteria . . . I needed the rest, I was hysterical, and I needed to get away." Whatever she called it, she nearly died. The OD put her on the cutting edge of drug abuse that was to overrun the movie industry in the 1960s. With Mankiewicz on ups and Elizabeth on downs, *Cleopatra* became the first of the drug-driven movies almost a full decade before *Easy Rider* established cocaine as filmdom's drug of choice.

When Eddie returned to Rome after a few days, Elizabeth told him to bring some beer to the hospital. He found her smoking a cigarette, and she popped open one of the beers as if nothing had happened. To all appearances the Fishers had reconciled, but Eddie expected Richard "to sneak into the house to fuck her" any minute.[19] In Paris, Richard was luxuriating in his new status as Eliza-

beth Taylor's lover. Moguls like Zanuck, who'd previously treated him like a peon, now listened with respect as he held forth on the mess Fox was in and how to salvage *Cleopatra*. "Richard Burton urged me to go to Rome and sit on the set to get Mankiewicz moving and scare hell out of him," Zanuck recalled. Vying with Spyros Skouras for the presidency of Fox, Zanuck wanted to shut the entire studio down and sell it, but Peter Levathes, Skouras's protégé, outranked him as production chief, and Levathes was aware that Skouras had given Mankiewicz and Wanger "carte blanche to make the greatest picture that has ever been made."[20] Richard was inclined to leave Sybil to her own devices and return to Rome. When he heard of Elizabeth's Seconal OD, he gave in to what he called "the pulling power" of Elizabeth and went back to her.

Sybil attempted suicide at their chalet in the Swiss village of Celigny. According to Richard, she took too many pills, but a friend said she "cut her wrists—I saw the scars," and Mike Nichols later noticed "two red razor-blade scars on her left wrist." Nichols, a stand-up comic at the time, had flown to Italy, alarmed by the brutal publicity surrounding Richard and Elizabeth's affair, and eager to help them any way he could. "Richard and I once shared an alley on Broadway," Nichols recalled. "*Camelot* was at the Majestic Theater, and *An Evening with Nichols and May* was at the Golden

Theater. He was a pal, and Elizabeth I was getting to know pretty well." Elizabeth would later reward Nichols by launching him as a movie director. In Rome, Elizabeth and Richard sneaked away each night to an apartment, and at Cinecittà they enjoyed afternoon delight in Casa Taylor. By February 20, *le scandale* was front-page news throughout the Western world. Fox was terrified that everyone would turn against Elizabeth *and* the picture and kept issuing denials. With the studio's future hanging in the balance, the *New York Times* prognosticated, "If Taylor doesn't make it, Fox is lost." Richard told Graham Jenkins that he'd never abandon Sybil, and he collaborated with Fox on a press release denying the affair but later rescinded it, lest it alienate Elizabeth and rob him of his newly won status in films. In the immediate aftermath, everyone, including Eddie, tried to pretend that both marriages were stable.

On February 27, 1962, Elizabeth turned thirty. Years later, after becoming a grandmother, she revealed, "I feared turning thirty more than I fear being called Grandma." Like Marilyn Monroe, she was afraid the world would reject her as her beauty faded. "In the industry, these were the suicide years," recalled Hedy Lamarr, the epitome of early 1940s Metro glamour, who explained that many actresses attempt suicide between thirty and forty because they're worn out by the inhuman working hours of the industry. J. Lewis Bruce, M.D., who

treated Lamarr and many other stars, urged studio chiefs to shorten the workday and eliminate overtime, as in England, and pointed out that no one could "withstand the nervous strain of picture making as it is done today" without psychic injury, especially in films like *Cleopatra*, made under unbearable pressure due to "scripts being written and rewritten as they work."

Sensing that Elizabeth was "scared to death" on her birthday, Eddie threw a champagne party for her in the Borgia Room, a nightclub in the fashionable Hostaria dell'Orso. Richard was not invited but slipped her a $150,000 diamond-and-emerald brooch from Bulgari's. Elizabeth's father, who'd come to Rome with Sara, insisted she return it. She did—and later retrieved it. Eddie gave her a ten-carat yellow diamond ring at the party and later recalled, "I got zip reaction." He saved his other present, a Bulgari folding mirror that opened into an emerald-studded snake, for bedtime, knowing "the sex was always wonderful after I'd given her a gift."[21] That night proved an exception to the rule, and he felt "ignored in the cold darkness."[22]

On March 9, Louella O. Parsons announced "another scandal involving Elizabeth" in her column and speculated whether the world would tolerate the end of the Taylor-Fisher marriage. Skouras rushed to Rome the next day, issuing frantic disclaimers. He scolded Richard but not Eliza-

beth. She threatened to quit if Skouras came near her. Nevertheless she released a public denial of the affair. During a drunken dinner party at Villa Papa on March 15, she told Richard that she loved him in front of Eddie. When Richard asked her to prove it by sticking her tongue down his throat, she obliged, and Eddie stalked from the room. A few nights later, Eddie made love to her as a kind of "farewell kiss" and left for New York, ending their marriage. Oddly, he agreed to deny their separation and to tell the press, if asked, that he'd come to New York on *Cleopatra* business. It made no sense, but neither did Eddie, who washed down Seconal with a couple of drinks as he left for Fumigino Airport.

Eddie, unlike Nicky Hilton, had loved being Mr. Elizabeth Taylor and wasn't quite ready to relinquish the title. In New York he detoxed from Seconal addiction at Gracie Square Hospital, but two days later started shooting up unmixed, undiluted meth. He disgraced himself globally at a wacky press conference in the Sapphire Room of the Pierre Hotel on March 30. Speeding his brains out, he attempted to prove to reporters that he was still Elizabeth's main man, getting her on the long-distance line from Rome. She refused to deny her affair with Richard, or to confirm that Eddie was in Manhattan on *Cleopatra* business. Sheilah Graham later wrote in her column, "In four-letter language she told him where to put their marriage."[23]

There would have been little point in Elizabeth's continuing to prevaricate. With both their spouses gone, she and Richard were flaunting their liaison on the Via Veneto. "Fuck it," Richard said, "let's go out to fucking Alfredo's and have some fucking fettucini." From his Vatican perch not far from Cinecittà, Pope John XXIII denounced *le scandale* as the "caprices of adult children" and scorned Elizabeth for "erotic vagrancy," calling into question her fitness as a mother and hinting that her children should be given to proper parents. The Hollywood establishment again turned against her, and even British friends like Peter O'Toole and David Niven were disloyal. Laurence Olivier cabled Richard, "Make up your mind, dear heart, do you wish to be a household word or a great actor?" But Richard's problem was not Elizabeth, career, or fame, but the bottle. As he put it, he drank to cope with the tensions of being an actor, believing that the need to act came from the homosexual part of his nature. Cavorting as Elizabeth's lover made him feel like a phony, and he took his anger out on her. According to Rex Harrison, they continually hit at each other, causing black eyes and making it impossible for them to appear before the camera.[24] Richard, like Elizabeth's father, exploited her even as he resented her, insanely jealous because her notoriety and income exceeded his own, and because she was part of the great sexual lie he was living.

Olivier was not the only homoerotic mentor

who attempted to sabotage his relationship with Elizabeth. "Philip Burton had a falling out with Richard," Frank Taylor recalled. "Philip disapproved of Richard and Elizabeth and sided with Sybil. There was much *sturm und drang*, and it was many years before that was patched up." The most snide and unwarranted attack came from the closety bisexual Emlyn Williams, who flew from London at his own expense to warn Richard that Elizabeth was "just a third-rate chorus girl." Not until 1973 did Williams reveal his love affair with a twenty-year-old Welsh drifter, Fess Griffith, "this silent boy, with the lithe, smooth body and the amiable smile," with whom he tried to have a ménage à trois after marrying Molly Carus-Wilson.[25] In Rome, Richard shut Williams up by telling him, in Welsh, *"Dwi am broidi'r eneth ma* [I am going to marry this girl]."

She no longer felt safe even on her own turf, Cinecittà, where she'd become the queen of denial, fornicating at work and lying about it to press and coworkers. For days, she lived in fear of assassination by stoning at the hands of the six thousand Catholic extras she faced during the filming of Cleopatra's triumphal entry into Rome, the most expensive scene in motion picture history. Carried by three hundred Nubian slaves, Elizabeth was seated atop a huge, mobile, fifty-foot-high sphinx. Slowly the two-ton prop lumbered beneath the massive Arch of Titus and out into the throng. "Oh

my God," she thought, "here it comes." Instead of stoning her, the extras loved her, throwing kisses and shouting, "*Leez! Leez! Baci! Baci!*" Holding on to a hidden handrail, Elizabeth borrowed the director's bullhorn, smiled at the crowd, and said, "*Grazie, grazie.*" Later she called it "one of the sweetest, wildest moments I've ever had."

Meanwhile, Elizabeth and Richard's respective spouses considered their next moves. Eddie consoled himself with endless shots of speed, and keeping company with Maria Schell,[26] and the friendship of Mafia boss Frank Costello, who offered to break Richard's legs. In a last-ditch effort to retrieve her husband, Sybil Burton returned to Rome at Easter and demanded a meeting, but Richard and Elizabeth had fled to a coastal resort one hundred miles to the north, Porto Santo Stefano, where they drank, according to Richard, "to the point of stupefaction and idiocy." Richard gave Elizabeth a brutal beating that left her with temporarily disfiguring facial contusions. She threatened to kill herself and Richard said, "Go ahead." After she gulped a handful of pills, he loaded a comatose and battered Elizabeth into their Fiat and drove back to Rome like a maniac.[27]

For the second time in four months, the star was hospitalized at Salvator Mundi, having her stomach pumped and remaining in the hospital twenty hours. In a letter to Zanuck, Skouras referred to "the beating Burton gave her in Santo Stefano. She got two black eyes, her nose was out of shape, and

it took twenty-two days for her to recover enough in order to resume filming."[28]

After that, it was easy for Skouras to blame all the studio's troubles on Elizabeth, but the real problem at Fox was the studio's own administrative ineptitude. Although 20th was currently employing the two biggest female stars in the world—Taylor and Monroe—studio executives were so dense and out of touch they couldn't figure out how to make money on either. With Elizabeth giving them grief in Rome and Marilyn skipping work to sing "Happy Birthday" to President Kennedy in New York, Fox finally decided to can Elizabeth, and studio chief Peter Levathes was dispatched to Rome to deliver the coup de grâce. "It began long before I became production chief, and was handled so unprofessionally," he said. "The inmates were running the asylum."

Always shrewd in the crunch, Elizabeth summoned Wanger and Mankiewicz and told them, "We can take over the film and fire Fox." Her lawyers had advised her that technically Levathes couldn't terminate her, and if he were foolish enough to try, she could sue and stall *Cleopatra* for years. Wary of crossing Elizabeth, Fox fired Marilyn instead, and shortly thereafter she was found dead in her apartment in L.A. of a drug overdose.

As corporate convulsions continued to rock Fox, executives convinced themselves that Elizabeth was their only hope of survival. In Rome, an ambu-

lance, complete with stomach pump, was kept on the set in case she tried to commit suicide, a distinct possibility after Richard told her he was going back to Sybil as soon as the film wrapped. The company left Cinecittà to shoot location scenes in Ischia in the summer of 1962. On her last day of filming, Elizabeth stood on Cleopatra's gold barge as it passed in front of a seething mass of extras lining the waterfront at Ischia Ponte. Begun 632 days earlier at Pinewood, *Cleopatra* had become a way of life, taking her from Hollywood to London and Rome, to the brink of death, to the end of a marriage and the beginning of the love of her life. Now that it was over, she didn't know what to do with herself.

In the wake of *Cleopatra*, Fox attempted to pull itself together again. Skouras was kicked upstairs to the board of directors. Zanuck returned to the presidency and shut down all production except *Cleopatra*. Levathes resigned as executive in charge of production and was replaced by Zanuck's son, Richard. Lawsuits proliferated, some of them instigated by those for whom *Cleopatra* had proved a career graveyard: *Wanger v. Fox* for $2.6 million for being terminated (he would settle for $100,000, and he would never produce another film); *Skouras v. Wanger* for mismanagement; *Harrison v. Fox* to get billing equal to Elizabeth and Richard's; and *Taylor v. Fox* for thirty-five percent of the profits.

On June 12, 1963, the film opened in Manhattan to snickers and jeers. Elizabeth received the worst reviews of her life, and the picture fared no better, quickly becoming known as the "Hollywood Edsel." Elizabeth saw it in London and threw up. Fox blanched over the movie's final tally: $62 million, making it the most expensive film ever made. Even decades later, after money-shredders like *Heaven's Gate*, *Ishtar*, *Waterworld*, and *Titanic*, the film still held its title as Hollywood's costliest. *Variety* estimated *Cleopatra's* expense in inflation-adjusted dollars at $300 million, a full $100 million more than *Titanic's* cost. *Cleopatra* would finally break even in 1966, but in 1963 the plodding epic played to yawning, half-full houses throughout the world. The worst of its many failures was the total lack of chemistry between Taylor and Burton. As an acting team they were about as exciting as Ma and Pa Kettle, and considerably less amusing. Elizabeth had been better with almost any of her other costars, including Lassie.

Two weeks after the premiere, Zanuck sued Elizabeth and Richard for $50 million, invoking the studio's morals clause and claiming damages from "the deplorable and amoral conduct of Richard Burton and Elizabeth Taylor."[29] Elizabeth was cited for "suffering herself to be held up to scorn, ridicule, and unfavorable publicity as a result of her conduct and deportment."[30] While Monroe had succumbed under such pressure, Eliza-

beth came out of her corner throwing knockout punches.

Fox sent Darryl Zanuck's son, Richard Zanuck, now vice president in charge of production, and David Brown, the studio's executive in charge of story operations, to confront Elizabeth, but she fired the opening shot when they tried to corner her at the Plaza Athenee Hotel. "Richard, you're a brat, and you always were a brat," she told Zanuck, reminding him that as children, he and Irving Thalberg Jr. had tied her to a beam in Thalberg's basement, with her hands behind her back. "Needless to say," Zanuck recalled, "we did not settle the lawsuit during the course of that meeting."[31]

Fox ended up apologizing to Elizabeth and Richard in public, paying them $2 million, and giving Elizabeth another $1 million to costar with Warren Beatty in *The Only Game in Town*. In one of the immortal malapropisms in film history, Darryl Zanuck, on viewing the final cut of *Cleopatra*, remarked, "If any woman behaved toward me the way Cleopatra treated Antony, I would cut her balls off."

Big talk—but with *Cleopatra*, it was Elizabeth who'd effectively demolished the old studio system and unmanned its moguls.

8

The Burtons:

ONE BRIGHT, SHINING MOMENT

The village of Gstaad lies in the Saane Valley, set among forests, mountains, lakes, and glaciers. Elizabeth's home, Chalet Ariel, a haven of luxury thanks to a $100,000 renovation, was the perfect place for her to regain her equilibrium. Her friend Princess Grace de Monaco also had a home in Gstaad, and eighty-five miles away, in the less fashionable village of Celigny, where he owned an Alpine cottage called Le Pays de Galles (French for Wales), Richard Burton found himself torn between conscience and ambition. The former nagged him to return to his wife and daughters; the latter prompted him to go for Elizabeth, who represented the promise of global superstardom and million-dollar film assignments. It took only a few weeks of soul-searching for him to choose the latter.

By December 7, 1962, Elizabeth and Richard were in London filming *The VIPs* and occupying

adjoining roof-garden penthouses at the Dor-
chester—the Terrace Suite for him and the Harle-
quin Suite for her, with a separate corridor of
rooms for the children and their nannies and Dick
Hanley and his assistants. Though still wed to
Sybil, Richard had already begun talking marriage
to Elizabeth. The film, a love story set during a cri-
sis at a London airport, was completed in eight
weeks, largely because Elizabeth was miffed at
Lloyd's of London for refusing to insure her and
determined to restore her reputation as an employ-
able actress. Their combined earnings from the
film, including percentages, was $3.2 million.
When the movie premiered in New York the fol-
lowing year, it was a commercial success, quickly
outgrossing *Cleopatra*, but audiences as well as crit-
ics once again noted the absence of sparks between
Elizabeth and Richard. He was overwrought in
their scenes together; she seemed emotionally
spent, though still worth the price of admission
just to look at.

While they were living together at the Dorch in
December, his wife and daughters arrived at the
Burton home in Hampstead for Christmas, joined
by Ifor Jenkins and his wife Gwen. "It was neither
one thing nor the other," Elizabeth recalled.
Richard wouldn't leave his family and he wouldn't
give her up. His twelve brothers and sisters all
took Sybil's side, and Sybil confidently announced,
"Richard can never leave me." Equally sure of her-

self, Elizabeth told Graham Jenkins, "Sybil was yesterday," but Richard's favorite sister Cecilia (Cis) James shook her head and muttered, "We all rue the day when he met Elizabeth."[1]

The press reported every development in the battle between wife and mistress. At last deciding to capitalize on the publicity, Sybil moved from Hampstead to a flat in Brompton Square, her first step in becoming a den mother to cafe society. Soon she was the personification of sixties London chic, holding forth at the Ad Lib nightclub, where her set included Princess Margaret, Lord Snowdon, Rex Harrison, Dirk Bogarde, Stanley Baker, and Emlyn Williams. In January 1963, Richard finally met with Sybil in the foyer of the Savoy and told her he wanted a divorce. Sybil left for New York, richer by $1 million, thanks to a divorce settlement that wiped Richard out. The following month he asked Elizabeth to marry him. Eddie was giving her a bad time, threatening to drag her through court. Sinatra called Eddie and said, "Why don't you lay off Liz?" Eddie responded with a threat of his own, saying, "Oh, come on, Frank, you know Elizabeth almost as well as I do." He heard no more from Sinatra.[2]

In New York, Sybil introduced the new Swinging London style, opening the mother of all discos, Arthur, on Manhattan's East Side. She snagged a young lover, Jordan Christopher, twenty-four, leader of Arthur's rock group The Wild Ones. Eliz-

abeth and Richard continued to maintain separate suites at the Dorch, staying in London through the early fall of 1963. Her adopted daughter, Maria, went through three of the five operations required to realign her malformed hip. Professionally, Richard was in such demand that he beat out Laurence Olivier for the lead in the film *Becket*, and Elizabeth made her first TV special, *Elizabeth Taylor in London*, a tour of cultural landmarks, for $250,000, the highest fee for a single TV show ever paid to that time. Aired on CBS in October 1963, her debut was a ratings success, hailed by the *L.A. Times* as "sensitive, poetic, [and] warm," but the script writer, S. J. Perelman, complained that she had "all the histrionic fervor of a broom handle."

Richard introduced her to his London circle, which ranged from nondescript, rugby-obsessed barflies to luminaries such as Sir Terence Rattigan, Welsh actor Stanley Baker, and playwright Robert Bolt, author of *Lawrence of Arabia*. At a dinner party, Elizabeth listened to Richard's theater friends for hours and then confessed, "I know nothing about the theater." Mock-melodramatically, she put her hand to her brow and added, "But I don't need to. I'm a Star." Her modesty and self-mockery won over some of his friends, but others found her tedious, at least when she was sober and babbling about her children. They liked her when she got high and started flirting with everyone.

Upon leaving actor Robert (Tim) Hardy's Chelsea home one night, she begged, "Don't hate me, Tim." Richard always defended her, insisting that she'd given him the secret of effective film acting, which was "absolute stillness . . . My very penetrating voice need not be pitched louder than a telephone conversation."

Melvyn Bragg believed that Burton's decline began with Elizabeth: "He was poisoned by guilt: equally, he was obsessed by one woman who brought out the finest and the most destructive forces in him." True, he was obsessed by Elizabeth, but she cannot be blamed for his decision to desert his wife and children or for bringing out the demon in him, which was alcohol-induced. Long before they met, he was already in the grip of a deadly drinking problem, starting each day with three bloody Marys at breakfast, followed by whiskey and wine at lunch and dinner. By 1963 Graham Jenkins viewed his brother as a full-fledged alcoholic but added that when Richard was feeling good, he could still "engulf you in a marvelous sensation of well-being."

Elizabeth finally browbeat Graham into endorsing her wish to meet the Jenkins clan, though they remained dead set against her. When Richard took her to Wales, she stepped out of their pale gray Daimler and "the gasp of wonder could be heard the length of the valley," Graham recalled. They stayed with his sister Hilda, sleeping in her tiny spare room,

one flight up from the only loo, and the sole luxury Elizabeth requested was a chamber pot under the bed. She followed Richard down narrow streets and into dank pubs where the only subject was rugby, and she sat through a family reunion wedged between argumentative windbags. With warm if calculated handshakes and juicy kisses, she finally captivated his family and friends, successfully negotiating one of the last obstacles to marriage.

After *The VIPs* she wasn't particularly eager to work again, her fascination with Richard eclipsing everything else in her life. Deciding to take a career respite, she deliberately faded into the background in the mid–1960s to let Richard shine. Had she continued to upstage him, their relationship might never have resulted in marriage. In September 1963, they left for Mexico City with the six-year-old Liza Todd for three months. Richard had signed to film Tennessee Williams's *The Night of the Iguana*, playing a defrocked priest escorting a group of women on a tour of Mexico. Directed by John Huston, the film was to be shot on location in Puerto Vallarta, a fishing village three hundred miles north of Acapulco. The two Wilding boys, Michael, eleven, and Christopher, nine, were dispatched to California for schooling, and Maria—Elizabeth's physically challenged daughter—remained in London with a nurse to undergo further medical treatment.

Elizabeth kept Richard and his delectable femi-

nine costars—Ava Gardner, Deborah Kerr, and Sue Lyon—under close surveillance throughout the shoot, most of which took place ten miles south of Puerto Vallarta, in Mismaloya, a fishing hamlet accessible only by boat, where about one hundred Indians lived in thatched huts. While the women in the cast had to wear dowdy costumes for filming, Elizabeth brought seventy-four suitcases full of exotic tropical outfits, including a Mexican-style green-and-white shift worn over a bikini, beaded thongs of turquoise and gold for her feet, and enormous black flowers on her head made from human hair purchased from a Paris couturier. She entertained the cast and crew at lavish parties notable for delicious food and abundant liquor.

On Richard's working days, after spending an hour teaching Liza how to read, Elizabeth dressed and took their rented motor launch, the *Taffy*, to Mismaloya. The film's hotel set had been constructed on a plateau three hundred feet above the Pacific, and Elizabeth climbed every inch of it to bring Richard a hot lunch. "She's seducing me again," he said, taking in her alluring tropical ensemble. He gloried in being, for once, the uncontested star of the movie and not just another member of her entourage, but he remained uneasily aware of his junior status in the relationship. "My sole ambition is to earn as much as Elizabeth and her only ambition is to play Hamlet," he said. Hard-drinking Ava Gardner, the ultimate

femme fatale, whose conquests included Sinatra and Artie Shaw, recognized in Richard a fellow alcoholic, describing him as a "ferocious drinker . . . someone I would've liked to have had for a brother and his teasing manner made me feel at ease." In her memoir, Ava added, "Elizabeth and I were friends from the old Metro days [and] pleased to find each other in the wilderness."[3]

The difficult jungle location had been suggested by Mexican architect Guillermo Wulff. Drawn to the wilderness by the notoriety of the Taylor-Burton affair, 130 journalists converged on Puerto Vallarta and spread the name and beauty of the locale around the globe. Soon it was crawling with tourists. Elizabeth and Richard settled in a section known as "Gringo Gulch." A tiled four-story stucco villa called Casa Kimberley was brought to their attention by Michael Wilding Sr., who, unable to find work as an actor, was now an assistant to Richard's agent Hugh French, and hoping to become a press agent. At fifty-two, he had been reduced to carrying suitcases full of chili con carne to Elizabeth from Chasen's in Beverly Hills. He arranged for her and Richard to rent Casa Kimberley, and they grew to love the sprawling twenty-two-thousand-square-foot compound with its ten bedrooms, eleven baths, three kitchens, and a swimming pool that measured seventeen feet by forty-seven feet. Guillermo Wulff later built another house directly across the narrow street and

joined the two structures with an exact replica of Venice's Bridge of Sighs. Since the compound was close to a garbage dump, locals called it "*la casa de los zopilotes* [the house of the buzzards]." Eventually Richard bought Casa Kimberley for $40,000. Their first home together, it would be their headquarters for the next decade.

The *Iguana* set was a nest of illicit romantic intrigues. Tennessee was cohabiting with his boyfriend, and seventeen-year-old Sue Lyon—fresh from playing the title role in Stanley Kubrick's *Lolita*—had brought along "a tall, pale youth ravaged by love [who] haunted the surrounding flora," according to Huston's biographer, Lawrence Grobel. "Word got about that he was murderously inclined toward both Burton and Skip Ward, who had love scenes with Sue." Deborah Kerr joked that she was the only member of the cast who wasn't shacking up with someone. Zoe Sallis, Huston's mistress and the mother of his son Danny, noticed that Elizabeth and Richard were perpetually pickled on tequila, which invariably touched off fights. Huston presented all five of his stars, Burton, Lyon, Gardner, Kerr, and Skip Ward, as well as Elizabeth, with gold-plated derringers, along with bullets engraved with their names.

The entire company was depressed on November 22, 1963. "We were sitting at a table in the middle of the day," Huston recalled. "The company manager came out of his office and said, 'Our

president is dead.' We were just shocked." Huston made a brief but moving speech. According to Melvyn Bragg, Richard was "liked by the Kennedys; Burton was invited to the White House." *Camelot* had symbolized for JFK "where America wanted to be. In a Kingdom of Grace and Righteousness, surrounded by monsters and dark enemies but triumphing over them all, the Democracy of Good over the Empire of Evil, with a big sword and a song." Earlier in 1963, Kirk Douglas and his publicist Warren Cowan had visited the White House and met Jacqueline Kennedy, who immediately asked, "Warren, do you think Elizabeth Taylor will marry Richard Burton?"

It was still a good question. They were free to marry now that Eddie had accepted a $500,000 settlement, but Richard was not eager to sacrifice his freedom to sample any pretty girl who caught his fancy: Sue Lyon, for example; Eddie Fisher has written that Burton had a fling with Sue, something he learned later when he himself had an affair with her. "She wanted to compare my sexual prowess with Richard Burton's," Fisher wrote.[4] At Casa Kimberley, where Elizabeth and Richard were making a home together for the first time, Richard discovered that Elizabeth's way of life was gratingly unsuitable to his temperament. Around Christmas, her large family descended on Gringo Gulch, including her parents and Howard and Mara and their five children. Elizabeth had all of

her offspring with her now, including Maria, who delighted her by being able to walk down the plane ramp without any assistance. As Edward Dmytryk said in 1998, "Elizabeth is the only one I know who adopted a cripple so she could make her well—little Maria. It required many surgeries." In addition, there was Dick Hanley and the rest of the entourage, as well as the usual menagerie of animals. Soon Richard could endure it no longer and repaired to the relative peace and quiet of various cantinas, where he recited Dylan Thomas, Lorca, and Shakespeare to anyone who would listen and confessed to an American tourist, "You understand I have to get out of the clutter of my house."

In frustration, he called Elizabeth "you scurrilous low creature," driving her to tears.[5] When he sobered up, he apologized, wallowing in abject remorse, and she forgave him. He was still plagued by vocational uncertainty, and she encouraged his high-flown ambitions to renounce show business and become a writer and teacher. On his thirty-eighth birthday, November 10, 1963, she'd given him a library of calfskin-bound classics valued at $35,000.[6] She encouraged his friendship with Oxford professor Nevill Coghill, who replaced Philip Burton as Richard's literary mentor after Philip annoyed Richard by bragging to the press that he'd discovered him. According to Graham Jenkins, Philip was "inflating his reputation as a talent spotter . . . to boost his own flagging career."

Often Richard retired to his writing hideaway upstairs and filled page after page with everything that popped into his mind. While drinking steadily, he composed lengthy accounts of his life with Elizabeth, his reading, his friends, politics, gossip, films, and rambling anecdotes, eventually amassing 350,000 words. When he at last published a book, *A Christmas Story*, he compared Elizabeth with his beloved sister Cis James, about whom he wrote, "She felt all tragedies except her own . . . It wasn't until thirty years later, when I saw her in another woman, that I realized I had been searching for her all my life." He also published a fictional version of his and Elizabeth's romance called *Meeting Mrs. Jenkins*. Elizabeth herself caught the writing bug and put together a self-serving memoir, *Elizabeth Taylor*, with *Life* staffer Richard Meryman, based on garrulous and diffuse tape recordings. Harper and Row gave her a $250,000 advance (the nineties equivalent of $1 million), but neither Elizabeth nor Burton emerged as a writer of substance. In Mexico, when her family cleared out, they drew closer as a couple, and there were times when she felt totally fulfilled. "He is the ocean," she said. "He is the sunset . . . He is such a vast person."

According to Graham Jenkins, it was at Casa Kimberley that Richard went beyond infatuation with Elizabeth and experienced the "full blossoming of love," finding "a sense of contentment he

had never known before." That of course depended on when you saw them and how much they'd been drinking. When Stephen Birmingham, author of the best-selling *Our Crowd*, visited Ava on the *Iguana* set, he noticed that Elizabeth was urging Richard to drink, despite his obvious alcoholism.[7] But no one denied she was often a source of strength, especially when Richard finally realized that he didn't have the right stuff to be a writer. She encouraged him once more to resume his ambition to be the world's leading Shakespearean actor and to assay the role of Hamlet on Broadway. He agreed, but not entirely wholeheartedly, for his true ambition was to top her by making $2 million a picture. "I've always believed that a husband should have a larger pay packet than his wife," he said, betraying his boneheaded sexism.

Since the Burtons were still the hottest celebrity news item in the world, everyone wanted to put money in Richard's *Hamlet*. The show was quickly financed and set for a Broadway opening in April 1964. Michael Jr., Christopher, and Liza stayed with their nanny in a bungalow at the Beverly Hills Hotel, and Maria was with Sara and Francis in West L.A. On January 28, Elizabeth and Richard left for Toronto for his *Hamlet* rehearsals. Her peregrinations had never been more constant or intense than they would be in 1964, a year marked by separations from her children as she followed Richard.

He'd played the Prince of Denmark with such authority at the Old Vic in 1953–1954 under Michael Benthall's direction, with Claire Bloom as Ophelia, and with Philip Burton supplying behind-the-scenes textual interpretations, that Winston Churchill had come to his dressing room and addressed Richard as "My Lord Hamlet." Now, ten years later, under the ineffectual direction of the patronizing John Gielgud, Richard floundered around in the role, trying various interpretations, including a homosexual Hamlet. Elizabeth saw failure on the horizon.

Interviewed in 1999, Richard's standby, Robert Burr, recalled, "There was a party every night, with so much money around this production. I was standing alone on a Sunday night when I saw Elizabeth circling the room. We'd never met before, and when she saw I was by myself, she came over and stood next to me. 'Are you having fun?' I asked, and she said, 'I'm so tired.' I told her, 'Why don't you go home and go to bed?'" That established the character of their relationship, and thereafter she knew she could count on a straight answer from Richard's ruggedly handsome, blue-eyed standby. She was less civil to Burr's blond, blue-eyed wife, Jacqueline, who recalled, "Richard liked women and was always nice to me. Elizabeth acted like a silly jealous teenager."

During the early part of the Toronto run, Richard still wasn't clicking with the audience.

Elizabeth knew that Philip Burton was the one drama coach he trusted, and despite Philip's disapproval of *le scandale*, she phoned him on February 2, 1964, begging him to come to Toronto. He said he'd need to check with Sybil. "Of course you must go," Sybil told him, "he needs you." When Philip arrived in Toronto, Elizabeth took him directly to the theater. Richard's only problem was that he badly needed to have his confidence restored, which Philip accomplished with a few supportive remarks. The next performance of *Hamlet* caught fire, the entire cast sparked by Richard's dash, driving attack, and verve.

Elizabeth pampered the cast, rounding them up after performances and inviting them up to the "Royal Suite" for champagne and theater talk, often staking them to dinner. William Redfield, who played Guildenstern, admired her "modesty, self-effacement, [and] softness." But the Toronto audiences hated her. She was hissed so viciously at the beginning of a February performance that Richard estimated the incident added twenty-eight minutes to the playing time. It was her thirty-second birthday, and she was damned if she'd let anyone intimidate her, remaining until final curtain. Richard punished his worshipful audience for their rudeness to Elizabeth by refusing to take more than two curtain calls.

They were finally married in Montreal on March 15, 1964. It was her fifth trip to the altar in a little

over a dozen years. Oscar Levant, a faithful friend throughout her marriages to Hilton, Wilding, Todd, and Fisher, quipped, "Always a bride, never a bridesmaid," and christened Elizabeth "the other woman of the year." The wedding party of ten, flown in by private jet, included her parents, Hugh French, and Hume Cronyn, *Hamlet*'s Polonius. Richard started drinking at 10 A.M. and was unsteady on his feet by the time of the civil ceremony at the Mexican embassy. Elizabeth kept them all waiting, and Richard grumbled, "She'll be late for the last bloody judgment." When she arrived, she looked at him and said, "I don't know why he's so nervous. We've been sleeping together for two years." Her yellow chiffon Irene Sharaff décolleté gown was based on the costume she'd worn in her first scene with Richard in *Cleopatra*; her hairdo, augmented by $600 worth of thirty-four-inch falls, had Roman hyacinths woven through it; and she wore the diamond necklace and matching diamond-and-emerald drop earrings Richard had given her. In his new suit, he stood next to his best man, Bob Wilson, his black dresser. The thirty-two-year-old Jewish bride and the thirty-eight-year-old Presbyterian groom exchanged their vows in front of a Unitarian Church of the Messiah pastor, Reverend Leonard Mason, the only member of the clergy willing to associate himself with a couple who, between them, had wrecked three families.

At a subsequent performance of *Hamlet*, Richard announced from the stage, "Some of you have come to see Alfred Drake, some have come to see Eileen Herlie, some have come to see Hume Cronyn, and some have come to see Elizabeth Taylor. For the first time on any stage, Elizabeth Taylor will be here to see you." It took several crew members to push her from the wings, and then she stood on the apron baffled and blushing, paralyzed by stage fright. Suddenly the audience exploded in the kind of sustained, orgiastic cheering only heard at football games or boxing matches—marking the beginning of her love affair with the legitimate theater. She knew Richard was using her to draw standing-room-only crowds, but she made it clear to producer Alexander Cohen that her support must never be taken for granted. One evening, when Cohen called for her a quarter of an hour before curtain, she was enjoying a TV rerun of Roddy's *How Green Was My Valley*. "Do you think you might dress?" Cohen inquired. "Not before the movie's over," she said. Knowing that she was the production's most valuable asset, though an unbilled and unsalaried one, the producer sat down and waited.

When the play opened at the Lunt-Fontanne in New York in April 1964, police had to block off the street as thousands of the curious surged in from Times Square to catch a glimpse of the Burtons. "Why?" Richard asked Truman Capote, and

Elizabeth said, "Because they're sex maniacs, and we're sinners and freaks." Sinatra told them that the bobbysoxers' siege of the Paramount during his forties heyday was nothing compared with the bedlam at the Lunt-Fontanne when Elizabeth, resplendent in diamonds, arrived. She'd sent Monty opening-night tickets. When he spotted her in the orchestra, he yelled, "Bessie Mae! Bessie Mae!" She stared in shock at his ravaged figure but stood up and hugged him warmly, inviting him to the cast party hosted by Alexander Cohen at the Rainbow Room.

The *New York Herald-Tribune* critic, Walter Kerr, called Richard "one of the most magnificently equipped actors living," but added a reservation: "His passion is always a *way* of doing passion, not passion proper, passion unpremeditated." Richard later admitted to the *New Yorker*'s Kenneth Tynan, "I played it absolutely as myself" (that is, Richard Burton playing Richard Burton playing Hamlet). That satisfied most of the critics, who were bowled over by the sheer force of Richard's energy, using superlatives such as "electrical," "bold," "virile," and "unprecedented" to describe his performance, but not the distinguished Harold Clurman, who walked out. "This is an actor who has lost interest in his profession," wrote Clurman.

During the run of the play Richard let Robert Burr substitute for him twice, telling him, "They won't have to change the marquee much, will

they?" Elizabeth's chilly relationship with Burr's wife, Jacqueline, eventually blossomed into friendship. "She went from being jealous to being maternal toward me," Jacqueline recalled. "Richard invited us to dinner at Sardi's, and Elizabeth was snippy and nasty with me at first. I ignored her. Later I mentioned that I had a tragic situation with one of my children and described how I intended to deal with it. My son as an infant had cancer of the retina. This was pre-laser, and his eye had to be removed. I thought I must protect him from playing tennis so the ball wouldn't hit his eye. I told them, 'He's a tough, masculine, good-looking kid, but I'm going to protect him from injury.' Elizabeth said, 'No, no, don't do that.' Suddenly she began to talk to me one-on-one, changing from black to white. She had been through physical pain and understood, talking common sense to me. I took her advice—did whatever I could, for example, to get him to wear sunglasses when driving in an open car—and was never sorry I'd listened to her suggestion that I let him live his own life. He's wonderful today.

"After that, Elizabeth and I spent some time together. We were to be photographed at the World's Fair in Flushing Meadows. I told her, 'I perspire on my head—my hair looks terrible.' She said, 'Oh, wear a hat, dear.' I told her I didn't have one. 'Well, you come with me,' she said. In her room, I'd never seen such a wardrobe, and she

picked out a white Belgian lace hat and wouldn't let me return it. She was always sending us champagne."

Running concurrently in New York with Burton's *Hamlet* was Joseph Papp's *Hamlet*, starring Alfred Ryder, in the highly regarded "Shakespeare in the Park" repertory at the Delacorte Theater in Central Park. When Ryder left the production Robert Burr was offered the role, and Richard magnanimously told his standby, "Any actor who gets a chance to play Hamlet must grab it." Burr received excellent reviews, as did Julie Harris as Ophelia and Stacey Keach as Horatio. "Though Richard was playing Hamlet the same night, Elizabeth told me she wanted to see Robert's Hamlet with me," Jackie said. "If you had a date with her, she took care of everything. Dick Hanley called and said, 'About this theater thing—the chauffeur will pick you up—' 'No,' I said, 'I'll meet Elizabeth at the theater.' Hanley said, 'Because of security, they don't like to do it that way. Can you do it our way?' I told him okay, and later the chauffeur took me to their hotel. She didn't have very good clothes then; like a kid, she put on outfits that didn't work. I was in a black dress and matching coat. Richard saw Elizabeth and said, 'See, I told you that's what to wear.' She ended up in black like me. When he dressed her she looked right. Roddy McDowall joined us and we left for the park.

"The security the Burtons required in those days

was like a head of state's. As the chauffeur drove us through the park, cops were stationed everywhere along the road for her. 'Okay, go ahead,'" one would say, and then a little later we'd stop again and another one would tell us it was all right to proceed. After we were seated and the play began, Elizabeth turned to me and said, 'Oh, Bob's good.' During the break she wanted to go to the john, but I told her, 'I'll take you to the actresses' dressing room.' Nan Martin, who was playing Gertrude, dropped her costume and her mouth flew open when Elizabeth entered. After Richard finished that night on Broadway, and Robert finished in the park, we all met at their hotel and partied. At closing time in the bar the maître d' said, 'This is the last drink.' Richard said, 'No, it isn't.' He was boss in the hotel but did it with great style." When the reviews came in that night, Burr was a hit as *Hamlet*, Lewis Funke of the *New York Times* calling him "a pleasure to behold and to hear, full of vigor and virility."

Elizabeth invited Monty to dinner at the Regency, and he reciprocated by asking her to his brownstone. Monty hadn't worked for three and a half years, largely out of choice, but also because he was uninsurable. Eager to help, Elizabeth suggested starring together in a film, adding that Richard would have to be included. Monty thought she vastly overestimated Richard's talent. He was nothing but a "reciter," Monty said, and

his Hamlet was "phony." Nevertheless, Elizabeth was determined to help Monty engineer a comeback. "If you ever get into Elizabeth's small circle of friends," said Rex Kennamer, "you always stay there."

She told Monty she'd been sent the script of *The Owl and the Pussycat* and reminded him they'd always wanted to do a comedy together. He agreed to read the script aloud with her, but in the end Seven Arts refused to insure him. "If he doesn't work soon he'll die," she told Richard, who suggested that he, Elizabeth, and Monty star together in a remake of the 1947 Gregory Peck–Joan Bennett–Robert Preston film, *The Macomber Affair*, but Monty still hated the prospect of working with Richard. This created complications when Elizabeth finally succeeded in finding a suitable vehicle, Carson McCullers's *Reflections in a Golden Eye,* which Ray Stark had first brought to her attention on the set of *Iguana*. McCullers's story of a boisterous, buxom woman married to a latent homosexual seemed a perfect property for her and Monty, and she told Stark she'd insure Monty herself, putting up her $1 million salary as bond. Since her contracts now stipulated that she and Richard were never to be more than half an hour's drive apart, she insisted that Richard costar and also direct. Elizabeth, Richard, and Monty shared a late dinner at Dinty Moore's after a performance of *Hamlet*, and Richard, with a wry smile, said, "Monty, Eliza-

beth likes me, but she loves you." Referring to Elizabeth's tracheotomy, ulcerated eye, ruptured spinal disc, phlebitis, and bronchitis, Monty said, "Bessie Mae is the only person I know who has more wrong with her than I have. Tragedies are not cathartic. They make life more mysterious." They continued to talk about *Reflections*, but actual filming would not begin for another two years.

Before her marriage to Richard, Elizabeth's children had never gone to her husbands with their problems. "Now . . . they're absolutely certain that Richard and I will always be married," she said. He played with them as if he were their age, acting out all the Shakespearean plays, taking all the parts, and the children sat mesmerized until the end and then asked him to do another play. They all loved living at the Regency, where the staff coddled Elizabeth after Richard warned Jacques Camus, the manager, "If you want to get along with my wife, say yes to everything she wants." At three o'clock one morning, she asked room service for "cheesecake from Lindy's." Room service advised her they didn't have any such item, but she insisted, "I must have it." Roused from bed, Camus got dressed and went to the kitchen. "I took our own cheesecake out of the ice box and brought it up to her, and said it was from Lindy's," he recalled. "It cost her $50 and all she ate was a tiny sliver."[8]

Richard did not permit *Hamlet* to interfere with his drinking, according to Graham Jenkins, who

watched him down four martinis before going on stage, "and these were just a top-up on the day's intake." On May 6, 1964, he was booed for blowing the "play's the thing" speech, and when he returned to the Regency expecting sympathy from Elizabeth, who was watching a Peter Sellers movie on TV, she told him, "It's just some idiot . . . Don't be silly." He kicked in the TV set, cutting his foot to the bone, and limped through the next few performances. Eddie Fisher visited them at the Regency, and they all decided to bury the hatchet. A few nights later at the Copacabana, Eddie was furious when he was consigned to the balcony, while the Burtons, who arrived fifteen minutes after Sammy Davis Jr. started his act, were shown to a ringside table hastily set up for them. Eddie's date was Pamela Turnure, Jacqueline Kennedy's press secretary, and his party included Sam Giancana, Walter Wanger, Mike Todd Jr., and Jennie Grossinger. Miss Turnure wanted to marry Eddie, but she did the one thing he "really couldn't handle," he said. "She fell in love with me."

In June 1964, Elizabeth made her stage debut in New York, reading poetry and prose selections at a fund-raiser, *World Enough and Time*, at the Lunt-Fontanne for Philip Burton's school, the American Musical and Dramatic Academy. She came on stage wearing a white Grecian pleated gown and emerald-and-diamond earrings, a spray of white flowers holding back her hair, and ner-

vously surveyed a celebrity-studded audience that included Mayor John Lindsay, Patricia Kennedy Lawford, Myrna Loy, Anita Loos, and Lady Peel (Beatrice Lillie). She knew they'd come to "see me fall flat on my face," she remembered. At first she fumbled lines and sweated through her silk jersey dress, but when Richard quipped, "This is funnier than *Hamlet*," a sudden rush of adrenaline restored her audacity, and the recital took on such power that Bea Lillie, during intermission, shouted to Carol Channing, "If she doesn't get worse soon, they'll be leaving." The next day, *Variety* lauded Elizabeth's "undeniable charm."[9]

The episode inspired her to resume her movie career. She was second choice for *The Sandpiper*, a hippie love story set in Big Sur. The property had been designed for Kim Novak by producer Martin Ransohoff, but their relationship ran into trouble and she was out of the picture. The role of Laura Reynolds, a painter, went to Elizabeth, and Richard was cast as the married Episcopal minister Laura falls in love with. Ransohoff handed them a list of directors to choose from, including William Wyler, but Elizabeth preferred Vincente Minnelli. The director flew to New York to be interviewed by the Burtons. Though he thought Ransohoff's story "ludicrous and dated," Minnelli wanted the job, knowing that the Burtons could now assure the success of any venture they undertook.[10]

Though set in the California wilderness, much

of the film had to be shot in Paris because the Burtons could work only four weeks in the United States and not at all in England due to tax considerations. Elizabeth's salary was $1 million, but she was uninsurable and had to pay her own $180,000 premium. Her eleven-year-old son Michael was given the opportunity to play her son in the film, but she wouldn't let him do it, explaining, "An ex-child actress in the family is enough—too much maybe."[11] The role went to Morgan Mason, son of James and Pamela Mason, who evidently was not damaged by the experience, since he grew up to become deputy protocol chief in the Reagan White House and later a successful Hollywood executive.[12]

After a month of filming in Big Sur, the *Sandpiper* company left for the Boulogne-Billancourt studios in Paris in October 1964. Such was Elizabeth's fame that customs officials merely kissed her hand and waved her through. "They enjoyed their fame enormously," said Colin Donnarumma, who was interviewed in 1999 aboard the *Queen Elizabeth 2*, where he works as assistant restaurant manager in the first-class Queen's Grill. Donnarumma served the Burtons on the ship's distinguished predecessor, the *Queen Elizabeth*, and recalled, "They immediately held a press conference on board." The Burtons took over all the ocean liner's six first-class suites save one, which was occupied by Debbie Reynolds and her latest husband Harry

Karl, whose family had been in shoe manufactur-
ing. "Well, isn't this the silliest," Elizabeth gig-
gled on seeing Debbie, who chirped, "It's just
totally ridiculous." Over cocktails, Elizabeth pro-
posed a Dom Perignon toast, telling Debbie, "Just
look how you lucked out, and how I lucked out.
Who the hell cares about Eddie?" Debbie's mar-
riage lasted until 1975, when she divorced Karl for
sleeping around and gambling away all her
money.[13]

In Paris, the Burtons checked into the Lancaster
Hotel and were later joined by Michael, eleven;
Christopher, nine; Liza, six, and Maria, four. "Their
lives have been up and down," Elizabeth recalled.
"We've lived like gypsies." Hardly. They occupied
twenty-one rooms in the Lancaster at a cost of
$10,000 a week, including room service. The
entourage of eleven included Bea, the governess;
the children's tutor; Dick Hanley; Richard's assis-
tant John Lee; chauffeur Gaston Sanz; and Maria's
nurse. According to the tutor, the children lived on
a different floor, and Elizabeth and Richard didn't
see them for weeks at a time. Periodically, they'd
receive the children for an hour's audience, and Bea
would dress them up like model kids. In her seven-
ties, the crotchety governess beat them when they
defied her, and Mike Jr. understandably was turn-
ing into a rebel.

The Burtons never bothered to make restaurant
reservations in Paris, even at Maxim's, often bring-

ing their dogs and expecting them to be fed as well. At Boulogne-sur-Seine, Metro assigned them quarters almost the size of a hotel, as well as a Rolls-Royce and a driver. When the studio hosted a cocktail party at the Georges Cinq, fans mobbed Elizabeth in the lobby, and Denise and Vincente Minnelli were terrified of being killed in the crush of more than one hundred photographers. Richard's strength and fearlessness came in handy. In his youth, he'd achieved varsity status in his Welsh school as a rugby football champion and captain of cricket. At the George Cinq he grabbed Elizabeth and the Minnellis and blocked, shoved, and tackled until he had them safely in a small office, where they were able to enjoy their drinks in peace before proceeding to the ballroom for the party.

Though physically strong, Richard lacked the confidence to accept Elizabeth for what she was, the most famous woman in the world. As they filmed at Boulogne-sur-Seine, their coworkers accorded her a deference he would never receive, no matter how hard he tried to outshine her. He became furious at an opening at the Lido when photographers leaned on him to grab shots of her, ignoring everyone else at their table, including Maria Callas, Aristotle Onassis, and the Minnellis. He was in such a rotten mood by the time they vacationed in Amalfi, Elizabeth tossed his clothes out the hotel window.[14]

In December, while in Switzerland, they visited Noel Coward at Château D'Oex. "Christmas is at

our throats again," the witty playwright observed in his diary, adding that Elizabeth, "engagingly thrilled" with a diamond ring Richard had given her, was "a girl anxious for us all to share her enjoyment, to try it on for ourselves and make the facets catch the light."

She had not been seen on the screen for two years. When *Sandpiper* opened at the Radio City Music Hall in 1965, her fans stormed the box office, breaking all-time records at the legendary Manhattan showplace—and making a top ten hit out of its theme song, "The Shadow of Your Smile." Richard's association with Elizabeth at last lifted his movie career out of the doldrums. He'd made twenty films in seventeen years, but it took *Sandpiper* to boost him into the select company of the top ten box-office stars. Somewhat ominously, Elizabeth trailed at number eleven.

He didn't include her in his next project. After they'd scored three critical duds as an acting couple, Richard temporarily dropped Elizabeth as his partner and attempted to redeem himself artistically by teaming up with his Old Vic Ophelia and sometime mistress, Claire Bloom, in *The Spy Who Came In from the Cold*. According to Bloom, Elizabeth "offered to play the part of the innocuous librarian herself, but the appearance of a star of her magnitude would have unbalanced the stark tone of the film. She settled for feeling extremely uncomfortable having me around."

Protecting her interests, Elizabeth accompanied Richard on February 9, 1965, to Dublin, where director Martin Ritt made the film at the Ardmore studio. Paramount paid Richard $750,000, but he was not happy working with Ritt, who disapproved of Richard's heavy drinking. Interviewed in 1999, *Show* magazine writer Jerry O'Connell said Elizabeth was often sloshed on brandy and champagne, and he also recalled a flirtation between Richard and Marya Mannes, the tall, attractive American talk-show personality and arts reviewer for the *Reporter* magazine, who spent a day interviewing Richard for *McCall's*. "Richard said Elizabeth was insanely jealous of him when she drank," Mannes said. "He liked 'statuesque' women like me, he said, adding that I looked elegant in my gray slacks, red silk blouse, and highland cap. 'You're the kind of tough-minded intelligent woman I enjoy talking and drinking with,' he told me. He left the *Spy* set and we spent the day bar-hopping. I'm no mean drinker myself, and we ended up at a romantic pub down the coast. I found Richard so dangerous and bawdy that I completely forgot to take notes for my article. When we returned to Dublin, he escorted me to the Anna Livia shop, a chic boutique, and insisted on buying me a long Irish-wool scarf."

The Burtons took over the top floor of the Gresham Hotel. They'd brought along a young man from Princeton, having found him in Switzerland, to teach their children. He was a draft dodger on

his way to Canada. The children hadn't gone to school at regular places and had a "noneducation," so he had to teach them all at different levels. A charmer and a drinker, the tutor appealed to the Burtons. Elizabeth and Richard became regulars at restaurateur Peter Parry's popular Soup Bowl restaurant, located in a townhouse in a cul-de-sac called Molesworth Place. The menu included game birds of the British Isles—widgeon, quail, and teal—and there was an impressive wine cellar. Sinatra and Laurence Harvey, Elizabeth's *Butterfield 8* costar, were often there, but Harvey's wicked tongue finally got him banned from the Soup Bowl.

On March 12, Francis Taylor barely survived a cerebral hemorrhage. Elizabeth flew to L.A. to be with her mother and brother at Francis's bedside at Cedars of Lebanon Hospital. "What can I do," she told reporters, "except pray?"[15] Francis, who was sixty-five, would never fully recover, and Elizabeth returned to Ireland. The rivalry between Elizabeth and the smug, vengeful Bloom spoiled everyone's fun during the tense shoot. When Richard complained that his dialogue lacked "balls," Ritt sent for author John le Carré, who came from Vienna to punch up the script. Over a pub lunch, Richard told le Carré, "I wish none of it had ever happened, Elizabeth is more famous than the Queen." Le Carré saw fights break out between Elizabeth and Richard in restaurants.

She refused to attend any social event to which Bloom was invited, but one night the two actresses somehow ended up together in the Burtons' suite, where Richard and le Carré were trying to top each other with witty stories. "Whether this—coupled with the fact that she was not the center of attention—triggered the lady's annoyance, I don't know," Bloom said. "But she left the table and went to her room, unremarked by her husband." Later, using the intercom, she ordered Richard to come to bed. He ignored her, and she started buzzing him at five-minute intervals. "Then Taylor appeared, like some spirit of vengeance, and a shouting match began," Bloom added.

In le Carré's recollection, Richard went into the bedroom to get Elizabeth "and they had a mother and father of a row. Sounds of slapping . . . Eventually she arrived in the sort of fluffy wrap-around dressing gown you send away for, barefooted, rather broad-arsed, but extremely cuddly . . . And she gave me one of those little-girl handshakes, 'How'd you do?' and left! Burton was wonderfully embarrassed: 'Do you mind? Elizabeth is, I think, not feeling . . .'" In Bloom's estimation, the evening was ruined, and she and le Carré quickly left.[16]

Like many couples in the throes of marital discord, the Burtons hoped that having a child of their own would strengthen the union. While in Dublin, Elizabeth went into the hospital for an

operation that might enable her to get pregnant. Richard spent the day in a pub, flirting with every girl in sight, beginning with the waitresses. Elizabeth emerged from surgery still unable to bear children. Though she was besotted by Richard, he seemed trapped in a "terrible melancholy . . . a permanent anxiety," according to a Dublin writer friend, Frank Delaney.[17]

When *The Spy Who Came In from the Cold* was released, many called it the best Burton film ever. He received his fourth Oscar nomination but lost to Lee Marvin for *Cat Ballou*. After four nominations in a row in the late 1950s, Elizabeth hadn't been cited by the Academy in five years, but she was about to make a comeback. *Who's Afraid of Virginia Woolf?*, Edward Albee's closety gay play, was attacked by some critics as being more about homosexual relationships than heterosexual ones. Resuming their career as a husband-and-wife acting team, Elizabeth and Richard would, in a sense, be playing in drag. They were well-paid to do so, Elizabeth holding out for a deal that brought them a total of $4 million. She had director approval and made a choice that was both daring and wise. Thirty-four-year-old cabaret entertainer Mike Nichols, who'd befriended her in Rome during *le scandale*, would give her the best direction she'd received since George Stevens. Throughout location filming on the campus of Smith College in Northampton, Massachusetts, and at Warner Bros.

Burbank lot in late 1965, a resentful Richard complained that Nichols worked too slowly, but what he really minded was the extra time the director spent helping Elizabeth create and sustain a top-flight performance. Many of those who worked with them realized the couple were playing out their own conflicts in the coruscating domestic tragicomedy of George and Martha. In both cases, marriage had become a combat zone. Elizabeth seemed to be surviving the flak better than Richard, according to Nichols, who said, "She was wearing him down."

The film opened in June 1966 to an almost unprecedented blast of controversy and acclaim. Warner bravely breached the censorship code and retained Albee's raw dialogue, appending a note to advertisements: "No one under 18 to be admitted unless accompanied by an adult," which marked the first time that a film with top actors had been so designated, paving the way for other movie makers to produce films of integrity, true to the way people actually talk and behave. Filming *The Taming of the Shrew* in Italy, the Burtons missed the world premiere at the Pantages Theater, which was such a hot ticket that not even Rock Hudson could get in. As kleig lights strafed the skies over Hollywood Boulevard, three thousand fans watched the arrival of Nichols, Jack Warner, Merle Oberon, Jonathan Winters, Pat Boone, and Julie Andrews.

Inside the 1,512-seat theater, from the moment

of Elizabeth's grand-slamming entrance on screen, a stunned hush fell over the audience. Speaking in a resonant contralto Nichols had somehow elicited from her, Elizabeth said, "What a dump," delivering Bette Davis's high-camp line from *Beyond the Forest*. As the reels spun out that night at the Pantages—from "Get the Guests" to "Hump the Hostess"—*Who's Afraid of Virginia Woolf?* set new movie standards in candor, spelling the end of old-fashioned Hollywood censorship. Stanley Kauffmann of the *New York Times* saluted "one of the most scathingly honest American films ever made" and credited Elizabeth for "the best work of her career." In a shower of top acting honors, she received the prestigious New York Film Critics Circle award, the National Board of Review award, and the British Film Academy's award as best actress of the year. She sent Brando, who'd been using her Gstaad chalet, to pick up her New York Critics award, and the actor used the occasion to excoriate the reviewers for having taken so long to acknowledge Elizabeth's talent. Then he flew to Elizabeth's overseas location and personally presented the award to her.

Movie insiders began to predict that both the Burtons would win Oscars, but Richard was pessimistic after Paul Scofield won the New York Critics award for *A Man for All Seasons*. On February 20, 1967, Elizabeth received her fifth Oscar nomination and Richard his fifth, both for their

work in the Albee film. Many felt she had the Oscar sewed up because, at thirty-five, she'd deglamorized herself to play the fifty-two-year-old Martha, following the trend set by Oscar-winners like Olivia de Havilland, who'd downplayed her beauty in *The Heiress*, and Grace Kelly, who'd worn glasses and drab housedresses in *The Country Girl*. The annual presentation ceremony was held on April 10 at the Santa Monica Civic Auditorium, with Bob Hope again emceeing. According to publicist John Springer, Elizabeth felt "the Academy Award was the most important thing in the world to her," but Richard was afraid of losing and persuaded her not to attend. When Elizabeth advised Jack Warner that she wasn't going, he warned her, "Do not burn the bridges you have built." She then asked Richard to reconsider. "It's for the industry," she said. Irritated, he told friends, "There's no guarantee she'll win. She could fly all that way and lose." When she showed him the telegram Warner had sent, Richard said, "Piss on him."

During the Oscar telecast, Hope made a joke at Elizabeth's expense, saying, "Leaving Richard alone in Paris is rather like leaving Jackie Gleason locked in a deli." Richard lost out to Scofield, but Elizabeth was victorious, scoring her second Oscar. In her absence Anne Bancroft accepted. "It must be nice to have enough talent just to send for one," quipped Hope, diminishing the importance of

Elizabeth's victory. A congratulatory call was put through to her, but she began cursing the minute she heard Richard had lost. For the first time in Oscar history, a winning actress refused to give a press statement. Never at a loss for words, Richard said he'd lost because Hollywood would never forgive him for marrying Elizabeth, but according to Oscar historian Anthony Holden, Richard was snubbed because he'd antagonized most of the men in Hollywood by sleeping with their wives.

Unfortunately, Elizabeth's second Oscar was the kiss of death for her career as a serious actress. Typecasting herself as Martha, she played Albee's loudmouthed harridan over and over in many of her succeeding movies. Jack Warner had been right: she'd burned her bridges, and she'd never again turn in a distinguished performance. After *Who's Afraid of Virginia Woolf?* she wasted herself in Richard's amateur production of Christopher Marlowe's *Doctor Faustus*, which he staged as a favor to his friend Nevill Coghill at Oxford. "University drama at its worst," scolded Irving Wardle of the *Times*, but Richard insisted on filming the wretched production and releasing it for commercial distribution.

Critics jeered the Burtons as the worst act in show business, but they stubbornly continued to work as an acting team. On July 22, 1966, while they were filming *The Taming of the Shrew* at Dino de Laurentiis's new studio in Rome, Elizabeth re-

ceived an urgent call from New York. It was about Monty, who'd been preparing to join her in Rome to film *Reflections in a Golden Eye*. His hired companion, Lorenzo James, explained that he'd found Monty sprawled on his bed at 6 A.M., naked except for his eyeglasses—and dead of "convulsions due to alcoholism" and a heart attack. He would have been forty-six the following October. "He was my brother," Elizabeth said, "my dearest friend." Due to filming, she couldn't attend his fifteen-minute funeral service on July 26 in Manhattan's St. James Episcopal Church, where Frank Taylor, Libby Holman, Nancy Walker, Lauren Bacall, Dore Schary, Mira Rostova, and Robbie Lantz were among 150 mourners. Elizabeth sent two jumbo bouquets of chrysanthemums with the message, "Rest, perturbed spirit."

When *The Taming of the Shrew* opened, critics thought Richard perfect as Petruchio, but Elizabeth was still playing Martha in *Who's Afraid of Virginia Woolf?*, screeching and posturing instead of acting. "When it comes to brewing up a real emotion, such as shrewish rage," wrote Wilfred Sheed in *Esquire*, "she can only flutter her surface and hope for the best." *Reflections in a Golden Eye*, her next film, was produced in Rome in October 1966, and she had to recast Monty's role. Lee Marvin, William Holden, and Robert Mitchum all turned it down, but Brando leaped at the $750,000 salary despite his reluctance to portray a

latent homosexual. Frequent rumors regarding his own alleged homoeroticism made him nervous in the role, but after he saw *Who's Afraid of Virginia Woolf?* he decided he wanted to work with Elizabeth, whose performance he respected.[18] Richard came to the set daily, so fascinated by Brando's acting that he was blind to the flirtation going on between Elizabeth and Brando, who later revealed that he "turned down" Elizabeth because "her ass was too small." Laurence Harvey evidently didn't agree, having called her "Fat Ass," though not to her face, when they'd filmed *Butterfield 8* in 1959.[19]

On the *Reflections* set, Elizabeth ordered John Huston around, telling the director of *The Maltese Falcon* and *The Treasure of the Sierra Madre*, "Let me know twenty minutes before you want me, then ten minutes, five, one . . . and then I'll do the shot. But don't keep me waiting." While filming a scene with Brando, Julie Harris, and Brian Keith, Elizabeth spoke her lines and waited for Brando's reply. He muttered something, but she didn't hear him and started ad-libbing. "Cut," Huston called. "Elizabeth flopped." Script girl Angela Allen said, "No, she didn't. She ad-libbed as long as she possibly could." Glancing at Brando, Elizabeth said, "Yes. When Mr. Mumbles can open his mouth, so any of us can even hear what he says, it would be wonderful."

One night in November, at a dinner with Brando and French actor Christian Marquand, the

Burtons and their guests drank so much that they blacked out, and the next day, according to Richard, "no two people remember[ed] what happened." When it finally occurred to him that booze was the root of all their problems, he tried to give it up, but Elizabeth refused to go on the wagon. "Elizabeth enjoyed her booze as usual and I don't resent it—much," he wrote, and soon he was drinking again. "I have been more or less drunk for two days," he wrote on November 2, confessing that he'd created havoc throughout the household, insulting Bob Wilson and breaking his vow of fidelity by hitting on Maria's nanny Karen. Elizabeth didn't mind his indiscretion so much as she did the possibility of losing a good nanny. The following morning he apologized to Karen in Elizabeth's presence and later wondered whatever could have possessed him, finally deciding that it must have been his impending forty-first birthday.[20]

By 1966, the Burtons' drinking was wrecking their health and turning their home into a bedlam, with Richard shouting at Elizabeth and even at Liza, who adored him. Elizabeth warned him to stop screaming at Liza, reminding him that he couldn't expect children to think and behave like adults. When Elizabeth began to hemorrhage in 1966, Richard wrote in his journal that he had "nightmares of her dying . . . from that bloody bleeding [and] shouted and bawled at her for being 'unfit,' for lack of discipline, for taking too much

booze." Dr. Middleton-Price of London was summoned to Italy "to knock her out," and she went into a Rome clinic for curettage—the scraping of fibroid tumors from the interior of the uterus, a fairly common condition in women. After the operation she called Richard and said she was "in pain," but would "live to be shouted at another day." They had been unable to have sex for a month, but within the week, they dined at home and later "made lovely love," he recalled, adding, "what a magnificent relief and release."[21]

On February 27, 1967, the Burtons celebrated Elizabeth's thirty-fifth birthday with Princess Margaret and Lord Snowdon in the Dorchester Hotel's Terrace Room. Richard commented to HRH, "I hope you are not as nervous tonight, M'am, as I am." She replied, "Would you like to bet?"[22] The royal marriage was headed for the divorce courts. In Paris, the Burtons dined with Elizabeth's old friends the Duke and Duchess of Windsor, and the Windsors found them so congenial they came home with them. The two notorious couples had much in common, both having survived international scandal to form marriages that were at once passionate and opportunistic— the American Wallis Warfield Simpson had wanted to be Queen of England and Richard Burton had wanted to be king of the world. "We all got on famously," Richard recalled. "The Duke and I sang the Welsh National Anthem in atro-

cious harmony." During Elizabeth's childhood in the 1930s, the Duke, who was then David, Prince of Wales, had ascended to the throne of England as King Edward VIII, reigning for 326 days before abdicating to marry Wallis, the current Duchess of Windsor, who was twice divorced. "Wallis taught me that life could be fun," the Duke explained. Outcasts in England, the Duke and Duchess went into exile in France, where they were befriended by Eugene and Kitty de Rothschild, marking the beginning of an alliance between the Windsors and the Rothschilds that the Burtons would shortly benefit from.

As the two couples visited that night in Paris, Richard got drunk and referred to Queen Elizabeth II, the reigning monarch and the Duke's niece, as "her dumpy majesty." The Windsors appeared to agree wholeheartedly with him. They resented the Royal Family's refusal to let Wallis be referred to as Her Majesty, as well as their failure to give the Duke an impressive ambassadorial post following his abdication. The Windsors' marriage had endured because from the first time they'd made love, when he was the Prince of Wales and heir to the throne, Wallis had been the dominant partner, ordering him around like a servant. He tolerated her abuse because she had succeeded, where earlier mistresses such as Freda Dudley Ward and Thelma Lady Furness had failed, in giving him the passional life of his dreams. "He was a masochist,"

Freda said. "He liked being humbled, degraded. He *begged* for it." Like Elizabeth Taylor, the Duchess had a-loving relationships with heterosexual men and loving, a-sexual relationships with gays. Her marriage almost ended when she became infatuated with a well-known gay, Jimmy Donahue, a cousin of Woolworth heiress Barbara Hutton. Eventually Donahue died of acute alcoholic and barbiturate intoxication, and Wallis refocused her attention on the Duke, though her contempt and boredom were sometimes as obvious and vocal as Martha's for George in *Who's Afraid of Virginia Woolf?*

For the jaded Windsors and increasingly for other titled figures in European society, the Burtons were a breath of fresh air. The Duchess, like Elizabeth, loved to talk about medical matters, especially plastic surgery (as long as everyone agreed she didn't need it), and she adored telling risqué jokes. "What is the difference between a night on the beach at Coney Island and a night on the beach in Hollywood?" she asked. "At Coney, the girls lie on the beach and look at the stars, and in Hollywood the stars lie on the girls and look at the beach."

Elizabeth and Richard won the British equivalent of the Oscar for *Who's Afraid of Virginia Woolf?* and, despite critical brickbats for their other joint ventures, found themselves the most famous acting couple in the world. On May 21, 1967, they cele-

brated by purchasing a luxurious, sixty-year-old motor yacht, naming it the *Kalizma*, after Liza, Maria, and Kate Burton, Richard's daughter from his marriage to Sybil. As millions of dollars continued to roll in from *Iguana*, *Who's Afraid of Virginia Woolf?*, and *Shrew*—the last brought them a $12 million return on a $2 million investment—they splurged again and purchased a $215,000 mink for Elizabeth and a $120,000 Monet for Richard.

On May 24, as the *Kalizma* set out for Portofino, Elizabeth was urging Richard to costar with her in *Boom!*, the film version of Tennessee Williams's play *The Milk Train Doesn't Stop Here Anymore*. Sean Connery had already turned down the role, and Maria Callas had declined Elizabeth's part. One of Elizabeth's closest friends, Norma Heyman, was married to the man producing the film, John Heyman. The play had flopped twice on Broadway, first in 1963 with Hermione Baddeley and Paul Roebling. The second version, directed by Tony Richardson and starring Tallulah Bankhead and Tab Hunter, fared no better, partly due to the unlikely pairing of the forceful Bankhead with timid Tab. When Bankhead, a lesbian, was asked if Tab were gay, she replied, "How would I know, darling, I never fucked him."[23] A London production starring Ruth Gordon had disintegrated before opening night due to Gordon's heckling of her costar Donald Madden.

The play's subject—a dying woman having a nervous breakdown while penning her memoirs—was an autobiographical elegy compounded of Tennessee's regret, relief, and guilt over the death of his gay lover, Frank Merlo. The play attempted to transmit homosexual angst through heterosexual characters, resulting in irrelevant pomposity. As Richard pondered the project during their stay in Portofino, they spent several evenings with Tennessee, who introduced them to his tall, handsome paid companion. At a restaurant one night, Elizabeth admonished the inebriated Tennessee to stop shouting. "We attract enough attention as it is," Richard added. He was annoyed when the playwright made a pass at their eight-year-old, Chris Wilding, and told Williams he was "a self-pitying pain in the neck . . . depressed all the time." Tennessee accused his companion of hiding or stealing his drugs and hypodermic needles, but the companion, who'd recently survived gastrointestinal surgery, denied ever touching his drugs.[24]

Richard at last agreed to film *Boom!*, largely to lend his box-office clout, which was now greater than Elizabeth's. During the filming in Sardinia in 1967, Tennessee said he was delighted with Elizabeth's performance as Flora (Sissy) Goforth, the richest woman in the world, whose companions are a gay gossip monger played by Noel Coward and a sexy drifter, Chris Flanders, played by Burton. Tennessee would later call *Boom!* "a beautiful picture,

the best ever made of one of my plays," but in *Memoirs* he executed a volte-face, writing that casting the Burtons had been "a dreadful mistake . . . Dick was too old for Chris and Liz was too young for Goforth . . . Despite its miscasting, I feel that *Boom!* was an artistic success and that eventually it will be received with acclaim." He could scarcely have been further off the mark. Critics loathed *Boom! Life* blamed the Burtons, deploring the "tired, slack quality in most of their work that is, by now, a form of insult." Casting aside, the fundamental flaw in the piece was Tennessee's dialogue, which had been composed under the influence of brain-scrambling methamphetamine and consequently was fraught with pseudo-poetic pontifications such as: "The Boss may be dying under the unsympathetic, insincere sympathy of the far-away stars." Elizabeth complained that the text's "changing rhythms" threw her, and Noel Coward wrote in his diary, "I had a bit of trouble with Tennessee's curiously phrased dialogue." Otherwise Coward enjoyed the shoot, writing that he "bathed in lovely sunshine all the time . . . I love Liz Taylor [and] Richard, of course, was sweet."

Elizabeth worked on her figure all summer, not only to lose weight but, through exercise and massage, to redistribute her assets. "I can barely keep my hands off her," Richard wrote in his notebook. "She is at the moment among the most dishiest girls I've ever seen." According to Tennessee, Eliz-

abeth briefly enjoyed the company of a man pseudonymously referred to in *Memoirs* as Ryan, "the handsomest of my companions ... Ryan embrac[ed] Elizabeth Taylor during the film *Boom!* on the island of Sardinia. He was bisexual and very attractive to ladies with the exception of the Lady Maria St. Just and Miss Ellen McCool, both of whom objected to [Elizabeth's] very beautiful and very blue eyes."[25]

During a break in filming that summer, the Burtons sailed to Santa Marguerita, where ten-year-old Kate Burton—"bonny and long-legged and freckled," in her father's description—came aboard with Aaron Frosch, their lawyer. Kate "immediately reestablished warm 'lovins' with Elizabeth," Richard recalled. Elizabeth and her stepdaughter were like a pair of giggly sisters, constantly laughing at each other's antics. "Kate jumping all over the place and slept with us the night," Richard wrote, and added, "I finally went to sleep downstairs in Kate's room."[26] In Portofino, Elizabeth took Kate shopping, and they returned to the yacht laden with watches, sweaters, and everything they could find designed by Pucci. Richard was spending a great deal of time coping with the educational crises of Elizabeth's sons. Mike Jr. was fifteen, and an exasperated Richard said, "Let's face it, our son is a hippie. His hair lies on his shoulders, and we can't keep him in school." The solution, Richard suggested, was to "kick the living daylights out of him," but

Elizabeth argued, "He has the right to wear his hair any length he wants; it's his right as an individual." Richard appealed to the boy's father, Wilding Sr., who immediately sided with Richard. Liza and Maria were in schools in Switzerland, and Kate stayed in the United States with Sybil most of the time, but the Wilding boys had been shifted in and out of so many schools during their mother's marriages and world travels that they were seriously behind in their classwork. Finally, Norma Heyman, who named two of her children after Elizabeth's kids, used her influence to get the Wilding boys admitted to Millfield, an expensive British boarding school.

Though suffering from arthritis, Richard took the boys to London to get them settled in. He thought that Mike was "lethargic, sluggish and graceless," but he appreciated that Mike was "loving and intelligent" and told Elizabeth that if they could keep him in school for another couple of years, they'd be lucky. The boys continued to worry Richard, who wrote in his notebook two years later, "The school has been bad for them. Their values have become tremendously coarsened, Michael started to smoke and drink there and found jail-bait companions . . . I have seen him read nothing but comic strips . . . I haven't seen Chris read anything else either." Mike was eventually "sacked" from Millfield, but Chris was popular and won the art prize.

Given Mike Todd's death in a plane crash, Elizabeth understandably had some trepidation regarding private aircraft, but on September 30, 1967, the Burtons couldn't resist splurging on a Hawker-Siddeley De Havilland 125 twin jet. "Something beyond outrage," Richard called it, adding that "it costs, brand new, $960,000. [Elizabeth] was not displeased." On one of their first flights they landed at Abingdon and then drove to Oxford University for the world premiere of Richard's film *Faustus*. Interviewed in 1998, Brian Hutton, who would soon direct Elizabeth and Richard in separate films, recalled, "I went up to Oxford with Elliott Kastner, who'd later do *Where Eagles Dare* with Richard and me. I don't own a suit or tie, so a friend lent me his tuxedo . . . We went to dinner, about twenty of us, including their close friends John and Norma Heyman, who were great fun. Princess Margaret or someone royal comes out, and there's great fanfare, heralds and all. Everybody gets up. Nothing. Five minutes later, more heralds, out comes Elizabeth and everyone goes wild—she's in a big tiara, black fur, and she's looking sensational, pearls, necklaces, jewels. Heralds, a third time, out comes the Duchess of Kent. She looked like the lady-in-waiting for Elizabeth. Then we sat through this god-awful movie. Elizabeth had a walk-on with no lines. Sad—they were running around trying to raise money for charity."

In 1968, Elizabeth accompanied Richard to the

location shoot of *Where Eagles Dare*, one of the first of the rugged action pictures. Brian Hutton recalled in 1998, "Elizabeth was an enormous plus on location in Austria. She really kept Richard in line, chased him around, and kept him from drinking. She was like a second assistant—very, very helpful. It was always in his best interests. I got to know her then, and afterward we did two films together." In a supporting role, paid a fraction of Richard's $1 million, Clint Eastwood said the picture should have been called *Where Doubles Dare*. "It was a very hard picture for Richard to make," Hutton acknowledged. "We had him in that fuckin' bus saying 'Turn the bus left, turn the bus right,' and it was all process, all rear projection, and he was pissed three quarters of the time, couldn't see the process behind him. He had one big beef with 'the bomb'—a stick of wood with a clock on it, made up to look like dynamite. I made it up as an all-purpose bomb. We threw it at everything, every time the script called for a bomb—the universal bomb. If you didn't kick the spring—it was on a timer—you could throw it, you could eat it. I wanted Burton to put this stick of 'dynamite' around a telegraph pole, he was gonna blow it up when the Germans came. So I said, 'Okay, Richard, take this and put the string around the pole.' 'No, no, no,' he says, 'I can't do it.' I said, 'Why not?' He replies, 'I don't touch high explosives.' "'It's a stick of wood, Richard,' I say, 'we've been using it

for two weeks, in every scene.' 'I'm not going to touch high explosives.' 'Richard, it's fuckin' wood.' He was drunk, pissed. 'No high explosives,' he says. 'Get me Elizabeth,' my second assistant says. Elizabeth got Richard to do a lot of things that he didn't want to do. They had to go back to the hotel to get her. She comes on the set twenty minutes later and says, 'You silly bastard, that's not dynamite, it's wood—Ri-CHARD, do it! Get up and do it. Get out of here!' Elizabeth and Richard were a great couple. I always rooted for them." One day, wrapped in sable, Elizabeth led a procession of hotel waiters up a mountain to the set and spread out a champagne picnic. "Isn't she beautiful," Richard said.

They arrived in London in mid-February for Elizabeth to film *Secret Ceremony*. Her $1 million fee overshadowed the salaries of costars Robert Mitchum ($150,000) and Mia Farrow ($75,000). Joseph Losey was again her director. Lacking the finesse of Mike Nichols, he let her indulge her worst excesses, and she trashed what was left of her reputation as a serious actress. "The disintegration of Elizabeth Taylor has been a very sad thing to stand by helplessly and watch," wrote Rex Reed. "Something ghastly has happened over the course of her last four or five films. She has become a hideous parody of herself—a fat, sloppy, yelling, screeching banshee." She was in excruciating pain much of the shoot, and her doctor advised her to lie flat on her

back for at least four weeks. The film was postponed, and Richard feared she was "going to end up in a wheelchair . . . [or] tottering about on crutches." Refusing to follow the doctor's orders, she got up and went to a bistro to dine with Richard and the Duke and Duchess of Windsor. She rarely stayed in bed as ordered for more than an hour. Her drinking worried Richard, who wrote, "It can't be alright for her to drink *and* take the doses of drugs that Caroline [her nurse] is forever pumping into her." After she had her drug injections at night, she was "only semi-articulate," Richard complained. The cortisone she had to take for her sciatica and other ailments bloated her and forced her to go on diets that she could never succeed in keeping to. In exasperation, Richard accused her of "total self-indulgence" and added she bored him with her "moans and groans in agony." He blamed his increased alcohol intake on her. With his drunken blackouts and her drugged stupor, they began to lead what he described as a "half-life." Eventually, he predicted, he'd die of alcohol poisoning, but Elizabeth, a classic survivor, would "go blithely on in her half world." Even after she resumed filming *Secret Ceremony*, she drank and took pills. One night, she came home "crocked as a sock, sloshed as a Cossack."[27]

As their passion for each other diminished, they attempted to compensate by cornering the world's diamond market. For $305,000, Richard acquired the 33.19-carat Krupp diamond, purchasing it

through Sotheby's Parke Bernet in New York. The previous owner, Vera Krupp, had been the wife of a convicted Nazi munitions manufacturer, but Elizabeth took the curse off it by quipping, "It's fitting . . . that a nice little Jewish girl like me has ended up with the Baron's rock." Richard also gave her La Peregrina Pearl (The Wanderer), which he acquired for $37,000. Bored with acting, he briefly considered writing a nonfiction book about La Peregrina. Philip, King of Spain, had given the gem to Mary Tudor in 1554. In Richard's proposed book, the pearl's peregrinations would be traced through all its owners. "Do I have the intellectual stamina to sustain such a big undertaking," he wondered, "and is my writing good enough?" He decided to seek Nevill Coghill's advice, but nothing came of the project. It would have been more practical and profitable for him simply to write his memoirs, but he feared being accused of exploiting Elizabeth, as if that wasn't what he'd been doing all along. The $37,000 tab for La Peregrina was a drop in the bucket compared with what the gem ended up costing him; Elizabeth required a $100,000 Oriental pearl-diamond-and-ruby necklace to attach La Peregrina to. She placed her jewels in red leather boxes, eventually amassing an $8 million collection. Her total wealth at the time, according to Richard, was $20 million; his, $10 million.[28] They could well afford to be generous to their staff of thirty. "The people who worked for

them worshipped them," Dominick Dunne re-
vealed in 1999.[29]

When Princess Margaret first beheld the Krupp,
she asked Elizabeth, "Is that the famous diamond?
It's so large. How very vulgar."

"Yes," Elizabeth said, "ain't it great!"

The Princess then asked, "Would you mind if I
tried it on?"

"Not at all," Elizabeth said, slipping it on
HRH's finger. She seemed to be in no hurry to take
it off, holding it up to catch the light and admire
it on her hand. "It's not so vulgar now, is it?" Eliz-
abeth said.

One day she screamed that her Pekinese had
swallowed La Peregrina. She was working on a film
set at the time, and shooting was delayed as every-
one searched for the gem, which ultimately turned
up, though not in her dog.[30]

The parenting of Elizabeth's boys continued to
pose a daunting responsibility for Richard. They
had been through four fathers, and he found it im-
possible to undo the damage of his predecessors,
who'd supplied no discipline. Cooped up at the
Dorch, Mike and Chris misbehaved, and Richard
complained of stereo blasts at 2:30 A.M. and ciga-
rette burns on sheets and curtains.[31] Elizabeth was
in no condition to help. Before completing *Secret
Ceremony*, she began hemorrhaging and was advised
she needed a partial hysterectomy. She finished the
film in a surgical corset due to sciatica and disc

troubles, and her pain led to a frightening buildup of prescription drugs. Physical frailty in others terrified Richard, and he no longer knew how to deal with her. On July 23, 1968, after being fired from his picture, *Laughter in the Dark*—he'd arrived on the set thirty minutes late, with Liza Todd in tow—he spent what he called "the two most horrible days of my adult life."

Elizabeth went into the hospital at 9:30 A.M. Sunday to have her uterus removed. The operation lasted until 1 P.M., and she came to screaming in agony. A powerful drug was administered, and soon she started hallucinating and yelling. Richard tried to help but she told him to fuck off, regarding him with "a malevolence that made a basilisk look like a bloodhound," he related. "That kind of stuff was a lot easier for Richard to tolerate when he was boxed," said a friend.[32]

It got worse. On July 24, 1968, news arrived from Le Pays de Galles in Celigny that the gardener-caretaker, a Burton employee since 1957, had hanged himself. Over Elizabeth's objections, Richard left for the funeral with Liza; Kate; his favorite brother Ifor and his wife, Gwen; and his best friend Brook Williams, son of Emlyn Williams. Le Pays de Galles was inextricably associated in Elizabeth's mind with Sybil Burton. Consumed with irrational jealousy, she begged Richard to stay at her home, Chalet Ariel, instead. He refused, they fought, and later on, in Celigny, he went on a

binge with Ifor, which ended tragically when Ifor slipped and broke his neck. Richard was disconsolate, feeling responsible. He'd always thought his rugged, coal-mining older brother invincible, but now Ifor was paralyzed from the neck down for the rest of his life. Richard never forgave himself.[33]

The battered Burtons resumed working in 1968, shooting separate films in Paris, Richard playing a gay man in *Staircase* with Rex Harrison and Elizabeth costarring with Warren Beatty in the Fox production *The Only Game in Town*, produced by Fred Kohlmar and directed by George Stevens. Based on a flop play by Frank Gilroy that had starred Tammy Grimes and Barry Nelson on Broadway, *Game* brought her $1.4 million but the film lost $5.8 million. Though the story was set in Las Vegas, Elizabeth insisted on shooting it in Paris to avoid ruinous taxes, and it ended up looking like a low-budget potboiler filmed on a Poverty Row sound stage. The sixty-four-year-old producer succumbed to a heart attack, and someone at Fox quipped that Kohlmar had died upon viewing the rushes. Richard's film, *Staircase*, was set in the East End of London but also had to be filmed in Paris for tax reasons. He earned $1.25 million but 20th Century–Fox lost $8 million. Stanley Donen, Elizabeth's old boyfriend, was Richard's director.

Tense and short-fused in Paris, Richard confessed that he was "ridiculously . . . jealous" be-

cause Elizabeth was working with Beatty, "a young and attractive man who obviously adores her." She tried to assure Richard that she looked on her costar "like a younger brother," and that Richard was "a fool" to distrust her. "Ah," Burton replied, "but there have been cases of incest. They have been known. Oh, yes." There was little Elizabeth could do to make him feel secure about his sexuality, since he was playing a homosexual in *Staircase*, the bottom man at that, and it stirred up all his homoerotic impulses and anxieties. As his daughter Kate said in the *Daily Mail*, "Dadda could not live with himself." For years he'd also been in denial about his alcoholism, but at last he told Mel Gussow of the *New York Times*, "From 1968 to 1972 I was pretty hopeless. I was fairly sloshed for five years. I hit the bottle. I was up there with Jack Barrymore and Robert Newton. The ghosts of them were looking over my shoulder."

Elizabeth could not have been pleased to overhear him say, "The only thing in life is language, not love, not anything else." To regain his love she attempted to satisfy his desire for social acceptance at the highest level of European society. For the collier's son, that was the ultimate accolade.

9

The Jet Set

According to Alexandre, Elizabeth was the only Hollywood star ever to succeed in French aristocracy entirely on her own. Rita Hayworth had been accepted as Princess Aly Khan and Grace Kelly as Princess Grace de Monaco, but Elizabeth attained social status in Paris by virtue of being, as Alexandre put it, the "star of stars." She had known the Rothschilds for some years, and Marie-Hélène, the leader of *tout Paris*, provided Elizabeth with wide access to the usually insular French beau monde.

On October 6, 1968, the Burtons lunched with Baron Alexis de Rede, whom Richard referred to as "de Redee." One hundred guests dined on fish, partridge, and ice cream with nuts and cake blended in ("magnificent," Richard pronounced), accompanied by three excellent wines and brandy. Elizabeth was seated between Maria Callas and

Baron Guy de Rothschild. Next to Richard, Marie-Hélène, Guy's wife, observed that de Rede's huge house was the best in Paris, but Richard said his favorite was Ferrières, the Rothschilds' château. The estate was such a source of worry to Guy, Marie-Hélène complained; he couldn't decide whether to leave Ferrières to his children, give it to the medical profession, or turn it into an art museum. "Give it to us," said Elizabeth, and Richard thought, "Cheek." Marie-Hélène was "quite an ugly woman with a large hooked nose and an almost negroid mouth but very beautiful blind eyes," Richard recalled, "and the vivacity of her manner and her machine-gun delivery in both languages makes her very attractive."

Callas made a bold play for Richard after confiding to him that she and Aristotle Onassis were finished. She'd once told director Franco Zeffirelli that Ari was the first man who'd made her feel like a woman, who'd brought her to life as a sexual being. As Elizabeth eavesdropped, Callas said her life with Ari in the jet set—discos, drinking, and late-night partying—had destroyed her voice. Suddenly, she began to flatter Richard, telling him his eyes were "beautiful," signifying "a good soul." She asked if she could play opposite him as Lady Macbeth. "I suppose she thought Elizabeth was going to play Macduff or Donalbain," Richard reflected. The stage, Callas insisted, and not grand opera, was now her "first love," and she saw Richard as

her ticket to fame as a straight actress. Uncomfortably aware that Elizabeth had "eyes in the back of her bum and ears on stalks," Richard promised nothing.

Afterward, the Burtons attended a running of the Grand Prix d'Arc de Triomphe, the French version of Ascot and Derby day, as guests of the Rothschilds. They were permitted to go into the ring, which was usually restricted to owners. When Elizabeth walked from the paddock to the loge between Guy and Marie-Hélène, thousands of startled spectators recognized her and broke into cheers. "Not bad for an old woman of thirty-six," Richard said.

The Burtons were in Paris to complete their movie commitments. Elizabeth was still filming *The Only Game in Town* with Warren Beatty at the old Boulogne Studios on the outskirts of the city. Richard was naturally suspicious that she was romancing Beatty, whose fame as a Lothario exceeded even his own. On October 9 he felt "desperate all day long," hating it when Elizabeth left him to work at the studio. He drank himself to sleep long before she got home. On October 12, they both had to work, but they were hoping to flee Paris for the weekend. On Richard's set, Rex developed a case of flu and was sent home early. Richard completed some close-ups and left his set at the Boulogne Studios at 6:45 P.M., driving over to Elizabeth's set to collect her and their guests for the

weekend. While waiting for her, he talked with Beatty, who offered him a drink. Elizabeth was "remarkably beautiful," Warren said, adding that she was "a great film actress." Elizabeth thought "similarly" of him, said Richard, somewhat stiffly, letting Warren pour him another martini. Elizabeth appeared, and the Burtons made the hour-and-a-quarter flight to Nice in their twin jet for a sail on the *Kalizma* with friends of Elizabeth's from her childhood in England, Sheran Cazalet Hornby and her husband Sir Simon, chairman of W. H. Smith, the publishing company. They drank all the way to the Riviera, boarding the *Kalizma* in St. Jean Cap Ferrat. For the Burtons, still tense from filming, the yacht was heaven. They went to bed at 3:30 A.M.

The next morning they relaxed on the poop deck and drank Salty Dogs—vodka and canned grapefruit juice with salt around the rim of the glass. "It is as quiet as prayers with hardly a stir on the waters," Richard wrote. Their guests were soft-spoken, well-read, and intelligent. Life seemed perfect as the Burtons strolled the deck, Richard running his hand appreciatively over the smooth walnut railings. In the salon, they admired their Monet and an Epstein bust of Churchill. Going into the dining room, they gazed lovingly at a Van Gogh and a Picasso, then moved on to the stairwell to the children's cabins, gazing at a Vlaminck. Back on deck, they enjoyed a lively conversation about books with the Hornbys. Sir Simon was even

more erudite than Richard. The day would have been sublime had Richard not gotten sloshed and started repeating himself.

He asked Elizabeth when he sobered up the next day whether he'd offended anyone, but she had more important things to think about than his blackout. Her feet had no feeling in them, and she was afraid of becoming permanently handicapped. Would he still adore her if she had to spend the rest of her days in a wheelchair as "a cripple"? she asked. He said he "didn't care if her legs, bum and bosoms fell off and her teeth turned yellow." Then, in an eerie foreshadowing of 1997, he added that he didn't even care if she went bald. He would love her always, he swore, because she had given him her all. At such moments, he seemed the ideal lover she'd always dreamed of.

Back in Paris, he returned from a difficult day on the *Staircase* set grumbling that his entire body had been smeared with makeup for a nude scene with Rex Harrison. With infinite care, Elizabeth washed the greasy mess off him, not unlike a miner's wife scrubbing her husband's back after a hard day in the mines. On another evening, Richard was studying his script at home, trying to memorize his lines for the next day, when Elizabeth suddenly appeared before him in a see-through nightgown, one of the shoulder straps already dangling on her arm. "I went back to bed for ten minutes," Richard related. "I was unquestionably seduced and I

teased her about it for the rest of the day . . . After all these years the girl can still blush." In time he came to rate her the best lover he'd ever known. "She is a wildly exciting lover-mistress," he wrote; "she can tolerate my impossibilities and my drunkenness . . . I'll love her till I die."[1] Their happiness came in rare periods of sobriety, and Elizabeth would always treasure them, she told Barbara Walters in 1999.

On a Friday evening in late October, they were again with Callas, who lived in Paris at 36 Avenue Georges Mandel. The newspapers had just reported Ari's forthcoming marriage to Jacqueline Kennedy, and Callas was in shock. Richard enveloped her in a bear hug, whispering into her ear that Ari was a son-of-a-bitch. Like the rest of the world, the Parisian haute monde was dismayed that the thirty-nine-year-old widow of the slain U.S. President had chosen to wed a sixty-nine-year-old foreigner. Though jilted and humiliated, Callas put on a brave face and even forced a tight little smile during dinner. Siding with Callas against Ari, Marie-Hélène whispered to the Burtons that Ari would never be invited to another Rothschild party. In his cups, Richard accused Marie-Hélène of lying, slurring that "the Onassises would be the toast of Europe." Certainly, the Burtons were as curious about the Onassises as Jackie and Ari were fascinated by the Burtons. Elizabeth liked Onassis and insisted, "Jackie made an excellent choice."[2]

Guy de Rothschild agreed and promised Elizabeth he'd invite the Onassises to Ferrières.

On October 20, the Burtons double dated with Callas and Warren Beatty, and Richard later wrote that Callas "needs our company & comfort & perhaps the attention we attract, tho God Knows she can attract enough at the moment in her own right." Elizabeth wore a white Dior with an emerald necklace and emerald earrings and monopolized the attention of reporters and photographers as if the others were invisible, causing Richard to reflect, "I look at her when she's asleep at the first light of a grey dawn and wonder at her." At this point she could upstage anyone in the world. The Burtons had been married eight years, and there were times when he still felt like the luckiest man alive. Such periods were short-lived.

By October 25, Elizabeth was putting Richard under pressure not to let Jackie Kennedy outdo her as owner of the world's greatest private jewel collection. Onassis had just given Jackie $2.5 million worth of rubies surrounded by diamonds. "The Battle of the Rubies is on," Richard sighed. "The idea has already been implanted that I shouldn't let myself be out-done by a bloody Greek."[3] Richard took it as another challenge to his virility, hard on the heels of his suspicions about her relationship with Beatty. According to author Stephen M. Silverman, his jealousy was the cause of another physical crisis with her back. One day Richard invaded

the *Only Game in Town* set and forcibly separated Elizabeth and Beatty, who were in the middle of an on-camera clinch. He yanked her hard, wrenching her back and creating an expensive two-week delay in production.[4]

"Marred royalty," as Richard called them, flocked to the Burtons' movie sets in Paris. The Duke and Duchess of Windsor paid a visit, as did Princess Elizabeth of Yugoslavia, one of the leaders of European society. For the moment, Richard did nothing to make his wife suspect that the Yugoslavian Princess was a rival for his love. Though Richard was drawn to the Princess and found her "very pretty," he also thought her "quite impertinent." He suspected that she was polite to his face, but as soon as he turned his back, out would come the daggers. The Princess confided that she had a date that night with Beatty, pretending, not very successfully, to be unexcited by the prospect. She seemed to be amused by the aging Rex, whose wife, Rachel Roberts, wore micro minis and flashed her bare bottom to the crew, bragging, "I can take any three of you." Her marriage to Rex was breaking up, and Rex later wrote, "Rachel and I had hoped that working together on *Flea in Her Ear* would be a help to our marriage, but we should have seen that our two life-styles would never fit, before we were married."[5]

When the Burtons and the Harrisons went together to the premiere of *Flea*, a Gallic farce by

Feydeau, Rachel screamed at Elizabeth because the Burtons' limousine was called first. A few days later, Rachel appeared on the *Staircase* set and proceeded to get drunk. Elizabeth rang from their hotel suite, and Richard asked Rachel if she'd like to talk to Elizabeth, thinking she'd apologize for having attacked her at the premiere. Instead, Rachel took the receiver and started barking like her basset hound, Homer. For once Elizabeth was at a loss for words, "so embarrassed that she didn't know what to do," Richard recalled. A few days later Rachel again visited the set and showed everyone her pubic hairs, then lay down on the floor and said that she'd show her ass to anyone who cared to see it. She pulled up her miniskirt and made good on her promise. Glaring at Rex, she hissed, "I don't care about his hard-faced blondes." Richard, who was playing Rex's "wife" in the film, said, "Neither do I." Richard was drawn to Rachel's firm, athletic body and eventually succumbed to her blatant come-ons.

The once-fat Callas aspired to look like Audrey Hepburn, a goal never reached because of the diva's rugged features, but in Paris, at her thinnest, Callas was a statuesque, dark-haired stunner. Elizabeth seems never to have regarded her as a serious rival, though Callas pursued Richard throughout November 1968, nagging him to help her film *Medea*. She was desperate to score a grand triumph that would make Onassis regret having left her for

Jackie, and she chose the Euripides play rather than an opera, because her singing voice was no longer capable of grandeur. Richard was not keen to play Jason, Medea's husband, an unchallenging role for an actor of his stature. In his opinion, Callas was "not beautiful," but he liked her face with its "black-eyed animation" and her body—at least the lean part from her midriff upward. Those "massive legs," however, left him cold. When Callas removed her dark glasses, he saw bags under her eyes and assumed she'd been on a crying jag.

After watching Richard and Rex film their scenes, Callas, at last realizing that Richard wasn't going to help her, left and went over to try her luck at Elizabeth's set. During a break in her *Only Game in Town* filming, Elizabeth was in her dressing room, playing gin rummy with her nurse, Caroline O'Connor. Callas sat watching them in silence, trying to pick up tips from Elizabeth's manner and gestures on how to become a movie queen. When Caroline scored a quick gin, Elizabeth yelled, "Shit," and Callas shot out of her chair and started pacing the room. Elizabeth later told Richard that Callas said, "Oh no, I've never heard such words. Oh no, no, no, never heard such things."

After Elizabeth turned down the role of Mary Magdalene in George Stevens's *The Greatest Story Ever Told*, Callas was set for the part. At the urging of Ari Onassis, Spyros Skouras asked Princess Grace to play the Virgin Mary, but Grace declined

upon learning that Callas had the juicier, prostitute's role, saying, "She gets to play Magdalene and I get stuck with the Virgin Mary? No way!" In the end neither appeared in the film.

November 12, 1968, marked a high point in French society's courtship of the Burtons, who were now one of the city's most sought after couples. They attended a dinner for twenty at the Windsors' home in Paris, where guests were expected to arrive punctually at 8:45 P.M. They entered by a marble hallway, dimly illuminated with candelabra and fragrant with incense. A butler stood by the open guest book, pen in hand. Ornate, grand, and in impeccable taste, the drawing room had soft French-blue-and-silver decor by M. Stephane Boudin and clusters of chairs and sofas for conversational groups. The adjoining dining room had a musicians' gallery and, over the fireplace, Brockhurst's portrait of the square-faced, square-jawed Duchess.

Liveried footmen appeared twice before dinner, offering highballs, martinis, sherry, and champagne. "Forty-five minutes of drinking before dinner is *quite* enough," ordained the Duchess. The chef, one of Europe's greatest, had an assistant chef, a pastry chef, and two kitchen boys. A meal at the Windsors' was, according to Lady Diana Mosley, "the perfection of perfection." At table, the Duchess changed her conversational partner frequently, forcing everyone to switch, a practice that

revitalized her wine-besotted guests. Richard was an exception. He'd drunk too much and was highly critical of everything. The Duke was also out of sorts, sulking because he hadn't been seated next to Elizabeth. Gulping the Duke's seventy-five-year-old Forge de Sazerac brandy, Richard sank into a blackout and, to Elizabeth's horror, glared at the Duchess of Windsor and said, "You are, without any question, the most vulgar woman I've ever met." Without blinking, the Duchess remarked that he and Elizabeth were the only untitled guests present.[6] Richard then picked up the Duchess and began swinging her in wild circles, her tiny aged feet a few inches from the floor. Elizabeth was sure he was going to drop her and kill her.

Whatever her shortcomings, the Duchess was not vulgar. "Her style of dress," Daphne Fielding wrote, "was based on classical simplicity of line and, with her trim figure, clear complexion and spick-and-span American grooming, she was capable of eclipsing more beautiful but less soignée English roses, who in her presence looked like croquet mallets beside a polished arrow." Richard later attributed his assault on the Duchess to "drink and the idiocies that it arouses . . . I shall die of drink and make-up." When they got home, he was so violent that Elizabeth locked him in the guest room, and he tried to kick the door down. His drinking continued to embarrass her at dinner parties, but the invitations kept coming. High

society worshipped Elizabeth and apparently would forgive her—and her husband—almost anything. One evening a drunken Richard cursed their hosts and stormed out, leaving Elizabeth to entertain the guests with a seemingly endless supply of near-death experiences: "When my back was fused . . . When I choked on my phlegm . . . When my eye was almost gouged out . . . When I almost died four times . . . When they nearly amputated my leg."[7] The haut monde hung on Elizabeth's every word, probably understanding very little of her English but content just to gaze at her. With the possible exception of Catherine Deneuve, she was still regarded as the world's foremost beauty.

Even the arrogant, belligerent Richard tried to be on his best behavior when with the Rothschilds, banking scions of one of Europe's noblest families. On November 16, the Burtons left to spend a few days as guests of Baron Guy and Baronne Marie-Hélène de Rothschild at Château de Ferrières outside Paris, bringing along nurse Caroline, who, according to Elizabeth, was thrilled by the great house and grounds, tended by one hundred servants. Their hosts' daughter, Lily, had had a blood clot on her brain two months previously, and Richard helped her husband carry her up two flights of stairs "fireman fashion."

There were thirteen for dinner, seated at two side-by-side tables to break up the spooky number thirteen. Conversation was surprisingly coarse,

focusing on sexual aberrations. Guy described a man who could have an orgasm only by imagining his mother hurtling from a building and passing his window at the crucial moment. Richard repeated a story of David Niven's about the actor who sat naked on a cake and masturbated until he was advised, "You can't have your cake and have it too."

Table talk at Ferrières also included matters of vanity. Marie-Hélène confessed she'd been given a complete makeover by Alberto di Rossi, but no one complimented her since she was still, according to Richard, as plain as a collier's wife on wash day. She was also a person of wit and eloquence, adored by both Burtons. A quarrel erupted during dinner between Marie-Helène and Lily when the inevitable subject of the Onassises resurfaced. Marie-Hélène was still banning Ari and Jackie from Ferrières, but Lily, like the Burtons, was dying to invite them.[8]

The following day was Marie-Hélène's birthday. Since the festivities didn't begin until high tea at 4:30 P.M., the Burtons slept until noon and brunched in their room on bacon, eggs, homemade brioche and toast, and home-grown apples. Elizabeth elected to remain in bed and read while Richard ambled through the estate's snowy woods. She went to a window and leaned out, breathing in the crisp winter air. Phillippe and the other young Rothschilds, including a pretty girl cousin, were

shooting rabbits and pheasants. For a moment, she listened to far-off sounds of the hunt. Then she saw Richard strolling in the park below and was touched when he looked up and waved to her. He walked on toward a lake where ducks and swans were still swimming in the unfrozen areas. Trees along the avenues had been planted by generations of reigning monarchs prior to the French Revolution.

Finally dressing and going downstairs, she joined twenty-five guests, including the minister of the interior, for tea, which consisted of chicken-in-the-pot and a cornucopia of vegetables, cheeses, desserts, roasted chestnuts, raisins, fresh figs, mandarins, oranges, apples, and homemade preserves. Later, at the cocktail hour, as the Burtons circulated among the sixty guests, Marie-Hélène approached them and asked Richard to chat up a dark lady standing by herself. "For God's sake, Marie-Hélène, I don't know her," he objected, "why should I?" The woman was dying to hear Richard's "heavenly" voice, Marie-Hélène explained. "Tell her I'll be over in a minute and give her an impersonation," Elizabeth said, affecting her tough American accent.[9] "My broad doesn't muck around," an appreciative Richard reflected. Marie-Hélène was so bent on flaunting Richard as her prize catch that she later joined a group at the bar, where Richard was trying to conduct a conversation with Mrs. Pierre Salinger, and

asked if anyone had seen Richard. Marie-Hélène's eyesight was failing, and she didn't recognize Richard. One of her guests was "dying" to meet him, she explained. Turning to Marie-Hélène, Richard said, "It is I, Hamlet, the Dane."[10] Still not recognizing him, she stared at him blankly before wandering off to look for him elsewhere.

At Marie-Hélène's birthday dinner, the guests, seated at numerous small tables, included former prime minister Georges Pompidou and Madame Pompidou; the Countess of Bardolini; and Alexis de Rede. Guy de Rothschild insisted on having Elizabeth at his table, but spent the entire meal looking after his ill dachshund, cowering in a basket by his chair. Richard was banished to a comparatively insignificant table, where he entertained everyone by impersonating the other guests, using only three words per impersonation. Since there were so many distinctive accents represented— French, German, Spanish, and Portuguese—"it was a piece of glottal cake," he remarked, but Madame Pompidou found his feat of thumbnail mimicry astounding. After dessert, all the children came to the head table, one by one, and made little speeches. "How boringly middle-class," one of Elizabeth's table-mates murmured, but she couldn't have agreed less and looked at him in surprise. Neither she nor Richard was "bored or blasé," he later wrote. "We are not even envious. We are merely lucky." As innocents abroad, they regarded

the Rothschilds with the same awe and wonder with which these titled aristocrats regarded the fabled Burtons. Most of the guests left for Paris after dinner, but Elizabeth and Richard sat up until three, entertaining Guy, Marie-Hélène, Alexis, and Lily, singing a Welsh duet, *"Ar lan y moree mae rhosys cochion,"* and Richard recited Shakespeare. The small children huddled at Elizabeth's feet, staring up at her as if she were Snow White come to life.[11]

The next day Richard had to break the news that her seventy-year-old father had died in Bel Air on November 20, 1968. She reacted "like a wild animal," which surprised him since Francis Taylor had been ill for years and everyone was supposedly prepared for his death. They flew to L.A. for the simple funeral service in Westwood, conducted by a Christian Science reader. By now, Elizabeth and Richard had become fashion slaves and looked silly in their matching fur coats; she'd given him a knee-length mink for his forty-third birthday. After her father's death Elizabeth drew closer to her mother, Sara, wanting only, according to Richard, "to protect and cherish her." Sara decided to live in Arizona, and the Burtons went there with Howard and Mara to help her get established in local society.

Francis Taylor's death was followed not long afterward by the demise of Nicky Hilton, who died of cardiac failure at the age of forty-two on Febru-

ary 5, 1969, surrounded by an arsenal of guns. In the weeks preceding his death, a psychiatrist had been planning to commit him to the Menninger clinic.[12] Elizabeth made no public comment, and was far more grieved by the death of her secretary and trusted confidant Dick Hanley, who died in 1970 after having taken care of her like a father since the death of Mike Todd. She paid for a lavish funeral for Hanley and later held a wake at the Beverly Hills Hotel, sending a spectacular floral display with a card saying, "I will love you always—Elizabeth."[13]

The Burtons roamed the world in late 1968 and well into 1969, hitting Paris, Gstaad, Las Vegas, Beverly Hills, London, and Puerto Vallarta. They spent Christmas 1968 in Gstaad, remaining until January 5, 1969, surrounded by family. The entourage was too large for their twin jet, so they chartered a sixteen-seat turbo jet to transport Mike and Chris, both teenagers; eleven-year-old Liza; six-year-old Maria; the septuagenarian Sara; nurse Caroline; Simmy, the adopted Samoan daughter of Howard and Mara Taylor; Simmy's boyfriend John from Hawaii; and a menagerie of pets including five dogs, a cat, and a canary. It was, the long-suffering Richard complained, the usual "screaming madhouse." He was sick to death of looking after luggage and keeping Elizabeth's growing children in line. The boys saw *Easy Rider* so many times that Richard lost count. The gritty New Hollywood

represented by Peter Fonda, Dennis Hopper (Elizabeth's son in *Giant*), and Jack Nicholson left the sybaritic Burtons cold, and the feeling was mutual.

Elizabeth was now hospitalized to get her off the painkillers she used for her back problems. Richard foresaw doom for both of them, writing that they would "live the rest of our lives in an alcoholic haze, seeing the world through fumes of spirits and cigarette smoke. Never quite sure what you did or said the day before or what you read, whether wise or foolish, tardy or too soon. God, I'm going to have a whisky and soda right now. There are few pleasures to match tipsiness in this murderous world." The pleasure induced by alcohol invariably backfired on them, beginning with tipsiness and ending in blackouts, screaming fights, hemorrhages, and delirium tremens. Their lifestyle, Richard wrote, was a "first-class recipe for suicide."[14]

On January 13, 1969, he noted that for the past month Elizabeth had been "not merely sozzled or tipsy but *stoned* . . . unfocused, unable to walk straight, talking in a slow meaningless baby voice." All that kept him from matching her drink for drink was the thought that one of them had to sober up occasionally or "we'll have to get a keeper to look after us both." Even worse, when he tried to leave her, he realized he couldn't. Typical codependent alcoholics, they'd taken each other hostage, and there was no escape short of institu-

tionalization or death.[15] "This woman is my life," he wrote.

Despite ill health, in February 1969, Elizabeth resumed filming *The Only Game in Town*, this time on location at Caesar's Palace in Las Vegas. In March, she made a rather lame attempt at drug detoxification at a hospital in L.A., using back trouble as a cover story for the press. Her liver had been damaged by alcohol and "hard narcotics," according to Richard.[16] After she left the hospital in March, she and Richard retreated to Casa Kimberley, where she received constant attention from nurse Caroline. The Wilding boys continued to worry Richard. In his sixteenth year, Mike was still neglecting his studies, but Chris, two years Mike's junior, was faring better at their school in Hawaii, where they were being raised by Howard Taylor. Liza was not exceptional at school but showed great promise and was improving regularly under Richard's generous if grudging encouragement. He also devoted extra time and attention to his adopted child Maria, whose surgeries were now completed. The Burtons were paying for the education of Simmy, Howard's daughter. Kate Burton was a winner, but her sister, the pale, darkhaired Jessica, was permanently hospitalized, a possible victim of *le scandale*. The youngest of Richard's two daughters with Sybil, Jessica had been a beautiful baby, but she'd screamed in terror when paparazzi stormed their home in Rome. The last recorded words Jessica

uttered, as Sybil took her to America, were, "Rich! Rich! Rich!" At the age of six, she went into the hospital of the Devereux Foundation. Richard blamed himself, convinced that his affair with Elizabeth plunged the child into the eternal darkness of schizophrenia and autism.

The village of Puerto Vallarta had grown from a population of one thousand when Elizabeth and Richard discovered it in 1963 to a bustling international resort of twenty-five thousand. The Burtons deservedly were regarded by the locals as founders, patrons, and unofficial leaders. They raised funds to establish a $100,000 school and performed numerous community services. One night, they attended the circus, and Elizabeth let the knife thrower hurl daggers at her, neither screaming nor wincing when a scimitar landed two inches from her ear. Though she was a few pounds overweight and beginning to gray, her smooth, unwrinkled skin still excited Richard, who would lie stroking her and wondering why they'd ever complicated their lives with alcohol and drugs. "The breasts despite their largeness and considerable weight, sag very slightly but no more than they did ten years ago," he wrote, and added, "her bottom is firm and round." Elizabeth lolled in the sunshine, relieved to be fondled for a change instead of yelled at. She caught up on current bestsellers, reading *Portnoy's Complaint* and *The Godfather*.[17]

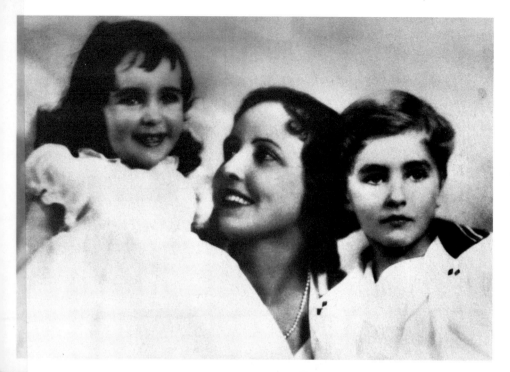

1

Captions for
photographs
begin on
page 546.

2

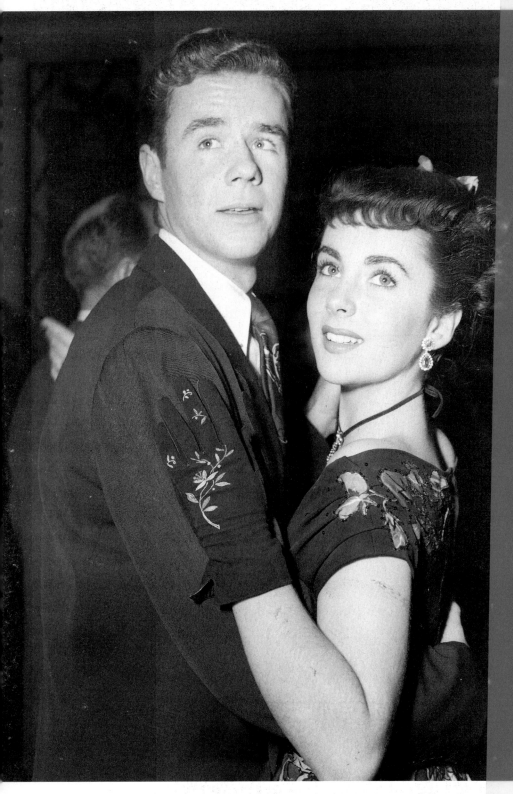

3

4

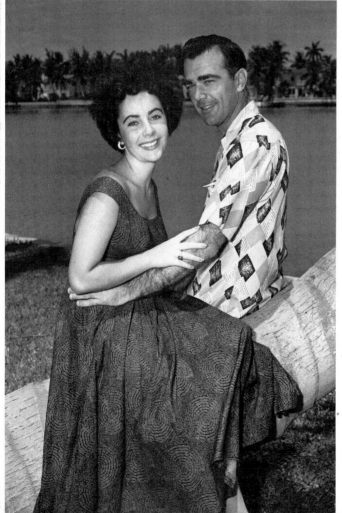

5

6

7

9

10

13

14

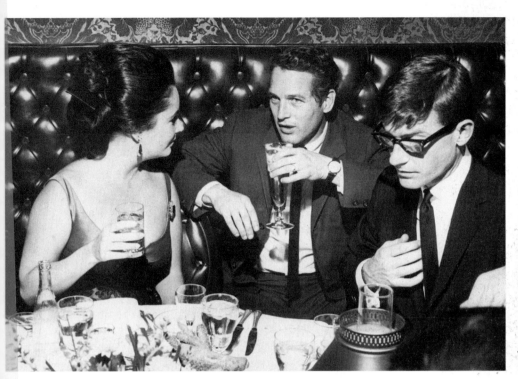

15

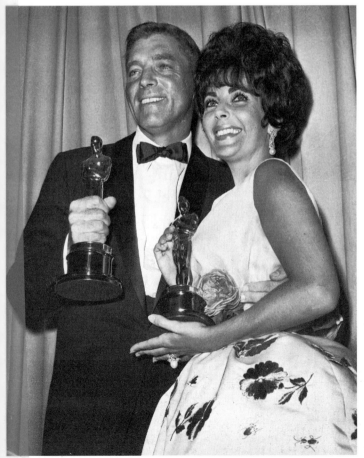

16

17

18

19

20

21

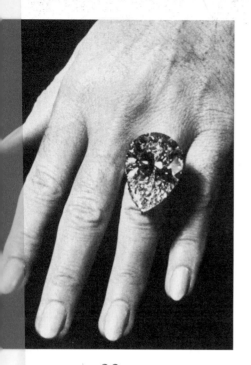

22

23

24

25

26

27

28

29

30

On April 3, after one too many, Richard reverted to bloody-mindedness and asked Elizabeth if "the bathroom [was] still smelling?"

"Yes," she replied.

He said, "Perhaps it's you," and she told him to "fuck off," storming out of the bedroom.

Later he looked up and saw her glaring at him from the doorway. "I dislike you and hate you," she said.

Sarcasm oozing from every syllable, he replied, "Goodnight and have a good sleep."

"You too," she said, but he wasn't ready to make up and left her alone in the bedroom to continue his reading in Christopher's room. Later he confessed that he'd been "testy for no very good reason," but there was no winning with him. He complained that, during their contretemps, she'd "bickered back with almost masculine pride." Any woman who disagreed with him ended up being called a lesbian, in so many words. Despite the advent of Betty Freidan's *The Feminine Mystique* and women's lib, his sexism remained as toxic as it was incurable. "In terms of being self-supporting, I've been women's lib ever since I was a baby,"[18] Elizabeth declared, but in a deeper sense, she was the antithesis of a liberated woman in her conviction that she was incomplete without a man. Nonetheless, as author and journalist Cy Egan pointed out, "She broke the mold that had trapped women for many years. She started in an era when it was a

social liability for a woman to be intelligent—you'd never get a man if you revealed how smart you were or said what you meant. Elizabeth Taylor said go out there and do what you want and say what's on your mind. Women love her. Whatever her faults, she's a feminist model."

In April 1969, peace at last returned to Casa Kimberley. Elizabeth was content to work jigsaw puzzles or play with her jewels while Richard, whose arthritic legs kept him from walking, lay abed reading. He called her "Lumpy" and said she looked "like a little girl." Their truce soon ended. By the time she accompanied him to London in May for his new film, *Anne of the Thousand Days*, they were fighting again "over anything and everything." She wanted to play Anne Boleyn opposite Richard's Henry VIII, but he frankly told her, "Sorry, luv, you're too long in the tooth." The fresh, vibrant twenty-seven-year-old French-Canadian actress Genevieve Bujold got the part. She wanted Elizabeth off the set, but it was written into the Burtons' contracts that spouses could be present any time they chose. "I'm going to give that bitch an acting lesson she'll never forget," Bujold said, and proceeded to deliver one of the screen's memorable performances, later receiving the Golden Globe trophy as the best dramatic actress of the year.[19]

During a 1969 trip to Paris, the Burtons' booze-fueled brawls at the Georges V attracted attention,

and the press dubbed them "the battling Burtons."[20] Thirty years later, in *USA Today*, they were still being referred to as "the world's most tempestuous couple." By May, they were back in London, mooring the *Kalizma* at Princess Steps on the Thames. Evidently the violence of their recent fights had rekindled their sex life. "Elizabeth is an eternal one night stand," Burton wrote on May 25. "She is my private and personal bought mistress. And lascivious with it." As a sex partner she was "a receiver, a perpetual returner of the ball," he wrote. They were just beginning to make love on June 6 when she started bleeding, "and I mean BLEED," he recalled. "Thick clots of blood that had to be fingered into disappearing down the drain." Many heavy drinkers attest that alcohol liquefies their food intake and gives them diarrhea, eventually resulting in injury to their rectums and hemorrhages with every bowel movement.

Returning to the United States, she consulted her Beverly Hills proctologist, Dr. Herman Swerdlow, at the Palm Springs home of her friend Dorothy Allen. She underwent a procedure that involved "the insertion of some dreadful machine up her behind," Richard related, but her recuperation was so speedy that by June 11, he was crowing that nothing excited him quite as much as seeing her "in the shortest mini-skirt. The slightest inclination from the vertical and her entire bum was revealed." She enraged him, however, when she

failed to cooperate with his attempts to go on the wagon.

By late September, in Gstaad, Richard's drinking had reduced him to a vegetable. Elizabeth had to help him raise his highballs to his lips because his own hands were so palsied from alcohol. On October 2, a terrible argument erupted, but Elizabeth attempted to pacify him, saying, "Come on, Richard, hold my hand."

He sneered, "I do not wish to touch your hands. They are large and ugly and red and masculine." As a guilty, unfulfilled, and repressed homoerotic male, the worst punishment he could think of was to cast aspersions on her heterosexuality. Learning at last how to capitalize on his sadistic streak, the following morning she informed him that the largest diamond in the world was for sale, and she wanted it. Perhaps it would be big enough to make her "ugly big hands look smaller," she said.[21] He was dumbfounded. She already had the 33.19-carat Krupp and La Peregrina Pearl, and now she expected him to acquire a 69.42-carat diamond ring being offered at auction by Mrs. Paul A. Ames, the sister of billionaire *TV Guide* publisher Walter Annenberg, U.S. ambassador to the Court of St. James's. At one inch long and one inch thick, it outsparkled the most famous diamond in the world, the blue 44.5-carat Hope diamond, bought by Edward B. McLean in 1911 and worn by Evelyn Walsh McLean. One of the few diamonds capable

of upstaging Mrs. Ames's was the Koh-i-noor, the principal jewel in Queen Elizabeth's state crown, which was 106.6 carats.

Having established his top bid for the Ames ring at $1 million, Richard lost it to Cartier, who outbid him by $50,000, but he later purchased the ring from the jeweler for $1.1 million, the highest price ever paid for a diamond to that date. Onassis had bid $700,000, hoping to acquire it for his wife Jackie. Elizabeth christened it the Taylor-Burton diamond. She originally wore it as a ring, but later commissioned Cartier to design a necklace for it, which she wore to Princess Grace's fortieth birth-day party at Hotel Hermitage in Monte Carlo, accompanied by two machine-gun-toting body-guards. Outraged by such ostentation, the *New York Times* implied editorially that she should wear it "on the way to the guillotine."

She was sometimes careless with the Taylor-Burton diamond. John Gielgud happened upon it after Elizabeth left it on the sink at Chalet Ariel. By November 18, 1969, its sparkle had evidently dimmed, for Elizabeth subjected Richard to what he called "a savage mauling," punishing him for having ruined his handsomeness with drink and boring her with his bragging, his insatiable greed, his womanizing, and his lies.[22]

In 1970, Sinatra invited them to visit his 2.5-acre compound in the California desert at the foot of the San Jacinto Mountains. After the splendors

of Château de Ferrières, Elizabeth and Richard weren't impressed by his Palm Springs dwelling, sadly missing the charm of one of America's utterly singular, historical houses. Situated along the seventeenth fairway of the Tamarisk Country Club in Rancho Mirage, on Wonder Palms Road, the Sinatra estate (today owned by Canadian businessman Jim Pattison) consists of a group of low, unadorned, anti-style houses that blend organically with the desert, but on the inside offer the ultimate in luxury and comfort. Sinatra told the Burtons he was campaigning for Ronald Reagan, and Richard reflected, "That's like Laurel coming out for Hardy." Elizabeth flirted with Sinatra in front of Richard, but the latter's only objection was that Sinatra "didn't respond" to her advances—so far as Richard knew. In Sinatra's bedroom was a small plaque with the inscription: "I believe in the sun even when it's not shining. I believe in love even when not feeling it. I believe in God even when he is silent."

A large oil portrait of Debbie Reynolds dominated the projection room, the entertainment center of the compound. Despite Richard's eagerness to leave, they overstayed their welcome by several days. In a 1998 interview Jean Porter explained, "Elizabeth learned to drink Jack Daniels from Sinatra." On the return flight to L.A. aboard Sinatra's jet, Elizabeth suggested they should buy one just like it, at a cost of $3,250,000. "We'd be flat,"

Richard moaned, reminding her that they were "out in the cold and fallen stars."

In Los Angeles, Richard stopped drinking after Dr. Kennamer told him he'd be dead in a year if he didn't. Later, jabbing a finger at Elizabeth during a luncheon with Norma Heyman, Richard said, "There's someone who could never give up drink." Elizabeth said she hated his guts. "Ah," said Norma, "but you do love him, don't you?" Elizabeth considered her reply carefully, for she was at a turning point in the relationship. "No," she said, "and I wish to Christ he'd get out of my life. It's been growing on me for a long time." To drive home her point, she looked at Richard and added, "Piss out of my sight." Her face, he recalled, was "ugly with loathing." She had said as much before, but never when sober and never in front of guests. He realized they were at the end of their love, if not their marriage.[23]

Observing a fragile armistice, they attended the Oscar ceremony on April 7, 1970, at the Dorothy Chandler Pavilion at the L.A. County Music Center. Richard and Gin Bujold were nominated for *Anne*—and both lost. As John Wayne accepted for *True Grit*, Richard was left to contemplate the dubious distinction of being the most-nominated actor who'd never won an Oscar. Backstage as one of the evening's presenters, Elizabeth barely managed to conceal her rage over Richard's defeat. At the climax of the evening, the presentation of the

Oscar for the best picture of the year, she flowed on stage in a gown of cascading ruffles, a regal, towering coif, and the Krupp on her sun-tanned bosom. After reading off the nominees, including Richard's *Anne*, she ripped open the envelope and announced Jerome Hellman's *Midnight Cowboy* as the winner. At the post-awards party, the Burtons were seated at the most prestigious table along with George Cukor; Gregory and Veronique Peck; and the Chandlers, owners of the *L.A. Times*. Photographers flocked to Elizabeth, ignoring Barbra Streisand and the night's Oscar winners, "to my delight," Richard recalled. Elizabeth "completely eclipsed" Streisand, the current queen of Hollywood, and so many people stopped at the table to tell Richard that he was "robbed" that he and Elizabeth were left to wonder who'd voted for John Wayne.

Three days later, Richard hosted a party at the Beverly Hills Hotel for the losers, including Jane Fonda, who was escorted by Donald Sutherland and wheedled $6,000 out of Richard for the Black Panthers, the darlings of the radical-chic set. Elizabeth disapproved of the Panthers, but she made a sizable contribution to Jane's Native American cause. After the party, the Burtons returned to their bungalow on the grounds of the hotel, where a drunken Elizabeth got into a screaming fight with her mother, Sara. Accusations flew back and forth all night, and the ruckus could be heard

through the walls.[24] Finally Richard interceded, effecting a reconciliation. "What a pair," he mused. Elizabeth then went into the bathroom and hemorrhaged. Dr. Kennamer instructed Richard on the phone to wrap ice in a towel and hold it, as Richard put it, to "her arse." When Kennamer arrived he applied bandages. On Monday, May 18, she entered Cedars-Sinai for a hemorrhoid operation performed by Dr. Swerdlow. "She had thus far had twenty-seven operations," Richard noted, describing her condition as "piles." Her doctors were attempting to wean her off heavy-duty medication, using tranquilizers instead of painkillers, and Dr. Kennamer assured Richard that he would limit the amount of "hard narcotics" prescribed for her post-op "since she is so susceptible to drugs." Dr. Swerdlow said "everything is perfect," and Richard went off to have breakfast.[25]

At 7:30 A.M. on May 21, she rang Richard at home. He complained that he was trying to enjoy a cigarette and a piece of medium-rare filet mignon salvaged from the refrigerator. In excruciating pain, she explained that Kennamer had been giving her 2.5 ccs of Demerol but now refused to, and was giving her instead, orally, "Emp & Chodine #3" and "Pergadon" pills. She insisted on being taken home, pointing out, quite logically, that pills, unlike IVs, do not require hospitalization. Her doctors objected. They wanted to observe her in the hospital as she detoxed. She would never for-

give Kennamer, Richard feared, if she discovered he hadn't been giving her Demerol, but merely tranquilizers, for the past thirty-six hours.[26] When she left Cedars-Sinai, she sneaked out in a wheel-chair to avoid photographers. If she ever intended to work again, her condition had to be hidden from the film industry, the press, and insurance under-writers. At home Richard looked at her bottom and "wondered . . . why any man would specialize in that particular part of the anatomy. So much more romantic to specialize in brain surgery."[27]

By May 29, she was almost back to normal, and Richard had succeeded in staying sober for two weeks. On June 3, in Palm Springs, with the desert heat reaching 120 degrees, Elizabeth started hem-orrhaging "great gouts of blood which were fright-ening to behold," Richard related. "I cleaned it up . . . The bathroom floor was awash with it . . . The blood was richly dark red and had the consistency and appearance of half-set jelly." She had eight anal "emissions" before Richard managed to get her back to the hospital. The doctor sedated her, but she remained fidgety and nervous. Richard urged the doctors to keep her away from hard narcotics, unable to face seeing her through another detox, which was "more than human flesh and blood can stand." Both Swerdlow and Kennamer thought her condition "minor" and suspected she was just angling "to swing for some hard shots again." In the end, she required another surgery to stop the

bleeding. One of her stitches had come undone, and it took thirty minutes for the doctors to restitch her. She emerged from surgery weakened and depressed, a semi-invalid who required months of rest to build up her blood count. Despite these tribulations, Richard was able to report on June 8 that he'd been "a teetotaler for three months."[28]

Back in Puerto Vallarta, every trip Elizabeth took to the bathroom was a "cliffhanger." For Richard, June 8 was not only an important ninety-day sobriety anniversary, but "one of the worst days I remember." Elizabeth complained of unendurable pain and cried from morning until afternoon, but Richard resisted giving her hard drugs, dreading a return to addiction. Her suffering made her, he wrote, "as helpless as a leaf in a whirlwind, a cork in a tempest." He finally called a doctor who gave her an intravenous shot. "She became dopy but easier," Richard wrote. On the morning of June 9, she was comfortable, but they were trapped again in her cycle of pain-painkillers-addiction. Sara came to visit, but Elizabeth despised the way her mother treated her like an infant, cooing "my baby, angel girl."

When Richard left for location shooting on *Rommel* in San Felipe, Elizabeth "mooned about" for a few nights, according to Richard, and then took the children and joined him in the desert. "Her sexual appetite," he wrote, "is as eager as ever

and so is mine though I don't think either of us attaches the urgent importance to it that we used to."

After a painful trip to the dentist, she went back on drugs with a vengeance. As Richard observed 140 days of sobriety that July, he ruefully observed, "Jesus, it's hard work when other people have had a few drinks and you haven't, even when that people is someone you deeply love." They had once fought over his drinking; now they fought over hers. Inevitably, he slipped.

It happened in early August 1970 as the Burtons traveled to New York by train. Elizabeth had a few drinks at dinner and told Richard he was not interesting unless he drank. To please her, he ordered a Jack Daniels and soda, downed it, and then killed two glasses of Napa Valley red wine. As he drank, he was abandoning not only sobriety but the new life he had carefully structured, one that had restored his health, good looks, strength, stamina, and the lucidity to write. He had also been able to cope with Elizabeth's illnesses, but in the future he would be incapable of nursing her. Two days after his slip, he drank an entire bottle of Burgundy with their liver and bacon meal. By the end of August, he was "stupefied with drink all day long." When Brando came from his home in Tahiti and joined them on a Mediterranean cruise aboard the *Kalizma*, Richard and Brando got into a violent shoving match.[29]

Under the circumstances Elizabeth was so eager
to return to work that she agreed to play a lesbian
in her new film *X, Y and Zee*, a story of Swinging
London's Bohemian upper crust, filmed at Shep-
perton Studios in October 1970, and costarring
Michael Caine as her husband. The director was
Brian Hutton. In our 1998 interview, I asked him
if he had to do anything to get Elizabeth to do the
lesbian scene with Susannah York. He replied,
"No! They were on the bed and they kissed. That
was the whole basis of the story. Two people who
play this game of running around, and suddenly
they get serious. Susannah York is never interested
in Michael Caine, not really. I couldn't get Susan-
nah to play the lesbian thing. I told her, 'Susannah,
it's not a lesbian thing, it's a love scene.' I had to
run the beginning of *Jane Eyre* for her to under-
stand. Elizabeth played the little girl in the rain,
going around with the iron. I said, 'She's Elizabeth
Taylor, and you're Peggy Ann Garner [a leading
child star of the 1940s who appeared with Eliza-
beth in the film and later won an Oscar for *A Tree
Grows in Brooklyn*]. You were in love with her when
you were little—and suddenly you see her grown
up. And you feel your attraction to her, but you've
loved her all your life, and you thought she'd died,
but now you can resume your relationship; it's not
a lesbian relationship. For Elizabeth Taylor it's a
lesbian relationship—she's the aggressive one
because when she figures out that you're goin' to

take her husband, in order to stop you she's goin' to fuck you. And she does. Michael Caine walks into the room and catches her. And that's when he says, 'Let's go, darling,' and she gets up and pounces out, and he just sits there, boom, that's the end. Columbia didn't have the guts and cut the sex out of the scene."

The final scene—a freeze-frame—shows the husband discovering his wife and girlfriend in bed together, and the implication, according to Edna O'Brien, the Irish novelist who wrote the screenplay, was a ménage à trois: "The last we see are their three bodies—arms, heads, torsos, all meeting for a consummation."[30] O'Brien, who was as beautiful as Elizabeth in her way, later wrote that Elizabeth seemed "surprisingly nervous, very watchful over Richard as if every woman was a threat."[31]

Brian Hutton continued, "Poor Elliott Kastner, who produced *Zee*, used to be up there at nine in the morning making bacon and eggs and getting Elizabeth sandwiches and doing anything in the world to get her down on the goddamn set and in the process became her personal gofer. I was so far behind, but it didn't matter because Roman Polanski was making *Macbeth* for *Playboy* down the street for Columbia, and he was twice as far behind as I was, spending three times the amount of money that I was, and at least twice as late, but he was terrific. Every morning I'd see him at Shepperton Stu-

dios and I'd say, 'Roman, are you getting your stuff?' 'I'm getting it,' he'd say, 'but they're always pressing me to speed it up. I do what I want to do. They can go fuck themselves.'

"They couldn't bother with me because he was so far behind. Elizabeth wouldn't get down to the set until ten or eleven o'clock, and she'd go to lunch at one o'clock, and she wouldn't get back from lunch until three o'clock—unintentionally, of course. This was what she was: a fuckin' major movie star and the most famous woman in the world. All her life, this is what she did. She was the nicest lady in the world, sweet, fun, a million laughs, I had a great time with her. But when I was two or three weeks shooting, I was already a week behind. Columbia was going hysterical about it. The studio's British chief, Stanley Shapiro, was a nice guy; he came on the set and expected Elizabeth to be there by 9:30. I told him, 'You watch now. That fuckin' broad hasn't gotten down here by 9:30 once since we started shootin' this picture.'

"If you'd have said anything to Elizabeth like, 'You're holding up production,' she would have broken down crying and said, 'Why, I'm here every day!' And she was. Stanley said to me, 'Get her down on the set. Get her down here.' I was a week behind schedule, and Stanley said, 'Oh, you got to get her down here.' I said, 'Look, it's eight o'clock in the morning. If you want her, you can get her.

It's not my job to get the actors onto the set. You do that, or get the producers to do it. When they get the actors on the set, that's when I start to direct a movie. You don't hire Elizabeth Taylor thinking that she's going to be here standing by at 8:30 in the morning. If you don't know what you're getting after she's been a star for thirty years, that's your problem, not my problem. I knew she wasn't going to be on time, and I don't give a shit if she's not on time.'

"Shapiro comes on the set. Now this is class: She told me, 'They can stick it up their ass.' Shapiro sat there for three hours waiting for her. She comes down a quarter till twelve. She's Elizabeth Taylor. She comes down when she wants to come down. I'm not goin' to go up and knock on her door and say, 'Hey, Elizabeth, we're waiting for you.' She'd start to cry. You tell her she's got to come down and she'll never come down. Or she'll come down a week from Friday. She'll fall down the fuckin' stairs or somethin'. She's the most accident-prone person in the world. But she was just wonderful.

"She was perfect with her lines. She would come in in the morning. She'd take the script and put it on the mirror. She'd sit there and learn the lines. She would know her lines perfectly. The great advantage of working with her was that I would make these enormous setups. I'd set up a shot, and when she came on the set, she went through the blocking once and you tell her you go here and you

go there, and I'd get six or seven pages on the first fuckin' setup. Even if she did come down at eleven o'clock, it wasn't so bad, the way we worked. I'd use the time to plan. She was a fuckin' babe, a real trooper. If she'd have been an unknown, the fuckin' critics would have raved about her in that role instead of knockin' her.

"Michael Caine had just started to go out with Shakira, his [future] wife, and they were very romantically involved at the time. He was great with Elizabeth, and would go upstairs and be able to get her on the set: 'Come on, moms,' he'd say, 'let's go!'" In his 1992 memoir *What's It All About* Caine recalled that Elizabeth always had a "huge jug" of bloody Marys on the set, and that Richard got drunk every night and slept off his hangovers on her dressing room sofa. Richard considered himself sober any time he didn't have more than a fifth of vodka in him, but at this point he was going through two to three bottles a day. After interviewing him on the set of his film *Villain*, a thriller in which he played a psychopathic Cockney gang-leader, Bernard Weintraub wrote in the *New York Times*, "The drinker, the lover, the celebrity have flattened into a surprisingly weary figure." The reporter found Richard to be "oddly vulnerable, even frail."[32]

On October 6, 1970, at London's Caxton Hall Registry, long-haired eighteen-year-old hippie Michael Wilding Jr. wed Beth Clutter, the nine-

teen-year-old daughter of a Portland, Oregon, oceanographer. As usual, all eyes were on Elizabeth, and a British daily headlined, "Here Comes the Mother of the Groom." With one of her elephantine diamonds flashing on her finger, Elizabeth wore a white wool knitted pants suit, a cardigan maxi, and a pearl necklace. Richard stood at her side in a conservative business suit. The father of the groom, Wilding Sr., was suffering from heart disease and unable to attend. Mike Jr.'s hair was so long people were yelling, "Hey, girlie," at him. Elizabeth had been so insulated in her jeweled cocoon the past ten years that she was ignorant of the "youthquake," the generational upheaval of the sixties, and admitted to Charles Collingwood on CBS's *60 Minutes* that she didn't know what the word "hippie" meant. Her son certainly did. His bare toes peeped out of his sandals, and he wore a Tudor tunic of maroon velvet and bell bottom trousers, while his flower-child bride appeared in white butter muslin and an Afro hairdo. A sensitive and intelligent girl, Beth seemed to understand Michael's unusual background and how it had affected his character. "Elizabeth was away so much," she said. "He dropped out of school at fifteen and lived on what Elizabeth gave him."[33] And Elizabeth was still doling it out—she generously gave the newlyweds an all-expense-paid honeymoon at the Dorch, a Jaguar, and $100,000 in cash. Richard gave them a

$70,000 house next to his home in Hampstead.

No amount of largesse could provide a solid foundation for Michael, who'd been deprived of a normal family life, and whose childhood acting ambitions had not been nurtured as they could have been a few years back when his parents had been among the most powerful figures in show business. "Michael is in danger of earning Elizabeth's hatred," Richard wrote. "He thinks of his mother simply as a beautiful woman who because of her looks alone is a highly-paid film star. He has no idea that she is a major talent and therefore resents her wealth." Michael eventually found work in his mother's entourage as an assistant to Gianni Bozzachi, her personal photographer, but he remained uncomfortable sharing the Burtons' affluent, let-them-eat-cake existence. Shortly after their marriage, Beth confided to Elizabeth that she was pregnant, and that Michael "didn't know what he wanted." Beth knew. She wanted the baby, and Elizabeth stood behind her, promising to help her in every way, including financially. "She spoke to me like a mother," Beth recalled. Though Elizabeth could no longer give birth, she hadn't given up hope of having more children, nor had Richard, who said, "We've been thinking about adopting another child for some time now."[34]

Though in poor health, Richard worked furiously to cover their skyrocketing expenses as the number of their dependents continued to grow. He

completed five films between the autumn of 1970 and the end of 1971, all box-office bombs. Though he'd dreamed of a knighthood, the most the Queen offered him was the lesser CBE (Commander of the Most Excellent Order of the British Empire), and an affronted Elizabeth advised him to turn it down. Though disappointed they weren't to be Sir Richard and Lady Burton, he viewed the CBE as preferable to the Beatles' "inferior" MBE. He claimed, somewhat disingenuously, that his CBE "was obtained without any attempt on our part to get it," though all their charitable donations and activities at Oxford had been undertaken with exactly that end in mind.[35] On Richard's forty-fifth birthday, Elizabeth and Cis James, his beloved sister, accompanied him to Buckingham Palace, where he received the only public honor of his career.

He blamed the Inland Revenue for his failure to appear higher on the Queen's honors list, saying, "How can they give a knighthood to someone who doesn't pay taxes?" But Noel Coward's tax dodges had not prevented him from being knighted. Richard simply couldn't come to terms with the fact that at the highest level of British society he would always be declassé, not for having sinned but for having done so indiscreetly. His intimacy with the disgraced Duke and Duchess of Windsor may also have annoyed Buckingham Palace. When the Burtons gave $100,000 to one of Princess Mar-

garet's charities, HRH said, "Good heavens, how very generous of you. I am absolutely staggered. We must simply spend some time together. Well, goodbye, I still can't get over your extraordinary generosity."[36] Still smarting over the palace's having withheld a knighthood, Richard called the Princess "fatuous."

Studio interest in the Burtons remained so nil that they worked for expenses and fifteen percent of the gross in Peter Ustinov's *Hammersmith Is Out*, a comic version of *Faust*, filmed in Cuernavaca, Mexico. Elizabeth played Jimmie Jean Jackson, a waitress in a blond wig, and Richard portrayed an escapee from an insane asylum. Robert Redford was approached to costar as the nose-picking antihero Billy Breedlove but declined, and the role went to Beau Bridges, a star of lower wattage. In her role, Elizabeth was erratic, in and out of character, and Richard tried to recapture his old fire, but there was no chemistry between them. They reminded some viewers of two worn-out prizefighters hanging on to each other in a last-round clinch. At one point during the filming, Richard made a wrong move on camera and Elizabeth yelled, "For God's sake, Richard, not that way. You're throwing shadows on Beau and me."[37] He endured her rudeness, according to an onlooker, like a "tranquilized lion."[38]

She became a grandmother at thirty-nine when Beth Wilding gave birth to a daughter, Laele, in

mid–1971. Arriving in London decked out in white lace hot pants, a plunging lace top, gold hoop earrings, and white knee boots, Elizabeth told reporters, "This is the baby Richard and I could never have," betraying somewhat possessive designs on the infant. She reportedly offered to help Michael Jr. establish himself in whatever profession he chose, but she refused to support the street people who were crashing in his townhouse, where sleeping bags were spread out on the floors. On July 28, Richard wrote, "I think Elizabeth and certainly I would abandon Mike to his own idiocy for a while—were it not for the baby and Beth."

Mike started a band and acquired $40,000 worth of electronic equipment, including guitars, drums, and speakers. Although the "British Invasion" dominated the top forty for a decade, his band never caught on.

That summer of 1971, Elizabeth had no film commitments and stayed at Chalet Ariel as Richard prepared to play Marshal Tito in *The Battle of Sutjeska*. Maria, Liza, Michael, Christopher, and Kate were in and out of their lives, and Richard objected that fourteen-year-old Liza, who was attending Heathfield, a British boarding school, took up too much of his time. Mike Todd's daughter had blossomed into a beautiful girl, much pursued by boys, and Elizabeth was as watchful "as a mother superior to a novice."[39] Liza's concerns, such as masturbation, which she'd seen mentioned in a "Dear Abby" col-

umn, were the kind normally taken to a mother, but she came to Richard. He assured her that masturbation was a normal part of growing up, but wisely cautioned that overindulgence could "spoil" her for sexual intercourse. When Liza had her first period, she went to neither parent, appealing instead to Elizabeth's blond, Swiss secretary-majordomo Raymond Vignale, who revealed that Elizabeth was not "closely involved" in her children's lives but loved them nonetheless.[40] "Raymond was a great character and wit, who stage-managed the Burtons' nomad hotel existence, took charge of the packing of their thirty trunks, carried the jewels, and hid the pills," remembered Dominick Dunne in 1999. "He could speak five or six languages and camp in all of them."[41]

Elizabeth accompanied Richard to Yugoslavia when he portrayed Marshal Tito as a wartime guerrilla in *Sutjeska*. Years later, Hollywood mogul David Geffen told her he was going to Yugoslavia and asked her to recommend a good hotel. "I don't know," she said. "Whenever I was in Yugoslavia, I stayed with Tito." Princess Margaret told the Burtons that Tito's palace "makes Buck House look pretty middle-class," and Richard later confirmed that Tito and his wife lived in "remarkable luxury unmatched by anything else I've seen." Tito, whose communist forces drove the Nazis from Yugoslavia in 1944, was "surprisingly small and delicate," Richard noted. Portraying him in the official state

film paid for by the Yugoslav government was "tedious" work, but Elizabeth thrived on the pomp and circumstance of palace life. Protocol decreed that they remain close to the president and his wife almost constantly—Tito with Elizabeth, Richard with Madame Broz. The liquor never stopped flowing in Dubrovnik. Elizabeth consumed both Smirnoff and Jack Daniels. Richard managed to put together two months of sobriety but the effort caused him to smoke one hundred cigarettes a day, and watching Tito gulp glass after glass of whiskey was demoralizing.

In October 1971 the Burtons were back in Paris, where Richard played the title role in Joseph Losey's *Trotsky*, costarring with Alain Delon and Romy Schneider. Neither of the Burtons was drinking, and as a result the children's behavior was exemplary. "Michael was himself again," Richard wrote, "loving with the baby, fun to talk to *and to listen to*. Elizabeth was happy as only a grandmother can be." Baby Laele was delightful, kicking her legs and blowing spit bubbles and almost never crying. Elizabeth slopped around in Levi's. Thanks to their sobriety the Burtons were like newlyweds again, forgiving old grudges and staying up half the night talking about places they'd been to and where they'd go next. Sometimes they performed their "bed exercises" together, running in place, and Richard loved to watch her holding on to her breasts, "one hand on

each, or firm as they are, really like a thirty year old's more than a nearly forty year old's, they are pretty big and the resultant wiggle-waggle would be pretty odd as well as bad for her. It's a very fetching sight." He found it profoundly satisfying to contemplate that ten million people would immediately rush into their bedroom if given the same access to her breasts that he enjoyed.[42]

Elizabeth swore off liquor altogether on November 1, 1971. One week later, she was thinner, less indolent, more high-spirited, less uptight, more beautiful, and even her double chin seemed to shrink. On November 10, Richard's forty-sixth birthday, both of them got drunk. "The rot set in when I made a large martini each about 1 o'clock," he recalled. They went on a binge, and Elizabeth later discovered a cyst on her nose. The growth had to be removed surgically in Paris. They dried out at their chalet in Gstaad, but Elizabeth fell ill at the end of November and wanted a drink. On the 29th she pulled herself together and cooked a steak au poivre for lunch, then tried to pressure Richard into having a martini because she didn't like to drink alone. He called her "the devil over my shoulder." Taking even a single drink with her, he tried to explain, meant "slowly reverting to being a drunkard again, and I simply will not tolerate a return to that." She kept at him, insisting that he make a martini for her. He began toying with the notion of a slip.[43]

In December 1971, the Rothschilds threw "the ball of the century," as it came to be known, and the Burtons were not only invited, but were asked to stay over at Ferrières. Van Cleef representatives showed up in plenty of time for Elizabeth to select her jewels, as Richard sarcastically wrote on December 1. The value of the gems she wore to the ball was estimated at $3 million. On their way to the party, they picked up Princess Grace at 32 Avenue Foch, where Prince Rainier escorted her to the gate. Her Serene Highness traveled light, carrying only two small suitcases, but, unlike Elizabeth, who traveled with enough clothes to stock a boutique, the Princess was not staying overnight at Ferrières. At the Champs Élysées, they hit heavy rush-hour traffic, due to Elizabeth's habitual tardiness, and they were two hours getting from Paris to Ferrières. The Rothschilds, who had employed Pompidou before he became prime minister, stationed Paris gendarmes, motorcycle cops, and police vans every one-half mile along the way in case their guests had car trouble or needed directions. Elizabeth and Grace chatted amicably in the back of the Caddy while Richard, up front with the driver, noted "the initial awkwardness . . . with people like Grace who are in a somewhat false position and know it." After they relaxed, Grace gave them a blow-by-blow account of the Shah of Iran's recent party, which she defended against the press's charges of vulgarity, pointing out that the Shah

had brought together people of different races, politics, and religions. Richard didn't buy that, and said it would have been better to provide jobs for his impoverished subjects by having a World's Fair or an Expo 72 in Iran. As a loyal member of the ruling class, Grace let the subject drop.

There was a crush at the main entrance of Ferrières, but the Burtons, as special weekend guests, were permitted to use a side door that led directly to their rooms, and they took Grace upstairs with them. The Princess had been assigned a room, the Chambre Balcon, for only a few hours, so that she could have her hair styled in privacy and change into her ball gown. The Burtons were given the Chambre Rose, which was less grand but adjoined Sir Laurence Olivier's room. Though the Chambre Rose was pretty, with pink decor and Wedgwood, they had to walk across the hall to the bathroom, and Richard resented having to wear more than his shorts to the loo. The walls of the château were surprisingly flimsy, and the Burtons could hear everything being said on either side of them, so they gossiped in whispers. After complaining to their hosts, they were assigned to the Chambre Balcon as soon as the Princess departed.

In the careful protocol of the ball, they were given instructions to go downstairs with Princess Grace and the Duchess of Windsor, and to appear promptly at 9:10 and sit down to dinner at 9:30. Alexandre was doing both Marie-Hélène's hair and

Elizabeth's, and he was late. The famous hair-dresser of the Rue du Faubourg Saint-Honoré was indebted to the Duchess of Windsor for his réclame, for she had been his first important client. When he finally arrived at Ferrières that evening, naturally he had to attend to Marie-Hélène first, and only later Elizabeth. Grace was ready before the other two women and joined Richard in the Chambre Rose for a cocktail. He suggested she didn't need the choker necklace she was wearing, which looked too tight. It had been borrowed, she replied, and it was awfully hard to get off, so she decided to keep it on. Finally, at 10:30, they all descended together to the great hall, but no one sat down to dinner until 11 P.M. The Burtons were at separate tables, and Elizabeth's was the more illus-trious, including Princess Grace, the Duchess of Windsor, Guy de Rothschild, Maurice Hertzog, and Jean-Paul Binet. "The lucky bastards," Richard observed from his position in Siberia, table number eleven, where his companions included Andy Warhol ("atrociously wigged"); the former, pre-Candace Bergen Mrs. Louis Malle (a "giant of a woman," who drank a dozen glasses of wine); and Madame de Montesquieu, who explained to a yawning Richard that she was a descendant of Charles Louis Secondat, Baron de Brede et Montesquieu, author of *L'Esprit des Lois*. "Where's my Elizabeth?" Warhol asked. "Eating at the corresponding table to this . . . but at the other

end," Richard rasped. "I wish she was here," Warhol whined. "So, as a matter of fact, do I," Richard replied. The pop artist's face reminded him of "funny putty [full of] odd lumps," fashioned by "an inept child." Had Richard known that Warhol sprang from a coal-mining town, Pittsburgh, they might have had more to talk about.

At Elizabeth's table, as at all the others in the crowded hall, waiters could reach only one of the guests, and each table selected someone to take the food from the waiter. Princess Grace became a "hander-over," passing dishes around to Elizabeth and the others. Wines included the legendary Lafite Rothschild, Château D'Yquem, and champagne. Elizabeth and Grace thought the doddering Duchess of Windsor hilarious in her elaborate feather headdress, which got stuck in Guy's glued-on mustache. The Duchess was so animated that her long feather also ended up in the soup and the ice cream, and it struck Guy in the mouth and eyes. Elizabeth got the impression that the Duke of Windsor was about to die, because the Duchess was insistent that the Burtons come to see him before their departure for Gstaad. Elizabeth said they'd dine with the Windsors on Monday night, and then the Duchess shrieked, "Do you like my feather?" Jean-Paul Binet flirted outrageously with Elizabeth, but Richard, peering from his table, raised no objection since Jean-Paul courted women in "the best

French manner." Just as he'd wanted her to have an affair with Sinatra, he now practically gave her to Binet, as if someone else were needed to relieve the pressure he was under as her husband.

He did his best that night not to fall off the wagon. In view of the provenance of the wine, he was "sorely tempted" but resisted it, with the result that he felt great the next day. He adored Madame de Montesquieu from the moment she said she owned and often listened to his recording of "The Ancient Mariner." At Elizabeth's table, Guy asked her if she would come to the bathroom with him, explaining that his fake mustache was uncomfortable and he needed help removing it. While a servant stood outside the lavatory, she went in and removed the mustache and was wiping Guy's mouth with a towel, their posture suggesting that they were necking, when the model Bettina opened the door. She said she was delighted by the sight of Elizabeth wiping around Guy's mouth, and Elizabeth told Bettina she could come up to the Chambre Rose if she needed to repair her makeup after dinner.

Following the banquet, a horde of "B" list guests arrived and each was announced by a butler with a booming voice as he pounded a huge staff on the floor. Richard escorted Madame Malle and Elsa Martinelli to the Chambre Rose and found Elizabeth and Bettina chatting. As the women

attended to their maquillage, Richard smoked nervously and tried to relax. Returning to the party, the Burtons sat with Princess Grace in a corner as hundreds of curious guests filed past for a quick gander. In search of more stimulating company, Richard left them and soon fell into a conversation with Jacqueline de Ribes, Pierre Salinger, Sam Spiegel, and "Broken-nose," Marie-Hélène's likable older brother. With Salinger, Richard reminisced about the night in Los Angeles when he and Bobby Kennedy had gotten into a good-natured insulting match about their respective races, "bloody Irish v. bloody Welsh." Mingling again, Richard saw that Elizabeth had left her corner and begun to circulate. Everywhere she went, people gazed at her covertly but admiringly. Even at forty, and in a roomful of titled swells, she was the belle of the ball of the century.

At 1:30, Princess Grace asked Richard to come upstairs and help extricate her from the choker. Tugging at the difficult necklace, Richard almost strangled the Princess before they managed to twist it around so that she could see the clasp in a mirror and unlock it herself. She asked Richard to escort her to her car, and as they went downstairs, Sam Spiegel, the Polish-born producer of *Suddenly Last Summer*, said, "Where are you going, you two?" "For God's sake," said Grace, "don't, Sam, say a word to Elizabeth. She's at the ball, she's

dancing, she's happy, let us go. Richard will let Elizabeth know. It's going to be a shock but . . . these things happen." Due to Grace's Oscar-caliber acting and Richard's guilt-ridden face, Spiegel gaped at them for a full half-minute before she and Richard left him, without explaining they were kidding. After waiting with Grace in the sharp cold air outside, Richard found her car and waved her off.

Back inside, Sir Cecil Beaton photographed Elizabeth and Richard, and also got shots of them with Marie-Hélène's sister-in-law Gabby Van Svillen, who insisted she was the Tsarina of All the Russias. Richard told her that at best she might have "Mike Romanoff blood," and turned to discuss poetry with Paul Valery's son. Though the party went on until 7 A.M., the Burtons went upstairs and moved into Chambre Balcon at 4:30. Elizabeth removed her jewels and placed the large ones in the "house coffre." They had tea at 5 A.M. and sat gossiping about the ball. Audrey Hepburn's Italian psychiatrist husband Dr. Dotti, they decided, was "not very nice." Richard reported that David Rothschild had been surprised to see Princess Grace acting "so gay [because] she had always . . . been a bit of a dead weight." Richard had told David that Grace always needed a little drawing out. The Burtons could still hear the orchestra playing downstairs, but promptly at seven it fell silent, and the diehards left to join the

early morning traffic into Paris. Though the Burtons only got four hours' sleep, Richard felt strong and healthy because of his abstinence.

On December 7, 1971, the Burtons dined with the Duke and Duchess of Windsor and, according to Richard, "half a dozen of the most consummate bores in Paris." A frequent guest of the Windsors, Sir Cecil Beaton, once wrote, "The cafe society the Duchess took up with in Paris was downright *trashy*." Another guest, Cyrus Sulzberger, found the Windsor set to be "a weird collection of social derelicts." The Duke's most prestigious friends had dropped him after the abdication, fearing palace reprisals, and they'd been replaced by people like the Alexander Farkases of New York's Alexander's discount stores, who lent the Windsors their villa, La Roseraie, at Cap Ferrat. Oddly, despite thirty years' residence in France, mostly in Paris, the Windsors had few French friends apart from the Rothschilds. Though the French government extended every hospitality, giving them their house for a token rent of $50 a month, charging them no income tax, and providing security guards around the clock, the Duchess still referred to the "*filthy* French," and the Duke said the only fault with the lovely Gallic countryside was that it was "populated with Frenchmen." The Burtons noticed that the Duke's left eye was permanently closed, and he limped as he walked with a cane; he "must die very soon," Richard commented, "but it is she

who is now nearly completely ga-ga." Though
Noel Coward once complained that the Duchess
talked of nothing but plastic surgery, with the
Burtons the Windsors talked of nothing but how
he had once been the King of England. "And
Emperor," Richard put in. "And Emperor," the
Duchess repeated, nodding and smiling apprecia-
tively, "and Emperor, we always forget that. And
Emperor." The Duchess's memory came and went,
sometimes returning in vivid detail. She viciously
gossiped about Grace Kelly, calling her "a boring
snob." Richard leaped to Grace's defense, but
finally gave up when he realized the Duchess had
fallen into a senile blackout. Though the Burtons
found the evening "sad and painful," they wouldn't
have missed it for the world, both of them being
incorrigible snobs. They came out of this period
with no real friends, and as his fourth wife Sally
would later observe, Elizabeth and Richard were
surrounded by attendants. Former friends like
Stanley Baker dropped away. "It seemed strange
that he didn't seem to have real pals. And he was
such a pally chap in one way. But it does not seem
to happen to the big stars."[44]

Elizabeth was ill in late December 1971, "her
back . . . kicking up again like fury," Richard
recalled. They had returned to Gstaad, and the
altitude was aggravating her condition. "She
sparkled in Dubrovnik, she was radiant in Rome,
she was a young girl in Paris, but here she seems

listless and slightly bored all the time, not just with me, but with everybody and everything," Richard wrote. Though the life they led was the envy of most, its price was the isolation that comes with self-absorption and selfishness. As Elizabeth would not discover until she sobered up and started helping others fifteen years later, boredom is not an affliction that besets those who dedicate themselves to the sick, the hungry, and the helpless. In 1971 she was still a young woman looking outside herself for approval, pleasure, and meaning, still a victim of expectations that would never be fulfilled. A deluded public thought the Burtons the luckiest couple in the world. "Theirs is obviously not only a good marriage," wrote the usually more astute *Life*, "but a great one."

The 1970s would become the decade of spectacular theme parties, and one of the first was the fortieth birthday celebration Richard threw for Elizabeth in Budapest, Hungary, on February 27, 1972. Richard's film *Bluebeard*, in which he hammed it up a la Vincent Price as Baron Kurt von Sepper, was financed by Hungarian and Italian money, and the Communist Party was fully cooperating with the production. The Burtons were now such fixtures in the jet set—rechristened "the beautiful people" by *New York Times* society reporter Marylin Bender in her 1967 best-seller—that Princess Grace de Monaco did not hesitate to RSVP with an enthusiastic yes when invited to Elizabeth's party,

though it was being held behind the Iron Curtain, in a Soviet satellite nation. It seemed to Her Serene Highness, one of Elizabeth's oldest friends, the perfect way to celebrate the new decade. But the seventies, for Elizabeth, would be anything but serene, beginning with the embarrassingly meretricious Budapest bash.

10

One More Go at Love:

THE DIVORCE AND REMARRIAGE
OF STURM UND DRANG

In the 1970s Hungary was a brave, freedom-loving, and defiant nation trying to survive under the yoke of communist tyranny—hardly the ideal setting for one of the most expensive and showy revels of modern times. Elizabeth's birthday party guests were flown to Budapest first-class and put up at the Duna-Intercontinental Hotel, all courtesy of the Burtons. Duna is the Hungarian word for Danube, the 1,770-mile river that flows beneath the penthouse suite the Burtons occupied in the winter of 1972. Richard's *Bluebeard* costars were four of the most attractive women in the world—Raquel Welch, Nathalie Delon, Virna Lisi, and Joey Heatherton—and none of them was among the two hundred guests Elizabeth invited for the weekend of February 26–27.

When guests arrived, they discovered huge bouquets of flowers in their rooms at the Duna, as well

as champagne on ice, wet bars stocked with hard liquor, and carte-blanche room service. There were several parties during the weekend, graded to the status of the guests, who included British Ambassador and Mrs. Derek Dodson; Ringo Starr and his wife; Michael Caine and Shakira Baaksh; Michael Wilding Sr. and his wife Margaret Leighton; David Niven; Susannah York; poet Stephen Spender; Princess Grace (with her lady-in-waiting Madame Aurelli); Mrs. Yul (Doris) Brynner; model Bettina; comedian Frankie Howerd, who'd given Richard a guest shot on his show early in his career; Nevill Coghill; Simon and Sheran Hornby; Kurt Frings; publicist John Springer; Emlyn Williams and his sons Brook and Alan; Welsh actor Victor Spinetti; Alexandre; Gianni Bozzachi; Joseph and Patricia Losey; Elizabeth's mother and brother; a dozen members of Richard's family, including Cis James and Graham Jenkins; Christopher Wilding (now at the University of Hawaii); and Liza Todd, released from Heathfield, her English boarding school, for the occasion. According to Hollywood agent Dorris Halsey, her friend George Cukor attended, and was feted by Hungarian film students, who called him "*Gyuri bacsi* [Uncle George]." Conspicuous by his absence was Michael Wilding Jr., who refused to attend, finding the Burtons' gaudy lifestyle increasingly repellent.[1]

During a cocktail party in the Burtons' suite, Richard introduced Maria to all her Welsh aunts

and uncles. The Jenkins family adored Maria because she closely resembled Kate Burton, and some of them said Maria could easily have been Sybil's daughter with her round face and cherubic cheeks. Richard's brother Verdun, who'd never been in an airplane before his flight from Wales to Budapest, sat next to Princess Grace at a small family dinner. Uncomfortable in a new shirt with a collar that was too small for his muscular neck, Verdun told the Princess, "I can't understand it. I know I asked for the right size." The sensible Grace suggested, "You must change. You can't sit there all evening looking as if you're about to have a seizure." Verdun left the table and when he returned in ten minutes, Grace noticed he was wearing the same shirt. "There was nothing wrong with the size," Verdun explained. "It was just that I'd forgotten to take out the cardboard stiffeners." Richard noted that both Elizabeth and Grace "behaved superbly" when introduced to his sprawling working-class clan, including brother Tom, who helped himself to the Beluga caviar and made a heaping deli-type sandwich.[2]

The Jenkinses gave Elizabeth an engraved plate made of Welsh steel and a box of laver (seaweed) bread, a Welsh specialty. Caine and Starr gave her paintings. In a spirit of high camp, Spinetti gave her a tin of diamond polish, perhaps anticipating Richard's gift: the legendary "Taj Mahal" diamond, a yellow heart-shaped gem costing $50,000. Cut in

1621, the jewel was inscribed "Love Is Everlasting" in Parsee and had been given by Shah Jahan, the Indian mogul who built the Taj Mahal, to his wife Mumtaz Mahal. The Taj Mahal diamond was set in an eighteen-karat gold latticework pendant and suspended from a gold chain studded with diamonds.

At her birthday supper, Elizabeth wore her new diamond on her bosom and the Krupp diamond on her finger. On either side of her were seated Michael Caine and the American ambassador, one of eight envoys in attendance, and sitting opposite her were the Ringo Starrs. Richard was surrounded by Princess Grace, Cis, the British ambassador, and Spender. A Hungarian pop group played as chicken Kiev and fruit salad were served, followed by iced chocolate cake with forty candles. "I would have liked to have brought the Taj Mahal for Elizabeth," Richard announced, "but it would have cost too much to transport it."

As the lavish weekend of partying got under way, the press was increasingly critical of the Burtons' boastful hedonism. Elizabeth got "fractious at the slightest hint of criticism," according to Richard, who found it necessary to round up all the reporters and mollify them at a press conference, "which went alright," he wrote. Elizabeth later grumbled, "We don't live in the jet set at all. We go to two or three parties a year. I haven't lived in a vacuum."[3] But reporters had been chronicling her life in the fast lane for too many years to be fooled.

The main event on Sunday evening was held in the Duna's rooftop nightclub, decorated for the occasion with white lilacs, red tulips, and thirty-five hundred helium-filled gold balloons from Paris. Guests danced to a thirty-piece orchestra, and the uninhibited exuberance of Richard's family made everyone relax and have a good time. At one point, Princess Grace unwound her braids, let down her hair, and broke into a wild Hungarian dance. Later she joined a conga line, sweeping merrily past the booth where Richard sat talking with Spender, Frankie Howerd, and Susannah York. Spinetti described it all as "a riot of fun and nonsense." Raquel Welch managed to crash the party, and one of Richard's brothers, noticing that Raquel had her arm in a plaster cast, inquired whether he could help her get into her bra. The party succeeded largely because Richard remained sober and embarrassed no one, sipping soda water throughout the weekend.

The only mistake had been inviting Emlyn Williams's older son Alan, author of a book on the Hungarian Revolution of 1956. Though Emlyn was Richard's discoverer and esteemed mentor, and though Emlyn's younger son Brook ("Brookie") was Richard's best friend and sometime employee, Alan called Elizabeth "a beautiful doughnut covered in diamonds and paint." Confronting her at the wine-cellar party in the Duna, he said, "Don't you know what happened here in 1956? What does

the Hungarian Revolution mean to you?"[4] A non-plused Elizabeth burst into sobs.[5] With admirable presence of mind, Richard promised to match the projected cost of the party, $45,000, with a donation to the United Nations Children's Fund (UNICEF). Bob Wilson and Gaston the chauffeur then tossed Alan out of the party.

Later, Emlyn strolled with his son beside the Danube, and they were observed conversing in a dark mood. Eventually Emlyn wrote the Burtons a thoughtful letter and Richard forgave them. The following July 8, Richard presented $45,000 to Peter Ustinov, ambassador-at-large for UNICEF, later telling reporters, "Elizabeth and I do this sort of thing to square our own consciences." Though extraordinarily generous, the UNICEF contribution fell short of the cost of Elizabeth's party by $955,000.[6]

Such extravagance disgusted Michael Wilding Jr., who told reporters, "I really don't want any part of my mother's life. It seems just as fantastic to me as it must appear to everyone else. I just don't dig all those diamonds and things. I suppose I've always rebelled against it." London's *Daily Mirror* headlined, "Liz's Dropout Son: Michael Wilding Jr. Lives the Hippie Life to Get Away from All Those Diamonds." Despite Elizabeth's protests, Michael moved his family into a commune in Pnterwyd, a remote village in Wales, and tried to grow natural foods. Richard, who'd fought

his way out of Welsh poverty, said, "I made it up and the boy's trying to make it down, and I try not to interfere, but I still get goddamned mad. When I think what it took to climb *out!*" Michael Jr. told reporters, "Mama has only Richard Burton on her mind, and he likes to live like a Roman emperor."[7]

The Burtons celebrated their eighth wedding anniversary on March 15, 1972, which Richard called "a monumental achievement." A monumental disaster was more like it, for the dinner party that Ambassador Dodson and his wife gave them turned into a scene out of *Virginia Woolf*, thanks to Richard and his drinking. Edward and Jean Dmytryk were there, along with dignitaries from several embassies, including the U.S. attaché and his wife, and Joey Heatherton. Recalled Eddie Dmytryk in 1998: "Elizabeth went through a lot; Burton was on the wagon when I was directing him, but then his brother [Ifor] died. There was something wrong with his brother mentally. He had an accident at their place in Switzerland. They were just waiting for him to die, and finally he died. I gave Richard a few days off to go to the funeral. When he returned, he was on the liquor. He'd use any excuse to get off the wagon. Elizabeth was having dinner with the American ambassador in Hungary, and other high diplomatic officers. Richard made a crack about a Belgian woman who was there with her diplomatic husband. Elizabeth said, 'Ri-CHARD!' He got up, went out, got his

chauffeur, and got into his car and left. One word from her was all it took." Earlier in the evening, Richard had enchanted their hosts' young daughter by reciting poetry. "He knew all of Dylan Thomas by heart and would recite it to the kids, the family," Dmytryk said. "He was a brilliant man in many ways, but when he got drunk, he was as nasty as Spencer Tracy. In *Bluebeard*, Richard had to be carried to work in the morning; his guard and his manager would each be under one shoulder."

In our 1998 interview, I asked Dmytryk what brought about the end of the Burtons' marriage, and he said, "He was fooling around with women all the time, and she always knew it." Dmytryk was doing some night shooting in Budapest, and Richard was to film a scene with Nathalie Delon. It was a simple sequence—Dmytryk told them to walk down the street and turn a corner. When the cameras started rolling, Richard and Nathalie walked down the street, turned the corner, and were not seen or heard from for the next twenty-four hours. Nathalie had previously had an affair with Eddie Fisher, her husband Alain Delon having "set up the situation," according to Fisher, because Alain always had to have "at least six woman [*sic*]," and he needed someone to amuse Nathalie during his extramarital dalliances. Fisher became infatuated with Nathalie after she turned to him following coitus one night and said she felt "*bien baise* [well-kissed]." After Richard's tryst

with Nathalie, he commented, "Once I started being attracted to other women, I knew—the game's up."8

Elizabeth took revenge by flying to Rome for "a quiet dinner" with Aristotle Onassis, whose marriage to Jacqueline Kennedy cooled off after Ari discovered a note she'd written to Roswell Gilpatric aboard the *Christina*, beginning "Dearest Roz." Ari and Jackie had feuded in January at Heathrow Airport, and he'd later said, "My God, what a fool I have made of myself. I'm afraid my wife is a calculating woman, coldhearted and shallow." Because he was suffering from myasthenia gravis, a neuromuscular disease, his appearance was increasingly gnomelike. The only way he could keep his eyes open was by hitching his eyelids up with Scotch tape, fastening them to his eyebrows. In Rome, Ari took Elizabeth to Hostaria Dell'Orso, and they commiserated with each other over a quiet dinner. Outside the restaurant, two dozen paparazzi got into a brawl with the restaurant's waiters. When the photographers finally burst in, Onassis threw his champagne at them and Elizabeth crawled under the table, afraid of Richard finding out. Eventually the *carabinieri* arrived and restored order. Elizabeth and Ari didn't leave until dawn. In at least one respect, Ari would have been perfect for her, since she expected a man to keep her in furs, diamonds, yachts, and airplanes. "Richard pays all the bills," Elizabeth once

boasted. "That's only happened in my life once before . . . Nowadays the money I earn goes mainly into trusts for the children." According to Richard, she spent an average of $1,000 an hour.[9] He was working himself to death in bad movies to keep them in booze, drugs, diamonds, jets, and yachts.

From Rome, she rang the Duna in Budapest and told Richard to "get that woman out of my bed." When he asked Dmytryk how she'd known, the director replied, "Don't you realize that you are surrounded by her agents?" Elizabeth returned to Budapest, and Richard scolded her for running to Onassis. She broke a plate over his head and, later, never took her eyes off him when he was filming with his leading ladies. Joey Heatherton complained that Elizabeth was so close to the camera during a love scene that she found herself looking into Elizabeth's eyes instead of Richard's. Though unnerved, Joey allowed that Elizabeth "was very nice and smiled at me."[10]

In June 1972, the Burtons went to London, where Elizabeth was again directed by Brian Hutton. *Night Watch* was her first genre movie—a mystery-thriller—representing the same kind of setback for an actress of her stature that *Whatever Happened to Baby Jane?* represented in the once-distinguished career of Bette Davis. In a 1998 interview in Beverly Hills, Brian Hutton said, "When I got Elizabeth and Larry Harvey, I thought, 'What am I directin'? She's gonna do what she does, and

he's gonna do what he does. And the dialogue's all written. A gorilla could be directin' this movie.' All I had to yell out was 'Cut! Print!' We did it in London in ten weeks. Elizabeth would go off to lunch with Richard and they'd start talkin' to people and eatin' and drinkin' and they wouldn't come back until 3:30. It was okay by me, because she was terrific. But Marty Poll [one of the three producers of *Night Watch*] hired a cordon bleu chef to make sure he'd get Elizabeth back from lunch on time, and he took over a restaurant-size room at Shepperton Studios. Shepperton only has about three sound stages and it's about twenty minutes away from the West End, as opposed to being out at Twickenham [site of British film studios], way out in the middle of nowhere. We took a big room, and every day the chef would ask Elizabeth, 'What would you like for lunch?' He would take the order for lunch at one o'clock, and after an hour, at two, I'd say, 'Okay, everybody, let's go back to work!' So she had to get up and go back to work because there was nobody around to play with. It was a very smart move."

During the production, Laurence Harvey underwent emergency cancer surgery, and twenty feet of his intestines were removed. Later, Elizabeth asked him to show her his surgical scar, but he showed her far more than that. "My scar is great and has a long nose at the end of it," he said. "Oh, Larry," Elizabeth said, "why don't you wear shorts?" When

the movie was released, the *New York Times* liked it, Howard Thompson writing, "Miss Taylor churns up a fine, understandable lather of nerves."[11]

In the Cambrian mountains of Wales, Elizabeth's daughter-in-law Beth was churning up something else—organic butter, most likely. After cooking and cleaning for Michael Jr. and his six communards, as well as looking after baby Laele, she took the infant and fled to the Establishment luxury of Elizabeth's suite at the Dorch. Richard felt "auto-blackmailed," he wrote, into caring for Michael's wife and baby, but Elizabeth became involved in a tug-of-war for the child with Beth, who recalled, "Laele was like a new toy, a new amusement to her." Poor as Beth was, she did not want Laele to be brought up by Elizabeth, later explaining, "It wouldn't be good for her to have all the material things she wanted and so little real family life." Once again in flight, Beth moved out of the Dorch, divorced the skeletal, glassy-eyed Michael, and returned to her mother in Oregon, taking Laele. Elizabeth cursed Beth, shouting, "Nobody tells me whether I can see my own grandchild. I'll never help you again."[12]

Elizabeth was disconsolate, but fortunately her daughter Liza was there to comfort her. "Liza was an angel to Elizabeth and watched her as if the positions were reversed, [as if] Liza were the mother and Elizabeth the child," Richard wrote. "I love that child. She can be a bit of a bastard at

times, but she is fundamentally an angel and great in a crisis." Michael Jr. soon had a new girlfriend, Johanna Lykke-Dahn. He also acquired a police record after a bust for growing marijuana. Christopher Wilding, whose eyes were as arresting as Elizabeth's, would also have to struggle, like many Hollywood offspring, to find a role for himself in life.[13]

In September 1972, the Burtons tried to bring off one more project together, a television movie, *Divorce His/Divorce Hers*, about the breakup of a marriage. After it was aired on ABC-TV in 1973, *Variety* sounded the death knell for the Burtons' career together, writing that the film "holds all the joy of standing by at an autopsy." Elizabeth was much better off working on her own, as her next project, *Ash Wednesday*, demonstrated, and she again received $1 million, plus expenses and a percentage. Produced by Dominick Dunne for Paramount, the film was to be shot in Italy, as was Richard's next project, Carlo Ponti's WWII story, *Massacre in Rome*, costarring Marcello Mastroianni. The Burtons took over ten connecting rooms in Rome's Grand Hotel, where they hosted a New Year's Eve party shortly before Elizabeth left for filming in Cortina d'Ampezzo in 1973. When Dunne and director Larry Peerce met the Burtons in their suite for champagne and caviar before joining the other guests downstairs, they found Richard in the sitting room, dressed in a green velvet dinner jacket and using a Kleenex to

wipe up after their unhousebroken Shih Tzu. Elizabeth made a blinding entrance in most of her jewels, poured herself a Jack Daniels, and said that she "drank mostly when Richard drank." It was a typical alcoholic copout indicating the depth of her denial. Everyone around her knew that she drank because she wanted to.

As the Burtons entertained Dunne and Peerce before their party, Raymond Vignale, the butler, interrupted them. Pointing to the Cartier timepiece on his wrist, he reminded Elizabeth that twenty guests were waiting in the lobby, including hairdressers Alexandre and Gianni Novelli and other members of the entourage. Leaving the suite, they made a regal entrance, descending the Grand's marble staircase to the lobby, and joining their assembled employees to see out 1972 together. For Christmas that year, Elizabeth had given Vignale a white mink coat with jeweled buttons, a knockoff of her double-breasted, knee-length white mink. Fortyish, Vignale was a blond, slender, Leslie Howard type, and one of his more unusual duties as the Burtons' butler was to hold Elizabeth in his arms and rock her to sleep after she'd spiked her Jack Daniels with Seconals. To jump-start the Burtons' passion for each other, sometimes "Ray-baby," as Elizabeth called him, would bring them pornographic magazines. When Richard vomited after drinking too much, it was Vignale who cleaned up the mess.[14] Elizabeth rewarded Vignale

by giving him the small role of Gregory de Rive in *Ash Wednesday*.

Costarring Henry Fonda and the dashing young Austrian actor Helmut Berger, the film was a stylish but otherwise trivial soap opera about a woman undergoing plastic surgery. The posh ski resort location shoot turned into a catastrophe when Paramount CEO Robert Evans exploded over Elizabeth's lateness and ordered Dunne, as her producer, to "read her the riot act." Dunne, who later admitted he was "drinking too much and snorting too much," was afraid Elizabeth would make mincemeat of him if he tried to shape her up. Relinquishing control of the film, he was reduced to being an audience for the Burtons' fights in their Miramonti Hotel suite. During a lunch break at a chalet nestled in the Dolomites, Richard started screaming, accusing Elizabeth in front of everyone of sleeping with Helmut Berger. His imagination was working overtime. According to Dunne, Italian director Luchino Visconti had been "more than [Helmut's] mentor for years and had assured Helmut that he would be his heir."[15]

One night, Elizabeth and Dunne were drinking in the Miramonti bar when she predicted, "This is the last movie you're ever going to produce, Dominick." Shortly thereafter, Vignale overheard *Ash Wednesday*'s screenwriter, Jean Claude Tramont, slamming Elizabeth's taste in clothes. The ever-loyal Vignale reported it to Elizabeth, and

Tramont was sent back to Los Angeles. He was the future husband of a powerful Hollywood agent named Sue Mengers, who was the best friend of Robert Evans. In the 1950s, Dunne had known Tramont in his pre-Mengers days as Jack Schwartz, a uniformed pageboy at NBC. While drunk at a party in Cortina, Dunne made insulting remarks about Mengers and Tramont that were repeated in the *Hollywood Reporter*. After that, Dunne was blackballed and never worked in the industry again, becoming, instead, a best-selling novelist. Recalling Elizabeth's prediction, he said in 1999, "It was meant as a joke, but I knew that what she said was going to prove to be true."[16] His drinking, drugging, and inability to handle stars like Elizabeth probably accounted for his downfall as a producer far more than the Tramont-Mengers-Evans episode.

In *Ash Wednesday*, thirty-eight-year-old director Larry Peerce, whose previous credits included *Goodbye Columbus* and *A Separate Peace*, and whose father was opera singer Jan Peerce, guided Elizabeth through a subdued and elegant performance in which she at last dropped the vulgarity of Albee's Martha and assumed the enigmatic mask and manner of a *Vogue* model. On release in 1973, the film reminded critics and public alike that Elizabeth could still act, and that her beauty was seemingly imperishable. Rex Reed cheered her in the *New York Daily News*, writing, "It's the first

time she hasn't been a bad parody of Bette Davis in
Beyond the Forest."[17]

By mid–1973, Burton watchers were predicting
the imminent end of the marriage. Zeffirelli
noticed that Richard was fed up with Elizabeth's
possessiveness,[18] and producer Ed Ditterline, who
saw them in a restaurant, recalled, "Liz berated
Richard Burton in front of everyone, cursing him,
humiliating him as a 'worthless lazy son of a
bitch.'" After virtually working himself to death to
support their lavish lifestyle, Richard had reached
the end of his willingness to squander his money
on her. In a March 28, 1973, letter to Maria, he
complained that Elizabeth was using her "feminine
wiles" to extract a new present from him. He'd
made the mistake of mentioning a silver-and-
lavender art nouveau vase he wanted, and Elizabeth
had said, "If ever you would like to buy me a pre-
sent, I wouldn't be averse to be given that."

Finally, Richard decided to bail, telling
reporters, "Our natures do not inspire domestic
tranquility." Later he explained, "The problem
wasn't drink, it was career." He blamed her for
everything—his inability to write books, teach,
and return to the theater—but it was not Eliza-
beth, or Hollywood, as he claimed, but alcohol
that robbed him of the clarity and strength to pur-
sue his dreams as a writer. A friend observed, "He
felt he would die without Elizabeth . . . and then
he realized that it was perhaps better to die than to

submit to the relationship again. It was too humil-
iating for him. It was killing him."[19] In fact,
Richard was killing himself—leaving Elizabeth
didn't remove the conflicts and character flaws that
continued to drive him to drink.

She flew to California in late June, leaving
Maria with Richard in their hotel suite in Rome.
In L.A., she looked in on her ailing mother and
sought solace from such old friends as Roddy, Rex
Kennamer, Peter Lawford, and Laurence Harvey.
"Women have always surrendered to Richard Bur-
ton," she said. "Not me. He has no rights over
me." She started going out with Peter Lawford and
his handsome young son Christopher, a nephew of
the late President Kennedy, who was trying to
break into the movie business. When Richard real-
ized that Elizabeth was enjoying herself in Holly-
wood, he called and jealously demanded, "Get your
ass back here, or you won't have an ass to sit on."
She told him to sober up and she might return.
Maria Burton, who was now twelve, packed her
suitcase and told Richard she was going to Amer-
ica "to be with Mommy." Richard asked, "Are you
packing for me too?" "No," said Maria, and
departed with her nanny. Richard soon followed,
and Elizabeth met him at JFK International Air-
port in New York. A shouting battle raged until
Elizabeth bolted and checked into the Regency
alone. "I told her to go," Richard explained to
reporters, "and she's gone." On July 4, 1973, she

released an oxymoronic statement announcing their split, but in effect she was begging Richard to come back. "Pray for us," she pleaded.

Referring to "her extraordinary statement," an amused Richard told reporters that he was no longer willing to be Elizabeth's personal nursemaid and career manager, and their resultant fights involved dangerous "physical force." He instructed attorney Aaron Frosch to work out financial arrangements, adding, "Just do whatever she wants." George Barrie, the director of Faberge who'd financed *Night Watch* with Joseph E. Levine, lent Elizabeth his private jet for her return flight to California amid rumors that she was being pursued by various suitors including Peter Lawford, Warren Beatty, Helmut Berger, and Roger Vadim. She and Maria stayed with Paramount costumer Edith Head and her husband, art director Wiard Ihnen, in their Mexican-style villa, Casa Ladera. Abetting Elizabeth in her scheme to get Richard back, Edith told reporters, "They need each other. They're just taking a little vacation." Smoking pot with Peter and Christopher Lawford, Elizabeth hit L.A. night spots like the Candy Store, a private club in Beverly Hills.[20]

Christopher Lawford became her frequent escort. He'd been brought up by his mother, Patricia Kennedy Lawford, who divorced Peter and took Chris and his three sisters to live with her when Chris was nine. Robert F. Kennedy had served as

surrogate father to Chris and his sisters just as he had to Caroline and John F. Kennedy Jr. after the assassination of the President. Then RFK was assassinated, and Chris felt like an orphan. He hitchhiked and panhandled for drug money with RFK's son David, smoking pot and dropping LSD and amphetamine "black beauties." Chris was expelled from Middlesex boarding school for drug use, and David Kennedy later died of an overdose. Chris started shooting up. One day, Pat Lawford found him behind a couch in her Fifth Avenue apartment with a needle in his arm. She sent him to stay with Peter in Hollywood in 1971. Peter was glad to share his drug stash with his teenage son, and asked him to serve as his best man at his Puerto Vallarta wedding to Mary Rowan, daughter of Dan Rowan of *Rowan and Martin's Laugh-In*. "He had to be the cutest guy I'd ever seen," said Mary, describing not her bridegroom but her new stepson Chris, who had dark hair down to his shoulders, carried a backpack, and looked like Andy Gibb of the Bee Gees. Chris joined Mary and Peter in pot-smoking sessions when Mary was twenty-one, Peter was forty-seven, and Chris was sixteen.[21]

By the time Elizabeth returned to L.A. in 1973, Chris was eighteen and living with his dad in an apartment on Cory Avenue, where Peter was dealing drugs. Earlier in the year Mary Rowan had gone back to her father in Holmby Hills after

deciding that Peter's life of Quaaludes, pot, painkillers, and booze wasn't for her. Peter resented it when Christopher asked him to act like a father and give him some guidance. "I need you, Dad," Chris said. "My life is a mess." Peter told him to lighten up or "get the hell out." At this point, Elizabeth started going around with the lanky, six-foot-two Christopher and with Peter, the trio's mutual interest in drugs forming a strong bond. Peter's friend Arthur Natoli recalled, "He and Elizabeth used to turn on together. They were high on pot a lot. I don't know if he supplied her." Elizabeth and Peter were both working on MGM's fiftieth anniversary movie, *That's Entertainment*, a compilation of old musical clips that proved a box-office hit. Elizabeth's sequence had been filmed in Rome, and she also appeared in clips from *Cynthia*, singing "The Melody of Spring" in a reedy soprano to the piano accompaniment of S. Z. Sakall, and *A Date with Judy*, lip-synching "Love Is Where You Find It."[22]

Dominick Dunne was in a party Elizabeth took to Disneyland that included Christopher, Peter, Liza, Maria, Roddy, and Cukor. "Elizabeth had a bottle of Jack Daniels, and Peter had something, and everybody got the bottle going," recalled Dunne. "Then a bit of coke was going around and you'd hear sniffing. Everybody was just screaming with laughter."[23] Some who saw Elizabeth and Christopher together got the impression she was

flirting with the youth. She took him along with her when, out of curiosity, she went to see legendary sex goddess Mae West, who appeared in a curve-hugging silver gown. Two bodybuilders accompanied Miss West and were introduced as her security guards. "Christopher, let's get the hell out of here," Elizabeth murmured. The following day, she was with Chris again, at a barbecue at the home of L. B. Mayer's daughter Edie Goetz, the doyenne of Hollywood society. Subsequently, Elizabeth and Christopher were seen at the Candy Store together. Inevitably reporters asked Peter Lawford if his son and Elizabeth were having an affair.[24]

Peter denied it but became so distressed by his teenager's relationship with the forty-one-year-old Elizabeth that he introduced her to someone closer to her own age, Henry Wynberg, a used-car salesman once indicted and fined $250 for setting back the odometers on the vehicles in his inventory. Elizabeth started dating him in July 1973, and he became a pivotal figure in her life the day he told her, speaking softly in his Dutch accent, "Darling, you could 'create' a superb perfume that will make you very comfortable for years to come."

She returned to Rome that month to film Muriel Spark's *The Driver's Seat*. She and Richard got back together again, taking over the guest house at Sophia Loren and Carlo Ponti's sixteenth-century villa in the Alban hills, half an hour from

the city. Elizabeth and her hostess were incompatible, Elizabeth slouching around in jeans and Madame Ponti dressed to the teeth, including Dior gloves, in her own home, "too piss-elegant for words," Elizabeth told her hairdresser and secretary, a pair of Mediterranean bodybuilders named Ramon and Gianni. The Burtons resumed their fighting, and the reconciliation was all over in nine days.

When Elizabeth reported for work on the *Driver* set at 5 P.M., she told producer Franco Rossellini and the crew that she'd never expected to see another day as sad as the one when Mike Todd had died. "I was wrong," she said. "Today is the second saddest day of my life. I am desolate." The crew applauded her, though she'd kept them waiting all day. She arranged for Andy Warhol to have a walk-on part, and the pop-art painter asked her to his rented villa for lunch the next day. He'd invited every titled Italian he could round up on short notice, hiring six cooks to prepare a meal to suit all tastes, including chicken, veal, lamb, beef, sole, shrimps, lobster, lasagna, ravioli, ziti, spaghetti, cavatelli, and gnocchi. Elizabeth finally arrived at 3 P.M. with Ramon and Gianni in tow, dressed in their customary matching white-and-red outfits. Wearing blue jeans, a purple T-shirt with mirrored embroidery, gold chains, and an American-flag ring of diamonds, rubies, and sapphires—a gift from Gianni Bulgari—Elizabeth was oblivious to

the ire of the other guests, most of them princes and princesses who'd been kept waiting for two hours. They retired to the dining room, but Elizabeth started coughing and asked for a Jack Daniels neat, explaining that she wanted to stay outside and talk with Warhol and his sidekick Bob Colacello. She had several more Jack Daniels and continued coughing. Warhol flattered her by saying she should direct films, and she replied that she'd always wanted to direct. She boasted that *Who's Afraid of Virginia Woolf?* was the highest-grossing black-and-white film ever made, and that she'd just purchased seventy-five percent of *Around the World in 80 Days* from the Todd estate and intended to rerelease it every year at Yuletide (not a good idea, since the film's vogue had long since passed). Another guest joined them on the terrace, and Elizabeth insisted that the man accompany her to the library to help her place a call to Richard. "He won't take calls from me," she sniffed, "but from you he would." She left with the guest, and a minute later screams were heard. Elizabeth emerged from the library shouting, "I'm no easy lay. That motherfucker tried to put the make on me. I'm crying on his shoulder and he tried to grab me." She dragged Andy into the garden with her, where she sat nervously, compulsively stripping the leaves from a hedge. "Elizabeth is staying for dinner," Andy told Colacello. "Maybe you should tell the cooks."

Dinner was served at eight o'clock, but Elizabeth had gone into the bathroom and wouldn't come out. Finally a doctor was summoned by Ramon and Gianni, and when he arrived, carrying a black bag, Elizabeth let him into the bathroom and then left with him without saying anything to her host. "Gee," Andy said, surveying a table groaning with an overcooked feast, "she has everything: magic, money, beauty, intelligence. Why can't she be happy?"

During a medical examination in late November 1973, doctors discovered Elizabeth had a tumor that might be malignant. The following day, she went into surgery, and an ovary upon which the cyst had grown was removed; fortunately it was benign. To keep Elizabeth company, Wynberg rented the suite next to hers at the Scripps Clinic in La Jolla, where she'd gone to recover. They planned to vacation in Hawaii upon her release, and they also got tickets for the Rose Bowl game. Meanwhile, Richard was filming in Palermo, but when he heard that she'd been operated on for a possible cancer he went to Carlo Ponti and requested time off to fly to her side. Pale and exhausted after an eleven-hour hop across the Arctic Circle, he came bearing a thirty-eight-carat cognac diamond. "Hello, Lumpy," he said. "How are you feeling?" Elizabeth smiled and replied, "Hello, Pockmarks." After telling Wynberg to get out, Richard asked for a bed to be placed next to

hers, and they spent one of the happiest nights of their married life. The next day they flew to Naples for the 1973 Christmas holidays. During her absence, Wynberg used her house and turned it into a harem. When advised of Wynberg's unusual genital endowment, Richard blurted, "I'm sure that like the used cars he sells, it will fall off just at the psychological moment." Elizabeth admitted she'd been "using" Wynberg and would eventually drop him.[25]

Elizabeth was in a wheelchair, and the nurse who accompanied them on their flight to London regularly administered painkilling pills prescribed by Elizabeth's surgeon, Dr. Herbert Machlader. The Burtons held hands and smiled throughout the flight. On December 10, they arrived by private jet in Naples, which was frigid but sunny. The *Kalizma* was waiting for them in the bay, Richard having told Graham Jenkins to bring the yacht to Italy. Graham recalled that when they came on board, he'd never seen them looking so happy. At dinner they began to reminisce about old times, and Richard turned to Graham and said, "Tell them at home the bad times are over."[26]

In reality, the worst was yet to come, for neither had changed. In Gstaad for Christmas, Michael Jr. joined them, evidently having decided that his mother's wealth was bearable after all. On NBC-TV, news anchor John Chancellor announced that the Burtons "are reconciling permanently—[pause]—as

opposed to temporarily." Richard waited on Elizabeth hand and foot, according to one of their servants, but as soon as her health improved, he started screaming at her. In January 1974, fifty-year-old pothead Peter Lawford arrived to spend the remainder of the holidays with them at Chalet Ariel. The Burtons were attempting to cure their alcoholism, someone suggested, with marijuana, not realizing that a drug is a drug, any way it's taken, and one drug invariably leads to another. Soon they resumed their drinking, but Elizabeth attempted to moderate Richard's intake by telling bartenders to substitute lemonade every time he ordered a drink. Richard told Lawford, "I know how to make that bitch shut up." When she wasn't looking, he slipped bartenders extra money to pour him a vodka. One day, Elizabeth went to the Gstaad branch of Van Cleef & Arpels to pick up a $300,000 jewel, and she told Peter to keep Richard away from the bar. When she returned and saw Richard sloshed, she snapped, "Peter, you cocksucker, I told you not to let him drink."[27]

The Burtons returned to Italy, completed their film assignments, and then flew to Puerto Vallarta to celebrate Elizabeth's forty-second birthday in February 1974. Then, attended by her private nurse, Elizabeth joined Richard in Oroville, California, where he filmed *The Klansman*, a story of racial violence in the South, with Lee Marvin. Interviewed in 1998, Dale Olson, a publicist,

recalled, "Lee Marvin goaded Richard into drinking. Assistants had to hold both of them up from behind to finish a scene. Everyone seemed to be staying in motels; I saw no hotels there. My room was next to Richard and Elizabeth's. They were a mismatched pair, deeply in love and undermined by booze on both parts. They fought a lot but couldn't keep away from each other. I could hear them fighting at night in their room. There were screams and then a door slammed. I looked outside and Elizabeth was on the ground where he'd flung her. I went out and helped her up. Her knees were bloody.

"For publicity we sent out a notice to the press, 'Mr. and Mrs. Richard Burton invite you to a day in Oroville.' I brought in about a hundred pundits, and NBC asked me if it was true that Elizabeth had left Richard. 'No,' I said, 'she can't. She's hosting a party for me tonight.'" Merv Griffin filmed an interview with Richard for his TV talk show, and later recalled that Richard was dating a local girl "in order to invest new drama into his relationship with Liz." Evidently he invested a little too much; Elizabeth packed up and left. Dale Olson told a planeload of journalists, "There's good news and bad news. The bad news is that Elizabeth has left Richard. The good news is that you're the first to see Richard after the split."

Elizabeth rebounded to Wynberg, later telling Max Lerner, "He fucks me beautifully, and I know

he's not a big mind like you are, but he takes care of me, and that is what I need." Elizabeth behaved as if the breakup of her marriage had all been Richard's fault, telling Sophia Loren his alcoholism was to blame, and bursting into tears when she described the horror of his drinking to Ava Gardner. Though she was just as alcoholic as Richard and equally responsible for the destruction of their relationship, Richard gallantly refused to expose her as a drunk and a drug addict and tolerated her indiscretions without reprisal.[28]

On April 26, 1974, the Burtons announced in Los Angeles that their reconciliation had failed, and they were seeking a divorce in Berne. On June 26, in a cream-and-brown silk suit and dark glasses, Elizabeth appeared at a wooden-frame courthouse in the Swiss town of Saarinen for the case of *Taylor v. Burton*. Throughout the forty-minute proceeding, she maintained a blank stare. Richard, who'd been drying out in a rehab, was not present for the end of a ten-year partnership that, at least in one respect, had been thunderously successful, producing eleven movies and $30 million in income. Divorce was granted on the grounds of incompatibility. In the financial settlement, Richard was magnanimous as usual, but Elizabeth chose to be tough, keeping $5 million in jewels, though they'd been a joint investment; Casa Kimberley; *Kalizma*; and their paintings, some of them priceless. "The main question of course," one of

their friends joked, "is who will get Brook Williams." Brook went with Richard.[29]

Elizabeth's old friends, Prince Rainier and Princess Grace, rallied to her support, premiering her film *The Driver's Seat* in Monte Carlo as a Red Cross benefit. Elizabeth's presence on the Riviera completely upstaged the nearby Cannes Film Festival as the cream of international society flocked to Monaco, including an old and enfeebled Ari Onassis, whose marriage to Jackie O. was on the rocks; Paulette Goddard and her ghost writer Andy Warhol, whose Harcourt Brace collaboration would never be completed; Ursula Andress; Elsa Martinelli; São Schlumberger; Stavros Niarchos; Princess Ira von Furstenberg; Countess Marina Cicogna; Helene Rochas; and Kim d'Estainville. On opening night Elizabeth sat in a box with Prince Rainier, Princess Grace, and Franco Rossellini. Later, at Regine's club, New Jimmy'z, she sat at the royal table, which enraged Paulette Goddard, who wasn't assigned a table because she'd refused Princess Grace's request to appear on TV in behalf of the Monaco Red Cross. "I never do TV," said Paulette, dripping blue-white diamonds. "Grace has to. It's her country." In conversation with Warhol, Paulette accused Elizabeth of spreading a rumor that she'd performed oral sex on director Anatole Litvak under a table at the Mocambo in Hollywood.[30]

Returning to L.A., Elizabeth leased an Italianate

mansion in Bel Air and moved Henry Wynberg in with her, but shortly thereafter her "disintegrating vertebrae" required that she be placed in traction with a twenty-pound weight. Wynberg daily injected her thigh with Demerol, a dangerously addictive painkiller. He became the latest in an endless succession of drug enablers, drawn like the other sexual, a-loving men in her life into a treacherous codependency. Wynberg eventually rebelled against this role and began to substitute distilled water for Demerol when she asked for a fix.[31] Richard told friends that Elizabeth would marry Wynberg "over my dead body," but Wynberg fulfilled her sexually as no one had done in years—they even experimented with amyl nitrate, an anti-angina drug that heightens orgasm if it doesn't kill you first. In the heady afterglow of popper-enhanced coitus, Elizabeth and Wynberg continued to discuss marketing Elizabeth Taylor fragrances, with a sixty-forty income split in his favor. He also drew up a contract for Elizabeth to associate herself with a diamond-selling firm, but the venture ended in litigation before it got off the ground.[32] Raymond Vignale warned her that Wynberg was using her, but it was more likely that she was using Wynberg. In the Polo Lounge one night, she pointed to him and said, "Would you buy a used car from this man?" Eventually Wynberg had to give up his automobile wholesale business and borrow $15,000 from friends to keep up with Elizabeth.[33] He

nursed her through a viral infection and amoebic dysentery when she made the soporific George Cukor megaflop *The Blue Bird* in Russia in 1975.

Another important influence as Elizabeth gradually prepared herself to enter the perfume business was her dress designer Halston, who launched his own successful fragrance line (within two years Halston perfume generated $85 million in worldwide sales). He created the low-cut strapless gown Elizabeth wore to the 1975 Oscar presentations. In New York he became her regular escort to Studio 54, introducing her to the American branch of the jet set. He consoled her during her single years and even tried to advise her on her love life, though his knowledge of intimate human relationships was restricted to negotiating $200-to-$500 fees for sex with black hustlers. One night Elizabeth telephoned Halston at his Manhattan townhouse at 101 East Sixty-third Street when Halston's favorite prostitute and pimp was in bed with the couturier. "There was a Burger King commercial on TV," the call boy remembered, "and Halston's advice to Elizabeth was, 'Have it your way.'"[34]

Wynberg was summarily dumped by Elizabeth when Richard decided he wanted her back. On August 11, 1975, she rendezvoused with Richard at the Hotel Beau Rivage in Lausanne, Switzerland. To her delight, he was sober, drinking only milk and Perrier, thanks to a black *Playboy* centerfold model named Jean Bell, who'd helped him

detox with sedatives, tranquilizers, and anticonvulsants. On August 18, Elizabeth summoned Wynberg to a meeting at Chalet Ariel and, in Richard's presence, gave him his walking papers as her lover, as well as a gold watch and $50,000 to set her up in the perfume business. On August 20, Richard announced that he and Elizabeth were remarrying, and fourteen-year-old Maria Burton asked, "For how long?" There was a tense twenty-four-hour scare that Elizabeth had cancer, but upon examination it proved to be old pneumonia scar tissue. Though sober, Richard's alcohol-related infirmities—gout, sciatica, epilepsy, and arthritis—were giving him the shakes, and Elizabeth again had to feed him like an invalid.[35]

They flew to Israel, where Richard was to discuss a possible picture, and on the plane, he relapsed and got drunk on champagne cocktails. Elizabeth started screaming at him, and she angrily canceled a press conference at the terminal and whisked him to the King David Hotel in Jerusalem. However bitter it was in private, their reunion ignited near-hysterical excitement among their Israeli fans, and a riot was barely averted at their charity benefit. U.S. Secretary of State Henry Kissinger, who was also staying at the King David, offered them the protection of his personal escort of seventy U.S. marines and one thousand Israeli troops. They declined, but later created such a commotion at the Wailing Wall that an onlooker

said, "The Messiah has come." Kissinger gave them a cocktail party in his suite, and they confirmed to him that a remarriage was imminent. "The Burtons prove the axiom that truth is lots stranger than fiction," said Kissinger. "There's nothing bland about that couple—they're simply fabulous."[36] In Kissinger, Elizabeth had made a powerful new friend, one who adored her and would do anything for her.

Campaigning for the Republican presidential nomination, both Ronald Reagan and Gerald Ford were quizzed about Elizabeth and Richard's rumored remarriage at press conferences. Ford called them "extremely colorful people," and Governor Reagan said they were "unlike some Hollywood types I know, they insist on being themselves." Henry Miller, author of *Tropic of Cancer*, praised them as a vanishing breed who did exactly as they pleased, regardless of public opinion. "If she wants to wiggle her ass, she wiggles her ass," Miller said. "If he wants a piece of tail, he's not afraid to get a piece of tail . . . They still reign supreme and are dear to the public's heart."[37]

The ceremony for the Burtons' second marriage was held on October 10, 1975, in Botswana, an African village in the Chobe Game Reserve, after they'd performed at a charity benefit in Johannesburg. Richard was drunk by 8 A.M. on his wedding day, and on awaking Elizabeth regarded his bleary

eyes and limp body with revulsion.[38] Nevertheless, she dressed in an exotic outfit the late Ifor Jenkins had given her: a floor-length green robe with pale-colored birds overlapping each other, ribbed with multicolored wooden beads on chiffon cords, and fringed with guinea-fowl feathers. Richard struggled into white slacks and a red silk turtleneck sweater. The district commissioner from the Tswana tribe, Ambrose Masalila, conducted the ceremony in a one-room cabin. The bride and groom exchanged $40 ivory wedding rings. The following day, the *Boston Globe* announced, "Sturm has remarried Drang and all is right with the world." But all was not right with the Burtons. Their traveling companion, Marguerite Glatz, Richard's long-time housekeeper, said, "It was difficult for Mr. Burton because Liz loved whiskey and always had a bottle with her, and he wasn't supposed to drink."[39]

His immune system radically compromised by alcohol, Richard could not withstand the hardships of the African bush and contracted malaria during their honeymoon safari. Chen Sam, a thirty-seven-year-old pharmacologist, expertly nursed Richard back to health and helped him detox again. She was an extraordinary creature to come across in the African bush, with her knee-length brown hair, voluptuous figure, and unique background (her father was an Egyptian Muslim and her mother an

Italian Catholic). Her marriage to a Spaniard had failed, but she had a son who was living in Paris. Chen Sam knew how to get drugs and how to inject them intravenously. When the Burtons left Africa, she came with them as a paid member of their entourage. Upon arriving in London, Chen Sam was informed that her son had just died of pneumonia. As she grieved in the following days, Chen Sam had less time to devote to keeping Richard sober, and he relapsed again.

Elizabeth threw a fiftieth birthday party for Richard at the Dorch in November 1975, but he looked terrible, like someone dying of cirrhosis of the liver or TB. She was also in poor health. When she entered Wellington Hospital in St. John's Wood, complaining of unbearable back and neck pains, she expected Richard to move in and take care of her as Mike Todd had once done, and as Eddie Fisher and Richard himself had often done. Tired and ailing himself, and bored with her problems, he no longer wanted to be her caregiver. She cursed him when he refused to come to the hospital after a few visits, but their friends sided with Richard, commenting that she was suffocating him with unreasonable demands. Alone in her room, she started flirting with bodyguard Brian Haynes in desperation. "She frequently slept nude or topless," recalled Haynes, "so that when I came racing in I would get a close-up of those famous boobs." In Richard's absence, she turned to Haynes to assuage her loneliness, calling him in one

night to show him "a very short, very sexy, and very transparent nightie."[40]

Richard knew the time had come, that the bell had tolled for them as a couple for the last time, but they doggedly went to Gstaad for Christmas 1975 with her children and Brook Williams. They found they couldn't stand each other anymore and took separate bedrooms. Though Elizabeth was only forty-three, Richard compared her with Norma Desmond, the crazy *Sunset Boulevard* has-been with delusions of grandeur. He hated the sight of her, and he hated the entourage even more—that hired claque of servants who doubled as spies, dealers, and enablers.[41] Elizabeth was astonished one day when Richard brought a pretty girl named Suzy Hunt back from the ski slopes and flaunted her at Chalet Ariel. To get even, Elizabeth picked up a young ad exec at a disco in the village and brought him home, giving Richard some of his own medicine. Green-eyed, twenty-seven-year-old Suzy Hunt was the estranged wife of British racing car ace James "The Shunt" Hunt. When Richard flew to New York to replace Anthony Perkins as the gay psychiatrist in Peter Shaffer's Broadway hit *Equus*, Suzy went with him. Elizabeth's new boy toy, thirty-seven-year-old Peter Darmanian, later recalled, "She is passionate in bed. I did not sleep much . . . We'd stay in bed until two in the afternoon and not get dressed until dinner." When Richard called in February and told her to meet him in New York, she immediately booked a flight, leaving Darmanian

with a broken heart and a gold charm engraved "*Obe-sanzo di Te* [I need you]."[42]

In Manhattan, Richard was waiting for her at the Lombardy Hotel with Suzy Hunt, looking nervous and uncomfortable. "What is wrong, love?" Elizabeth asked. "I want a divorce," Richard said. After catching her breath, she said, "Why the hell did you have me come all this way to tell me that?" Richard thought it would be simpler to discuss their second divorce face-to-face, but she swept out of the room with Chen Sam, canceled a forty-fourth birthday party in her honor, and bowed out of a commitment to host the annual Tony Awards. Producer Alexander Cohen lined up Jane Fonda to replace Elizabeth as Tony emcee, leaving Elizabeth free to fly to L.A., where she moved into Wynberg's rented four-bedroom house, 400 Truesdale Place. On wacky weed and Jack Daniels, she went at sex "relentlessly," Wynberg said.[43] He gave her a small birthday dinner on February 27, 1976. From various parts of the world, all the children called, including Mike Jr., twenty-three, who was playing saxophone and flute in a rock band in London and Wales; Chris, twenty-one, still a student at the University of Hawaii; Liza, eighteen, studying sculpture in London; and Maria, fifteen, a student at the International School in Geneva. In reply to a reporter who asked if she was divorcing Richard, Elizabeth said, "You don't read the newspapers, do you? My husband is getting the divorce, and don't

worry your pretty little mustache about it." Darmanian rang repeatedly from Gstaad, but Chen Sam, following Elizabeth's orders, got rid of him. Like Eddie Fisher, Darmanian was a little too fond of basking in Elizabeth's limelight.

Wynberg kicked her out when he discovered that she was having assignations with a forty-seven-year-old screenwriter named Harvey Herman in Bungalow 8 at the Beverly Hills Hotel. He took everything she'd brought to 400 Truesdale—including two dogs—called a cab, and told the driver to deposit the lot on her doorstep at Bungalow 8. She was well out of it with Wynberg. The following year he was jailed for ninety days after admitting sexual misconduct with a sixteen-year-old girl.[44] Elizabeth's dalliance with Harvey Herman ended when she rang his house during a birthday party for his wife, and he told her to stop calling.[45]

Actor Ray Stricklyn saw Elizabeth after the final split with Burton and described her as "drinking heavily, quite bloated, and no longer the great beauty." At a dinner party in Cukor's home, a guest attempted to make polite conversation by inquiring about the pendant on her neck. Through tightened lips she hissed, "That's the Taj Mahal diamond, you dumb shit." She seemed just about ready to go over the edge, but a meeting with Secretary of State Henry Kissinger in Palm Springs in 1976 opened up a new world for her to conquer—Washington, D.C.

11

Showbiz Takes Over D.C.:

ELIZABETH TAYLOR + JOHN WARNER = RONALD REAGAN

Henry and Nancy Kissinger were vacationing with Kirk and Ann Douglas in California when Kissinger asked about Elizabeth, whom he'd admired ever since meeting her and Richard the previous year in Israel. On hearing how miserable, bored, and heartbroken she was, the secretary of state asked Elizabeth to dinner and later invited her to Washington in April 1976 for a round of high-profile bicentennial events. She could not have found a better man to throw open the doors of the nation's capital. Looking for new challenges after the failure of her sixth marriage, and with Kissinger's social imprimatur as her banner, she stormed Washington and had the capital at her feet by the late 1970s, just as she'd charmed the jet set in the 1960s.

Her D.C. blitz began with a fund-raiser for the

American Ballet Theatre at the Kennedy Center for the Performing Arts. Halston, who'd dressed her for the occasion, was her escort, and they were double dating with Liza Minnelli and Elizabeth's hairdresser Arthur Bruckeld. "She swept into Washington like Cleopatra into Rome," wrote one reporter, and the *Washington Post* estimated the cost of the jewels she wore to the Kennedy Center at $1 million, including a diamond-and-emerald necklace, matching diamond-and-emerald drop earrings, a ring, a bracelet, and a large brooch.

After the ballet gala she attended a reception and dinner at the Iranian Embassy. The United States and Iran were not yet at each other's throats. Under Ambassador Ardeshir Zahedi, the embassy had become an important social center in the capital, operating on a lavish budget from the oil-rich Peacock Throne. The sexual current between Elizabeth and Zahedi was sizzling. He was forty-eight, intelligent, rich, had a head of shiny black hair, and was an irresistible flirt. When he asked her to dance, he boldly embraced her with both arms, and she nestled into him, her hands at the nape of his neck. Watching them from a divan in the Persian Room, Polly Bergen said, "It looks like Liz is still carrying the torch for Burton."[1]

Elizabeth was installed in the royal suite as a permanent guest of the Iranian government, and a sizable contingent of Washington society turned out for a caviar luncheon in her honor. Barbara

Howar christened Elizabeth and Zahedi Washington's "hottest couple," and for a while she and His Excellency seemed altar-bound. Then the Shah got wind of his ambassador's affair with the Jewish Elizabeth and ordered him to end it. On the prowl for a new life, she began to divide her time equally between Washington, with its political diversions and unabashed veneration of her; Hollywood, where she snared her most important role in years, that of Desirée Armfeldt, the aging actress in turn-of-the-century Vienna who sings "Send in the Clowns" in Stephen Sondheim's *A Little Night Music*; and New York, where Halston and Warhol crowned her queen of the disco circuit. Like many another seventies partygoer, she made Studio 54 her home base in Manhattan, falling in with club owner Steve Rubell and Studio regulars Capote, Minnelli, Bianca Jagger, and Paloma Picasso. One night she sat among the coke-snorting Studio denizens complaining to Warhol about the offhanded way Zahedi had let their relationship wither. By the following year, 1977, the fickle Zahedi was pursuing Lee Radziwill.[2] According to producer Ed Ditterline, "During this crazy period Chen Sam was all that held Liz together."

Back in Washington on July 4, 1976, she was presented to Queen Elizabeth II, both of them smiling as they recalled other meetings over the years. The occasion was the Queen's dinner at the British Embassy for the President of the United

States on the occasion of America's bicentennial year. Without a special man in her life, Elizabeth had planned to attend with her hairdresser, but Sir Peter Ramsbotham, the British ambassador, fixed her up with John W. Warner, a Republican who was the Ford Administration's Bicentennial Year Committee chairman. Fifty years old, a Harrison Ford look-alike, and a former secretary of the navy, Warner had been divorced for three months from millionairess Catherine Mellon, with whom he'd had three children. Barbara Walters declined Warner's proposal when he'd told her, "A woman like you could probably get me elected senator." Warner had just resigned his bicentennial duties to run for political office.[3]

He must have learned from his experience with Barbara Walters to be less candid about his motives. When he proposed to Elizabeth at Atoka Farms, his Virginia estate, shortly after they met, she thought he loved her and said yes. He put her to work campaigning almost immediately, driving her harder than L. B. Mayer or George Stevens ever had. Garry Clifford, chief of *People* magazine's Washington bureau, summed up John's behavior during the next year, calling it "fucking upward . . . Elizabeth Taylor was responsible for netting him the Senate seat." The Warners spent $1.2 million trying to get John elected, and Elizabeth had to sell the Taylor-Burton diamond to cover their expenses. I had dinner with Elizabeth and a small

group when she came to New York to raise funds for John. Members of what would later come to be known as her "millionaire's club"—rich Elizabeth Taylor fans—had been assembled for a dinner party, during which a number of items were to be auctioned off. I was there as the escort of Radie Harris, a columnist for the *Hollywood Reporter* and one of Elizabeth's oldest friends in the press. Radie, Elizabeth, and I were seated alongside Halston and Warhol at a U-shaped banquet table. Elizabeth was slightly zaftig, but her body looked curvy and appealing beneath her sleeveless, décolleté, gold-lamé gown, which was slit to the knees. She wore no diamonds. Her only jewelry was a long, heavy necklace of crude, hammered gold that had a primitive, rough-hewn look, like something Martha Graham would have worn as Medea or Clytemnestra. When Radie introduced us, Elizabeth looked me directly in the eye, appearing genuinely, even warmly interested, and shook my hand firmly.

When we were seated, Elizabeth leaned over and told Warhol that John wasn't coming. She stood up and delivered a pitch for her conservative Republican husband. "He really believes in what he's doing," she said. "He really believes he can make the world a better place. With your help we can make it come true." It was a persuasive performance, but I could sense underneath her show of sincerity that she didn't believe what she was say-

ing. She must have loathed his reactionary views on women and minorities.

Aline Franzen got up and announced that she was the auctioneer. She started badgering the dinner guests to fork over their money. The prizes were things like a shopping bag full of Estée Lauder beauty products; a rather sad-looking fur stole; and some mediocre costume jewelry.[4] As we stood talking with Elizabeth later, Radie asked her if it were true that she'd recently choked on some food. Elizabeth explained that she'd been eating fried chicken on the campaign trail in Big Stone Gap when a bone got stuck in her throat. She was taken to Lonesome Pine Hospital, where a thoracic surgeon went to work on her with an extended plastic tube. "This could have lodged in her larynx and killed her," the doctor said.

After the auction-dinner, Elizabeth joined Warhol and Halston at the latter's townhouse. "He gave her some coke and she got high and happy," Warhol recalled. "Look," Warhol told her, "you've got nine days until the election, you've got to really get down and talk to the Negroes. This lady stuff isn't going to work." Stoned, Elizabeth said, "Oh lawdy lawdy lawdy." Warhol and another gay friend went off to the kitchen. "Halston and Liz were talking intimately in the other room," Warhol recalled, "and he told me later that John Warner wasn't fucking her."[5]

John squeaked into the U.S. Senate by a mere one percent after the GOP sent in President Ford, Ronald Reagan, Barry Goldwater, and John Connally to help Elizabeth campaign for him. Unfortunately, after the election John paid little attention to her. She'd served her purpose and now could be discarded, or, as Professor Arthur Green of the University of Virginia put it, John "used that woman miserably." Garry Trudeau's popular comic strip *Doonesbury*, syndicated in 450 U.S. newspapers including ten in Virginia, referred to Warner as Senator Elizabeth Taylor, "a dim dilettante who managed to buy, marry, and luck his way into the United States Senate."[6] Warner knew that he'd always be Mr. Elizabeth Taylor until she faded into the background, and the sooner the better.

That was something she would never do. Earlier in the year, she'd celebrated her forty-sixth birthday at Studio 54. In deference to John's need for respectability, Steve Rubell and Ian Schrager declared the unisex men's room off limits to women and vice versa. The birthday cake was a portrait of Elizabeth with jutting breasts in buttercream. Forty-eight Rockettes in black tights held sparklers as they high-kicked their way around the cake. Halston told Elizabeth to make a wish, and then she sliced into a buttercream breast. John Warner hid from the cameras, but everyone else tried to crowd into Elizabeth's birthday picture, including Diana Vreeland, Warhol, Bianca Jagger,

Timothy Leary, Sylvia Miles, and Margaret Trudeau. Ian Schrager released an avalanche of plastic snow from the ceiling, and Lauren Bacall slipped and fell on the floor. "There goes Betty," said Vreeland, who continued to shimmy to a disco version of "Happy Birthday."

In 1978, Elizabeth accepted $200,000 to appear in the NBC television drama *Return Engagement*, playing Dr. Emily Loomis, an ex-singer-dancer turned professor of ancient history at a small California college. In the story, Emily rents a room in her house to one of her students, Stewart Anderson, played by Joseph Bottoms, and falls in love with him. In the play's big payoff, Stewart persuades Emily to recreate one of her old dance numbers for the campus variety show. Emily and Stewart become a campus sensation doing their Ginger Rogers–Fred Astaire routine.

The role presented obvious difficulties for Elizabeth and Joseph Bottoms, neither of whom could sing or dance, and yet the television audience would be asked to accept that they received a standing ovation. Playwright James Prideaux wrote the show for Jean Stapleton, an accomplished hoofer, but the producers wanted Elizabeth, thinking, mistakenly, that she could garner high ratings.

Rehearsals started, but Elizabeth remained with John Warner in Bungalow 134 at the Beverly Hills Hotel, complaining of strep throat. Dark-haired

Joseph Bottoms, whose youthful good looks were as striking as they were unusual, came to visit, and she immediately perked up. When the company went on location to the campus of Whittier College, he was the only member of the cast permitted to seek refuge from the heat in her air-conditioned trailer. Prideaux later wrote that Elizabeth "was setting [Joey] up for a fling with Liza [Todd], which they ultimately flung."[7]

When the show aired in November 1978, the ratings were mediocre. Rex Reed wrote in the *New York Daily News* that Elizabeth and Joey's big musical number reminded him of a "mating dance between Jughead and Kate Smith." The same could be said for Elizabeth and John Warner's performance as a Washington couple. Instead of being able to enjoy the life of a senator's wife for which she'd campaigned so hard, she regarded John's victory as the "beginning of the end of my marriage." He was so busy trying to keep up with his new job that she rarely saw him. After she moved into his S Street house in Georgetown, she discovered that "Washington is the hardest town for a woman in the world—especially if you're married to a politician . . . You are a robot. They even tell you what you can wear." In her unhappiness, she began to overeat and gain weight, ultimately becoming the butt of cruel TV talk-show fat jokes.

To relieve her blahs in the capital she started spending most of her time in Manhattan with Hal-

ston. The seventies was America's wildest, most debauched decade since the Roaring Twenties and Studio 54 was its decadent epicenter. In May 1979 she was at Studio the night a newly clean and sober Betty Ford, the former First Lady, sat on Liza Minnelli's lap as Warhol, Martha Graham, Bianca, President Jimmy Carter's sister Ruth Carter Stapleton, Capote, Mayor Edward I. Koch, and Barbara Walters looked on.[8] Elizabeth embraced disco as a way of life, arriving at Studio's crowded entrance nightly in a black limo and rolling her obese body out, looking like a drag queen in a garish caftan.

On a trip to Los Angeles, she went to the pool at the Beverly Hills Hotel to relax and sunbathe. "Miss Taylor was quite heavy at that time," the poolman, Svend Petersen, recalled in 1999. "Several ladies kept walking back and forth talking about her weight. I couldn't stand it." The forty-seven-year-old Petersen had been bringing towels and drinks to Elizabeth poolside ever since he'd begun working at the hotel as a lifeguard in 1959. Feeling sorry for her, he went to her deck chair and said, "Would you follow me?" He led her to a private, upper cabana. Appreciating his thoughtfulness, she said, "I love you."[9] Periodically Elizabeth would pull herself together and lose weight, invariably putting it on again.

When Michael Wilding Sr. died on July 9, 1979, at the age of sixty-six, Elizabeth attended his

funeral in Chichester, England, with their sons and Liza Todd. Wilding Sr., an alcoholic and epileptic, had sustained fatal head injuries after a fall at home. On a wreath of white roses Elizabeth appended the message, "Dearest Michael, God bless you. I love you. Elizabeth." Just two days after his death, while still in his Chichester home, she met Aileen Getty, who was fond of both of Elizabeth's sons and having difficulty choosing between them. Resembling both Genevieve Bujold and Gilda Radner, the petite Aileen was an oil heiress, one of fifteen grandchildren of billionaire John Paul Getty. She'd been raised in Italy, moving to London when she was fifteen and to the United States when she was seventeen. The following year, she fell in love with Chris Wilding, though the relationship was complex due to her feelings for Mike Jr. In a further complication, if she married before she was twenty-two, she'd lose her share of the $750 million Getty trust fund, which stood to bring her $500,000 a year in interest. With regard to Chris she said, "We've been desperately in love for a long time." When she asked the Getty trustees to waive the marriage ban, they refused.[10]

Returning to Washington, Elizabeth attended a Redskins football game with Senator Warner, but spent most of her time talking and drinking with a male reporter. The senator sent word for her to rejoin him. "Fuck him," she told the newsman, "I'm having fun." The remark ended up in

the *Washington Post*, along with the news that "Mrs. Warner's much publicized recent weight loss has now been regained." At a dinner at Katharine Graham's house, Mrs. Graham asked Elizabeth if she and John were breaking up. Elizabeth denied it, but Mrs. Graham added that both of the major publications she owned, the *Post* and *Newsweek*, were getting regular reports of marital strife.[11] At a Republican caucus, Elizabeth did not hesitate to make it clear that she disagreed with every word her husband said when he opposed servicewomen's rights to participate in combat. Later, in an interview with the Warners, Barbara Walters asked John, "Do you ever want her to shut up?"

Hoping to deflect her interest from politics and get her out of the capital, John urged her to return to show business. She needed little encouraging. By 1979, Washington struck her as "the biggest bullshit town." On March 5, 1980, she went to London to film Agatha Christie's *The Mirror Crack'd*, accepting a $250,000 fee and slimming down to 125 pounds. Then, in an ill-conceived foray into legitimate theater, she took Lillian Hellman's creaky old warhorse, *The Little Foxes*, to Broadway in 1981. Completely misunderstanding the role of Regina Giddens, Elizabeth turned her into a women's lib heroine instead of the evil bitch portrayed by Tallulah Bankhead in the original 1939 stage production and by Bette Davis in the

1941 movie. Hellman tried to make trouble between Elizabeth and the cast, focusing on Elizabeth's close friendship with costar Maureen Stapleton. Feeling excluded from their intimacy, Hellman, who'd once written a wrong-headed lesbian play, *The Children's Hour*, told her friend Peter Feibleman, "What's the matter with Maureen, she spends more time with *that woman* than she does with her own children . . . There's something unpleasant at the bottom of it."[12]

In deference to the decrepit Hellman, Elizabeth controlled herself during their confrontations, keeping her gaze on the floor. One night, Hellman stomped backstage and objected to Elizabeth's costume, a $50,000 ball gown Regina would never have worn to breakfast. At the next rehearsal Elizabeth was dressed more appropriately. "Maybe Maureen's right," conceded Hellman, "maybe there *is* something special about her." Nonetheless, Hellman persisted in calling Elizabeth "Liz," fully aware that she hated the name. Finally Elizabeth told her to stop, and Hellman said, "All right, honey, I won't . . . I'll call you anything you like, Lizzie." Caught off guard, Elizabeth started laughing and spent the rest of the meeting sitting next to the dowager playwright and holding her hand.

When *Foxes* opened at the Martin Beck, the public loved Elizabeth, and the show was a box-office smash, netting Elizabeth $1.5 million for nine months' work. "Not surprisingly," Elizabeth

said, "my marriage did not survive the run."[13] Though her Washington period was over, Elizabeth would go down in history as the first wave in Hollywood's takeover of the U.S. government. Apart from George Murphy and Helen Gahagan Douglas, no actor had ever before been taken seriously in public life, but Elizabeth's friend Ronald Reagan, emboldened by her siege of Washington, and by the conservative tide that washed John into the Senate, decided to run for President. When Ronnie and Nancy moved next door to the Warners in Virginia, Elizabeth threw a chicken barbecue at Atoka Farms in the Reagans' honor. Four thousand guests showed up, most of them, as usual, to gawk at Elizabeth. On July 16, 1980, Elizabeth sat with Nancy in the VIP box as the GOP National Convention nominated Ronnie for President. In November 1980, he became the first movie-star President. After his inauguration on January 20, 1981, the Warners hosted one of the inaugural balls in the capital.

The end came for the Warner marriage when John abruptly told Elizabeth he'd sold the Georgetown house and bought a two-bedroom flat in the Watergate. "You've got to be fucking kidding me," she screamed. Two bedrooms wouldn't even hold her furs and diamonds, not to mention her pets. On December 21, 1981, Chen Sam formally announced their separation, and Elizabeth went home to Hollywood. On Christmas Eve 1981 an

ambulance rushed her to the hospital in L.A.,
where she was treated overnight for chest pains.
She called Richard, whose marriage to Susan Hunt
had also failed. He commiserated with Elizabeth
and later said, "I can't live without her." While
filming *Wagner* in Europe he called her frequently,
wondering if a third marriage might be the answer
for both of them.

She was standing by herself at a party when
Radie Harris and I encountered her following a
screening of *Endless Love* in 1981. The party was
held in the Mykonos Restaurant on Manhattan's
Upper East Side for Brooke Shields, the star of the
movie, and her young leading man Martin Hewitt,
whom Radie was writing about in the *Hollywood
Reporter*. Radie and I were with Hewitt, Zeffirelli's
associate Dyson Lovell, and Timothy Hutton in a
small group around the radiant, laughing Brooke. I
was aware of Elizabeth standing slightly apart from
the group, and I could hardly believe my ears when
I heard her say, "So *that's* my competition." I
turned and looked into her tired, rather dead-look-
ing eyes, and she added, "I don't have anything to
worry about." In the car going home I told Radie I
couldn't believe that a middle-aged woman, hard-
looking in her dyed black hair, could possibly com-
pare herself with the dewy Brooke.

But in a sense Elizabeth was right. No one
would ever call Brooke Shields a legend.

12

Private Lives and
Public Bottoms

On a bright, crisp day in November 1981, Elizabeth attended Natalie Wood's funeral in Westwood Memorial Park off Wilshire Boulevard in L.A., where her father was buried. Only days before, as a member of the board of directors of L.A.'s Ahmanson Theater, Elizabeth had encouraged Natalie, whose career was faltering in her forties, to try her luck as a stage actress and star in the Ahmanson's revival of *Anastasia*. After Natalie got drunk and fell off her yacht, drowning in the Pacific, Elizabeth was one of the first to call on her husband, Robert (R. J.) Wagner. "R. J. knows I'll always be there for him," she said. "It's that simple." She'd always remember Natalie as "warm, loving, giving, supportive." A few yards away from Natalie's white-and-gold coffin, which was covered with 450 white gardenias, was Marilyn Monroe's

crypt with its vase holding a single rose from Joe DiMaggio.

Deciding to settle down in L.A., Elizabeth bought Nancy Sinatra Sr.'s $2.8 million house in Bel Air, the exclusive community that stretches from imposing gates on Sunset Boulevard into the high, steep terrain dividing Beverly Hills and Santa Monica. This would be her home to the end of the twentieth century and beyond. Elizabeth's house teeters atop winding Nimes Road, concealed behind white gates. The curious are discouraged by aggressive guards who patrol the area, including Secret Service personnel who protect neighbors Ronald and Nancy Reagan. Elizabeth's sitting room features two Warhol portraits of her. The comfortable overstuffed couch has rose-print pillows, and the lampshades are also rose-print. On the coffee table lie boxes inlaid with semiprecious stones, as well as an assortment of figurines. Framed photos stand on the end tables, along with a large mother-of-pearl peanut and a violet orchid plant. White walls, English antiques, and Aubusson carpets provide an elegant setting for her collection of Monet, Modigliani, Utrillo, van Gogh, Degas, and Renoir.

Elizabeth's son, Christopher Wilding, married Aileen Getty in 1981 after Getty trustees gave permission. They established an antique clothing boutique in Santa Barbara, but it soon failed because of

its unusual location. They had two children, Caleb and Andrew, and moved to the Monterey Peninsula, settling in Pebble Beach. There Christopher studied glassblowing and worked for a few years as a stained-glass artist. "He does beautiful work," said his brother Michael, who married Jack Palance's daughter, Brooke, in 1982. This time twenty-nine-year-old Michael wore a white tuxedo to the ceremony, which was more traditional than his hippie wedding to Beth Clutter, signaling his embrace of respectability in the 1980s. Fame as an actor still eluded him, but Elizabeth went to New York to see his performance in the Riverwest Theater's off-Broadway production of *Dead Wrong*, quietly entering the auditorium and taking an inconspicuous seat in the back. Later, she arranged for Brooke to host a cast party, and the following night she took the couple to a quiet dinner. "Our relationship is a good one," Michael said, referring to his mother. "There's friendship and kindness. We see each other often and have good feelings for one another." In later years, she could scarcely have been more solicitous of his career. When she was unable to come to New York to catch his off-Broadway efforts, she'd fly the whole cast out to Bel Air for a private performance. The recipient of boundless maternal indulgence, Michael Jr. at last stopped complaining about Elizabeth's diamonds and superficial values, even acknowledging that she had some talent. "I

think she's a very fine actress," he allowed. "I'm sure I've learned from her—just by watching her over the years."[1]

On February 13, 1982, Elizabeth attended her twenty-one-year-old daughter Maria's wedding in New York. The groom was talent agent Steve Carson, the son of wealthy Florida orange growers, whom Maria had met at Studio 54. After a physically challenged childhood and a shy adolescence, Maria had turned into a swan and was working as a model. Elizabeth and Princess Grace de Monaco came to the wedding rehearsal, which was held in a Manhattan restaurant. By the following September, Grace, overweight and suffering from menopausal depression, would be dead at age fifty-two. She lost control of her Rover 3500, plunging 110 feet from a zigzagging mountain road near the palace in Monaco. In one of Grace's last conversations with Judy Balaban Quine, one of the bridesmaids at the royal wedding in 1956, Grace had been "marveling again about Elizabeth Taylor's beauty," Quine recalled.

At the wedding of Maria Burton and Steve Carson, the bride sounded exactly like her mother, saying, "My marriage will be long-lasting. The fact that there have been divorces in my parents' pasts doesn't scare me. I'm a separate person." Separate, yes, but different, no. Soon Maria was burning up the telephone lines to Elizabeth for marital advice. Her husband complained, "Maria wants a more

glamorous life, more like her mother's. I'm not offering that. I want a family life-style. I'm devastated over the split. I'm still in shock." At first Elizabeth advised a clean break but later reversed herself and tried to get the couple back together. Perhaps the Carsons had broken up in the heat of anger, she suggested, and should reconsider once they'd cooled off. Besides, she added, she'd be hurt by their divorce. Eventually Maria decided she'd acted hastily and returned to Carson.[2]

When Elizabeth arrived in London on February 23, 1982, to prepare *Foxes* for a West End opening on March 11, she emerged from the plane wearing a mink coat over her jeans. During a chauffeured ride from the airport in her new $135,000 Rolls-Royce, she told the driver to stop at The Feathers pub in Chiswick, where she downed a pint of bitter. A leased Chelsea townhouse at 22 Cheyne Walk— redecorated in lavender—was part of her deal with producer Zev Bufman. She settled in with Chen Sam, an Italian hairdresser, a dresser, and four full-time security guards. At the Victoria Palace, where she'd shortly open, the marquee and two dressing rooms were also being painted lavender.

Ever since Elizabeth learned that Susan Hunt had left Richard, she'd been calling him three times a week, asking if she could join him on his film location for *Wagner* in Europe. Richard had asked his brilliant, award-winning director, Tony Palmer, if Elizabeth could visit him on the set, but

Palmer wisely demurred. Now Richard rang Elizabeth from Venice to say he was flying in a private jet to London for a charity performance of *Under Milk Wood*. She asked him to be her escort while in London, and he agreed, but before leaving Vienna for the long weekend break, he became interested in one of Palmer's production assistants, thirty-four-year-old Sally Hay. "She was not the type to stand out in a crowd," wrote Graham Jenkins. "She had neither the salary nor the style to make the best of herself." Such niceties no longer mattered to the aging, trembly Richard, who was shopping for someone who could offer comfort, not glamour. After spending some time with Sally that night, he told Brook Williams, "She can do everything— cook, type, do shorthand."[3]

In London, Elizabeth dispatched her chocolate-colored Rolls to collect Richard at the airport and bring him straight to Cheyne Walk. "Where's my present?" she joked, but she was shocked at how much older he looked than his fifty-six years with his lined, sagging, pasty face and fragile, 140-pound body. Richard was concerned over her condition and appearance as well. Later, she would confirm that she was taking too much Percodan at this time. She invited Burton to her fiftieth birthday party at the trendy Legends disco. Though overweight, she stuffed herself into a silver-and-lavender harem pants outfit. "My eyes had disappeared into suet," she admitted. The guests included Nureyev, Ringo

Starr, Tony Bennett, Maureen Stapleton, and Elizabeth's children. The pregnant Maria, also in attendance, commented, "It's almost impossible to describe the anticipation—the specialness—I feel about having a child of my own flesh and blood." Grateful for the attention and advice she'd received from Elizabeth and Richard, Maria added, "She makes me feel that I too can be and do anything I want. After all, it was they who taught us how precious love is." The Carsons would name their baby daughter Elizabeth.[4]

After the party, Richard claimed that he made love to Elizabeth at Cheyne Walk after throwing her entourage out, calling them "homos and hangers-on." Later, when she read his newspaper interview bragging that she'd begged him to marry her, she rang Graham Jenkins and said, "I could kill your brother. He's shouted his mouth off about making love to me on the night of my birthday. He was too drunk to find his way down the street, let alone into my bedroom."[5] Still fiercely competitive and apparently determined to sabotage Elizabeth's imminent West End opening, Richard delivered a parting shot before leaving London, telling reporters, "I firmly believe she cannot act onstage." He returned to Venice and proposed to Sally Hay.

When *Foxes* opened in March, the London critics, less indulgent than their American counterparts, demolished Elizabeth. "She made an entrance worthy of Miss Piggy, trailing mauve lin-

gerie," wrote the *Express* critic. Nonetheless, she was the toast of London, holding a press conference at the Palladium. She received Princess Diana, pregnant with Prince William at the time, backstage at the Victoria Palace. Princess Margaret invited her to dinner at Kensington Palace, and she met with Princess Michael of Kent for supper. Richard wanted to catch her performance, but Sally Hay was understandably reluctant, and plans for Richard to go to London were twice scuttled. "Sally pulled every trick she could think of to stop him from coming," Jenkins said. Finally, they saw the play at the end of the run. After the show, Elizabeth was gracious to the terrified Sally[6] and told Richard, "What do you say to having some fun and making a pile of money on Broadway?" She assured him that they could each clear $60,000 a week. Intrigued by her proposal, Richard recalled that Noel Coward had once said they reminded him of Elyot and Amanda in *Private Lives*. The stinging romantic comedy portrays the reunion of a couple once married to each other, who are now bored with their current partners, and are considering having another go at love.

Sally later suggested that Richard was duped by a "very clever" Elizabeth into doing *Private Lives*. She accused Elizabeth of presenting the project to him first as a taping instead of a long-running play. "Had the deal been: 'Do you want seven months on tour with *Private Lives*,' Richard would have fled,"

Sally claimed. "But it only came to that when he was too far in."[7] "According to Richard, Elizabeth was on something" and sometimes "crocked" when she attempted to begin rehearsals with him and director Milton Katselas for *Private Lives* in Manhattan in March 1983. Sally was with Richard, and it was humiliating for Elizabeth to watch him become increasingly attached to his fiancée. After seeing his daughter Kate in an off-Broadway play, he called on Elizabeth at the Beresford, accompanied by Maria and her baby, Elizabeth Diane Carson. She was staying in Rock Hudson's apartment, and the place was "horrid," Richard recalled, adding that it had "little or no library." Elizabeth, he wrote, was "OK but figure splop! Also drinking. Also has not yet read the play! That's my girl!" She told Richard "twice an hour," he related, "how lonely she is." Bloated on pills and booze, she no longer appealed to him.

Opening on Broadway at the Lunt-Fontanne on May 8, 1983, the show was a disaster, getting what Sheilah Graham called "the most devastating reviews I have ever read." When Richard married Sally Hay during the run, Graham Jenkins asked him if he missed Elizabeth. "Of course," Richard replied. "All the time. But Elizabeth can't look after me. I need Sally. She takes care of an old man."[8] The play toured cross-country until November. By the time it finally folded in Los Angeles, critics had dubbed it "The Liz 'n' Dick

Show." Elizabeth was so bored that in the third-act breakfast scene, she threw her biscuits at the audience. HBO dropped its plans to tape the play, which closed on November 6, 1983. Many who saw the production liked it better than the critics and still remembered it fondly when interviewed in 1999. "My daughter and I saw it in New York and loved it," recalled Joanne Cates of Key West. "Liz and Dick let the audience in on the big joke, reliving every minute of their marriages. It was like a visit with them, a big party—they were adorable."

At the end of the run Elizabeth was in a state of physical and mental anguish, suffering back pains and filled, she later wrote, with "self-pity and self-disgust." Lonely and friendless, she retreated to her home and shut the door on life, surrendering to her alcohol and pills. In late 1983, she landed in the hospital at her lowest bottom ever. Chen Sam and Dr. William Skinner alerted her family, and an intervention was held in her hospital room. In view of its later impact on contemporary society and particularly on the disease of alcoholism, the scene should be the subject some day of a heroic canvas by a modern super-realist such as Alfred Leslie— the distraught screen goddess surrounded by her brother, Howard Taylor, her children Chris and Mike Wilding and Liza Todd, her oldest friend Roddy McDowall, and Dr. Skinner, the facilitator-healer. In one of the key moments in the history of

modern recovery, they made Elizabeth face the fact that she was killing herself. One of them picked up the phone, dialed 1-800-854-9211, and made reservations for her at the Betty Ford Center, which had opened the previous year at the Eisenhower Medical Center at 39000 Bob Hope Drive in Rancho Mirage, California. Unlike many alcoholics who adamantly deny their problem and refuse help, Elizabeth thought, "It's time to change before it's too late."

That evening, December 5, 1983, she entered the Betty Ford Center (hereafter referred to as BFC), feeling "lonely and frightened," she recalled. In withdrawal, she was "stuttering, stumbling, incoherent." An assigned "buddy" usually takes newcomers to their rooms, where their luggage is gone through to make sure nothing with alcohol is in it. At some point, they undergo a physical, including an EKG, at the Eisenhower Center hospital. The next morning they are awakened at 6:30 A.M. After breakfast, they walk 1.5 miles around the compound. Then comes clean-up detail. Treated like any other person in recovery, Elizabeth was instructed to take out the garbage and hose down the patio. Referred to as an "inmate," she was "terrified," she recalled. "I had never felt alone in my entire life." For the first time, she was without her entourage, that band of yes-men and enablers that had cheered her down her long road to hell. She at last had an opportunity to undergo

ego-deflation at depth—to renounce the sham of a pride-driven existence and join the human race.

Clean-up detail is followed by group therapy, which routinely begins with the reading of a daily meditation aloud, such as, "Happiness cannot be sought directly; it is a by-product of love and service." After the reading, each patient talks about the meaning of the meditation. Later there are lectures and nightly AA (Alcoholics Anonymous) or NA (Narcotics Anonymous) meetings. Sober alcoholics come in from the outside community and tell their stories, and patients also share, receiving candid feedback from the meeting. "This group experience," according to BFC, "provides a mirror which helps each person to look at themselves with honesty and courage." The recovery program's emphasis on personal humility and placing principles above personalities undoubtedly proved deeply unnerving to the movie queen, who was far from humble and whose entire life had always thrived on fame. When a friend sent Elizabeth five hundred roses, she proudly displayed them in the rehab. "Those must have been sent to Elizabeth Taylor," her counselor said. "Nobody else suffers from that kind of grandiosity." Stung, Elizabeth fired back, "Look, I didn't send them to myself." But the counselor was right: the five hundred roses symbolized a glamorous life that had brought her nothing but misery, finally dumping her in AA. She was perhaps too willful to submit to the ego deflation essential to the process of achieving sobriety.

She made a stab at working AA's famous Twelve Steps, which suggest reviewing one's life honestly and sharing the results with a sponsor who has racked up enough sobriety to assist a newcomer on the rocky road to recovery. "I was fortunate to have Betty Ford herself as my sponsor," Elizabeth recalled. For the first time, she was able to see that she had been an abused child. "I didn't understand how deeply it affected me until years later, when I went to BFC," she said. "There, I thought through my early experiences in order to live the rest of my life in the healthiest way possible ... When I derailed in Washington, I had no idea that my real problem was a lack of self-worth and that all the food in the world would not fill up my inner feelings of emptiness."

At BFC, the staff told Elizabeth not to diet, since it was dangerous to undertake too many changes at once, and nothing was as important as getting clean and sober. Nevertheless, she lost eleven pounds of bloat "simply because I stopped drinking," she related. She didn't stop smoking, according to the shopping lists that fellow inmate Peter Lawford read to Patricia Seaton on the phone. "Liz wants you to stop at the Rexall Drug Store in Palm Springs," he told Patricia. "She wants pancake makeup and deep olive eyeliner by Max Factor and two cartons of Salem."[9]

Elizabeth's busy days in rehab included time for reflection and study. She was allowed four thirty-

minute telephone calls during twenty-nine days, and occasionally a movie was shown in Firestone Hall. She had to be in bed by 10:30 P.M. Family visits were permitted on weekends. The third week was devoted to family therapy, and one family member was allowed in free (the total BFC bill was $12,000). Elizabeth checked out in January 1984 despite Dr. Skinner's recommendation she stay another week to complete detoxification. She became impatient and screamed she'd had enough, though in the coming year she would continue to participate in BFC's outpatient program.

Elizabeth had successfully kept her alcoholism and drug abuse out of the press for decades, but several days after arriving at BFC, she rang Betty Ford and said she had a feeling the news was about to break. "I felt an unauthorized presence at the clinic and it turned out I was absolutely right," Elizabeth recalled. A reporter had sneaked in with the help of Peter Lawford, who informed on Elizabeth to the *National Enquirer* for $15,000 and then followed her into BFC, bringing the reporter and passing him off as his cousin. The *Enquirer* also stationed photographers with high-powered lenses in the desert near BFC, but Elizabeth beat them all to the punch, authorizing BFC to release an announcement revealing her history of substance abuse.[10]

The publicity surrounding her effort to get sober stirred worldwide interest in alcoholism as a

genuine disease like cancer or tuberculosis and helped dispel long-held prejudices against alcoholics as spineless, weak-willed dregs of society. More than any film she'd ever made, getting sober was Elizabeth's greatest accomplishment and gave courage to others to face their own alcoholism, beginning with Liza Minnelli. A month after Elizabeth went into BFC, Lorna Luft, Liza's sister, decided to force an intervention on Liza. She called Chen Sam for advice, and Chen sent Lorna straight to Dr. Skinner, who helped stage the intervention that ultimately brought Liza to BFC. As a result, thousands of news stories appeared about Elizabeth and Liza in the press and on television, and recovery became one of the trendiest waves of the eighties and nineties. Hordes of celebrities came forward to admit their alcoholism and/or drug addiction, including Mary Tyler Moore, Eric Clapton, Carrie Fisher, Robert Downey Jr., Kelsey Grammer, Stevie Nicks, Chevy Chase, Don Johnson, Johnny Cash, Tony Curtis, Gary Busey, Andy Gibb, Bobby Brown, Matthew Perry, Shelley Winters, Eddie Fisher, Melanie Griffith, Christian Slater, Andy Dick, Tim Allen, Charlie Sheen, Lynda Carter, Mackenzie Phillips, Kate Moss, Julie Andrews, and Judd Nelson.[11]

Unfortunately, out of the ebullience of being newly sober—known by recovering alcoholics as a "pink cloud"—and perhaps out of the ego-driven desire to show her new self and spread the news far

and wide, Elizabeth jeopardized her sobriety by going on *Good Morning America* almost immediately and talking about it. She was violating the principles of anonymity and humility that are the very underpinnings of a sober life.

Little did she know her celebration was premature, but she did appear to be making her most triumphant comeback. She was sober, she was lighter, she was beautiful, and she'd had a spiritual awakening. "I believe in a higher power," Elizabeth said. "I believe in one God. I'm so glad I asked for help." Her willingness to seek help from a power greater than herself would impact the rest of her life, changing her into the kind of person who'd help save others from drugs and alcohol and raise millions of dollars for people suffering from AIDS. AA's big message is that one should give rather than take, understand rather than be understood, and love rather than be loved. Liberating one from unrealistic expectations, the program also liberates one from disappointment. "Finally, give of yourself," Elizabeth wrote. "There are many organizations that need help . . . Nothing will raise your self-esteem as much as helping others. It will make you like yourself more and make you more likable . . . BFC changed my life."

As the public woke up to the new Elizabeth Taylor—svelte, gorgeous, and evidently healthier both physically and emotionally—the world cheered her once again. They had their favorite

movie star and world beauty back, and she looked great. In certain crucial ways, she remained unchanged, and therefore in danger of a relapse. "The new house I bought when I moved back to Los Angeles helped keep my emotions on an even keel and encouraged me to stick to my resolve," she said, still looking to material comforts rather than inner meaning for stability. "Happiness," as AA puts it, "is an inside job." Possibly to avoid the tumult her attendance at regular AA meetings might cause, she held meetings in her home or at the homes of people she'd met at BFC. This exclusive approach deprived her of meeting the wide variety of alcoholics in the program who freely— and sometimes bluntly—share their experience and knowledge with one another, ignoring all differences in race, creed, and social status in favor of working together to stay sober. With input from only those she admired and who admired her and were not likely to talk candidly, she predictably fell back into her old thinking patterns and inevitably slid into a pain-painkillers-addiction-recovery-slip cycle. Her public statements indicated that her old negative attitudes were returning, full of rationalization and self-justification. "I get ill because I live too hard," she said. "I give too much—out of a lust for life. I never back away. I relish life and face it head-on. Sometimes it's almost more than I can face." She was still in denial about her character defects—the drama, the overdoing everything, the

greed, the lust, the love of fighting and arguing, overextending herself—and even, tragically, her drinking.

She was still expecting the knight on the white charger, but he was nowhere in sight, certainly not balding, paunchy Victor Gonzalez Luna, a fifty-five-year-old divorced Mexican lawyer who wanted to marry her. A quiet, courtly, paternal man, Señor Luna had handled Elizabeth and Richard's holdings in Mexico. He was accustomed to a calm life in Guadalajara with his daughters, and although he told reporters he was willing to make concessions for his "beautiful lady,"[12] he expected Elizabeth to settle down in what he described as "the strict, socially enclosed atmosphere of Guadalajara." Her serial divorces were a source of embarrassment to him, and he was certain they would end up social outcasts in his hometown as soon as they got married. "My life," he said, "isn't flying and cruising and mixing with the international jet set—the life Elizabeth enjoys."[13] He wasn't prepared to indulge her expensive whims.[14] When they took a trip to the Far East together in the spring of 1984, she pointed to an elephant and said she wanted it. "No, Elizabeth," he said, "you can't take the elephant home."[15]

They concluded their tour in a London pub with Richard and Sally Burton, and then Victor had to resume running his family's business in Guadalajara, which put his relationship with Elizabeth

under severe strain. According to Sally, Elizabeth was "having another go" at winning back Richard, "making phone calls. Making suggestions that they should work together." Upon returning to Celigny, Richard told actor John Hurt, "I'm still fascinated by her." A guest at Le Pays de Galles, Hurt went out a few nights with Richard, who was drinking again in 1984, but his marriage remained intact. Elizabeth's engagement to Luna could not have been shakier, and Luna told reporters, "Since we can't be together, we can't get married."[16] Wealthy and politically well-connected, Luna may have harbored dreams of Elizabeth putting him into office as she had Warner. Her hairdresser Zak Taylor suspected that Luna enjoyed the publicity of being seen with Elizabeth a little too much. When they became engaged, Luna gave her a 16.5-carat sapphire-and-diamond ring from Cartier valued at $250,000.

No one could quite understand it when Elizabeth, fifty-two, and rock star Michael Jackson, twenty-six, became intimates that year. Elizabeth was worth about $60-$80 million at the time, and Michael was worth $300 million, and the two stars also had in common an almost unparalleled degree of megafame. Michael was at the summit of a notoriety that equaled Elvis's, or Elizabeth and Richard's twenty years before. One day, out of nowhere, Jackson called Elizabeth and announced, "This is Michael Jackson," his breathy, boyish

voice as recognizable as a Vuitton steamer trunk. He was into iconography and had long been a collector of Elizabeth Taylor memorabilia. "I feel as if I've known you for years," she told him."[17] Would she like fourteen tickets to his Dodgers Stadium concert? She leaped at the offer; the show fell on February 27, her and her son Christopher's birthday. Unfortunately they were assigned to the VIP box, and Elizabeth and her party left, complaining, "You might as well have been watching it on TV." In tears, Michael apologized over the telephone the following day, and they enjoyed a two-hour conversation. "Both of us had really strange childhoods," Elizabeth explained in 1997,[18] and two years later Michael added, "We've lived the same life: the great tragedy of childhood stars . . . My father took the money."[19] For Elizabeth, it was like having Monty back—a loving, a-sexual relationship with a spiritual twin.

They continued their phone relationship for two or three months before meeting face-to-face, Michael later explaining, "I've never liked people-contact. Everyone is looking and judging."[20] After inquiring if he could drop by her house and bring his chimpanzee, Bubbles, he appeared at her door, holding the monkey's hand. "There is something in him that is so dear and childlike," she said, "not childish, but childlike, that we both have and identify with."[21] Later, President Nelson Mandela called Elizabeth and invited her to accompany Michael on

his tour of South Africa, telling her to call him by his given name. The next time Mandela rang her, she said, "Hi, Nelson," and they chatted like old buddies. It had long ago ceased to surprise her that everyone from Toscanini to Tito wanted to know her. She didn't go with Jackson on his South African tour, but when he returned, their friendship deepened. In 1999, Jackson said, "She's a warm, cuddly blanket that I love to snuggle up to and cover myself with. I can confide in her and trust her. In my business you can't trust anyone. You don't know who's your friend . . . because you're so popular . . . Elizabeth is also like a mother—and more than that. She's a friend. She's Mother Teresa, Princess Diana, the queen of England, and Wendy."[22]

Wendy is one of the characters in *Peter Pan, or The Boy Who Wouldn't Grow Up*, Sir James M. Barrie's 1902 dramatic fantasy about a heroic boy who becomes the leader of a band of lost children. During one of his adventures, he discovers Wendy Darling and her brothers, teaches them to fly, and takes them back with him to Never-Never-Land. The Barrie story was like a scenario of the relationship that unfolded between Elizabeth and Michael Jackson. One day she found herself flying in a helicopter to Jackson's twenty-seven-hundred-acre Neverland Ranch, his Xanadu-type hideaway near Los Olivos in the Santa Ynez Valley. From the corkscrewing helicopter, Elizabeth looked down on a wilderness wonderland of carnival rides, twin-

kling lights, galloping giraffes and llamas, swans on a pond, a movie theater, a large railway station, and an Indian reservation with tall teepees peeping out of the woods. The only people visible were uniformed security guards, some of them driving golf carts over acres of deep green lawns.

The chopper touched down at nearby Van Nuys airport, and a limousine whisked her to Neverland, which is near Santa Barbara. In front of Jackson's mansion, she paused in the circular driveway, looking up at a thirty-foot-high statue of Mercury, the winged and helmeted god of commerce. The house had dark shingles and mullioned windows. Inside, she discovered an Elizabeth Taylor shrine in one of the rooms. Michael took her on a picnic in a wooded area on a cliff. For Elizabeth the relationship had an oddly therapeutic effect; with Michael she revisited childhood and at last had all the fun their parents had denied them. "Some of the money was put aside for me," said Michael, referring to the millions he'd earned as a child, "but a lot of the money was put back into the entire family. I was just working the whole time." Later, describing his relationship with Elizabeth, he said, "We try to escape and fantasize." He wrote a song for her entitled "Childhood," in which the singer asks if anyone can help him find his lost childhood.[23]

At Neverland, Elizabeth enjoyed a long, eye-to-eye, kissy visit with an orangutan named Brandy,

and cooed to the critters in the reptile house, home to pythons, a cobra, and a rattlesnake. Sad little statues of smiling children were all over the compound, lining golf-cart paths and gravel trails, some of the bronze tots holding hands with each other or carrying fishing poles or banjos. These figures delighted throngs of children suffering from various illnesses who regularly visited Neverland.

Back at the main house, Michael gave Elizabeth beanbag beds for her pets. Her films played around the clock on a large video screen, and her face decorated wallpaper designed by Michael. Like one of the lost children in the Barrie fantasy, she felt completely at home in Neverland. She ate carob brownies with Michael and shared vegetarian dinners prepared by his Sikh chef, but she could order anything she wanted—and did. While she munched a cheese omelet with ketchup in the dining room, someone passed by with a plate of French fries. "Hey!" Elizabeth said, "where did you get those?" Before five minutes had passed, she was scarfing a large order of fries, the frozen Mickey D. variety.

Singer Lionel Richie was a friend of Michael's, and one evening in January 1985, just after Michael's Victory tour and his purchase of the Beatles songbook for $47.5 million, Elizabeth dined with the two singers. "They talked about isolation and what you do when you're lonely," Lionel recalled. "It was good for Michael to hear that Eliz-

abeth often went out of the house without security
guards. The idea that you could live without them
was a revelation to him."[24] Elizabeth and Michael
went to the movies together in Westwood after
disguising themselves. Sitting in the back, they
held hands. She came to enjoy a privileged place in
his entourage and was his only guest during the
highly publicized filming of *Captain Eo*. She and
Michael had food fights on his *Captain Eo* set,
doing $3,000 worth of damage a week to his dress-
ing room trailer. He squired her around Southern
California and continued to visit her Bel Air home.

Michael had a ten-year-old friend who wiped
sweat from Michael's brow with a towel, and
according to *People* magazine writer Todd Gold,
Michael and the boy would "nuzzle and hug a lot
. . . definitely a close friendship."[25] When asked in
1999 how she could reconcile herself to "his eccen-
tricity," Elizabeth explained that she accepted
Michael because "he is magic. And I think all truly
magical people have to have that genuine eccen-
tricity."[26] In 1998 Elizabeth's friend Jean Porter
said, "She's sweet. She will stick up for Michael
Jackson forever and ever." One day Michael told
Elizabeth that he wanted to direct his next video
himself, and asked her to recommend someone to
teach him how to direct. She put him in touch
with Eddie Dmytryk, who recalled in our 1998
interview, "I got to know Michael Jackson and
found him to be a very nice guy. I was teaching at

UCLA when Elizabeth put us together, and we had several meetings. There were always interruptions and finally the scandal erupted, and I haven't seen him since then. He's very good; I saw one of his videos on TV and it was tremendous. I met the kid he was having trouble with. Michael had dolls, dolls, dolls everywhere. He never had a chance to be a kid. Lifesize dolls, little dolls, teddy bears. The place was full of dolls. This boy was a friend at the time. He was a very nice kid, very bright kid, about fourteen. I didn't see anything sexual going on between them, but it might be possible. When you're talking with Michael, he's very polite, but not soft spoken—he speaks up, he looks at you and talks right to you. I liked the guy."

Michael wanted to alter his appearance to resemble Elizabeth as she'd appeared in *National Velvet*.[27] Eventually, he even proposed marriage to her.[28] One night she suggested they go to dinner but he told her he already had plans to dine with Diana Ross at Le Dôme. An expert at one-upmanship, she told Michael to have Diana meet them at the restaurant, but when Michael called Diana, she immediately detected Elizabeth's ruse and canceled.[29]

Elizabeth and Victor Luna began to drift apart, and she spent more time in Switzerland, not far from Richard in Celigny. They didn't see each other, but Richard's brother Graham Jenkins dined with Richard in the summer of 1984 and reported

that Richard was referring to his wife Sally as "Elizabeth." Richard also lived in Elizabeth's memory. She kept whole rows of photographs of him in her Bel Air home, but found the prospect of seeing him again too painful. When Liza Todd became engaged to be married to sculptor Hap Tivey, she asked Elizabeth if she could invite Richard Burton to the wedding. Elizabeth persuaded her not to.[30] The wedding was held at the home of friends in upstate New York, and a country band played for square dancing. Liza and Hap settled down on a farm in Rhinebeck, New York, and Liza continued selling her equestrian statues in Saratoga galleries near the racetrack. Elizabeth purchased Liza's *Northern Dancer*.

Not long after, Richard sat alone one day in Celigny, drinking at the Café de la Gare until he could feel that sunrise in his belly that booze brought about. He saw Oona Chaplin and told her to give his "undying love" to Claire Bloom. Later, at dinner with Graham Jenkins, he said, "Do you know what I heard the other day? That I've never found a part as good as playing the husband of Elizabeth Taylor." His brother asked him if he missed Elizabeth and he replied, "Of course. All the time." On August 4, 1984, just before going to bed at 10 P.M., he wrote on his bedside pad, "Our revels now are ended." In his sleep, he suffered a colossal hemorrhage from which he never recovered. The following day he died at age fifty-eight.

On August 6, Valerie Douglas, his manager, rang Chen Sam, who relayed the news to Elizabeth. According to Victor Luna, she became "completely hysterical. I could never have that special place in her heart she keeps for Burton. For me, the romance was over, and I told Elizabeth that."[31] The romance had probably long since been over for Elizabeth if it had ever existed at all. She gave Luna back his ring.

Richard's funeral was to be held in Celigny, followed some days later by a memorial service in Wales. Elizabeth rang Graham Jenkins and asked, "What do you suggest I should do?" Graham replied, "I might quarrel with Sally's motives, but . . . we could end up with a riot on our hands . . . Come to the memorial service at Pontrhydyfen." Elizabeth replied, "Sally is ahead of you. She already thought of the memorial service. She doesn't want me in Wales either." Although Sally had lived only two years with Richard, she "resented any assumptions of intimacy from family or friends which excluded her," Jenkins wrote. "Most particularly, she resented the enduring love of the woman who gave Rich his happiest years—Elizabeth Taylor."[32]

Valerie was also against Elizabeth's coming and said, "Her appearance here would be inappropriate . . . What does she think she's up to?" According to Valerie, the funeral had to be held in Switzerland "for tax reasons," and she insisted, "Elizabeth

must be told not to come." When Graham objected, Valerie said, "Sally's not going to like it." On the day before the funeral in Celigny, Elizabeth told Graham on the phone that she wouldn't be there but asked if the family wanted her at the Wales memorial. Graham said, "Of course, but—" Sally was listening to the conversation, and he couldn't go on.[33] Later, Sally told Graham, "Can't you get it straight? I don't want Elizabeth here or at the service in Wales." Graham said, "You have no right to make demands of the family or of Elizabeth."

The funeral was attended by Liza and Hap Tivey and Maria and Steve Carson. According to Graham, "Neither Christopher nor Michael Wilding put in an appearance, which surprised me." Brook Williams and Kate Burton read from Richard's favorite works, a friend played the organ, and Sally placed a poem on the coffin, enclosed in an envelope. Later she said to Graham, "Tell Elizabeth . . . that you don't want her to come to Wales." Graham defiantly replied, "She'll be welcome." Sally rejoined, "Unless you ring the woman, I'll do something desperate."[34] In a subsequent telephone conversation with Graham, Elizabeth said she naturally wanted to come to Wales but added, "I don't want a fight with Sally. Do you think she will do something stupid?"

Sally finally relented at the last moment and told Elizabeth that ex-wives would be welcome,

but by that time Elizabeth couldn't make it to Wales from L.A..[35] "The press would have gone mad," Sally told Elizabeth, but later she admitted, "I regret that now."[36] The Wales memorial was held in the gray stone Bethel Chapel just thirty yards from the home of one of Richard's sisters. Five hundred Welsh voices were joined in song and prayer.

Eight days later, Elizabeth knelt and prayed at Richard's grave in Switzerland, and two days after that she went to Pontrhydyfen on her own, flying to Wales in an executive jet. A crowd of one hundred cheered her at Swansea Airport, and later Richard's neighbors serenaded her, singing, "We'll keep a welcome in the hillside." Wearing pink silk and flashing the Krupp diamond, she told them, "I feel as if I'm home." She stayed with Richard's sister, spending the night in the two-bed front room next to the chapel where the memorial had been held. When David Frost later asked her if she was sorry that she and Richard had not been reunited, she replied, "Well, I'm sure we will be, some day."

There were other memorials as the theater and movie worlds woke up to the fact that they'd lost one of their most talented actors. Of his wives, only Susan Hunt attended the L.A. memorial, and Sally was the only wife in attendance at the New York ceremony. Elizabeth at last had her day at the best of the memorials, attended by fourteen hundred mourners on August 30, 1984, in the heart of

London, at St. Martin's in the Fields on Trafalgar Square. Dressed and beturbaned in black silk and looking, according to one observer, "like a queen in mourning," she led the procession into the church arm-in-arm with Cis James. Susan followed, and Sally, the widow, brought up the rear. "Sybil was not there," Graham recalled. "For her, I guess, it was all too long ago." Sally was angry that Elizabeth sat with the Jenkins clan, and she objected to Emlyn Williams's making many references to Elizabeth in his eulogy without once mentioning Sally. Elizabeth bore no animosity toward the widow, having seen Richard's women come and go. She said she would gladly have walked "hand in hand" with Sally at Celigny.

13

Lesions, White Diamonds, and Rough Trade

It began when Chen Sam noticed that many of Elizabeth's friends were sick with AIDS, and that Elizabeth was getting increasingly frustrated that the United States, and the world, seemed indifferent to their plight. In January 1985, Chen Sam convinced Elizabeth to see Bill Misenhimer, a pioneering AIDS activist, and Bill Jones, a prominent L.A. caterer, who were seeking Elizabeth's support for AIDS Project Los Angeles (APLA), a service organization offering hands-on help to AIDS patients. "Everyone wanted to get Elizabeth," Misenhimer recalled, "because there are three big draws in the world: Elizabeth II, the pope, and Elizabeth Taylor." Together with five other gay men, Misenhimer and Jones persuaded her to become chairperson of the first major AIDS benefit, the Commitment to Life dinner (CTL),

with proceeds to go to APLA. At the time, no other celebrity had been bold enough to help in the AIDS crisis, fearing loss of stardom and possible smearing as a gay or a gay sympathizer. A date for the CTL dinner was set almost a year away— September 1985.

It was not easy to put together a benefit with the double stigma of homosexuality and AIDS. "Nobody in this town wanted to know or be a part of it," Elizabeth recalled. Three notable exceptions were Michael Jackson, Barry Manilow, and Betty Ford, who agreed to be the guest of honor, thus lending a respectability and status to the enterprise that far exceeded Misenhimer's wildest dreams. Sinatra turned her down, warning, "Oh, Elizabeth, this is one of your lame-duck causes. Back away from it. It's going to hurt you." Instead, she redoubled her efforts. "Without homosexuals there would be no Hollywood, no show business," she said. "Yet the industry was turning its back on what it considered a gay disease."[1]

The major obstacle she faced in de-demonizing AIDS was overcoming the secrecy and shame that had always surrounded homosexuality. Famous, powerful people suffering from the disease, including Rock Hudson, Liberace, Tony Perkins, and Brad Davis, had never come out as homosexuals, and now that they were dying of AIDS they insisted on remaining in the closet. As a compassionate person who valued privacy, Elizabeth was

in no position to "out" anyone, but if only one gay celebrity stricken with AIDS would go public, the disease would lose some of its stigma, opening an avenue to public acceptance, research moneys, and a possible cure.

After the breakup with Victor Luna, Elizabeth had her pick of suitors, but she began declining dates, suspecting that most men only wanted to brag they'd been with her. Dennis Stein seemed an exception. Solicitous in a fatherly way, barrel-chested and gray-haired, he struck her as "the best-looking man," and, even more important, he was "even *available*."[2] Nor did it hurt that he was solvent. An entrepreneur for tycoon Ronald Perelman of MacAndrews & Forbes, the holding company that owned Technicolor and Revlon, Stein surprised her with a twenty-carat diamond ring. Occasionally they trysted in the Waldorf Towers suite that Frank Sinatra had lent to Stein. A tall, heavyset man, Stein was having as much trouble keeping off pounds as Elizabeth was, and they both looked pretty hefty the day Peter Lawford's wife, Patricia Seaton, walked in on them making love in Elizabeth's bedroom in Bel Air. Stein was on top of Elizabeth, and her pet parrot Alvin was hanging on to a window screen, screeching, "Help me! Help me!"[3]

Among Elizabeth's presents from Stein were a white Pekinese puppy, a mink coat, and a pair of amethyst-yellow, sapphire-and-diamond earrings. According to Seaton, Stein was not very attractive,

looking like someone who should be pushing a cart down the street. Elizabeth thought him funny and sexy. She liked it that he didn't drink, take drugs, or smoke.[4] He was "almost a mistake," she later told *Vanity Fair*.[5] She also dated Carl Bernstein, the Watergate journalist, who'd divorced his wife Nora Ephron and was about a dozen years younger than Elizabeth. Bernstein stayed with her in her duplex suite at the Plaza Athenee whenever she was in New York. Her room service waiter Kirk Kerber told an interviewer that she was not abusing alcohol and liked to chat about Alcoholics Anonymous while drinking mint tea. One night at the Palladium disco in downtown Manhattan, Bernstein and Dennis Stein came close to squaring off with each other after Stein said, "You have to answer to me about Elizabeth."[6] Bernstein kept his hands in his pockets, and the expected fisticuffs never materialized, though Stein later bragged that he could easily have taken the writer.

In January 1985, Elizabeth attended President Reagan's second inauguration with Stein and Frank and Barbara Sinatra. She urged Nancy to lend her support to the AIDS battle, but the First Lady turned a deaf ear.[7] Though the Reagans' son Ron was a ballet dancer, a profession largely populated by gays, the President had never uttered the word "AIDS" in public, not even when he spoke to his old friend Rock Hudson on the phone. Rock was still in denial, though lesions were clearly visible

on his neck, and President Reagan always referred to Rock's disease as hepatitis. To the consternation of the First Couple, Elizabeth continued to nudge them about AIDS every time they met. Fortunately, Elizabeth was too much of an American icon to be brushed off indefinitely.

She dissolved her six-month engagement to Dennis Stein after the inauguration, in February 1985, and sent him on his way with a gold watch, the traditional retirement present for those who have hung on valiantly but never quite made the grade. "I will marry once more, but *only* once more," she told writer Dominick Dunne. She still did not know that Rock had AIDS when he went to Paris for injections of the experimental drug HPA 23 in the belief it could inhibit the deadly virus. On July 25, 1985, his representative in Paris, Yannou Collart, announced that Rock was suffering from AIDS. The impact was immediate and seismic, and it ended public indifference to the disease. Elizabeth immediately sent word to Rock that by coming out he'd saved "millions of lives." He seemed puzzled by her statement and asked, "Why?" When congratulatory and sympathy messages poured in from Madonna, Gregory Peck, James Garner, Ali MacGraw, Jack Lemmon, and Ava Gardner, Rock at last realized the magnitude of what he'd done.[8] On leaving the Ritz lobby in the Place Vendôme, he fainted, and was returned to America on a stretcher.

In California, he was taken to the UCLA Med-

ical Center. The news that Rock was gay—let alone suffering from AIDS—continued to astonish a largely homophobic public, and even Elizabeth seemed surprised. "Oh, God, yes, I knew he was gay," she said, "but I thought he had cancer."[9] She visited him at the hospital, entering by the back door. Though AIDS had been discovered at UCLA, the administration was nervous about having Rock on campus. "Rock Hudson will die at home, won't he?" inquired a nervous UCLA doctor. "He won't get readmitted to UCLA?"[10] Before entering Rock's room, Elizabeth met with his own physician, Dr. Michael Gottlieb, and asked a number of questions. Her manner was "very down-to-earth," Gottlieb recalled. "She wanted to know what she could do and I said, 'Just be there.'" Like everyone at the time, she was anxious about catching the disease. "Is it safe to touch and kiss?" she asked. Although nothing definitive was yet known, Gottlieb gave her his opinion that nonsexual contact was harmless. "She kissed his cheek," Gottlieb said, "hugged him, and sat on the bed . . . A visit from Elizabeth Taylor could be a cheerful thing." Rock was gaunt and withered and didn't know where he was, but when he saw Elizabeth he laughed about the chocolate martini cocktail they'd invented during *Giant*.

While working on the CTL dinner, Elizabeth decided to establish a national AIDS foundation to

finance scientific research and hands-on care for persons with AIDS. Together with Gottlieb and Misenhimer, she held a summit conference over dinner at a French restaurant in Santa Monica. "[Elizabeth] and I were crying," Misenhimer remembered. He tried to warn her of the difficulties ahead. "Don't worry," she said. "I've been through a lot." Later she told a reporter, "We decided that night we were going to make a difference. Goddamn, we would!" She visited the AIDS wing of San Francisco General Hospital, chatting with patients and touching them. "I find being 'Elizabeth Taylor' really boring," she told a reporter. "Giving is one of the reasons that we are put on this earth." After a meeting with her core AIDS group at the Occidental Petroleum Building, she "popped in to see Armand Hammer and got him to give $10,000," Misenhimer recalled.

Again, she took her involvement with the AIDS crisis to the White House. On July 23, 1985, she was a guest of the Reagans during the state visit of President Li of China. "Liz Taylor was at the table, looking lovely," recalled Nancy Reagan.[11] Though the President had just had two feet of cancerous intestine removed from his body, Elizabeth never let him forget that she expected him to face reality and do something about AIDS. Thanks to her fund-raising trip to Japan, philanthropist Ryoichi Sasakawa became the first $1 million AIDS donor.

As she continued to promote the September

1985 CTL dinner, Rock was barely holding on, his body covered with rashes. The situation at his house, known as "The Castle," at 9402 Beverly Crest Drive in Coldwater Canyon, could not have been more complicated. The group around him included Marc Christian, a blond surfer type who'd moved in with Rock in 1983; Rock's lover Jack Coates; Tom Clark, a white-haired, blue-eyed man who'd lived with Rock for ten years before Christian; and gay 1950s matinee idol George Nader, a friend of Rock's for thirty-five years, who lived with Rock's secretary Mark Miller.[12] Christian was contemplating a lawsuit charging that Rock continued to have sex with him until February 1985, exposing him to AIDS.[13] Rock told friends that it could have been Marc who'd brought the AIDS virus into his house. After losing interest in Marc in 1984, Rock fell in love with Ron Channell, his straight personal trainer, a tall, strapping youth who wanted Rock to pay for his dancing lessons so he could become a Las Vegas hoofer, but Ron successfully kept the relationship on a friendship basis.[14] In the midst of sexual intrigue and palace revolutions, Rock was delighted to hear that Elizabeth's CTL dinner had to be moved to a more spacious venue following his coming out. "Before your announcement," Miller told him, "they'd sold 200 tickets. Now they've sold 2,500, and they've raised $1 million." Rock said, "All that because I said I have AIDS?" George Nader reminded him that he

was the first celebrity to come out, and that if AIDS could strike Rock Hudson, anyone could get it.

Tom Clark answered the door at 9402 Beverly Crest Drive when Elizabeth called that autumn. The Castle was situated on a steep ridge overlooking Beverly Hills, affording a view west to the Pacific Ocean and east across the sprawling metroplex to the San Gabriel Mountains. Rock was tired of sickroom visitors and trying to rest, but when Elizabeth arrived and Tom put his hand on Rock's and said, "Elizabeth is here," Rock revived somewhat. "Oh, good," he said. He'd dropped from 225 pounds to 140, and she felt nothing but bones when they hugged. His body itched all over from a rash, and he couldn't digest anything except Swiss Miss tapioca pudding. He put the film they made together at the top of his list of his best pictures: "*Giant, Seconds, Pillow Talk, Lover Come Back.*"

In his final days, Rock occasionally wandered around The Castle, but most of the time he slept, sometimes twelve hours at a stretch. Born-again Christian singer Pat Boone led prayers in his bedroom, and actress Susan Stafford brought a Catholic priest, Father Terry Sweeney, to Rock's bedside, where he received Communion and the Anointing of the Sick. He was heartened that her CTL dinner grew so big that a producer was assigned to help Elizabeth with the planning.

Gary Pudney, a former ABC vice president, laid out the dinner and its accompanying entertain-

ment on cards, and he took these, as well as an easel on which to display them, to Elizabeth's home in Bel Air. At the door, he was advised that she would receive him in the pool area. He went through the house and out onto the patio. It was a blazing Southern California day, and Pudney was sweating in his suit and tie. Finally she appeared, wearing a scanty red bikini and one of her mammoth diamonds. Pudney noticed she'd lost weight and was in good shape. She lay down on a chaise longue and, suddenly all business, said, "Just start flipping the cards." Quickly grasping his concepts for the show, she made pertinent, helpful remarks about the musical numbers and the speeches. With an admirable lack of ego, she seemed completely indifferent to matters such as where she'd be seated, when she'd be called on, or what she was to say, focusing entirely on the overall effect of the dinner.

On September 19, 1985, twenty-five hundred guests jammed into the ballroom of L.A.'s Bonaventure Hotel for the CTL benefit. Betty Ford showed up as promised, and it was announced that Rock's AIDS case had launched a historic turning point in public acceptance of the disease. Burt Reynolds read a telegram from President Reagan, marking the first time that the Chief Executive had acknowledged the existence of the health crisis. Most important of all, the CTL dinner netted $1 million for APLA. Two weeks later, on October 2, Rock succumbed, in his sixtieth year, the first

celebrity to die of AIDS. A memorial service was held at The Castle on October 19. Wearing a navy-and-white dress and pearls, Elizabeth addressed the three hundred mourners, reminiscing about *Giant* and concluding, "Rock would have wanted us to be happy—let's raise a glass to him." On October 20, his ashes were strewn in Catalina Channel. On November 2, Christian engaged Marvin Mitchelson, the palimony lawyer, to sue Rock's estate for conspiring to endanger his life,[15] but nothing could diminish the importance Rock had achieved in finally coming out. According to Misenhimer, "From an AIDS-activist viewpoint, Hudson's announcement was the best thing that had happened since AIDS started, because, finally, people could connect a name to AIDS."[16]

Rock had bequeathed $250,000 to Elizabeth's AIDS foundation. Mathilde Krim, a doctor of biology studying interferons at New York's Memorial Sloan-Kettering Cancer Center and wife of Arthur Krim of Orion Pictures, had started the AIDS Medical Foundation. When she heard about Rock's donation, she called Elizabeth and suggested they combine forces. Along with businessman Jonathan Canno, they founded AmFAR, the American Foundation for AIDS Research—which represented a marriage of science (Mathilde) and pizzazz (Elizabeth). "A shotgun marriage," Gottlieb called it, and conflict was not long in developing between the strong-minded Elizabeth and the indomitable

Mathilde. The board of directors did not want AmFAR to go international, but Elizabeth insisted they were being "chauvinistic" and rammed her proposal through anyway, later remarking, "I did have a big fight . . . The United States is not the only nation that is suffering with AIDS." In recognition of her global humanitarian efforts, France gave her its highest civilian award, the Legion d'honneur.

Friends observed that without Elizabeth's charitable work, she'd probably "stay home and eat." She went back on painkillers in 1985, and spent a total of five and a half months in bed using drugs prescribed by Dr. Skinner, including Percodan, Hycodan, Demerol, Dilaudid, morphine sulfate, and Halcion. By 1986, she was in the hospital for plastic surgery and liposuction, and her deadly pain-painkillers-addiction cycle kicked in again. She stopped going to AA meetings and soon became one of the program's "revolving door" statistics. As an active alcoholic and drug addict, she was further weakening her system and leaving it open to a host of maladies.

On Mother's Day 1986, Liza Tivey gave birth to Quinn, Elizabeth's latest grandchild. Hap painted a portrait of Liza and the baby and gave it to Elizabeth, who hung it over the fireplace in her bedroom. Christopher Wilding's marriage to Aileen Getty was a troubled one. When Elizabeth discovered that Aileen was a drug addict, she screamed at

her on the phone. "I sobered up very quickly after that," Aileen said. Christopher and Aileen managed to put together five years of sobriety and gave Elizabeth two grandchildren but finally separated. Elizabeth advised them to spare no effort in working out their differences and preserving their family life, but Aileen finally filed for divorce in September 1987. Elizabeth remained close to her thereafter and took care of her when she fell ill.[17] "I had had an unsafe sexual affair outside of my marriage," Aileen confessed, and at her next test she proved HIV positive, though she told no one. Neither Christopher nor his children were exposed.

Aileen said nothing to Elizabeth about having AIDS until they found themselves together in Paris for the first AIDS dinner in France. After raising a large amount of money that night, Elizabeth returned to her hotel, "worn out and happy," she recalled. "Aileen crawled into my bed and we were snuggling and talking and all of a sudden she told me that she was HIV positive." To Elizabeth it was both a "shock" and "strangely ironic." Aileen's own family found it difficult to cope with, but Elizabeth boldly defended her in the press, and Aileen started calling her Mom. "It was always very easy to talk to her," Aileen said. "She taught me I was still a beautiful person . . . I know that I could die with Mom, and she would hold me safe and tight."[18] Elizabeth told the press, "I have two grandchildren under ten whose mother is dying of AIDS. My grandchildren

ask their mother, 'Mom, will you be around for my ninth birthday? Will you be alive for my fourteenth?'" Before her death, Aileen set up hospices for women with AIDS, establishing the Aileen Getty Women's Program. Elizabeth stayed with her until the end, holding and comforting her.[19]

Though screen roles no longer came Elizabeth's way, she kept busy making television movies. In May 1986, she appeared with Robert Wagner and Chad Lowe in James Kirkwood's *There Must Be a Pony*, which was about the gay Kirkwood's adolescent rivalry with his movie star mother Lila Lee over her boyfriend. "She triumphs, even as the production sinks," according to the *New York Times* reviewer. "She looks fab, svelte and sexy," wrote the *Hollywood Reporter* critic, but Laurel Gross asked in the *New York Post*, "Where is the acting depth we've seen in *Butterfield 8* or *Who's Afraid of Virginia Woolf?*"[20] The best acting in the piece was turned in by young Chad Lowe, who projected genuine feelings and reactions that made Elizabeth's dazed performance seem bland in comparison. She seemed no longer able to access the wellspring of emotions an actress must call on for a believable performance. Something seemed to have numbed her emotional recall.

In March 1986 she began dating suave, dark-haired, forty-eight-year-old George Hamilton, who'd had a promising start in films, playing in *Crime and Punishment* in 1958; *Home from the Hill* in

1960; *Act One* in 1963 (as Moss Hart); and *Your Cheating Heart* in 1965 (as Hank Williams), but had later become something of a joke—a little too tanned, a little too slick, a little too facile—and evolved into a talk-show personality. As a lover, he was said to be in the same league with Sinatra, Beatty, and Joe DiMaggio. "He was funny, charming and attentive to my every need," said Sandra Grant, who had an affair with Hamilton just before meeting and marrying Tony Bennett. "We soon became lovers and made love often. George loved to see me nude and once said, 'Aphrodite would be jealous.'" Elizabeth put him back to work as an actor, casting him as her obsequious sidekick in the 1987 television movie *Poker Alice*, in which she played the madam of a bordello. George gave her a $5,000 pendant with diamonds spelling out "Liz," but she'd hated the nickname ever since Howard Taylor had called her "Liz the Lizard" in childhood, and she sent George back to the jeweler with instructions to spell out "Elizabeth" in diamonds.[21]

George occasionally sought solace in the arms of other women, including ex-wife Alana (Mrs. Rod) Stewart and actress Allene Simmons, while Elizabeth dated singer Bob Dylan and international financier Sir Gordon White. On February 27, 1987, she turned fifty-five during the twenty-two-day *Poker Alice* shoot in Tucson, Arizona. George gave her a $50,000 mink walking jacket with a front zipper, wide collar, and pleated cuffs. The next day they

flew back to L.A. for her diamond-theme birthday party at the Bel Air home of Burt Bacharach and Carole Bayer Sager. Down to a twenty-two-inch waistline, Elizabeth wore a low-cut white dress by Texas-born Nolan Miller, the *Dynasty* designer, accessorized with an array of diamonds. Serenading the birthday girl was a solid A-list houseful of 150 guests including her ninety-one-year-old mother, who came from Palm Springs, Jennifer Jones (Mrs. Norton Simon), Arthur Loew, Sydney Guilaroff, Michael Jackson, Stevie Wonder, Melissa Manchester, Charles Bronson, Jill Ireland, Joan Collins, Bette Davis, Dionne Warwick, Barry Manilow, Bette Midler, Shirley MacLaine, and Whoopi Goldberg. Elizabeth arrived an hour and a half late, but they saved her a piece of chocolate cake. The coat George had given her was "so soft, it feels like sable," she purred. Correcting her, George said, "No, darling, it's moon-dust mink."[22]

Her reviews for *Poker Alice* were respectful and reflected the critics' awareness of her intimate relationship with Hamilton. Kay Gardella in the *New York Daily News* wrote that Elizabeth had "slimmed down to perfection," and her costar was "her offscreen companion, George Hamilton, in his well-rehearsed role: keeping an eye on La Liz."[23] According to the *New York Post*, Elizabeth "reclaims her former status as a larger-than-life, hypnotically beautiful media personality."[24]

Elizabeth and George were seen together every-

where from Hollywood to Spain. He accompanied her to L.A.'s Del Mar Race Track, where her horse, Basic Image, was ridden by a jockey wearing her *National Velvet* colors of cerise with chartreuse diamonds. Fortunately George was a health-and-fitness enthusiast, and when they went cruising on his yacht, which he moored at Marina del Rey, he had the vessel cleared of all alcohol and cigarettes before she came on board. "George keeps her on her toes," said a friend. "He won't let her slip. He looks fantastic. As long as she's with him, she has to keep up."[25] They both laughed off marriage rumors, but traveled the world together, showing up at Aspinall's in London, where they paid $3,000 a night for adjoining rooms; Spago in Hollywood, where George wandered away with an attractive woman only to be told by Elizabeth to get his "suntanned keister"[26] back over to her table pronto; arms dealer Adnan Khashoggi's estate in Spain; Gstaad for Christmas 1986; and at Las Brisas in Acapulco, where one of the maids reported that they were "hot and heavy . . . at it like cats and dogs."[27] By the next autumn, the romance cooled off, replaced by an enduring friendship.

Following the AIDS deaths of Chester Weinberg and other top fashion designers, Elizabeth attended a Seventh Avenue fund-raiser, "To Care Is to Cure," for AmFAR. Sponsored by Bloomingdale's Marvin Traub, Peter Allen, Jeffrey Banks, Claudette Colbert, Brooke Shields, Gloria Steinem, Albert

Nipon, Fabrice, and Mary McFadden, the $150-a-person cocktail party was held at the Jacob Javits Convention Center on Manhattan's West Side. The fashion industry was still very timid and paranoid about AIDS. Only Donna Karan came forward to help. "What the event needed, quite clearly, was Calvin Klein," said Sally Morrison, who was director of program development for AmFAR, "but Calvin was resistant to our approaches for some time." Mathilde Krim told David Geffen to let Calvin know that if he would help, he could take Elizabeth to the event as his date. The bait worked. One hour later, Calvin called and asked, "What do you want me to do?" Previously he'd been AIDS-phobic, in contrast to Geffen, who candidly supported the cause on the West Coast. Now Calvin underwrote the entire event, and soon all of Seventh Avenue fell in behind him.

Two hours late, Elizabeth made her entrance on Calvin's arm. "The sight of the two stars together caused such a commotion that the crowd and press began to stampede them, nearly knocking Elizabeth Taylor off her feet," wrote Calvin's biographer Steven Gaines. "As the mob grew in ferocity, a human circle of security police had to be formed around the frightened couple to prevent them from being trampled." "To Care Is to Cure" raised $300,000 for AmFAR, and Calvin later raised $1 million at the Hollywood Bowl.

In May 1986, Elizabeth testified before a con-

gressional subcommittee, trying to get more money for emergency AIDS care. It was still an uphill battle. Despite Rock's coming out, other prominent homosexuals with AIDS remained secretive, quite realistically fearing loss of reputation and career. Both Halston and Freddie Mercury of the rock band Queen were dying of AIDS, but neither came forward to help the cause. Nor did Elizabeth pressure them. As a champion of gays, the last thing she wanted to do was harm them. She disagreed with Mathilde Krim over AmFAR's use of famous AIDS sufferers. As soon as Magic Johnson announced he was HIV-positive, Mathilde wanted him on the board of directors. Elizabeth thought that was indiscreet and said, "I don't want to use him . . . It's the same with Arthur Ashe . . . The way [somebody] chooses to die is their own goddamn business."

Like a gigantic karmic payoff for her good works of the 1980s, Elizabeth hit the jackpot as a businesswoman when her perfume took off like a rocket. For years she'd been playing around with the idea of licensing a fragrance line, and in 1986 the Parfums International division of Chesebrough-Pond's asked her to lend her name to one of their scents. An inveterate experimenter with perfumes throughout her adult life, she'd always layered four or five different ones to create the floral/Oriental fragrance she loved. She assured Parfums International that she'd find the right blend

for them, one producing a violet aroma, and she was adamant about being involved "all the way with choosing the scent." Perfume is one of the cheapest items to manufacture in the fashion industry, and one with the highest markup and profit. The chief ingredient is alcohol; the liquid in the bottle accounts for only 5 percent of the retail price. The smell of the fragrance is less crucial to its success than the bottle and the box it comes in and the image created by the advertising campaign. Six out of seven perfumes bomb in the stores and quickly disappear, so Chesebrough-Pond's was counting heavily on the clout of Elizabeth's fame. When the company went looking for a name for her product, she said, "I have a passion for love, food, children, and animals. I have a passion for life in everything I do." The perfume became known as Elizabeth Taylor's Passion, and it was packaged in containers in varying shades of purple.

Before the fragrance could be manufactured, she had to settle her old agreement with Wynberg stipulating a sixty-forty split in his favor. Inviting him to her home in Bel Air, she served him dinner, and they spent the night together in her bed. Although they didn't have sex, they did agree on a fifty-fifty split. The deal eventually came unraveled, and they ended up in court, where a settlement was finally hammered out.[28] Chesebrough-Pond's launched Passion with a $10 million promotion campaign.

When Elizabeth made the TV ad, she'd evidently been drinking the previous evening and looked hung over; Ogilvy & Mather, the advertising agency, spent $40,000 retouching the video to make her look ravishing.[29] She worked hard for the success of Passion, also posing for an alluring aquatic still photo that became Passion's trademark.

She cited January 14, 1987, as "one of the major high points of my life—the announcement of my perfume, Elizabeth Taylor's Passion, in New York." In a fur hat and a fur-trimmed tweed coat, she introduced Passion at a press conference attended by five hundred reporters, but the journalists were more interested in whether she was going to marry George Hamilton, who was in attendance. "I just married Chesebrough-Pond's," she said. "You don't want to make a bigamist out of me!" At $200 an ounce, Passion became the fourth largest-selling women's perfume in America, grossing $70 million annually and raising Elizabeth's net worth to nearly $100 million.[30] She treated herself to a historic bauble, purchasing the late Duchess of Windsor's 1935-style plume-and-crown diamond brooch for $623,000 at auction. The price she paid was donated to a leading AIDS research center, the Pasteur Institute in Paris. "It's the first time I've ever had to buy myself a piece of jewelry," she joked. Though she'd occasionally lost her patience with the Reagans for being derelict in recognizing the

AIDS crisis, she was pleased on April 1, 1987, when the President at last announced, "We declared the war against AIDS public priority No. 1."

In 1987, Malcolm Forbes, perhaps the world's richest closet homosexual, began pursuing Elizabeth. Though it was rumored that the sixty-seven-year-old billionaire's personal preferences ran to boys, leather, chains, and bikers, he loved publicity and saw Elizabeth as a way to turn himself into a household name. For Elizabeth, Malcolm was another of her a-sexual, loving partners, as well as a potential AIDS benefactor. His business-oriented magazine, *Forbes*, published fortnightly since 1917, profiled leaders in industry and analyzed the nature and effect of management policies. Founded by Malcolm's father Bertie Charles Forbes, who died in 1954, the magazine flourished under Malcolm's management, reaching a circulation of 735,000. One day Malcolm rang the AmFAR office to invite Elizabeth to an upcoming party for the seventieth anniversary of *Forbes*. A staffer told him Elizabeth was in Japan raising money for AIDS. Malcolm volunteered that he'd make a donation if Elizabeth would come to his party. The staffer informed him that Elizabeth "doesn't go for less than a million dollars." No problem, said Malcolm.

The party was held in May 1987 at Timberfield, Forbes's seventy-five-acre New Jersey estate. He presented Elizabeth with a $1 million check for

AmFAR. She called him her "million dollar baby," and he said, "What I do, I do to enjoy life and to promote my business. The $1 million contribution to the campaign against AIDS was given to give *Forbes* magazine's celebration more significance." Though George Hamilton was present, Elizabeth stayed by Malcolm's side, holding his hand as he greeted eleven hundred guests. Later in the evening she kissed him. "It was one of the most beautiful parties I've ever been to," she said. One hundred bagpipers marched over the hills toward a thirteen-foot-by-twenty-foot replica of a Scottish castle surrounded by artificial fog. After a lavish feast served by 302 waiters, the guests enjoyed a fireworks display to the music of Gershwin and Beethoven. Sun-tanned and soignée, Elizabeth wore a Dior dress and a white stole with her red Legion of Honor ribbon. Teasing her, Henry Kissinger said, "Your laundry tag is showing." Dancing in a circus-sized tent, Elizabeth and Malcolm "got on like a house afire," Chen Sam recalled.

Elizabeth and Malcolm started going out together, and the press—still in the dark regarding Malcolm's alleged homoeroticism—soon regarded them as an item. In addition to Kissinger, Forbes's social circle included Donald Trump and Walter Cronkite, who often joined him and Elizabeth for motorcycle rides or excursions in hot-air balloons shaped like a Normandy chateau, a light bulb, or a

pair of jeans. When Malcolm gave Elizabeth a purple Harley-Davidson with "Elizabeth Taylor's Passion" sprayed on the fuel tank in amethyst, she told Nolan Miller, "I need motorcycle clothes." The designer tried to explain, "That's not me," but she insisted, saying, "Do elegant motorcycle clothes." Subsequently, the black-lace-over-leather motorcycle jacket he ran up for her went into his couture collection. Malcolm made at least one play for her. Taking her home one evening to the Plaza Athenee in Manhattan, he said at the elevator, "What would it take to get you to let me come upstairs?" She told the tycoon, "A big thing in a little blue box—from Tiffany's." She went upstairs alone.

Malcolm dined her at "21" and Le Cirque and entertained her at his château in France, his ranch in Colorado, and his Tangier palace, and aboard his 150-foot yacht, *The Highlander*. He took her on a fifty-mile Harley ride around his New Jersey property. They flew to Rome on a private jet in the summer of 1987 for a meeting with Zeffirelli, who later costarred her in his film *Young Toscanini* with Brat Packer C. Thomas Howell in the title role and Elizabeth as his opera-diva muse. Metropolitan Opera star Aprile Millo recorded the aria from *Aïda* that Elizabeth's character sings in the movie, and when Elizabeth went to Aprile for help in interpreting the scene, Elizabeth asked, "Who is *Aïda?*" Elizabeth had known Arturo Toscanini in the 1950s when Mike Todd was planning to film

his life, and she recalled that the maestro was the biggest flirt she'd ever met. When the film later premiered at the Venice Film Festival, the prescient Elizabeth, divining disaster, refused to attend. Zeffirelli was booed, and the picture never went into general release. Malcolm offered consolation in the form of a diamond-and-amethyst necklace and matching bracelet.

In Miami, during a 1987 AIDS benefit advertised as "An Extraordinary Evening with Elizabeth Taylor and Friends," she charmed another philanthropist into donating $1.2 million for AmFAR. As the foundation's new national chairperson, she persuaded President Reagan to speak at the AmFAR Awards Dinner in the capital in 1987. Reagan was cautioned by AmFAR about the danger of mandatory testing, a controversial issue at the time, one smacking of totalitarianism and police state tactics. According to Mathilde Krim, mandatory testing was not advisable "scientifically, legally, or medically." AmFAR wrote the first half of Reagan's speech, the thrust of which was the need for compassion, care, and justice, but the President gave the manuscript to his White House staff, and it was radically revised.

The awards dinner was held in a tent during a heat wave, and there was no air-conditioning. "Let's talk about warm," Elizabeth recalled, and added, "The President mentioned mandatory testing and people jumped out of their seats. Then they started

heckling him." She leaped into the fray and scolded the crowd, telling them, "Don't be rude. This is your President and he is our guest." No one dared defy her, and a nasty incident that could have set AIDS back many years was averted.

After taking acting lessons in England and L.A., Mike Wilding Jr. played Jesus Christ in the television miniseries *A.D.* He attributed his success, such as it was, to his male parent, Wilding Sr., and stepfather Richard Burton.[31] With his wife, Brooke Palance, an actress and producer, he visited Elizabeth often, "but not often enough," she complained. "My only regret is that I don't get to see Michael's daughters, my two oldest grandchildren, Laele and Naomi, as frequently as I'd like." Christopher was working in L.A. behind the scenes as a movie and TV editor. His sons, Caleb and Andrew, often visited Elizabeth, allowing her to play granny. Chris inherited her sweet tooth, but followed a diet included in the book she was writing, *Elizabeth Takes Off*, and lost twenty-five pounds. Maria Carson was still living in New York and raising her daughter, Eliza.

By 1987, Elizabeth's old party crowd was scattered and decimated, some of them dying from AIDS or substance abuse. Warhol expired after gallbladder surgery at New York Hospital on February 22, 1987, and Elizabeth immediately called his friend Francesco Clemente, anxiously inquiring about Warhol's taped conversations with her about

her sex life and her husbands' reproductive organs.[32] Steve Rubell died at forty-five of drug- and alcohol-related illnesses including hepatitis and kidney failure. After founding a fragrance called Eternity, Calvin Klein checked into a rehab, the Hanley Hazelden Center at St. Mary's for Alcohol and Drug Rehabilitation in Center City, Minnesota, near Minneapolis–St. Paul. Quipped Robin Burns, president of Calvin's cosmetics division, "I hope that it does for Eternity what Elizabeth Taylor in BFC did for Passion."[33] Not quite—Eternity grossed $35 million at the end of its first year, while Passion was earning twice that much.

Nolan Miller made the stunning gown Elizabeth wore to the Oscar ceremony in March of 1988. Though she hadn't been a contender for the award in years, she continued to lend her inimitable glamour to the occasion as a presenter. The female nominees had been sporting bizarre creations in the past decade, so Elizabeth told Nolan, "I want to wear something they would not expect of me." The dress he designed featured a low Edwardian neckline, puffed shoulders, and long sleeves, and it gave her a perfect hour-glass figure. Like Poker Alice, she often dressed like Belle Watling, the cathouse owner in *Gone with the Wind*, but she was also, as on this occasion, capable of elegance, and she more than held her own, fashion-wise, with the new generation of superstars, including Cher, who won the best actress Oscar for *Moonstruck*.

Early in 1988, Elizabeth was svelte and pretty at 122 pounds, and her face appeared young and fresh. She admitted, "I did have a chin tuck because there was some loose skin. And that is all!"[34] But columnist Erma Bombeck thought otherwise, writing that Elizabeth's hands were "probably the only part of Elizabeth Taylor left over from *National Velvet*." Michael Jackson was on his *Bad* tour from April until December 1988, and Elizabeth and Sophia Loren greeted him after his show in Switzerland, where sixty thousand attended his concert. Later, in London, influenced by Elizabeth's humanitarian activities, Jackson gave Prince Charles and Princess Diana a check for $450,000—the proceeds from his Wembly concert—for redevelopment of the Great Ormand Street Children's Hospital. Under fire for his alleged activities with young boys, he was desperately trying to salvage his reputation by projecting an impression of normalcy. During the song "Leave Me Alone" in his ninety-minute video *Moonwalker*, he even poked fun at his Neverland shrine to Elizabeth.[35]

On an AIDS fund-raising junket to Japan in 1988, Elizabeth was invited aboard Malcolm Forbes's yacht, *The Highlander*, where she was greeted by bagpipers and, to her surprise and dismay, the entire crew of Robin Leach's television show *Lifestyles of the Rich and Famous*. She never appeared on television without pay, but the publicity-mad Malcolm had set a trap. She adroitly side-

stepped it by refusing to let Leach's cameramen near her until he'd agreed to give her an Erte painting.

During the summer of 1988, Elizabeth hurt her already damaged back, propelling her into another cycle of pain-painkillers-addiction. Then came her return to BFC in October 1988, following a relapse somewhat provoked by the promotional effort for her huge best-seller, *Elizabeth Takes Off*, in which she bragged about overcoming her addictions. The book is a genuine, if misguided, attempt to help readers gain self-esteem and conquer compulsive behavior such as overeating and substance abuse, but its emphasis on dogged willpower as the key to self-improvement was irresponsible and reckless. In BFC she had been taught that self-will is useless in changing one's life, and that recovery depends on a willingness to ask for help. In her book she espoused the opposite tack. "You and only you can take charge of your self-image," she wrote. Instead of crediting the help she got from others, she crowed, "I finally worked my own miracles." Her message was essentially an empty one, and the book unwittingly revealed that she had not really changed.

In *Elizabeth Takes Off* she blamed her fat on John Warner rather than taking responsibility for her own eating habits. She propounded the same false values that had always gotten her into trouble, quoting the adage, "You can never be too thin or

too rich," and observing, "I subscribe wholeheart-
edly to the latter and not at all to the former." She
was still addicted to money although it had never
brought her happiness. Her confusion was
poignantly obvious in the slack-jawed, open-
mouthed photograph of her on the dustjacket, in
which she appears lost, vulnerable, and stoned.

"I had the arrogance to think I could be a social
drinker," she said after her relapse, "and I was
addicted to painkillers." One of her biographers
blamed her relapse on her promotional tour for G.
P. Putnam's Sons, publisher of the book, pointing
out that in July 1988, when she came home from
touting *Elizabeth Takes Off*, she was exhausted,
overeating, and drinking alcohol. She entered BFC
for the second time on October 25, 1988, looking
puffy and confined to a wheelchair after having
"wallowed in booze, pills, and food," she con-
fessed.[36] If she had deliberately planned to destroy
herself and Larry Fortensky, the rough-hewn
thirty-six-year-old truckdriver she met at BFC, she
could not have found a surer way than "thirteenth
stepping" him in rehab. In recovery lingo, "thir-
teenth stepping" means romance, and experience
has shown that it usually produces disastrous
results. Newly sober couples too often codepend on
each other rather than draw on the stunning
breadth of the program and its pool of wisdom to
achieve a measure of stability within themselves

before taking on the challenging complexities of a relationship.

Elizabeth later discussed the danger of thirteenth stepping, telling Oprah Winfrey, "We were friends for a year before we got 'together' in that sense," but elsewhere she admitted, "They tell you in recovery not to get romantically involved for a year at least. But Larry and I did not wait a year."[37] According to Kelly Matzinger, a close friend of Larry's sister and later one of Larry's lovers, Elizabeth and Larry fell in love on sight and he was "living with" Elizabeth and "sharing her bed" within sixty days of their first date following rehab.[38]

They'd met in group therapy at BFC. "We were at our most vulnerable," Elizabeth recalled. "They knock you down [verbally], kick the shit out of you, then give you the tools to build yourself up. Larry felt very protective toward me. He told me later there were times he wanted to kill the counselor."[39] Obviously, she and Larry had immediately fallen into a dangerous codependency when they should have been working independently to find their own individual answers. She was still looking for a man to lead her life for her, but this particular man couldn't even lead his own. Larry had been remanded to seek help after numerous DWI arrests. "I drink and do a little coke now and then, but I don't smoke marijuana," he told a policeman who'd just chased him down.[40]

He was a husky construction worker who operated an off-road Caterpillar dirt compactor. At BFC, he operated Elizabeth's wheelchair, pushing her around the rehab when her back acted up. Using his Teamsters Union insurance to cover his BFC bill, Larry came from Stanton, California, an Orange County working-class community of thirty thousand. He'd already been married twice, and his first marriage of eighteen months produced a daughter. His second wife said he attempted to strangle her during an altercation.[41] Kelly Matzinger said Larry was "a total nightmare."[42] Matzinger was careful during a 1998 interview to point out that he did not abuse Elizabeth, but he "beat me like crazy," she said. "He blackened my eyes, kicked me and pounded my head with his fists. And when he hit me, he didn't hold back, even though I'm just 5'6' and weigh 132 pounds while he's 6'2' and weighs over 200 . . . He drank and popped pills all day long. He smoked pot. He was drunk every day. And he's a mean drunk."[43]

In 1999 George Hamilton recalled, "I saw her and Larry in BFC, and already there was a humor going on between them. Imagine his situation—trying to keep your day job in construction and handle a famous woman."[44] Her relationship with Larry at first struck most people as ridiculous, but eventually everyone accepted his presence in her life, figuring that she'd stay sober if she was with someone from Betty Ford. She and Larry both left

the rehab just before Christmas 1988, and she asked him to come to her home for a holiday meal. "It didn't take long for him to realize that Liz had the 'hots' for him," Matzinger said, "and after that dinner they were hooked on each other."[45] Larry recalled that he accepted her invitations to Bel Air "mostly on weekends. I didn't think I fitted in, but I kept on coming."[46] They were sleeping together regularly by the spring of 1989. Before the new year, he was living at 700 Nimes Road, Elizabeth's Bel Air home, while still holding down his job. As Elizabeth explained to *Life*, he needed his job to "maintain [his] balls."[47]

Understandably, Larry must have been uncertain how to entertain such a world-class celebrity as Elizabeth, finally taking her on a series of ordinary outings. She thoroughly enjoyed herself on a picnic and at McDonald's, her first fast-food restaurant. On his work days, she awoke at four in the morning and had breakfast with him. After he left the house, she went back to sleep. When she finally got up much later in the day, she dressed in her motorcycle outfit—leather jacket and jeans—and went to Larry's construction site, wowing the hardhats with her trim figure. "Then he would come home," she continued, "and it was wonderful—he was sweaty, he had dirty hands, he was beautiful, and he played with his [homing] pigeons. I was so proud of him for working."[48]

Sober and drug-free, they had a fairly good rela-

tionship, though one likely based on lust and opportunism—about as stable as a house built over a sinkhole. He described her as an "extremely passionate kisser," but added that she had a condition called TMJ, a jaw disorder, and that the affliction on occasion interfered with "intimate moments."[49] Kelly Matzinger said Larry told her Elizabeth was "a wild woman in bed. She loved passionate sex with him," and they "did things that he'd never experienced before."[50] Despite their twenty-one-year age difference, they were at first quite compatible sexually.[51] "Larry never thought of Liz as an old woman," Matzinger said. "He loved Liz's big breasts."[52]

When Elizabeth resumed her AIDS work, she tried to involve Larry, but as a typical hardhat, he needed to adjust to gays. "He probably never met a homosexual until he moved into this house," she said, "and now, as the saying goes, some of his best friends are." For a start, she invited some gay pals to Bel Air to meet him, including interior designer Waldo Fernandez. "She wanted to see [Larry's] reaction," Waldo recalled. "And he was very easy . . . Now he is our best buddy." Eventually, Larry became the godparent of Waldo and longtime partner Trip Haenisch's adopted son Jake. At first, Waldo only asked Elizabeth and Larry to be the baby's aunt and uncle, but Elizabeth said, "What's this aunt-and-uncle thing?" and insisted on being godparents. Larry worked with an AIDS commu-

nity group, Project Angel Food, taking meals to AIDS patients. Two times weekly he cleaned the project's large commercial ovens while Elizabeth read a book, waiting for him.[53]

For all her talk of being in love with Larry, when she felt like spending time with someone else, she did not hesitate to regard Larry as disposable. According to Malcolm Forbes, who thought Larry "strange," Elizabeth and George Hamilton flirted "like mad" in front of Larry, who adopted an "anything goes" attitude.[54] Though Larry was not invited, Elizabeth was Malcolm's hostess at his seventieth birthday party in August 1989 at his Palais Mendoub in Tangier, where, in oppressive summer heat, she greeted six hundred guests including Cronkite, Kissinger, Robert Maxwell, Barbara Walters, Cindy Adams, and Beverly Sills, who'd been flown in to sing "Happy Birthday." Elizabeth attempted to conceal an embarrassing weight gain beneath a green-and-gold caftan. Hoping to dissuade her from marrying Larry, Malcolm gave her a set of diamond earrings and condescendingly referred to Larry as "a nice fellow" but hardly a suitable one for Elizabeth. Malcolm reminded her that Larry hadn't wasted "too much time in giving up the construction business" after moving in. Larry's sole qualification was that he "had all the time in the world to devote to her," Malcolm said.[55]

His Moroccan birthday bash set Malcolm back

$2 million and was replete with acrobats, jugglers, belly dancers, camels, and chandelier-lighted tents on the palace grounds—a tasteless affair that was sordid at the edges. Some guests were bothered by the presence of his young Arab friends and S&M leather types who circulated among the guests, smoking marijuana and hashish. Afterward Elizabeth joined Larry, who was at her home in Gstaad (the flight from the United States marked his first time in a plane). Within months Malcolm Forbes was dead of a heart attack. Elizabeth attended his funeral at St. Bartholomew's Church in Manhattan. Swathed in diamonds and mink, she sat next to former President Richard Nixon, who rose to greet her. Steve Forbes, Malcolm's son, would be a candidate for the Republican presidential nomination in 2000.

Elizabeth launched a new fragrance, Passion for Men, and another perfume for women, White Diamonds, attending promotional parties in New York, Paris, and London in 1989. White Diamonds couldn't miss; it was manufactured by the $450 billion Dutch-based corporation Unilever Company NV, which sold soaps and detergents worldwide. Saudi arms dealer Adnan Khashoggi, a sometime beau who'd entertained her at his homes in Cannes and Marbella, escorted her to the New York Stock Exchange for a publicity appearance, and she attended a party at his Olympic Tower duplex. She added Khashoggi to her AmFAR mil-

lionaires' club. His nephew was Dodi Fayed, who later died with Princess Diana.

Making her fourth appearance as a Tennessee Williams heroine, Elizabeth filmed her last major TV movie, *Sweet Bird of Youth*, in October 1989. Lucille Ball had turned down the role of the aging film star, Alexandra del Lago, played to perfection on Broadway and later in a Hollywood film by Geraldine Page. Elizabeth's weight fluctuations made the shoot a difficult one. She looked drawn in some sequences, puffy in others. British director Nicholas Roeg wanted her to perform topless in a love scene with costar Mark Harmon, cited by *People* as the most beautiful man in the world, and she supposedly refused.[56] As Chance Wayne, Harmon played a good-for-nothing drifter, a role originated on Broadway by Paul Newman and repeated by him on film. Elizabeth's relationship with Harmon was prickly; he objected to filming delays brought on by her back problems and her determination to make a perfect film. "Mark hasn't paid his dues yet," she said. "He has to earn them, like I have over the years. I want this movie to be a success, and I'm doing all I can to make it work." Happily she was able to get her son Michael a bit part. He played a producer, a precipitous comedown from Jesus Christ. Elizabeth held the wrap party at home, serving barbecued ribs, hot dogs, hamburgers, corn-on-the-cob, and salads. The show received bad ratings. Critic John Leonard confessed he

could no longer judge her. "She's a palimpsest of all the revisions we've made of our fantasies about her over the decades," Leonard wrote.

After years of alcohol and drug abuse, Elizabeth's body had taken such a beating that she could no longer fight off infection. In March 1990 she contracted a simple sinus infection, and a month later she was in Santa Monica's St. John's Hospital and Health Center. For the next three months, she valiantly struggled to overcome a pulmonary virus. During this period, Larry had the run of her house and it was rumored that he threw noisy bashes that disturbed her sedate neighbors on Nimes Road. On May 29, 1990, she told a friend, "I'm dying." The Aaron Diamond Institute's Dr. David Ho saved her life, opening her chest surgically and inserting catheters. She not only had a virus, but a fungal infection called candidiasis, better known as thrush, a condition common among AIDS sufferers. Fortunately, she was not HIV-positive. "All those tubes coming out of your nose, your mouth, all sorts of places, and the tubes are full of little pieces of you," she remembered, "swimming by like little fishes."

At last, in June 1990, after a nine weeks' struggle with viral pneumonia, she emerged from the hospital thin and weak, and convalesced at a rented beach house in Santa Monica. Larry gave her a miniature goat, and Senator Warner sent her a home-cooked meal. On June 3, Michael Jackson,

who'd visited her at St. John's, entered the same hospital, complaining of chest pains. His HIV test for AIDS came back negative. It was said that Michael was diagnosed with costochondritis—cartilage inflammation in the front part of the ribs—due to overexertion and stress, but a friend said he'd had an anxiety attack trying to decide whether to sign with Disney or Universal. Elizabeth's a-sexual, loving relationship with Michael was as nurturing and emotionally reinforcing as her a-loving, sexual relationship with Larry was draining. When she introduced the two men, Jackson, who reads Hemingway, Somerset Maugham, Whitman, and Twain, said he liked the monosyllabic Fortensky.

Elizabeth made lurid headlines again when accusations were filed in 1990 by the California attorney general's office alleging that three prominent physicians had prescribed excessive doses of painkillers for her—more than one thousand prescriptions dating back to 1983. The doctors involved were Drs. Skinner, Gottlieb, and Michael Roth, a prominent internist who'd treated her for ten years. According to the *L.A. Times*, the three physicians were reprimanded by the Medical Board of California for falsifying patient records to cover up the addictive drugs prescribed to Elizabeth. Gottlieb's attorney, Harland Braun, said the doctors did not accurately record the drugs Elizabeth was given "to protect her from ending up in

the *National Enquirer* . . . Liz Taylor is a different patient, with intractable long term, untreatable pain. She had no life without painkillers."[57] Nonetheless, the DEA accused both Skinner and Roth of improperly administering drugs to Elizabeth.[58] According to a prominent L.A. doctor interviewed in 1998, the case was dropped "because Elizabeth Taylor is very powerful."

By now her good works were so well-known that she seemed immune to scandal. "God must have some reason for keeping me alive," she observed. "Something He wants me to do. And I'll know. I'll know. I just have to be still. God knows where we all are." As she regained her strength she realized, "I've got to do something to help people who are *really* sick." Halston, his fashion empire in ashes, had died of AIDS—pneumocystis carinii, complicated by Kaposi's sarcoma lesions in his lungs—in early 1990, when Elizabeth was still in the hospital. The fifty-seven-year-old designer spent his last days in San Francisco, surrounded by white orchids, wearing silk pajamas and a red Halston robe, and looking out his hospital window at the Golden Gate Bridge. His funeral at Calvary Presbyterian Church on Fillmore Street was attended by Liza Minnelli, Berry Berenson Perkins, Dennis Christopher, Pat Ast, and D. D. Ryan. Desperately ill herself, Elizabeth had been unable to attend.

Upon her recovery, she rededicated herself to

raising funds for AIDS sufferers. By the end of 1990, AmFAR had banked $30 million largely thanks to her efforts. She celebrated by making a public appearance to launch the International Conference on AIDS in San Francisco. She continued to collect $1 million donations for AIDS just by showing up at a party. "I'm a great hustler," she said. "There's certain things only I can do." As a result, AmFAR raised $20.6 million in 1992. Seven years later, the figure stood at $100 million. "That's why I do photo shoots—to keep my fame alive," she said in 1999. "So people won't say, 'Who's that broad?'"

Though a survivor of seven failed marriages, she was still convinced in the early 1990s that she was "the marrying kind." According to Kelly Matzinger, "Finally Liz popped the question. Larry was dumbfounded. He told me, 'I didn't know what to say. I'd been married twice before and didn't ever want to be married again.'" In July 1991 they became engaged. On such occasions in the past, men had given Elizabeth priceless gems, but on this one, she bought Larry's grandmother and aunt new dresses and shoes.⁵⁹

When Larry said he was ready to marry her, Elizabeth put her better judgment on hold. "My heart says to do it," she recalled. Asked what people would think of her for marrying a man twenty years her junior, she said, "I don't give a shit what people think."⁶⁰ The wedding took place in early

October 1991 at Michael Jackson's Neverland, with two former U.S. Presidents, Reagan and Ford, among the 160 guests. As Elizabeth and Larry stood beneath a gazebo, exchanging vows in front of New Age personality Marianne Williamson, a helicopter buzzed them, and suddenly a reporter parachuted into the wedding party. "Do you want me to talk louder so everyone can hear?" Williamson inquired. "No," Elizabeth replied. "Why don't you just speak to Larry and me?" She gave him a plain gold ring, and he gave her one set with pave diamonds. José Eber, Elizabeth's hairdresser, was Larry's best man. Other guests included Sara Taylor, Phyllis Diller, Eva Gabor, Merv Griffin, Diane von Furstenberg, Carole Bayer Sager, Gregory Peck, Elizabeth's children and grandchildren, and Larry's family, except for his father, from whom he was estranged.

The final tab for the wedding came to $1.5 million, and Jackson picked up the bill. Later, when he fell into disgrace, charged with child molestation, Elizabeth rushed to his defense, calling him the least weird man she'd ever known. The Fortenskys accompanied Michael to London, where he entered a private clinic for addiction to painkillers. Subsequently he resolved a civil case involving his relationship with a young boy by paying out $26 million. A criminal investigation continued but was dropped at the end of 1994, and no charges were ever filed.[61] When Oprah Winfrey conducted

a joint interview with Elizabeth and Michael, Elizabeth revealed for the first time that her father had beaten her. "We both had abusive fathers," she said, and she later told Barbara Walters, "That just popped out of my mouth."[62]

In October 1991, as a thank-you present for their million-dollar wedding, the Fortenskys gave Michael a $20,000 rare albino bird from the Amazon. Elizabeth also gave Michael a moody five-thousand-pound elephant named Gypsy. After honeymooning in Europe, the Fortenskys returned to the United States in November 1991. Elizabeth celebrated her sixtieth birthday at Disneyland in February 1992 with hundreds of guests. On national television she told Johnny Carson that she was astonished to have made it to sixty. One of the guests at her Disneyland party, Michael Lerner, was nominated for a 1991 Oscar as best supporting actor in *Barton Fink*. On the sixty-fourth annual Oscar night in March, Lerner lost to Mike Wilding's father-in-law, Jack Palance, for *City Slickers*. In the evening's grand finale, after Jodie Foster and Anthony Hopkins accepted their Oscars for *The Silence of the Lambs*, Elizabeth swept into the spotlight in a white gown, wearing the distinctive red AIDS ribbon. Thirty-four years after they'd costarred in *Cat on a Hot Tin Roof*, Paul Newman gave her the Jean Hersholt Humanitarian Award—her third Oscar—presented in recognition of her breakthrough work with AIDS. When she got home,

she placed the statuette on the game-room book-shelf alongside her Oscars for *Butterfield 8* and *Who's Afraid of Virginia Woolf?*

At 700 Nimes Road, the Fortenskys settled in with four dogs, including Larry's German shepherd and a lovable Maltese he gave her named Sugar. Her gay friends, being outsiders themselves, understood Larry's feelings of not belonging, but among her Bel Air and Beverly Hills chums, such as R. J. Wagner, Burt Bacharach, and George Hamilton, Larry looked ridiculous. During the course of her eight-year marriage to Larry, well-meaning old friends struggled to convince themselves that this unlikely relationship was eventually going to prove viable. "Larry's authentic," said the usually more perceptive Carole Bayer Sager. "He means what he says and he says what he means. He's strong and supports her emotionally." Such friends were unwittingly reinforcing her worst delusions, the most pitiful of which was that Larry had "quickly . . . adjusted" to her life.[63]

Of course he hadn't and couldn't, but she deliberately mistook his bumptiousness for gritty horse sense, just as Richard had once attributed mythic qualities to her that proved equally bogus. Larry, she maintained, had discovered some "larceny in my world. Some of it's petty and some grand." Her ill-considered flattery made him smug. He cockily informed her that Stanton had it all over Bel Air, and he could teach her a thing or two. In his hey-

day as a member of Teamsters Local 420 in L.A., he'd pulled down $18.50 an hour. "I like the work, I like the dirt, I like the mountains, I like the big machines," he boasted.[64] Perhaps blinded by love, or lust, Elizabeth must have believed him, for she told a reporter, "Larry sees through the world of bullshit I live in. He's very protective."[65] As the pink-cloud period of their marriage continued, she saw him as "very strong and wise"; he "eased into my life with grace and style."[66]

She played Svengali to his Galatea, trying to turn him into someone she wouldn't be ashamed of, giving him a new haircut and speech lessons. It didn't work. At parties he looked like her bodyguard, saying little and lurking in the background. Since they obviously had little in common, friends assumed he was a great lover like John Warner, but his former wife asserted that he was perfectly average.[67]

Asked by a reporter if she and Larry practiced safe sex, she replied, "Larry and I are regularly checked. And at the present moment we do not use condoms. If you're in a monogamous relationship for a certain amount of time and are true to each other and have tested negative a couple of times for AIDS, I think you're safe."[68] She posed for a magazine cover dangling a condom on her finger, shocking both the press and religious leaders by advising young people to use rubbers. Sensibly, she argued that kids have a right to be informed and educated

by parents, teachers, preachers, and politicians.

If Elizabeth could have accepted Larry as the un-ambitious, unkempt Homer Simpson he was, there might have been at least the ghost of a chance for the marriage, but "she wanted to change him," said Kelly Matzinger, "and there's no one in the world who can do that—not even Elizabeth Taylor."[69] A long-time party girl and jet setter, Elizabeth enjoyed socializing, but Larry's idea of a good time was lolling in front of the TV, where no one would call him "Mr. Elizabeth Taylor," and watching *Matlock* and *The Andy Griffith Show*.

She used the vast sums of money collected from selling their Neverland wedding pictures to establish the Elizabeth Taylor AIDS Foundation (ETAF), which unlike AmFAR concentrated on patient care.

As Elizabeth's fragrance line continued to flourish, by the end of 1992 she was among the ten richest women in Hollywood, with a fortune estimated at $150 million. She was listed in sixth place, between Dolly Parton ($158 million) and Jane Fonda ($143 million), and the number one spot was occupied by Oprah Winfrey, who was worth $200 million. Unfortunately, Elizabeth began to have a series of serious falls the following year, partly due to the stressful situation at home. Her marriage had been deteriorating ever since Larry quit his job. Surrounded by a multimillionaire's luxuries, he'd seen no point in knocking himself out driving a Caterpillar. "I was kind of hurt

when he stopped," Elizabeth said. Idle in the lap of luxury, he started drinking beer again.[70] For a while, she ran around Bel Air trying to scare up odd jobs for him. Nancy Reagan hired Larry to build some shelves for her and the former President. But Larry preferred lying abed, or watching TV in his bathrobe all day. Afraid of losing him, desperate to make life more diverting for him in Bel Air, Elizabeth had a private den and a basketball court built for his amusement.

Like Auntie Mame, who hoped world travel would be broadening for her young ward, Elizabeth took Larry overseas. "I got such a kick out of taking him to places that I have never gone to, so that I wouldn't have an advantage over him and we could share the newness together," she recalled. She took him to Thailand, where they were guests of the royal family. Everywhere they went, a motorcycle escort was provided, and all roads were cleared of traffic. Larry assumed that everyone who went abroad received salutes from the police. Foreign travel bored him, and he wouldn't eat the food. "He wanted to go to McDonald's wherever we were," she said.[71]

What had been intended by Elizabeth as a romantic excursion to Paris was a disappointment for both. She wanted to share her favorite places with him, but he remained in the hotel, refusing to go out. Even the mountain air of Gstaad failed to enliven him, and he was not pleased to discover that

she'd rung the staff at Chalet Ariel before their arrival and ordered them to remove the satellite dish. "She wanted his undivided attention," said Matzinger. Inevitably, he felt "smothered."[72]

Back in Los Angeles, he began to ignore her completely. As in her previous marriages, Elizabeth attempted to hold her husband hostage. "Liz didn't want him out of her sight," Matzinger said. Even when he was busy in an adjoining room, she would call and harass him on the intercom.[73] On a trip to New York, while staying at the Plaza, she fell asleep and Larry went down to the desk and rented a room for himself. In Bel Air, they maintained separate bedrooms, but her obsessive focus on him, according to Matzinger, made him feel like a slave who had to be in constant attendance. He fell into a depression and began sleeping until mid-afternoon, remaining in his dressing gown all day. According to Matzinger, "He was happiest hanging out at her Bel Air house . . . talking on the phone to his friends." All efforts to get him to go out with her were rebuffed because, if he so much as smiled at another woman, she lectured him, and her jealousy became unbearably cloying. "I'm not like your other husbands," he said, according to Matzinger. "You're not going to push me around." His threat stunned her, and she backed off, but Larry closed his door to her, putting a damper on their sex life. One day a fe-

male assistant wearing nothing but a longish T-shirt came into the breakfast room where he was eating. Suspecting that Elizabeth had set up the situation to test his fidelity, he controlled himself and later rang his sister, asking for advice. She wisely told him to shun anyone who wasn't wearing panties.[74]

In July 1992 Elizabeth attended the Eighth International Conference on AIDS in Amsterdam. When demonstrators from the radical gay organization ACT UP saw her, they began yelling, "Act up, Liz. Act up." She thought, "Well, you've got the right girl. Worry not, I *will*." At a crowded 11 A.M. press conference, after only two hours' sleep and suffering from flu, she denounced the U.S. government for imposing immigration restrictions on AIDS victims, slamming into President George Bush. "I don't think President Bush is doing anything at all about AIDS," she said. "In fact, I'm not even sure if he knows how to spell 'AIDS.'" According to *Vanity Fair*, "It was the A-I-D-S shot heard round the world, front page news from Tokyo to Washington." At a press conference the next day, the medical reporter from CNN told her that the Bush administration would not be "browbeaten by movie stars or anyone else on their AIDS policies." Elizabeth asked, "Who said that?" The reporter replied that the announcement had come from Secretary of Health and Human Services

Louis Sullivan. "I wasn't addressing my remarks to him," she said. "I was addressing my remarks to the President."[75]

From late July to the end of September 1992, while on the road promoting White Diamonds, she put on twenty pounds, and when she returned to Bel Air, she added another four pounds. Part of the problem was her kitchen staff. Her longtime chef Penny Newfield had departed over the summer of 1992, and Elizabeth had hired Ladoris Jackson, a middle-aged whiz at rich Southern cooking. While Penny had been calorie-conscious and reluctant to give Elizabeth fatty foods, Ladoris served fried chicken, mashed potatoes and gravy, lobster dishes, pork roasts, and peach cobbler with whipped cream. After Elizabeth's weight gain, Larry ordered Ladoris to start preparing low-cal, low-fat dishes, but Ladoris explained she wasn't trained in lean cuisine. The Fortenskys let her go and hired a new cook, Derick Duke, a nonfat specialist who gave them soybeans, tofu, fish, and eight glasses of water a day. Soon Elizabeth was on her way to the trim 110 she'd weighed on the day she'd married Larry.[76]

On June 19, 1994, she had her left hip-replacement operation. Later, to her horror, she realized one of her legs was shorter than the other, and she had an exaggerated limp. She would have to undergo a total of three hip operations. "I learned to walk as a baby," she said. "Why did I have to learn

all over again—in my sixties?" As she attempted to recover from surgery with the help of a physical therapist, her life was one of unrelieved domestic strain. A friend noted that her marriage went on the rocks after the first hip replacement, when she began "picking fights." Larry was equally responsible, bitching that she was sick all the time, couldn't have sex, and generally was "too much trouble." Observed one friend, "They shout first and think later." When she'd told David Frost after Richard's death, "We had a ball fighting," she seemed to forget that their fights were so unbearable they divorced each other twice. Her arguments with Larry grew even more vitriolic after the second hip operation in June. Her only source of comfort now was the serenity she found on the outdoor walking trail at 700 Nimes Road.[77]

Though she was months recovering in physical therapy, it was difficult to get doctors to prescribe painkillers, due to drawn-out investigations into her drug use. As she struggled to learn to walk again, Larry was not supportive and even poked fun, calling her a "cripple." He spent his leisure time with hardhat friends, giving up any pretense of trying to fit into her Bel Air life. According to Kelly Matzinger, Elizabeth turned "moody and stopped having sex with him . . . She even remodeled the guest room and moved him in there alone for three years." There was so little contact between them that she finally resorted to leaving

Post-It notes at strategic points in the house, asking, "Did you shave today?" "Are you going to get up this morning?" "Please spend time with me today?"[78] Sexually stymied, she began a dangerous eating binge at his fortieth birthday party, held at a soul-food restaurant, and started to regain all the weight she'd taken off.

Though Elizabeth is not reflective and abhors analyzing feelings and relationships, she found herself, as Mrs. Larry Fortensky, dragooned into going to a marriage counselor. "I thought, 'Why not? I'll try anything,'" she recalled. But she was at a distinct disadvantage: Larry knew the counselor well, having sought help during marital crises with previous wives. "They had a conversation which had become a sort of code," Elizabeth said. "I felt left out. But we did it. Got into the car. Did it. Then we wouldn't speak until the next appointment."[79]

Her marriage having soured, she proved to be particularly testy and even litigious when she discovered that a new biography was portraying her as a battered wife, the victim of male abuse. Though it was true, she feared that anything but a romantic image of herself would jeopardize her perfume line. She lodged a $10 million lawsuit against the Carol Publishing Group, publisher of David Heymann's *Liz*; against the author himself; and against Lester Persky and NBC, who were planning a miniseries based on her life. She had vanquished ABC a dozen years previously when the network

announced a Taylor biopic. Heymann's book al-
leged that she'd been beaten by Nicky Hilton,
Mike Todd, and Richard Burton. Despite her later
admissions of abuse at the hands of her father and
Nicky, she charged that such allegations would
damage her business enterprises and diminish the
worth of the rights to her life should she decide to
sell them herself. After all, she said, she was her
own "commodity." An L.A. Superior Court judge
ruled her case "unconstitutional."[80] For once in her
life, she came out of a clash with the establishment
looking bad. Obviously, when the principles of a
free democracy came into conflict with the Eliza-
beth Taylor industry, she was willing to sacrifice
those principles, but she was proved wrong.

It was a timely reminder to a public ready to
canonize her as AIDS's Mother Theresa that she
was, after all, only human. Producer Ed Ditterline
recalled, "I was setting up an entertainment con-
nected with one of her perfume lines. She is a com-
plete control freak right down to the last detail,
and I went to her suite at the Plaza to discuss some
promotional point or other. She had been on a huge
binge and looked like a Moroccan whore. She was
wearing a sheer lavender nightgown, and I could
see huge, horrendous scars, horrifying. The suite
was a shambles, incredible squalor—dog shit
everywhere, and what looked like dinner trays and
leftovers for about eight meals because she would-
n't let the maids in until she was ready to. Though

pets are not allowed in the hotel, they would let her do anything she wanted to, bring a horse in if she liked, just to have Elizabeth Taylor as a guest. Liz screamed at me over a minor issue. I hadn't been given proper instructions about how a glass of water was to be positioned on the podium, and she exploded and called me a 'motherfucking asshole.' I burst into tears. She was so shocked by my reaction that she stopped and walked away."

Since she had begun her career with Alfalfa Switzer in a 1942 screwball comedy, it made an odd kind of sense, despite three Oscars, for her final film to be *The Flintstones,* a spin-off of the popular cartoon strip, starring John Goodman and Rosie O'Donnell. Elizabeth played Fred Flintstone's cranky mother-in-law, Pearl Slaghoople, and hard-core Elizabeth Taylor fans cringed when John Goodman's character called her "a dried-up old fossil," but the film grossed a whopping $130 million.[81] Part of her deal stipulated that proceeds from the premiere go to ETAF. Rosie told Elizabeth, "I love your perfume."[82] She continued to take on occasional TV assignments, doing a voice-over on *The Simpsons* and playing herself in the CBS sitcoms *The Nanny* and *Murphy Brown,* mostly in an effort to promote her sluggish new fragrance, Black Pearls.

Sara died on September 11, 1994, in the Rancho Mirage condo that Elizabeth had given her. Her last years had been spent playing bridge with Zsa

Zsa Gabor's mother Jolie and being escorted by numerous gay men, mostly actors she'd met at MGM who were now retired and living in the same complex at the Sunrise Country Club. Elizabeth had always provided generously for her mother, hiring a family to look after her and installing them in an adjoining condo. Sara was buried next to Francis in Westwood. Though Sara had driven her too hard in her youth, Elizabeth was grateful for the sturdy stock she sprang from, remarking, "My mother lived to be ninety-nine. I have good genes."

Good genes or bad, she was back in St. John's Hospital in 1995, this time for treatment of arrhythmia, an irregular heartbeat. Alone at Nimes Road, Larry called up masseuses and enjoyed total body rubs, including sex. "He told me it was the greatest thing in the world," said Matzinger, "and Liz paid for it."[83] When Elizabeth returned, he holed up in his bachelor's quarters to escape her carping. A bundle of contradictions, Larry readily accepted Elizabeth's gifts of a motorcycle and a sport car, but objected to the public's perception of him as a kept man, though that was precisely what he'd permitted himself to become. In August, after he went out without Elizabeth and didn't return until the next afternoon, she at last kicked him out. He stripped his quarters bare, including carpet and curtains, and drove away. Elizabeth was sixty-three, Larry forty-three. When their trial separation was announced in mid-September 1995,

L.A. socialite Wendy Goldberg said, "We were all surprised that she would marry him."[84]

Filing a divorce action in L.A. Superior Court, Elizabeth cited "irreconcilable differences." Larry returned to construction work but also got himself a lawyer, New York attorney Raoul Felder, later emerging from the marriage with more money than he'd ever seen in his life, $2 million.[85] Elizabeth emerged with something she probably loved more than any man she'd ever known: Sugar, the adorable white Maltese pooch Larry had given her. She said she'd never marry again, but added, "I expect to fall in love again."[86]

Despite illnesses and marital wars, she had worked hard to keep Passion and White Diamonds near the top of the fragrance industry, and by 1994 her perfumes had grossed $500 million. Only one of them, Black Pearls, proved disappointing, perhaps because she and her associates, in an overconfident mood, alienated department stores by refusing to grant the usual discount. On a typical Passion promotional trip to Houston's Galleria, she visited the sales staff briefly and then told the clerks, "Okay, girls, enough of this chitchat. Now I want you to get busy and really push my perfume." Eventually, Passion sales slowed down, but White Diamonds remained popular. In frail health, Elizabeth was overextending herself and the effort began to show. According to Ditterline, "The greatest loss was the death of her friend and assis-

tant Chen Sam. After that, Liz went straight downhill."

By the end of the year Elizabeth was at a low point. "These last couple of years have been hard," she said. "My marriage to Larry had come undone, and I lost Chen Sam . . . Truly, she was my sister—for more than twenty-five years. She died of cancer, here in my house. I had gone to her room to say good night and found her breathing laboriously. I kissed her and held her and talked to her. After a while, I left. Five minutes later she was gone."[87]

Like the rest of the world, Elizabeth was mesmerized in the mid–1990s by the O. J. Simpson murder trial, following it daily and avidly on television. Every Sunday, Dominick Dunne, covering the trial for *Vanity Fair*, was invited to Nimes Road to give her the inside scoop. Apart from having worked together in *Ash Wednesday*, Elizabeth and Dominick had a special rapport, both having survived hideous alcohol and drug bottoms. Carrying marijuana back from Mexico, Dominick was busted and strip-searched at Los Angeles airport. "Stoned again," he wrote, "a crazed psychopath, whom I'd invited over for some cocaine, beat me up, tied me up, put a brown bag over my face, and dropped lighted matches on the bag."[88] Dominick sobered up in a cabin in the wilds of Oregon, and in the following years wrote five best-selling novels and an account of the Simpson trial, *Another City, Not My Own*. "This whole police-conspiracy thing

is ridiculous," Elizabeth told Dominick. "One minute they're accusing the LAPD of being inept, incompetent, and careless, and the next they're saying that they're all part of a brilliant conspiracy to frame O. J." Like a yo-yo, Dunne ran back and forth between Elizabeth and Nancy Reagan, who also expected him to provide a behind-the-scenes account of the trial. Elizabeth was using a walker at the time, due to hip-replacement complications, and she told Dunne not to reveal her secret use of the walker to anyone. "One leg came out shorter than the other," she explained. "That's all the tabloids need to hear."[89]

In 1996, though she now had metal hips, she led a procession as grand marshal of the National AIDS Candlelight March, from the Capitol in Washington, D.C., to the Lincoln Memorial. "I was sick for two years and had my hips fiddled around with," she remarked. During this period of physical difficulty she became particularly impatient with any sign of complacency in the fight against the AIDS virus and stunned the National Press Club by advocating blunt safe-sex talk to teens.[90] She read aloud from the NAMES Project Memorial Quilt, at the quilt's last full display in the capital.

"I was agoraphobic for about two years," she recalled. "Didn't leave the house, hardly got out of bed. Rod Steiger got me out of here. He said I was depressed. Then we dated."[91] It was during the

1997 Christmas holidays that Rodney Stephen (Rod) Steiger, New Jersey's burly gift to Method acting, took her out for hamburgers and fried chicken. "I was after her diamonds, and I didn't get anywhere," he joked. "I went to see her about a movie I wanted to direct. She was interested, so I went back. I had eight years of clinical depression, and I noticed she was always alone and didn't seem very happy. She hadn't been out of the house except for her AIDS work for two years. I asked her to dinner. It was just like when I called Joan Crawford regarding a picture and asked her to dinner at the Luau. 'Oh, God, yes,' Joan said. 'Anything to get out of the house.'"[92] The movie was *Somewhere*, a script Steiger cowrote, set in the mythical land of Oz, with Dorothy and her friends, the Tin Man, the Scarecrow, and the Cowardly Lion, all grown older. Elizabeth was to play the aging Dorothy in this new version of Frank Baum's classic fairy tale. Shocked to find Elizabeth cooped up and depressed, he realized, "She'll go anywhere for fresh air."

He took Elizabeth to a party at the Bob Dalys, where everyone agreed that Elizabeth and Rod, two perdurable veterans of the Hollywood wars, made a remarkable couple. Rod had emerged as an actor in 1954 on the strength of a single movie sequence—the famous taxicab scene in *On the Waterfront* in which gangster Charlie Malloy, played by Steiger, pulls a gun on his brother, Terry, played by Marlon Brando, who says, "I cudda been a con-

tender. I cudda been *somebody* instead of a bum—
which is what I am." Steiger's first marriage, to a
woman named Sally Gracie, ended in divorce. At
thirty-four, he starred on Broadway in 1958's
Rashomon, impregnating his leading lady, Claire
Bloom, twenty-eight and rebounding from her af-
fair with Richard Burton. "I was searching for the
paternal masculine support of the kind I had been
deprived of when I was a child—the support that
Richard, because of his marriage to Sybil, had not
been in a position to give me," Bloom recalled.
Steiger was not the tough guy he appeared to be,
but "sensitive, sentimental, kind, even if, like
many actors, somewhat self-involved," Bloom
added.[93] They got married, and their daughter
Anna was born in 1960. In 1967, the year after
Elizabeth's Oscar for *Who's Afraid of Virginia
Woolf?*, Steiger won the best actor Oscar for his
performance as Sheriff Gillespie in *In the Heat of the
Night*.

He received no film offers for the next year, and
his marriage suffered as he went into a near-cata-
tonic state. A city girl who'd never learned how to
drive, Bloom hated the isolation of Steiger's remote
Malibu beach house. During his depression, they
evolved into a father-daughter relationship, and
Bloom found their sexual life "only partially fulfill-
ing."[94] When he began to work again, playing
Benito Mussolini and Al Capone, Bloom com-
plained, "He seemed to think it necessary to play

Mussolini and Capone at home."[95] In 1969, Steiger left for Russia to film *Waterloo*, and asked his friend, flashy, street-wise, opportunistic Hillard (Hilly) Elkins, producer of *Oh! Calcutta!*, the revue that introduced nudity to Broadway, to take Bloom out while he was away. Elkins got her high on marijuana and showed her "the dark part of my sexual nature," Bloom wrote. To her eternal regret she divorced Steiger and married Elkins, who, during their five-year marriage, filled her with "self-loathing."[96] Steiger sought happiness in his subsequent brief marriages to Sherry Nelson and Paula Ellis. His reputation as an actor was trashed by his grotesque biopic of W. C. Fields, and he underwent open-heart surgery. When he started dating Elizabeth, he'd just emerged from ten years of hell.

At the December 23 party, Steiger called Elizabeth a "heroic" survivor. "We're both survivors," he added.[97] Indeed, his career would shortly be on the upswing. There were persistent rumors that Rod and Elizabeth would wed, but nothing came of them.

Appearing with Barbara Walters on *20/20*, Elizabeth said, "If you hear of me getting married, slap me." She remained friendly with Larry Fortensky. Thanks to his divorce settlement, he was able to purchase an $800,000 home in San Juan Capistrano, putting down $300,000. According to Kelly Matzinger, he lived for a while on the remainder of the settlement but when he failed to

keep up his payments on a $73,000 RV, Elizabeth came to his rescue and paid the $53,000 balance. He soon acquired a bad reputation around local bars, picking fights with patrons and making numerous enemies. Before the divorce from Elizabeth was final, he became involved with Matzinger, who was thirty-four at the time. She left her husband and two sons to live with him, and recalled, "He liked going out to bars and giving mean stares to guys to try to start fights. One of his favorite places to start trouble was the Swallow Inn." He used his new house as a base for partying with girlfriends, while the hapless Matzinger was reduced to being a live-in maid. She recalled in 1998 that Larry quickly "went down the tubes" after his divorce from Elizabeth. According to Kelly Matzinger, "He drank and popped pills all day. He smoked pot. He was drunk every day." Unsurprisingly, his relationship with Matzinger eventually erupted into violence. The police were summoned, and Matzinger charged assault but Larry counter-charged that she'd defrauded him of thousands of dollars. He was arrested for investigation of felony domestic violence, jailed for a day, and released on $25,000 bail. He told the police that he was firing Matzinger as both mistress and maid, and the police helped him throw her out of the house.[98]

According to Matzinger, Elizabeth and Larry often talked on the telephone. "She still loves the guy," Matzinger said, but common sense prevailed,

and Elizabeth resisted the temptation to take Larry back. Though she felt lonely and helpless with the approach of age and sickness, at least she had her self-respect, something she'd never been able to lay claim to in codependent relationships, whether with a U.S. Senator or a truckdriver. Her new self-esteem would stand her in good stead in the trials that lay ahead.

14

September Songs:

As Katharine Hepburn once said, "Old age is not for sissies." In *Steel Magnolias*, Dolly Parton described an aging friend and added, "When it comes to suffering, she is right up there with Elizabeth Taylor." Under unprecedented public scrutiny for an actress her age, Elizabeth met the challenges of her senior years with characteristic pluck and wit. "I've been through it all," she said. "I'm Mother Courage. I'll be dragging my sable coat behind me into old age." After her three hip operations, she was left with what interviewer Paul Theroux described as "a struggling sideways gait."[1] In December 1996, she began having headaches and lapses of memory, and then she started dropping things. In February 1997, she had a seizure and was diagnosed with a brain tumor the size of a golf ball. Friends found her the

best brain surgeon in California, Dr. Martin Cooper, whom she fell in love with the minute he told her she could bring Sugar, her five-year-old Maltese, to the hospital with her. At first it appeared she would have to cancel a commitment to attend ABC's sixty-fifth birthday party for her, but doctors postponed the operation, and Michael Jackson escorted her to the Pantages Theater. Twenty members of her family attended, coming from all over the world, and the invited audience contributed $1 million to ETAF.

Two days later she was in Cedars-Sinai Medical Center, where doctors inserted a catheter into an artery in her groin and pumped dye up through her body into her brain, hoping to discover, she later said, "what's going on in there. It hurts like hell!"[2] After a decade of devoting herself to the sick and dying, she felt in touch with a higher power. Prayer had become a way of life, a state of consciousness. "I pray to God all the time," she said. "We have a conversational relationship and those conversations calm my fears." After the successful removal of the two-and-a-half-inch tumor from the lining of her brain, the first thing she wanted to know on regaining consciousness was whether she still had all her "marbles." She did, but at first she had difficulty forming certain words. Her right hand was almost useless, but in time it healed. She was completely bald. With an seven-inch incision extending across the back of

her shaved head, she looked like "an ax-murderer's victim," she said. When her hair grew back, doctors told her not to dye it while there were still scars on her scalp, and she decided to leave it natural.[3]

One week after her surgery she had a seizure, and afterward went on daily medication to prevent further attacks. Rock star Madonna and her baby, Lourdes, came to Nimes Road to visit, as did Billy Bob Thornton, who'd just received an Oscar for *Sling Blade*. During Billy Bob's acceptance speech he thanked "Miss Elizabeth Taylor," acknowledging that she'd helped spread word-of-mouth about his performance, swinging the vote his way.[4] During an interview with Kevin Sessums, Elizabeth said she no longer believed in marriage, but she begged Sessums to fix her up with someone. There was an unguarded candor in the plea, and somehow it didn't sound exactly like Elizabeth Taylor. In subsequent public appearances, she didn't seem to be quite the same following brain surgery. A poignant and shocking example was her hysterical interview on national television hours after Princess Diana was killed in a car wreck on August 31, 1997. When a TV reporter told her that photographers had been chasing Diana, Elizabeth screamed, *"She must have been TERRIFIED!"* There was something out of control in her voice and expression, and indeed on that occasion something about Elizabeth seemed to be permanently out of kilter.

Though she still clearly had her intelligence, there was a glitch somewhere in the circuitry, and she was not the same familiar Elizabeth, at least in manner and delivery.

Shortly after Princess Diana's death, Elizabeth gave a Labor Day picnic at her home on Nimes Road, serving baked chicken and cole slaw to Gregory Peck, Cher, Johnny Depp, Nastassja Kinski, and Roddy. Everyone shared his feelings about the late Princess of Wales, and the picnic turned into a somber affair. Later Elizabeth and AmFAR took out an advertisement of condolence in the *New York Times* hailing Diana's "willingness to reach out to those who suffered from HIV and AIDS when it was unpopular to do so."[5]

Severe back pains plagued Elizabeth in 1998, and she was swept up into a new cycle of pain-painkillers-addiction. She felt so confused and depressed that her family begged her to go back into rehab. When she appeared at the Passport AIDS benefits in San Francisco and L.A., she was so unsteady that K. D. Lang and Magic Johnson had to help her to the podium. Nor was she herself at her granddaughter's wedding in northern California. Her weight was up to 175 pounds. "I had seventeen falls," she said, "breaking my ribs and ankle." On January 6, 1998, looking swollen and feeble, she entered Cedars-Sinai Medical Center for spine scans. She was at her lowest point in years, overusing painkillers to ease the discomfort of her

two artificial hips. "I'll kill myself before I go through another drug clinic," she reportedly stated. "They were the darkest days of my life."

Throughout early 1998, there were rumors that she was romantically involved with Burt Reynolds, and she continued to date Rod Steiger. Reynolds frequently saw Elizabeth in conjunction with a new multimillion-dollar White Diamonds ad campaign, for which he was the model. The seventy-one-year-old Steiger was still in trauma over the breakup of his marriage to thirty-eight-year-old Paula, with whom he shared a four-year-old son. When Rod had come across evidence of Paula's affection for a married contractor, he'd hired a private detective, who'd uncovered Paula's affair, ending the Steigers' eighteen-year relationship. Rod served Paula with divorce papers as she pulled into the driveway of their Malibu home on her birthday in June 1997, and Paula fired back in the press, calling Rod "a lonely, twice-divorced, washed-up actor. He was an alcoholic with black moods and a violent temper. One minute he was loving and kind. The next, he was angry, violent and often abusive. Numerous times he tried to take his life by overdosing on pills. Our sex life came to a crashing halt. There was no passion, no sex, no loving nights." Though in 1999 Rod and Elizabeth seemed to draw closer every day, he told the press, "I have four marriages and I ain't goin' with nobody."[6] Elizabeth told *Talk* magazine they "dated."

She had yet another terrible accident on February 27, 1998, as she prepared to celebrate her sixty-sixth birthday with her son Christopher and his family at Nimes Road. She woke up at 10:30 A.M., watched the Home Shopping Network, breakfasted on toast, tea, and orange juice, and then resumed watching TV. Around 3 P.M., she started getting ready for her party. She was walking across the bedroom, heading for her dressing room, when she lost her balance. She fell forward, hitting her head on a nightstand and losing consciousness. Her housekeeper found her sprawled on the floor, blood smeared on her face. When paramedics arrived in fifteen minutes, they found her confused and desperate, clutching her throat and struggling to breathe.

She'd broken her back in the fall, later describing the injury as "a severe compression fracture of my first lumbar [vertebra]." She was rushed to Cedars-Sinai's luxurious suite 8401 in the exclusive North Tower, by now like a second home. Emerging from Cedars ten days later, she looked "zoned out—her eyes were glassy," according to observers. Doctors again insisted she drop twenty-five pounds as soon as possible and told her to use a wheelchair or walker, but she allegedly said, "A wheelchair is my worst nightmare. It makes me feel like such an invalid."[7]

At home, her pain was so intense that she remained in bed, seeing only José Eber, Nastassja

Kinski, Christopher Wilding, and Laele, daughter of forty-five-year-old Michael Jr. Laele was living in San Francisco, and she and Todd McMurray were expecting a child. Elizabeth looked forward to the birth of her first great-grandchild.[8] When a baby boy arrived the following August, Laele and Todd named him Finnian McMurray. After visiting Elizabeth, a family friend said, "You can usually tell when she's in pain—she won't say anything to anyone. She'll just sit there, her eyes open as if she's looking into the distance with her mouth tightened. Her staff will do anything for her. But when they see her like that, they know just to leave her in peace and make sure she's not disturbed."[9] Her torso was confined in an uncomfortable back brace for two months. Possibly fearing the end was near, forty-two thousand fans showered her with get-well cards, and show business colleagues heaped more and more honors on her.

On March 8 she was awarded the Life Achievement Award of the Screen Actors Guild for her acting as well as humanitarian contributions. On March 10 she reentered Cedars-Sinai for tests and remained overnight for treatment of her pain. On April 7, after an ominous announcement canceling all engagements for the next four months, she went into seclusion in Bel Air. In agony, she reverted to pain medication that made her unsteady on her feet. Though the prognosis was grim, one friend recalled what Elizabeth had said on being wheeled

into the operating room during a previous crisis: "The fat lady has not sung." Nonetheless, she disappeared from public view, later recalling, "I did not want to leave my bedroom. I just didn't want to go out."[10]

She amused herself as best she could, admiring a new Chrysler Town & Country car in a TV advertisement and having it delivered to her in a metallic blue model. A check for $35,000 was waiting when the car arrived at Nimes Road, and though she refused the delivery man's request to meet her, she tipped him $500. Her friends had not forgotten her, and instead of flowers, Madonna sent over a male stripper. Elizabeth permitted the beefcake dancer to go through his routine, commenting, "It's just what the doctor ordered."

Eventually she resumed her regular daily schedule, getting up when Sugar woke her at 6 A.M. One of her three round-the-clock nurses helped her go through a stretching exercise routine. After reading the morning papers, she breakfasted at 9 A.M. on toast, fruit, and coffee, following the low-fat diet prescribed by her doctors, who again urged a twenty-five-pound weight loss to ease pressure on her spine. While breakfasting she planned the day's activities with her three secretaries, her housekeeper, and several servants. As usual, the chatelaine of Nimes Road did her own makeup and hairdo.

Despite the danger of falls and other accidents,

Elizabeth insisted on taking short walks, strolling around her two-acre estate, inspecting her rose plants, always accompanied by a nurse in case of a spill. As seventy-five-year-old author Norman Mailer once said, "When you get older, every time you drop something it's a drama. What bones are you going to use to pick it up?" Elizabeth enjoyed spending time with her pets, including Nellie, a Shetland collie; twenty rabbits; pheasants; peacocks; and of course the ubiquitous Sugar. Before going back inside, she always checked to make sure that enough food had been put out for Bel Air's stray cats. From 11 A.M. to 1 P.M., she was at her desk answering mail and attending to AIDS business. Sometimes she sent comforting letters to people in trouble, such as the letter she wrote to Delta Burke after the TV star was bumped from her popular series, *Designing Women*, following a run-in with the producers over her weight and mood swings. "It was like a letter from God," Delta revealed, "thanking me for describing her as a role model and calling me 'beautiful, courageous, and radiant.' I carried that letter around in my purse until it practically disintegrated in my hands."[11]

At one o'clock each day, Elizabeth had her lunch, and at 3 P.M. she caught *The Rosie O'Donnell Show*, her favorite TV program. Afterward, over tea and scones, she relaxed in her sitting room, with its two fireplaces and a view of the garden. For the rest of the afternoon she napped or rang up friends.

Dinner—pasta or fish and rice—was at seven o'clock if she was alone, eight o'clock if guests were expected. Then she retired to her upstairs suite to read or watch TV until bedtime at 11 P.M.

All her family were with her for her traditional Mother's Day brunch. "I owe it to my kids to make the most of my life," she said.[12] Rod Steiger was photographed on dates with *General Hospital* soap star Joan Benedict,[13] and Elizabeth found herself "in this dark place," she recalled, "like a pit." At one point she was desperate enough to try anything, engaging a Kabbalah rabbi, Eitan Yardeni, who conducted classes at her home several times a week. Though there was no charge, a typical celebrity donation—Dolly Parton, Madonna, and Roseanne Barr were also studying the mystical text—was $200 to $300 per session. Healing prayers attempt to banish negativity and replace it with positive energy, lessening pain. Followers wear a red string tied with seven knots that they keep on at all times, even when bathing. Kabbalah's teachings come from twenty-four books called the *Zohar*, which include several chapters on health. The Kabbalah movement brought Elizabeth and Madonna closer together. Elizabeth gave the singer advice on raising her daughter Lourdes, whom Madonna was allegedly rearing according to the wisdom of Kabbalah.[14]

José Eber came to fix her hair, Michael Jackson dropped in, and other friends who offered support

included Shirley MacLaine, Liza Minnelli, Roddy, Farrah Fawcett, and Nastassja. The love she and Michael Jackson shared had sustained them through the early 1990s, a rocky time for both stars. When Michael told Elizabeth he was marrying Lisa Marie Presley, she gave Lisa maternal tips on marriage and urged her to have a child with Michael as soon as possible.[15] Though Lisa told Diane Sawyer on national television, "Do we have sex? Yes, yes, yes," no issue came of their short-lived union. Jay Leno quipped, "Lisa Marie bought Michael a beautiful wedding gift—the Vienna Boys Choir."

Steiger reappeared one day, driving his little Honda up Nimes Road, and "saved my life," Elizabeth said, "got me out of the doldrums. I'd been stuck—out at sea without any wind. We love each other, but in a platonic way. I would do anything to help him. He has already helped me." With Rod's encouragement, she made a tentative reentry into the L.A. social swirl, hosting a Memorial Day party on May 28, 1998, at 700 Nimes Road for sixty guests, including her children, Roddy, Demi Moore, Johnny Depp, Rebecca deMornay, Gregory Peck, Carole Bayer Sager, and Anthony Hopkins.[16]

In late June, she took several friends, including British actor Bill Hootkins, who was living in Steiger's house, to a restaurant in L.A., wearing a full body cast like an iron lung but looking fit in her muumuu. She told Hootkins she'd been wear-

ing the body cast for many weeks and was due to remain in it for another two weeks. Though he felt sorry for her, he noticed that her confinement in the cast did nothing to diminish her sense of humor, which he found to be deliciously self-deprecating during a three-and-a-half-hour lunch. Later, Hootkins, who was an excellent cook, sent Elizabeth some barbecued ribs. "I only got four of them," she said. "The maids and the cook ate the rest." Hootkins promised to host a party for Elizabeth at Steiger's home.

Largely thanks to Steiger, she was able to say, "I haven't felt this good in years!" In midsummer, she heard from Larry, who regretted their divorce and offered to move back in. He still referred to her as his wife. Wisely, she gave him no encouragement. Victor Luna also rang, telling her she was "the love of my life," but at sixty-six she'd at last learned not to depend on relationships to solve her issues, particularly relationships with straight men, which always turned combative. Now she looked within for answers, through meditation, prayer, and, most important of all, through service to others.

Burt Reynolds remained a staunch champion, and the May 4, 1998, issue of *People* magazine ran a full-page color ad with a close-up of Reynolds holding a bottle of Elizabeth Taylor's White Diamonds. The caption read: "I never forget a woman in diamonds." In TV ads for the fragrance he advised, "Don't take your partner for granted." The

glamour and romance of the ads contrasted starkly with Elizabeth's present reality, that of a virtual shut-in who spent her days in bed. But at least she hadn't lost her appetite—for convenience, a mini-refrigerator was installed beside her bed.[17]

Her lifetime of hard work—fifty-five movies plus nine TV films—continued to bring her prizes, and get her out of the house. Once all the honorary achievement awards had been exhausted, organizations started making up peculiar prizes for her, like the Special Award for a Lifetime of Glamour. Demi Moore made the presentation at the Seventeenth Annual Council of Fashion Designers of America Awards, attended by Ashley Judd, Sigourney Weaver, Isabella Rossellini, Rupert Everett, Matt Leblanc, John Stamos, Elizabeth Hurley, and Hugh Grant. After years of flaunting brassy Nolan Miller *Dynasty*-type getups that bordered on drag, she thought it hilarious to be cited as a fashion plate, admitting she'd "been on every Worst Dressed list ever compiled."[18]

In October she spoke at a fund-raiser for Children with AIDS in Santa Monica emceed by Jamie Lee Curtis. A Mattel doll of Elizabeth was auctioned off for $25,000. Similar to Mattel's famous Barbie doll, the Elizabeth Taylor doll was twelve inches tall, costumed in the white formal she'd worn to the 1954 Oscar ceremony, standing on stiletto heels, and sporting twenty-seven diamonds set in platinum.

When Elizabeth saw Stephen Fry in the film *Wilde*, she told Rod Steiger, "That guy was amazing. I would love a part with him." She optimistically announced plans to assay the grandiloquent Lady Bracknell in *The Importance of Being Earnest*, a role previously played by Dame Edith Evans and Maggie Smith. The PolyGram film was to be updated to the 1930s, but nothing came of it.[19]

On a Sunday in early November 1998, she hosted a private memorial service at 700 Nimes Road for Roddy McDowall. "Roddy died of untreatable cancer, brain tumor and elsewhere in his system," said Jack Larson, who attended the service. "I visited him; we knew each other through Libby Holman who was always close to Roddy. At the end, Roddy looked good; he was on massive painkillers." According to the *Times* of London, Elizabeth and Sybil Burton Christopher "visited the ape impersonator [Roddy starred in *Planet of the Apes*] as he stood at death's door." Dominick Dunne observed, "The two ex-wives of Richard Burton I believe had not been in the same room since 1962 in Rome during the shooting of *Cleopatra* . . . It is said that the two women held hands as they sat with their dying friend."[20] Sybil's marriage to rocker Jordan Christopher hadn't lasted, costing her $50,000 a year in alimony. She later moved to Sag Harbor, New York, and became a popular and respected figure in community theater, producing offbeat shows like *Splendora*, a

musical in which a gay man in drag makes love to a preacher.

"Roddy arranged everything with the Neptune Society and wanted no memorials," said Jack Larson. "After he died, one persistent man insisted on putting together a memorial at the Academy's Samuel Goldwyn Theater, but Elizabeth and another friend of Roddy's used their clout to have it canceled. Later, Elizabeth had a private memorial at her house for the friends Roddy had wanted to see in the last six weeks of his life. It was a lovely quiet affair with about eighty to one hundred present. Elizabeth was standing up without the aid of a cane but walked carefully. She was not wildly overweight; her clothes were not tight fitting or fashionable. Her hair was white and short and she looked beautiful. The guests were gathered around the pool. She spoke and others spoke, and then, in the distance, an older man entered the house, from the street, playing a bagpipe. He came into the living room, played a farewell dirge, then walked out of the house. That was the only structured thing that happened; the rest was entirely informal." Among the mourners were Lew Wasserman, Gregory Peck, George Axelrod, and Suzanne Pleshette.

Nine days before Christmas 1998, she was again in Cedars-Sinai. Steiger was by her bedside, and marital rumors immediately resurfaced. A spokesperson for Elizabeth denied these reports.[21] Elizabeth was still grieving over the death of her

beloved ex-daughter-in-law Aileen Getty from AIDS. In support of AIDS in 1999, Elizabeth donated her 1970 Oscar gown—an ice-blue Edith Head creation, low cut with spaghetti straps and a full skirt—for a Christie's auction benefiting AmFAR.

At forty-seven, Larry Fortensky was still despairing over his divorce from Elizabeth, and spending all day lolling around his Southern California condo in San Juan Capistrano or drinking and starting brawls at the Swallow Inn. Kelly Matzinger felt that many people around town wanted to get rid of him. On January 28, 1999, he either fell or was pushed headfirst down a seven-foot circular staircase in his home, landing on his head and sustaining a broken bone in his neck, several splintered discs in his spine, and massive head injuries so serious he might never walk, talk, or move again. His alcohol level at the time was .265. According to Larry's daughter Julie, doctors performed emergency surgery to remove a blood clot from his brain. Elizabeth comforted Julie, speaking with her on the phone several times daily, and issued a brief statement through publicist Shirine Ann Coburn. "I am deeply shocked," she said. "My prayers are with him." The tragic thirteenth-stepping that she and Larry had engaged in during recovery had done neither of them any good. By rushing into a relationship in early sobriety rather than taking time to get to know themselves, they'd

courted disaster. "The money that Liz gave Larry became his curse, a curse that may lead to him losing his life," opined one of Larry's friends. The well-intentioned theorizing failed to take into account that Larry, who'd risen from being a big fish in the little pond of Stanton, California, to fame as Mr. Elizabeth Taylor, had not succeeded in either role, as a "slave in heaven or a star in hell." Elizabeth was not the cause, but only a symptom, of his malaise. At the root of it, as with Richard Burton and Elizabeth herself, was alcohol.

Larry lay in a coma, on life support, finally regaining consciousness in March 1999, five weeks later.[22] "He has a tracheotomy, and they were feeding him through his stomach," Elizabeth told Barbara Walters. "He sounds much improved. I think he'll be all right. He doesn't remember what happened." Walters reminded Elizabeth that Larry had been bugging her for money, and asked how she could forgive him. Elizabeth replied, "You can't be with someone eight years and have loved them and shared a life with them and have it disappear like turning off a faucet." The hard-boiled Walters disagreed, pointing out that some people certainly could. "Well, I can't," Elizabeth said. "If I love someone, I love them always." Evidently she'd never felt love, only lust, for Eddie Fisher, about whom she said in 1999, "We're not exactly intimate buds."[23] Her great loves, she revealed, had

been Mike Todd and Richard Burton. "If love came along," she added, "I wouldn't push it away."

She continued to date the shaven-headed, broad-shouldered Rod Steiger. They flew to Las Vegas in January 1999 to take in the act of popular blind Italian tenor Andrea Bocelli, tickets to whose sold-out concert were going for $200. After hearing Bocelli sing Carole Bayer Sager's Oscar-nominated song, she told Sager the tune should win and actively campaigned for it (it lost).[24] Steiger went to work on a film in February, and Elizabeth started dating her handsome, relatively young Beverly Hills dentist, fifty-five-year-old Cary Schwartz.[25] On the 27th, she celebrated her birthday at the Bellagio Hotel in Vegas with Dr. Schwartz and his two grown sons; chalky-faced Michael Jackson, who gave her a cantaloupe-sized, elephant-shaped, jeweled handbag inspired by Gypsy; long-haired, behatted José Eber; and Dr. Arnie Klein, Jackson's dermatologist.

Movie offers were no longer coming her way, but Demi Moore suggested that Elizabeth join Planet Hollywood and donate memorabilia and make appearances to save the ailing restaurant chain. According to TV's *Entertainment Tonight*, Elizabeth was "thinking it over."[26] She remained a shrewd, cautious businesswoman who preferred investments that paid off. In a late January date with Steiger, they dined in a restaurant in Santa Monica, Elizabeth holding her pooch Sugar, and

Steiger holding a pillow for her back. Looking chipper, she was now wearing her grown-out platinum hair in her familiar teased bubble. In early February she and Steiger dined at Ago's restaurant in West Hollywood with the irrepressible Italian actor Roberto Begnini and his wife Nicoletta Braschi. Afterward Elizabeth and Steiger went alone to a coffee bar on Melrose Avenue. She also continued dating Dr. Schwartz.

A working girl all her life, she longed to return to the screen though past the age of retirement. Rod tried to help. His own career was taking off again in the Melanie Griffith–Antonio Banderas film *Crazy in Alabama* and in Arnold Schwarzenegger's *End of Days*. There was talk of Elizabeth appearing in a video for Madonna, after Elizabeth convinced the rock star to reconcile with her English beau Andy Bird. Carrie Fisher was said to be writing a costarring vehicle for Elizabeth and Debbie Reynolds, but what Elizabeth most longed to play was the vengeful heiress in *The Visit*, a role originated by Lynn Fontanne on Broadway. Producer Robert Halmi said that Arthur Penn would direct the film, but Elizabeth confessed to Barbara Walters that her career was going nowhere. "No one will hire me," she said. "They're scared to insure me. That was like a red flag—made me want to work." And work she did, though behind the scenes—when fans thought they heard her familiar voice on TV ads for the

new Beau Rivage casino in Biloxi, Mississippi, they were right. Dusting off her Southern belle drawl from *Raintree County* and *Cat*, she narrated the ad for her friend, casino owner Steve Wynn.[27]

Along with Celine Dion and Susan Sarandon, she was one of three celebrities chosen for Barbara Walters's 1999 pre-Oscar telecast, the opening section of the most watched show on television except for sports specials. When a reporter inquired if she'd been chosen because she was an icon, Elizabeth replied, "No, it's because I'm the oldest." During the telecast, Walters asked her if she'd marry again and Elizabeth screamed, "No!" The odd outburst again was jolting, suggesting that Elizabeth had changed. And her speech seemed to have been slowed down by a fraction of a beat; her responses seemed exaggerated. When Walters asked her to rise from the couch to prove she could walk, she not only got up and walked, but went into an embarrassing shimmy, waddling and shaking her hips. Walters told her to "behave herself" and sit back down, like a caregiver gently reproving a somewhat addled senior. Clearly this was no longer the Elizabeth Taylor of legend, and it seemed unduly cruel of Walters to egg her on.[28]

Embattled but undaunted, Elizabeth still felt life was worth living—"to go on feeling good and healthy and doing things for AIDS," she said, "getting my ass out of this house, to Texas, to New York. I would give up movies to be healthy and

well enough to work for AIDS." In April 1999, the wedding dresses Helen Rose had designed for her, the white one for her marriage to Nicky and the daffodil yellow for her marriage to Larry, were auctioned off at Christie's and all proceeds went to AmFAR. Apart from her AIDS work, she was sometimes a reliable source of knowing advice for a younger generation of Hollywood vamps. When Demi Moore's career began to falter in 1999, Elizabeth told her to get rid of her breast implants and go down a few bra sizes if she wanted better roles. Following surgery, Demi allegedly planned to recuperate at 700 Nimes Road as Elizabeth's guest.[29]

In the spring of 1999, she jetted off to London with Dr. Schwartz. On April 11, glowing in Harlow platinum hair, dark caftan, and loads of heavy jewelry, she held a press conference in the Dorchester Hotel heralding her receipt of the British Academy of Film and Television Arts' Fellowship award—the UK version of the Lifetime Achievement Oscar. On May 10, she appealed for work to the industry she'd once reigned over as number one box-office champion, asking to play character roles.[30] There was a time in the movie industry when plentiful work was available for such seniors as Ethel Barrymore, Lillian Gish, and Mary Astor, but good character roles for older actresses no longer exist, except for a precious few such as Lauren Bacall and Angela Lansbury. In June 1999,

Elizabeth went to the Cannes Film Festival looking for work. Though tastefully dressed in a bouffant iridescent gown that seemed to float about her in clouds of satin and silk, and wearing many of her diamonds, she was, at sixty-seven, heavy, unsteady on her feet, and in obvious need of a walker. No offers of starring roles were forthcoming, but Elizabeth found work as a voice-over in a new NBC cartoon series, playing Sarah, God's girlfriend. Elizabeth and Demi Moore tried to raise money for a film about a mother and a daughter. On June 28, 1999, she appeared on the cover of *Newsweek*'s millennium issue, as the symbol of a century that "twinkled with superstars . . . who shaped the way we live now."

Invariably in the life of Elizabeth Taylor, every crisis is followed by a medical emergency. Unfortunately, the emergency was not long in coming. She'd been given some painkillers while recovering from extensive dental implant surgery, and at 3 A.M. on August 18, 1999, she got out of bed and walked to her dresser to get a dose of pills, turned, and fell forward, crashing to the floor. "I was like the Flying Nun," she later joked. Her maid helped her back into bed, and Elizabeth took the pain pills and fell asleep. Later in the day the medication wore off, leaving her in agony. She was taken to Cedars-Sinai Medical Center, where Dr. Patrick Rhoten, a neurosurgeon, diagnosed her injury as "a compressive fracture of the twelfth thoracic vertebra." The

word "thoracic" refers to the thorax, the part of the body between the neck and the abdomen. In other words she'd broken her back again, and later sources said she'd broken two bones.

In pain every time she moved, she lay in an ivory-colored, two-room suite on the eighth floor at Cedars, paying $8,800 a night, with three personal bodyguards and revolving shifts of hospital security personnel. Two personal assistants and three nurses pampered her, always having her favorite oils and soaps at hand. Her chef brought her gourmet meals, and her weight ballooned to two hundred pounds. She took Tylenol for her pain but tried to avoid drugs for fear of a relapse. She watched *Sally Jessy Raphael* and *Days of Our Lives* on television, and donned a pink chiffon negligee to welcome visitors. Forty-six-year-old Michael Wilding Jr. was by her side, as was Sugar. Demi Moore sent her one hundred violet orchids in an antique vase. Michael Jackson cheered her up with a stuffed animal wearing a pair of $30,000 diamond earrings.[31] When publicist Warren Cowan visited her, he said, "Come on, get out of here," and she laughed good-naturedly. Mother Courage hadn't given up, on herself or others.

The previous month, Project Angel Food, a meal-delivery program that serves homebound AIDS patients, had given her the Angel Award in recognition of her sponsorship of the program from day one ten years ago. In front of an audience that

included Shirley MacLaine, Camryn Manheim, and Barry Manilow, Elizabeth accepted the award and shared a lifetime of hard-won wisdom in eleven words: "It's all about hope, kindness, and a connection with one another."

Beyond that, she refuses to analyze her life—one that has included eight marriages and seventeen romances—preferring to live in an eternal present, as if the past never existed. She says no to proposals that she author a serious autobiography. She has always avoided psychiatry. "It has been so painful," she says, "I couldn't relive it." If anyone makes the mistake of bringing up failed marriages or health crises, she bursts into tears. If she ever forgets herself and slips into a reflective mood, she chases away ghosts with a self-mocking laugh that is one of her most beguiling qualities. When forced in 1999 by a reporter who'd called her "the last true Hollywood star" to comment on the state of the movie industry, and why something seems to be missing in present-day Hollywood, Elizabeth said, "There's no tits anymore. And if they are, they're fake balloons. I mean, you can spot them a mile off. It's not very sexy." More reflective than that, she won't get, beyond pointing out, in 1999, "It's a mixed blessing, discovering boys."[32] Marriage? Strictly for the birds—and "for those who haven't tried it two hundred times," but the new generation of girls contemplating matrimony shouldn't be "such suckers."

By late November 1999 she and Dr. Schwartz were no longer seeing each other, but she recovered sufficiently from her latest fall to attend Andrea Bocelli's L.A. concert. The tenor's victory over blindness had been a steady source of inspiration throughout her latest medical crisis. She was reportedly mulling over an offer from Whoopi Goldberg, star of TV's *Hollywood Squares*, to fill a square on a permanent basis for $7 million a season. There was talk of Larry Fortensky trying to break into show business as a standup comic; during his recuperation he started writing jokes and working up an act as "the male Roseanne." Elizabeth was reportedly "all for it." Strolling along Rodeo Drive one chilly November day, she was a vision of vintage oomph in her snow-colored coat and shoulder-length platinum tresses. To many, she remains the most beautiful woman in the world, not so much because of her physical appearance, though she's striking enough, but because of what she has become inside. On Queen Elizabeth II's honors list in 2000, Elizabeth became Dame Elizabeth Taylor. President Clinton invited her to the White House millennium celebration. Dame Elizabeth stole the spotlight, showing up in bright red, a diamond choker—and newly dyed brunette tresses. Her brief days as a senior-citizen blond bombshell were over.

The one constant in her wild, careening ride through the past decade has been Michael Jackson,

and she has been a rock for him as well. The relationship between the Matriarch of Bel Air and the King of Pop has already lasted longer than any of Elizabeth's marriages, and there has never been a report of a fight between them, let alone violence. "He is part of my heart," she says. "Elizabeth is someone who loves me—really loves me," he says. Two children, a son named Prince Michael and a daughter named Paris-Michael Katherine, were born during Michael's marriage to Debbie Rowe, a former nurse in the Beverly Hills office of Dr. Arnold Klein. When pictures of two-year-old Prince Michael were published, some speculated that Jackson was not the father, since the child's skin was white, his hair golden blond, and his face devoid of African-American features. Some observers conjectured that donated sperm was used, and that fertilized eggs were implanted in Debbie. Elizabeth agreed to be Prince Michael's godmother. Michael and Debbie lived apart, Michael and the children staying at Neverland and Debbie residing in a split-level apartment in Van Nuys. Eventually, Michael bought Debbie a $1.3 million house in the Franklin Canyon area on the outskirts of Beverly Hills. She filed for divorce in 1999, and reports of the settlement range from $5 million to $36 million.[33] Debbie allegedly teamed up with a tattooed biker who rides a Harley. In late 1999 Michael, at forty-one, was poised for a comeback, appearing on the cover of TV *Guide* and set to star

as the eponymous protagonist of Gary L. Pudney's biopic *The Nightmares of Edgar Allan Poe*. In 1985 Pudney had helped Elizabeth produce the first AIDS fundraiser, the CTL dinner. The unconditional love Michael felt for Elizabeth never wavered during his marriages to Lisa Marie and Debbie. Indeed, the bond between Elizabeth and Michael grew even stronger. "We love each other, Michael and I," Elizabeth said. "If nobody understands it— or doesn't dig it—then tough shit."[34]

Her voracious appetite for life remains undiminished. Singing along with a Bocelli CD one day, she heard a word she liked, *piu*, and stopped, asking what it meant. In Italian, *piu* means "more." "*Piu! Piu!* I love *piu!*" she said. Flying to Neverland Valley Ranch in a helicopter with Sugar in 1999, as usual she begged the pilot to swoop ever lower so she could see more—the gazebo where she and Larry had exchanged wedding rings, the railway station, the carousel. "Whee!" she shrilled. "What a rush! Whee!" As a joke, Michael Jackson once gave her a twenty-pound crystal ball, calling it "the biggest diamond in the world." It certainly sparkled like one, and if there were such a thing as magic, one might peer into it and see that she and Michael had found, in each other, the love of their life. The portrait he gave her is inscribed, "To my True Love Elizabeth, I'll love you Forever, Michael."

When she arrives at the main house at Neverland, Michael hugs her, and they resume their role-playing, she as the youngish mother, he as her boyish protector. They touch and tease and play. As her patron, he gives her anything she wants, from a jet plane to a concert. And there is always, whenever she's at Neverland, a hint of sex in the air. "Yeah. Yeah," she admitted in 1999. "There's a kind of magic between us."

There was talk that Michael wanted to have a baby with her. Here's how it would work: Eggs would be taken from Elizabeth's daughter, so some of Elizabeth's genes would be in the baby; sperm would allegedly be taken from Michael; and a third person, a woman, would be required to carry the baby. "If that's what sex has become," said one Hollywood wag, "I'll pass." Elizabeth also reportedly passed, finding the scheme too unconventional, even for her.

Photo Captions

1 Elizabeth Rosemond Taylor, born February 27, 1932, with her mother, Sara, and brother Howard, born in 1929. Eerily beautiful even as a child, her eyes were "not violet as publicized," she later said, but were "different colors" depending on what she wore. ©*Bettman*/CORBIS

2 Though unbilled, ten-year-old Elizabeth, as the orphan Helen Burns, stole the scene from child star Peggy Ann Garner in *Jane Eyre* in 1943.

3 Elizabeth's first off-screen kiss came from lanky, likable, curly-haired Marshall Thompson. ©*Bettman*/CORBIS

4 In 1946, Elizabeth went to Washington, D.C., with Sara to kick off the 1946 March of Dimes campaign. At the White House, she met President Truman and did a broadcast with Cornelia Otis Skinner, Bess Truman,

and FDR Jr. She didn't like President Truman and told her mother, "He looks just like Louis B. Mayer." ©*Bettman*/CORBIS

5 Mesmerized by fiancé William Pawley's dark, hirsute sensuality, Elizabeth appeared to agree when he insisted she give up Hollywood, remarking that she was bored with making movies and would rather "make babies" with Bill. ©*Bettman*/CORBIS

6 Elizabeth's 1950s Metro series, *Father of the Bride* and *Father's Little Dividend*, would have produced many other installments had the husband of Joan Bennett (shown in Spencer Tracy's arms) not shot her lover Jennings Lang in the groin, causing a scandal that wiped out Bennett's film career and trashed the series. Elizabeth's groom was Don Taylor, who went on to a career as a director and writer before dying in 1999, at the age of seventy-eight. ©*Bettman*/CORBIS

7 Elizabeth, only recently graduated from high school, with Nicky Hilton following their 1950 marriage. It was all over with Nicky, a heroin addict and compulsive gambler, in less than a year. ©*Bettman*/CORBIS

8 Elizabeth at a premiere with *Singin' in the Rain* codirector and future Irving Thalberg Award winner Stanley Donen after splitting from Nicky Hilton in 1951. *©Bettman/* CORBIS

9 Elizabeth washes up at the premiere of *Giant* after imprinting her hands and feet in cement at Grauman's (now Mann's) Chinese Theater in Hollywood. *(Collection of Gary Graver)*

10 James Dean hadn't decided whether to live his life straight or gay when he and Elizabeth filmed *Giant* in 1955, but Elizabeth loved him. "He and I . . . 'twinkled,'" she recalled. "We had a . . . well . . . a little 'twinkle' for each other." *©Bettman/*CORBIS

11 Director Edward Dmytryk with Elizabeth and Montgomery Clift on the set of *Raintree Country*. During filming in May 1956, Monty's face was disfigured in a car wreck. *(Collection of Edward Dmytryk)*

12 The twenty-six-year-old bride with her fifty-year-old husband, Mike Todd. Mike died in a crash of his twin-engine Lockheed Lodestar after just 414 days. He was one of the two

grand passions of Elizabeth's life. ©*Bettman/*
CORBIS

13 Classic ménage à trois: When Elizabeth married Mike Todd (right), the groom invited his yes man and gofer, Eddie Fisher (left), to view the scantily clad bride in bed the morning after the wedding. After Todd's death, Elizabeth went to bed with Eddie, telling an outraged press, "What do you expect me to do, sleep alone?" ©*Bettman/*CORBIS

14 Jewish Waldheim Cemetery, Zurich, Illinois, March 25, 1958: Ten thousand violent onlookers attacked Elizabeth at Mike Todd's funeral before she finally escaped into her limousine with her stepson, Mike Todd Jr. ©*Bettman/*CORBIS

15 Elizabeth and her *Cat on a Hot Tin Roof* costar Paul Newman, with Roddy McDowell (right). She and Roddy remained friends from the time they filmed together as child stars in the early 1940s in *Lassie Come Home* and *The White Cliffs of Dover* until his death from cancer in 1999.

16 Santa Monica Civic Auditorium, April 17, 1961: Elizabeth and Burt Lancaster hold their Oscars for *Butterfield 8* and *Elmer*

Gantry, respectively. Elizabeth dismissed hers as a sympathy award for her recent tracheotomy, but in fact she was rarely more persuasive than as the high-priced hooker in Butterfield 8.

17 With Richard Burton on the set of *Cleopatra* in the early 1960s. Though he was the second grand passion of her life, he was homoerotically inclined enough to have had sex with Laurence Olivier. ©*Bettman*/CORBIS

18 Elizabeth at the height of her beauty and excitement as Richard Burton's mistress in the mid-1960s. As he filmed *The Night of the Iguana* in Puerto Vallarta, she loved to entertain the cast and crew, outdazzling Richard's glamorous costars, Ava Gardner, Deborah Kerr, and Sue Lyon. ©*Bettman*/CORBIS

19 Elizabeth with two of the significant gays in her life in the 1960s: Philip Burton, who was in love with Richard Burton and kept him in his youth, and Montgomery Clift, who tried to be her lover but, in rare bisexual interludes, preferred such older women as Myrna Loy. ©*Bettman*/CORBIS

20 Elizabeth and Richard Burton at the Paris Opera House. The personification of the

Swinging Sixties, she was the toast of tout Paris, courted by European aristocracy, including the Rothschilds and the Duke and Duchess of Windsor—the only actress to conquer the beau monde on the strength of sheer star power, unlike Rita Hayworth and Grace Kelly, who married into royalty. ©*Bettman*/CORBIS

21 Richard Burton, who despised illness, resented the role of caregiver that his two marriages to Elizabeth reduced him to during the 1960s and 1970s. Here he pushes the ailing diva, swathed in fur, in a wheelchair. ©*Bettman*/CORBIS

22 & 23 In the 1960s, Elizabeth amassed one of the most impressive private jewelry collections in the world, including the 33.19-carat Krupp diamond for $305,000; the legendary La Peregina Pearl for $37,000, suspended from a $100,000 pearl, diamond, and ruby necklace; and the 69.42-carat Taylor-Burton diamond, purchased for $1.1 million and sold the following decade to cover expenses during her marriage to John Warner. ©*Bettman*/CORBIS

24 Shown here with George Segal and Richard Burton, she received her second Academy

Award for *Who's Afraid of Virginia Woolf?*. She had arranged for Mike Nichols to direct the picture, his first, in appreciation of his personal support during a time she and Richard were denounced by the Pope and the U.S. Congress for having sex out of wedlock. *©Bettman*/CORBIS

25 With John Warner, whom she wed in 1976, and family. Left to right: Michael Wilding Jr., Liza Todd, Mary Warner, Naomi Wilding (baby daughter of Michael Jr. and his wife Jo), and Jo Wilding.*©Bettman*/CORBIS

26 Elizabeth and grand couturier Halston ruled Studio 54 at the height of the brief, dazzling disco era of the 1970s. Here she celebrates her forty-sixth birthday at Studio. AIDS claimed the lives of both Halston and Studio owner Steve Rubell, and Elizabeth intensified her fund-raising efforts in behalf of AIDS research and patient care. *©Bettman*/CORBIS

27 Former First Lady Betty Ford, a recovering alcoholic, became Elizabeth's first AA sponsor when Elizabeth got clean and sober on December 5, 1983. Later, Betty agreed to be guest of honor at Elizabeth's first AIDS fundraiser. (Martha Graham and Gregory Peck on right.) *©Bettman*/CORBIS

28 Magazine publisher Malcolm Forbes made a pass at Elizabeth in the late 1980s, asking, "What would it take to get you to let me come upstairs?" She replied, "A big thing in a little blue box—from Tiffany's." ©*Bettman*/CORBIS

29 Elizabeth launching a $10 million campaign for her fragrance line in early 1987. With her name behind White Diamonds, she hit the jackpot, becoming the sixth-richest woman in Hollywood (between Dolly Parton and Jane Fonda), worth $150 million. ©*Zen Icknow*/CORBIS

30 Newly titled by Queen Elizabeth II, and brunette again after spending a few years as a platinum blond following brain surgery, Dame Elizabeth Taylor saw in New Year's 2000 at the White House with President Bill Clinton (center) and photographer Firhooz Zahedi (right), nephew of former beau Ardeshir Zahedi, Iranian Ambassador to Washington. At left, the President's daughter, Chelsea, and First Lady Hillary Rodham Clinton. ©*Reuters Newmedia Inc.*/CORBIS

Notes

CHAPTER 1

1 E.T. revealed her father's abuse to Barbara Walters on national television. See also C. David Heymann, *Liz* (Secaucus, N.J.: Carol, 1995), pp. 24–25.

2 Paul Theroux, "Ms. Taylor Will See You Now," *Talk*, October 1999, p. 169; Roddy's quote: Jackie Cooper and Dick Kleiner, *Please Don't Shoot My Dog* (New York: Morrow, 1981), pp. 160–161; Shirley Temple Black, *Child Star* (New York: Warner), 1988, pp. 485–490.

3. Sheilah Graham, *Hollywood Revisited* (New York: St. Martin's, 1984), pp. 113–114.

4 Warren G. Harris, *Natalie and R. J.* (New York: Doubleday, 1988) p. 26.

5 Heymann, *Liz*, p. 51.

6 Black, *Child Star*, pp. 322–323.

7. Kitty Kelley, *Elizabeth Taylor: The Last Star* (New York: Dell, 1981), pp. 28–32; see also Kevin Sessums, "Elizabeth Taylor Tells the Truth," *POZ* (November 1997), p. 72.

8 Sydney Guilaroff and Cathy Griffin, *Crowning Glory* (Santa Monica: General, 1996), pp. 188–189.

9 Heymann, *Liz*, p. 60.

10 Guilaroff and Griffin, *Crowning Glory*, p. 189; "might not show up": Mary Astor in Heymann, p. 60 ("required more sick leave than any other performer").

11 Jerry Vermilye and Mark Ricci, *The Films of Elizabeth Taylor* (New York: Carol, 1993), p. 70.

12. Elizabeth Taylor, *Elizabeth Takes Off* (New York: Putnam's, 1987), p. 23 (hereafter *ETO*).

13. Vermilye and Ricci, *Films of Elizabeth Taylor*, p. 71.

14. "Howard's kid sister": Christopher Nickens, *Elizabeth Taylor* (New York: Dolphin, 1994), p. 14; Astor's harsh remarks: Donald Spoto, *A Passion for Life* (New York: HarperCollins, 1995), p. 54; and Kelley, *Elizabeth Taylor*, p. 29.

15. *ETO*, p. 56.

16. Heymann, *Liz*, p. 58.

17. E.T., "Loving You," quoted in Kelley, *Elizabeth Taylor*, p. 33.

18. Davis, Kearns, Blanchard: Heymann, *Liz*, p. 67; Spoto, *Passion for Life*, p. 58.

19. Lester David and Jhan Robbins, *Richard and Elizabeth* (New York: Funk and Wagnalls, 1977), p. 71.

20. Spoto, *Passion for Life*, p. 57.

21. Ibid., pp. 58–59.

22. Glenn Davis, Leigh, and E.T.: Heymann, *Liz*, pp. 67, 68; Kelley, *Elizabeth Taylor*, p. 42.

23. *ETO*, p. 64.

24. E.T., parent, chaperone, Robert Taylor in London: Nickens, *Elizabeth Taylor*, pp. 20, 23; Spoto, *Passion for Life*, p. 59; Alexander Walker, *Elizabeth* (London: Weidenfeld and Nicolson, 1990), p. 80; Heymann, *Liz*, p. 73. Patricia Neal and Richard Deneut, *As I Am* (New York: Simon & Schuster, 1988), p. 112.

25. Michael Wilding, *The Wilding Way: The Story of My Life* (New York: St. Martin's, 1982), p. 75; Ruth

Waterbury with Gene Arceri, *Elizabeth Taylor* (New York: Bantam, 1982), p. 31.

26. "Screw it" and "Please do me one last favor": Kelley, *Elizabeth Taylor*, pp. 41–42.

27. Mike Todd Jr. and Susan McCarthy Todd, *A Valuable Property: The Life Story of Michael Todd* (New York: Arbor House, 1983), p. 318.

28. E.T. and Howard Hughes: Graham, *Hollywood Revisited*, p. 103; Walker, *Elizabeth*, pp. 81–82; Marianne Robin-Tani, *The New Elizabeth* (New York: St. Martin's, 1988), p. 25; Peter Harry and Pat H. Broeske, *Howard Hughes* (New York: Dutton, 1996), p. 241; Kevin Sessums, "Elizabeth Taylor Tells the Truth," *POZ*, November 1997, p. 74.

29. Spoto, *Passion for Life*, p. 66.

Interviews with Jean Porter, Jerry O'Connell, Frank Taylor, and editorial notes from meetings with Shelley Winters when I was senior editor, William Morrow, for *Shelley*, and collaborator for *Shelley II*; notes from meetings with June Allyson when I was editorial director of G. P. Putnam's Sons for *June Allyson*, and notes from a meeting in Ojai, California, with June Allyson, Paul Rosenfield of the *L.A. Times*, and Ms. Allyson's husband, David Ashrow; notes from a meeting at l'Hotel in Paris with Olivia de Havilland when I was editor-in-chief of the Delacorte Press; notes from meetings with George Cukor and Hector Arce when I was at Morrow.

Other books consulted for this chapter: Dick Sheppard, *Elizabeth* (New York: Warner, 1974), p. 46; Monty Roberts, *The Man Who Listens to Horses* (New York: Random House, 1996), p. 44; Michael Troyan, *A Rose for Ms. Miniver* (Lexington: University Press of Kentucky, 1999), pp. 209–210; Anthony Holden, *Behind the Oscar* (New York: Simon and Schuster, 1993), pp. 190–195; Janet Leigh, *There Really Was a Hollywood* (New York: Jove, 1984), p. 91; Carroll Baker,

Baby Doll (New York: Arbor House, 1983), p. 134 (E.T.'s reckless driving); Rona Barrett, *Miss Rona* (New York: Bantam, 1974), p. 54; Mel Gussow, *Don't Say Yes Until I Finish Talking: A Biography of Darryl F. Zanuck* (New York: Pocket, 1972), pp. 152, 125–127; Stephen M. Silverman, *The Fox That Got Away* (Secaucus, N.J.: Lyle Stuart, 1988), p. 111.

CHAPTER 2

1. Boze Hadleigh, Hollywood Gays (New York: Barricade, 1996), pp. 298–299.
2. Theroux, "Ms. Taylor Will See You Now," p. 214.
3. Ibid.
4. Natalie Wood television biography written by Gavin Lambert, produced by Howard Jeffrey, AMC.

Interviews with Frank Taylor, Jack Larson; notes from editorial meetings with Shelley Winters, William Morrow and Company.

Other books and articles consulted: Barney Hoskyns, *Montgomery Clift* (New York: Grove Weidenfeld, 1991); Robert LaGuardia, *Monty* (New York: Arbor House, 1977); Sessums, "Elizabeth Taylor Tells the Truth," p. 52.

CHAPTER 3

1. Walker, Elizabeth, p. 100.
2. Ruth Waterbury with Gene Arceri, *Elizabeth Taylor* (New York: Bantam, 1982), p. 53.
3. Ibid.
4. Heymann, *Liz*, p. 86.
5. Sheppard, *Elizabeth*, p. 55.
6. Walker, *Elizabeth*, p. 100.
7. Waterbury and Arceri, *Elizabeth Taylor*, p. 55.
8. Zsa Zsa Gabor, *Zsa Zsa Gabor, My Story, Written for Me by Gerold Frank* (Cleveland: World, 1960), pp.

109, 114, 119, 147, 151–152; Zsa Zsa described her institutionalization: "I was released through a writ of habeas corpus, charging that I was being wrongfully detained."

9. Heymann, *Liz*, p. 84.

10. Gabor, *Zsa Zsa Gabor*, p. 127: "My husband locked his door against me." pp. 128–129: Conrad sent Father Kelly to Zsa Zsa; he told her, "Conrad's wife is still alive . . . Conrad knows that he is living in sin with you."

11. Waterbury and Arceri, *Elizabeth Taylor*, p. 55.

12. Kelley, *Elizabeth Taylor,* pp. 60, 63.

13. Heymann, *Liz*, p. 85.

14. Gabor, *Zsa Zsa Gabor*, p. 119.

15. Kelley, *Elizabeth Taylor*, p. 132; Spoto, *Passion for Life,* p. 72.

16. Nickens, *Elizabeth Taylor*, p. 26.

17. Waterbury and Arceri, *Elizabeth Taylor*, p. 57.

18. Kelley, *Elizabeth Taylor*, p. 63.

19. Heymann, *Liz*, p. 86; Kelley, *Elizabeth Taylor*, p. 62; Walker, *Elizabeth*, p. 101 Nickens, *Elizabeth Taylor*, p. 26.

20. Walker, *Elizabeth*, pp. 102, 103.

21. Spoto, *Passion for Life*, p. 73.

22. Waterbury and Arceri, *Elizabeth Taylor*, p. 60.

23. Sheppard, *Elizabeth*, p. 98.

24. Nickens, *Elizabeth Taylor*, p. 32.

25. Spoto, *Passion for Life*, p. 76. E.T. employee Raymond Vignale said she told him the marriage was not consummated until the third night.

26. Heymann, *Liz*, p. 102.

27. Walker, *Elizabeth*, pp. 114–115.

28. Ibid., pp. 118–120.

29. Heymann, *Liz*, p. 104. Nicky Hilton slugged E.T., according to Kelley, *Elizabeth Taylor*, pp. 288.

30. Waterbury and Arceri, *Elizabeth Taylor*, p. 70.

31. Final days of Hilton marriage: Theroux, "Ms. Taylor Will See You Now," p. 214; Eddie Fisher with David Fisher, *Been There, Done That* (New York: St. Martin's, 1999), p. 123; Harris, *Natalie and R. J.*, p. 48; Nickens, *Elizabeth Taylor*, p. 32; Brad Darrach "If the Knife Slips Tomorrow, I'll Die Knowing I've Had an Extraordinary Life" *Life*, April 1997, pp. 78-88.

32. Walker, *Elizabeth*, p. 123.

33. Waterbury and Arceri, *Elizabeth Taylor*, p. 72.

34. Kelley, *Elizabeth Taylor*, p. 85.

35. Waterbury and Arceri, *Elizabeth Taylor*, pp. 77–78.

36. Matthew Bernstein, *Walter Wanger, Hollywood Independent* (Berkeley: University of California Press, 1994), pp. 273–274.

37. Kelley, *Elizabeth Taylor*, pp. 80, 86, 98; Waterbury and Arceri, *Elizabeth Taylor*, p. 74; Vermilye and Ricci, *Films of Elizabeth Taylor*, p. 87; "lost one ball": Paul Rosenfield, *The Club Rules*, (New York: Warner, 1992), p. 68; Kelley, *Elizabeth Taylor*, pp. 86, 98.

38. Fisher and Fisher, *Been There, Done That*, p. 117.

39. Wilding, *Wilding Way*, p. 75.

40. Ibid., pp. 26, 75.

41. Maria Riva, *Marlene Dietrich*, (New York: Knopf, 1993), p. 626.

42. Elaine Dundy, Tynan's wife at the time, said that Ken did not have an affair with Marlene.

43. Hadleigh, *Hollywood Gays*, p. 210.

44. Ray Stricklyn, *Angels and Demons* (Los Angeles: Belle, 1999); pp. 65, 101; Charles Winecoff, *Split Image* (New York: Dutton, 1996), pp. 106, 110, 122, 136.

45. Walker, *Elizabeth*, p. 136.

46. David and Robbins, *Richard and Elizabeth*, p. 88.

47. Heymann, *Liz*, p. 113.
48. Walker, *Elizabeth*, p. 133.
49. Wilding, *Wilding Way*, p. 76.
50. Patricia Bosworth, *Montgomery Clift* (New York: Bantam, 1979), pp. 32, 74.
51. Heymann, *Liz*, p. 113.
52. Ibid., p. 114.
53. Wilding, *Wilding Way*, pp. 108–109.
54. Graham, *Hollywood Revisited*, p. 68.
55. Wilding, *Wilding Way*, pp. 108–109.
56. Hadleigh, *Hollywood Gays*, p. 279; Hopper's son gay: Ibid., p. 42.
57. Wilding, *Wilding Way*, pp. 109, 125.
58. Walker, *Elizabeth*, p. 137.
59. Wilding, *Wilding Way*, pp. 73, 76.
60. Walker, *Elizabeth*, p. 136.
61. Ibid., p. 138.
62. Heymann, *Liz*, p. 120.
63. Wilding, *Wilding Way*, pp. 106–107; "Those shi-tassed": Heymann, Liz, p. 171; E T. and Finch: Walker, *Elizabeth*, pp. 150–151.
64. Nickens, *Elizabeth Taylor*, p. 50.
65. David and Robbins, *Richard and Elizabeth*, p. 86.
66. Ibid., p. 86.
67. Baker, *Baby Doll*, p. 136.

Interviews: Jack Larson, Joanne Jacobson, Elaine Dundy, Edward Dmytryk, Jean Porter, Cy Egan (*New York Post*), Dorris Halsey, Jerry O'Connell (*Show* magazine), and editorial notes from meetings with Joan Bennett while editor-in-chief of the Delacorte Press and senior editor at Morrow; with Zsa Zsa Gabor while collaborating on her book, *One Lifetime Is Not Enough*, for Patricia Soliman at the Delacorte Press; with Stewart Granger as his editor at G. P. Putnam's Sons.

Other books consulted for this chapter: Conrad Hilton, *Be

My Guest (New York, Prentice-Hall, 1957); Anne Edwards, *Vivien Leigh* (New York: Simon and Schuster, 1977); Anthony Holden, *Laurence Olivier* (New York: Atheneum, 1988); *ETO*; Elizabeth Taylor, *Elizabeth Taylor* (New York: Harper and Row, 1964) (hereafter *ET*); Leigh, *There Really Was a Hollywood*, p. 147; Hedy Lamarr, *Ecstasy and Me* (New York: Fawcett, 1966), p. 69; Cooper and Kleiner, *Please Don't Shoot My Dog*, p. 68.

CHAPTER 4

1. Stevens's correspondence and Warner memos are in the George Stevens archive, Special Collections, Academy of Motion Picture Arts and Sciences (AMPAS).
2. Graham, *Hollywood Revisited*, p. 163.
3. Louella O. Parsons: "Rock Hudson Given Lead in Edna Ferber's *Giant*," *L.A. Examiner*, November 6, 1954, p. 13, section 1.
4. Rock Hudson to George Stevens, November 4, 1954, AMPAS.
5. Rock Hudson and Sara Davidson, *Rock Hudson* (New York: Morrow, 1986), p. 92.
6. *ET*, p. 50.
7. Baker, *Baby Doll*, pp. 134–135.
8. Burton as Jett Rink: David Dalton, *The Mutant King* (New York: St. Martin's, 1974), p. 292; Ladd as Jett Rink: Marceau Devillers, *James Dean* (Singapore: Chartwell, n.d.), p. 43.
9. Marvin H. Schenck to Henry Ginsberg, April 4, 1956, AMPAS.
10. *ET*, p. 51.
11. Stricklyn, *Angels and Demons*, p. 31.
12. Ibid, p. 66.
13. Hudson and Davidson, *Rock Hudson*, p. 93.

14. *ET*, p. 55.
15. Joe Hyams with Jay Hyams, *James Dean* (New York: Warner, 1992), p. 227.
16. Hadleigh, *Hollywood Gays*, p. 250; Nick Adams opening fly, associating with gays, and death: Barrett, *Miss Rona*, pp. 197–198.
17. Stricklyn, *Angels and Demons*, p. 61.
18. Hyams and Hyams, *James Dean*, pp. 79, 80.
19. Ibid., p. 120.
20. Waterbury and Arceri, *Elizabeth Taylor*, p. 103.
21. Hadleigh, *Hollywood Gays*, p. 250.
22. Dalton, *Mutant King*, p. 302.
23. Wilding, *Wilding Way*, p. 113.
24. Hudson and Davidson, *Rock Hudson*, p. 94.
25. John Davis, M.D., to A. Morgan Maree, March 12, 1956, George Stevens archive, casting file, AMPAS.
26. John Davis, M.D., to A. Morgan Maree, August 9, 1955, George Stevens archive, AMPAS.
27. Tom Andre to George Stevens, July 30, 1955, AMPAS.
28. Tom Andre to Eric Stacey, August 2, 1955, AMPAS.
29. Tom Andre to Eric Stacey, August 8, 1955, AMPAS.
30. Tom Andre to Eric Stacey, August 11, 1955, AMPAS; *ET*, p. 52; Tom Andre to Eric Stacey, August 12, 1955, AMPAS.
31. Henry Ginsberg to Loew's, August 12, 1955, AMPAS; Tom Andre to Eric Stacey with copies to George Stevens and Henry Ginsberg, August 31, 1955, AMPAS; Henry Ginsberg to Loew's, September 14, 1955, AMPAS.
32. Hyams and Hyams, *James Dean*, p. 227.
33. Ibid., p. 242.
34. Roberts, *Man Who Listens to Horses*, p. 104.
35. *ET*, p. 56.
36. Hyams and Hyams, *James Dean*, p. 255.

37. Tom Andre to Eric Stacey, October 4, 1955, AMPAS.

38. Waterbury and Arceri, *Elizabeth Taylor*, p. 102; Spoto, *Passion for Life*, p. 116.

39. Waterbury and Arceri, *Elizabeth Taylor*, p. 97.

40. Tom Andre to Eric Stacey, October 3, 1955, AMPAS; John Davis, M.D., to A. Morgan Maree, March 12, 1956, AMPAS; Tom Andre to Eric Stacey, October 3, 1955, AMPAS.

41. Tom Andre to Eric Stacey, 12 noon, October 4, 1955, AMPAS; F. E. Witt to Tom Andre, October 4, 1955, AMPAS.

42. John H. Davis, M.D., and Robert Buckley, M.D., 20 S. Lasky Drive, Beverly Hills, to Henry Ginsberg, November 10, 1955.

43. Hudson and Davidson, *Rock Hudson*, pp. 98, 104, 187.

44. Heymann, *Liz*, p. 135.

45. Fisher and Fisher, *Been There, Done That*, p. 125.

46. Kitty Kelley, *His Way* (New York: Bantam, 1986), p. 236; Esther Williams interview on *Today Show*, NBC, September 17, 1999.

47. Heymann, *Liz*, p. 134; Esther Williams interview on *Today Show*, NBC, September 17, 1999.

48. Heymann, *Liz*, p. 135.

49. Wilding, *Wilding Way*, pp. 117–118.

50. Dmytryk added during our interview, "Then they gave me the script of *The Young Lions* and I said, 'There's only one guy who can play Noah in this.' I sent Monty the script and got back a telegram in two days. He said yes, and he never lost me a day on that picture. It was a long picture—I had Montgomery Clift and Marlon Brando in the same picture, and they're both time losers. It was entirely my choice to cast Monty. We had a producer who had

been an executive in the New York office. They re-
tired him, and gave him a production deal. He died
before the picture came out. He took no part in
casting at all. When I took it, they had what I call a
number two cast lined up for it—second rate people
for all the major parts. I was the first one to get
Monty, I got Dean Martin, who had never played in
anything like that. He had to work with Clift a lot.
I wanted Clift to be a happy man on this one, didn't
want any problems. I called him on the phone and
said, 'What about Dean Martin for this part?' He
said, 'Dean Martin? Oh, no, no, no!' [Martin had
been doing slapstick with Jerry Lewis.] They had
had Tony Randall for the part. I said, 'The other
choice is Tony Randall.' I told him Tony was in a
current picture with Ginger Rogers and Monty said,
'I'll go see him.' He went to see it and called me the
next day and said, 'Get Dean Martin.'"

Interviews: Ray Stricklyn, Millard Kaufman, Edward
Dmytryk, Frank Taylor, Jack Larson, Jean Porter, Dorris
Halsey.

Other books and an article consulted: Robert Lacey, *Grace*
(New York: Putnam's, 1994); Hoskyns, *Montgomery Clift*;
Bosworth, *Montgomery Clift*; *ET*; Baker, *Baby Doll*, p. 129;
Sessums, "Elizabeth Taylor Tells the Truth," *POZ*.

CHAPTER 5

1. Heymann, Liz, p. 160; Todd and Todd, Valuable
 Property, pp. 280, 286: "You know, I have a speech
 im-p-p-pediment, and Mike so took me by surprise
 I couldn't get a word out."
2. Heymann, *Liz*, pp. 137, 166.
3. *ET*, p. 60.
4. Wilding, *Wilding Way*, p. 121.

5. As unwittingly revealed in Fisher's 1999 memoir, *Been There, Done That*, passim and pp. 307–309; Debbie Reynolds and David Patrick Columbia, *Debbie* (New York: Pocket, 1988), p. 169.
6. Dr. Max Jacobson died in 1978 after New York State took away his license to practice medicine in 1975.
7. Fisher and Fisher, *Been There, Done That,* p. 63; Reynolds and Columbia, *Debbie*, p. 160, 165, 169.
8. Todd and Todd, *Valuable Property*, p. 311.
9. Waterbury and Arceri, *Elizabeth Taylor*, pp. 111–112.
10. Heymann, *Liz*, p. 147.
11. Ibid., p. 129.
12. Ibid., p. 149, quoting Gwin Tate, an acquaintance of E.T.'s who lives in Natchez. Tate also related the story of E.T. and Montgomery Clift running through downtown Natchez.
13. Blondell's nervous breakdown: Kelley, *Elizabeth Taylor*, p. 125; broken arm: Graham, *Hollywood Revisited*, p. 184. Also see Earl Wilson quoted in Heymann, *Liz*, p. 146.
14. Todd and Todd, *Valuable Property*, p. 156.
15. Fisher and Fisher, *Been There, Done That*, pp. 121, 124.
16. Fisher and Fisher, *Been There, Done That*, pp. 121, 123–124.
17. *ET*, p. 64.
18. Kelley, *Elizabeth Taylor*, p. 128.
19. Fisher and Fisher, *Been There, Done That*, p. 114.
20. *ET*, p. 64.
21. Fisher and Fisher, *Been There, Done That*, p. 128; Eddie Fisher writes that E.T. pregnant with Todd's child while still married to Wilding.
22. Walker, *Elizabeth*, p. 178.

23. Fisher and Fisher, *Been There, Done That*, p. 128.
24. Sheppard, *Elizabeth*, p. 216.
25. *ETO*, p. 73.
26. Kelley, *Elizabeth Taylor*, pp. 127–128.
27. Fisher and Fisher, *Been There, Done That*, p. 106; Gates and La Fiorentina: David Patrick Columbia, "Social Diary," *Avenue*, October 1999.
28. Kelley, *Elizabeth Taylor*, p. 152.
29. Sheppard, *Elizabeth*, p. 218; Kelley, *Elizabeth Taylor*, p. 136; Spoto, *Passion for Life*, p. 141.
30. Noel Coward, *The Noel Coward Diaries*, edited by Graham Payne and Sheridan Morley (Boston: Little, Brown, 1982), pp. 356, 358.
31. Heymann, *Liz*, p. 133.
32. *ET*, p. 78.
33. Kelley, *Elizabeth Taylor*, p. 141; Todd and Todd, *Valuable Property*, p. 349.
34. Fisher and Fisher, *Been There, Done That*, pp. 128–129.
35. Todd and Todd, *Valuable Property*, pp. 350, 363.
36. Ibid., p. 305: Todd's son says that his father's interest in Dietrich was confined to her boiled beef, but added that E.T. told him that Eddie Fisher insisted Dietrich and Todd Sr. definitely had an affair.
37. Sheppard, *Elizabeth*, p. 230.
38. Ibid., p. 234. Logan elaborated on the anecdote to me when I acquired his memoirs for the Delacorte Press.
39. Sheppard, *Elizabeth*, pp. 233, 236, 238–239; Heymann, *Liz*, p. 175; Todd and Todd, *Valuable Property*, p. 356; Kelley, *Elizabeth Taylor*, p. 135.
40. Fisher and Fisher, *Been There, Done That*, p. 132.
41. *ET,* p. 81; *ETO*, p. 75; Waterbury and Arceri, *Elizabeth Taylor*, p. 143.
42. Sheppard, *Elizabeth*, p. 237; *ETO*, p. 76; Heymann,

Liz, p. 177.

43. Walker, *Elizabeth*, pp. 193–194, quoting director Richard Brooks; Waterbury and Arceri, *Elizabeth Taylor*, pp. 146; *Debbie*, p. 188.
44. ET, p. 93.
45. Fisher and Fisher, *Been There, Done That*, p. 134.
46. Guilaroff and Griffin, *Crowning Glory*, p. 193.
47. Waterbury and Arceri, *Elizabeth Taylor*, p. 146.
48. *ET*, p. 83; Waterbury and Arceri, *Elizabeth Taylor*, p. 147.
49. Fisher and Fisher, *Been There, Done That*, p. 136.
50. Guilaroff and Griffin, *Crowning Glory*, p. 194; Waterbury and Arceri, *Elizabeth Taylor*, pp. 148, 248; Holden, *Behind the Oscar*, p. 220; Sheppard, *Elizabeth*, p. 243; Heymann, *Liz*, p. 181.
51. Waterbury and Arceri, *Elizabeth Taylor*, pp. 150, 153; Nickens, *Elizabeth Taylor*, p. 75; Sheppard, *Elizabeth*, p. 245.
52. Kelley, *Elizabeth Taylor*, p. 154.

Interviews with Ross Claiborne, Millard Kaufman, Edward Dmytryk, Jean Porter Dmytryk, and editorial notes from meetings with Joan Blondell and Joshua Logan at Delacorte Press and with Shelley Winters at Morrow.

Other books consulted: Joan Blondell, *Center Door Fancy* (New York: Delacorte, 1972); Joan Collins, *Past Imperfect* (New York: Berkley, 1985); Baker, *Baby Doll*, p. 200.

CHAPTER 6

1. Heymann, Liz, pp. 187–188; Wilding, Wilding Way, pp. 121–122; ET, pp. 61, 93; Reynolds and Columbia, Debbie, p. 170; Waterbury and Arceri, Elizabeth Taylor, p. 165.
2. Fisher and Fisher, *Been There, Done That*, p. 145.
3. Todd and Todd, *Valuable Property*, p. 361; Kelley,

Elizabeth Taylor, p. 155.

4. Fisher and Fisher, *Been There, Done That*, p. 153.

5. Guilaroff and Griffin, *Crowning Glory*, p. 200; Sheppard, *Elizabeth*, p. 258; Reynolds and Columbia, *Debbie*, p. 172; Heymann, *Liz*, p. 170; Robin-Tani, *New Elizabeth*, p. 149.

6. Fisher and Fisher, *Been There, Done That*, pp. 126–127.

7. Ibid., p. 15 ("never fall in love with a *shiksa*"), 244; Barrett, *Miss Rona*, pp. 54–60; Sam Kashner and Nancy Schoenberger, *A Talent for Genius: The Life and Times of Oscar Levant* (New York: Villard, 1994) p. 392.

8. Fisher and Fisher, *Been There, Done That*, p. 152.

9. Ibid., p. 160.

10. Ibid., p. 162. Eddie admits, "When they make the list of the worst fathers, I know my name will be right on the top."

11. Heymann, *Liz*, p. 188; Debbie's income boost: Fisher and Fisher, *Been There, Done That*, p. 151; "the best fuck . . . ruined everything": Barrett, *Miss Rona*, p. 187.

12. Donald Spoto, *The Kindness of Strangers* (New York: Ballantine, 1985), p. 66; Fisher and Fisher, *Been There, Done That*, p. 163: "I kept busy meeting with studio executives to discuss movies Elizabeth might make or I might produce. In fact, my real job was keeping Elizabeth happy"; "impotent": Janet Charlton, "Star People," *Star*, November 23, 1999, p. 14; "so-so": Wayne Grover, "Tony Bennett's Ex Tells All," *National Enquirer*, November 2, 1999, pp. 60–61.

13. Kelley, *Elizabeth Taylor*, p. 166; Heymann, *Liz*, p. 203; E.T.–Mankiewicz relationship: Heymann, *Liz*, p. 203 and Graham, *Hollywood Revisited*, pp.

179–180.

14. Waterbury and Arceri, *Elizabeth Taylor*, pp. 175, 176; Holden, *Behind the Oscar*, p. 226; Spoto, *Kindness of Strangers*, p. 192.
15. Fisher and Fisher, *Been There, Done That*, pp. 63–64.
16. Heymann, *Liz*, p. 210.
17. Ibid.
18. Vermilye and Ricci, *Films of Elizabeth Taylor*, p. 151; Nickens, *Elizabeth Taylor*, pp. 84–86.
19. Bernstein, *Walter Wanger, Hollywood Independent*, p. 45.
20. Sheppard, *Elizabeth*, p. 279.
21. Bernstein, *Walter Wanger, Hollywood Independent*, p. 55.
22. Fisher and Fisher, *Been There, Done That*, p. 175; also see Heymann, *Liz*, p. 219.
23. Guilaroff and Griffin, *Crowning Glory*, pp. 214–215; Shirley MacLaine, *You Can Get There From Here* (New York: Norton, 1975), p. 19.
24. Fisher and Fisher, *Been There, Done That*, p. 177.
25. Ibid., p. 176.
26. Ibid., p. 177.
27. CNN Today, February 1999.
28. Fisher and Fisher, *Been There, Done That*, p. 123.
29. Ibid., p. 182.
30. Ibid., p. 183.
31. Ibid., p. 186.
32. *ET*, p. 97.
33. Heymann, *Liz*, p. 219.
34. Collins, *Past Imperfect*, p. 188.
35. Fisher and Fisher, *Been There, Done That*, p. 186.
36. "lose my girl": Spoto, *Passion for Life*, p. 189; in Fisher and Fisher, *Been There, Done That*, p. 186, Eddie Fisher revealed her crisis was "brought on by depressant drugs. Her pills. So I thought it very

strange that they continued to treat her with other pills. For five days she slipped in and out of consciousness. I stayed with her day and night."

37. Fisher and Fisher, *Been There, Done That*, p. 186.
38. David and Robbins, *Richard and Elizabeth*, p. 115.
39. Heymann, *Liz*, p. 224.
40. Fisher and Fisher, *Been There, Done That*, p. 125.
41. Mamoulian resigned after E.T. promised she'd support his reinstatement as director should the production ever be resuscitated, but in the event she demanded Mankiewicz, according to Heymann, *Liz*, p. 223.
42. Fisher and Fisher, *Been There, Done That*, p. 171.
43. Ibid., p. 140.
44. Harris, *Natalie and R. J.*, p. 92.
45. *ET*, pp. 97–104; Waterbury and Arceri, *Elizabeth Taylor*, p. 194; Kelley, *Elizabeth Taylor*, p. 211.

Interviews: Joanne Jacobson, Elaine Dundy, Brian Hutton, Edward Dmytryk.

Other books and articles consulted: Tennessee Williams, *Memoirs* (New York: Bantam, 1975); Lamarr, *Ecstasy and Me*, p. 139.

Chapter 7

1. Fisher and Fisher, Been There, Done That, p. 204.
2. *ET*, p. 104; Paul Ferris, *Richard Burton* (New York: Coward-McCann, 1981), pp. 82, 159, 165; Richard Burton's notebook, November 19, 1968, in Melvyn Bragg, *Richard Burton* (Boston: Little, Brown), p. 277; Waterbury and Arceri, *Elizabeth Taylor*, p. 197.
3. Waterbury and Arceri, *Elizabeth Taylor*, pp. 197–198; Ferris, *Richard Burton*, p. 156; Walker, *Elizabeth*, pp. 243, 244.
4. Bragg, *Richard Burton*, p. 258; Ferris, *Richard*

Burton, p. 106. To prevent gay speculation, Richard always claimed that he was a mere twelve-year-old when Philip became his guardian, but according to Richard's brother Graham Jenkins, Richard was "well past his seventeenth birthday when he moved in with his guardian." Emlyn Williams, *Emlyn: An Early Autobiography: 1927–1935* (New York: Viking, 1973), pp. 169, 205, 346; in his 1961 memoir, *George: An Early Autobiography (1905–1927)* (New York: Random House), Williams outed himself, writing of homoerotic yearnings that led to his nervous breakdown at the age of twenty.

5. Bragg, *Richard Burton*, pp. 64, 126, 149; Ferris, *Richard Burton*, p. 114.

6. Susan Strasberg, *Bittersweet* (New York: Putnam's, 1980), p. 87; Claire Bloom, *Leaving a Doll's House* (Boston: Little Brown, 1996), p. 106.

7. Fisher and Fisher, *Been There, Done That*, p. 207; Burton's homosexuality: Heyman, *Liz*, p. 29 and Bragg, *Richard Burton*, p. 258.

8. Heymann, *Liz*, p. 242.

9. "She needed a lot": "Liz Is Furious as Ex-Hubby Eddie Sells Her Secrets," *National Enquirer*, Vol. 72, No. 24, 1998, pp. 4–5; Heymann, *Liz*, p. 244, writes that Burton used the term "nailed"; Nickens, *Elizabeth Taylor*, p. 101; Walker, *Elizabeth*, p. 244; Walter Wanger to Joe Hyams, collaborator on *My Life with Cleopatra*, 1963, quoted in David Kamp, "When Liz Met Dick," *Vanity Fair*, April 1998, p. 384.

10. Fisher and Fisher, *Been There, Done That*, p. 208: "I was Eddie Fisher. Women loved me, they didn't cheat on me"; re Percodans: Ibid.

11. Kamp, "When Liz Met Dick," p. 384; Walker, *Elizabeth*, pp. 246–247; *ET*, p. 106.

12. Kelley, *Elizabeth Taylor*, p. 221.
13. *ET*, p. 105, caption following p. 118; Bragg, *Richard Burton*, p. 82.
14. Fisher and Fisher, *Been There, Done That*, p. 208; re gun: Ibid., p. 209.
15. Ibid., p. 212.
16. Ibid., pp. 199, 211.
17. Guilaroff and Griffin, *Crowning Glory*, p. 253; Jack Brodsky and Nathan Weiss, *The Cleopatra Papers* (New York: Simon and Schuster, 1963), p. 37; Fisher and Fisher, *Been There, Done That*, pp. 202, 213.
18. Kamp, "When Liz Met Dick," p. 384.
19. Fisher and Fisher, *Been There, Done That*, pp. 214, 216; Brodsky and Weiss, *Cleopatra Papers*, p. 38; Bragg, *Richard Burton*, p. 149; Walker, *Elizabeth*, p. 248.
20. Silverman, *Fox That Got Away*, p. 96; Gussow, *Don't Say Yes Until I Finish Talking*, p. 221.
21. E.T.'s Seconal OD: Kamp, "When Liz met Dick," p. 385; Heymann, *Liz*, pp. 243, 249; Nickens, *Elizabeth Taylor*, p. 143; Kelley, *Elizabeth Taylor*, p. 215; Paul Rosenfield: *The Club Rules* (New York: Warner, 1992), pp. 63–64; Sybil's suicide attempt: Heymann, *Liz*, p. 256 and Bragg, *Richard Burton*, pp. 149, 366 and Ferris, *Richard Burton*, p. 159.
22. Fisher and Fisher, *Been There, Done That*, p. 218.
23. Waterbury and Arceri, *Elizabeth Taylor*, p. 201; Graham, *Hollywood Revisited*, p. 181; Eddie Fisher's version of E.T.'s statement: Fisher and Fisher, *Been There, Done That*, p. 223.
24. Spoto, *Passion for Life*, p. 207.
25. Williams, *Emlyn*, pp. 169, 205, 346.
26. Fisher and Fisher, *Been There, Done That*, p. 225.
27. The quotations in the last two paragraphs are

Richard Burton's in his notebook, August 13, 1971, in Bragg, *Richard Burton*, p. 366.

28. Kamp, "When Liz Met Dick," p. 388.
29. Silverman, *Fox That Got Away*, p. 110.
30. Kamp, "When Liz Met Dick," p. 394.
31. Silverman, *Fox That Got Away*, p. 111.

Interviews: Frank Taylor, Edward Dmytryk; editorial notes from conversations with Susan Strasberg while editorial director, G. P. Putnam's Sons.

Other books consulted: Bernstein, *Walter Wanger, Hollywood Independent*; Rex Harrison, *A Damned Serious Business* (New York: Bantam, 1991); Collins, *Past Imperfect*, p. 82; Lamarr, *Ecstasy and Me*, pp. 7–8, 155.

CHAPTER 8

1. Ferris, Richard Burton, pp. 77, 154; Bragg, Richard Burton, pp. 166, 168.
2. Bragg, *Richard Burton*, p. 173; Ferris, *Richard Burton*, p. 171; Fisher and Fisher, *Been There, Done That*, p. 125 (Eddie Fisher writes, "He knew exactly what I meant by that and backed off. End of conversation").
3. Ava Gardner, *Ava* (Thorndike, Me.: Thorndike, 1990), p. 438.
4. Walker, *Elizabeth*, pp. 261, 270; Eddie Fisher's $500,000: Fisher and Fisher, *Been There, Done That*, p. 272; Sue Lyon sleeping with Richard Burton and Eddie Fisher: Ibid., p. 16.
5. Heymann, *Liz*, p. 264.
6. By 1990s standards; E.T. paid $10,000 in 1963.
7. Heymann, *Liz*, p. 266.
8. Graham, *Hollywood Revisited*, p. 186–187.
9. Sheppard, *Elizabeth*, p. 459.
10. Vincente Minnelli and Hector Arce, *I Remember It*

Well (Garden City, NY: Doubleday, 1974), pp. 355–356.

11. *ET*, p. 142.
12. Graham, *Hollywood Revisited*, p. 208.
13. Reynolds and Columbia, *Debbie*, pp. 231, 283–84, 287, 284, 329; Fisher and Fisher, *Been There, Done That*, p. 97.
14. Heymann, *Liz*, p. 277; Minnelli, *I Remember It Well*, p. 356.
15. Waterbury and Arceri, *Elizabeth Taylor*, p. 225.
16. Bloom, *Leaving a Doll's House*, p. 119; Bragg, *Richard Burton*, p. 201.
17. Bragg, *Richard Burton*, p. 203.
18. Charles Higham, *Brando* (New York: NAL, 1987), p. 250.
19. Daniel Mann, director of *Butterfield 8*, quoted in Heymann, *Liz*, p. 211.
20. Bragg, *Richard Burton*, p. 221.
21. Ibid., p. 226.
22. Sheppard, *Elizabeth*, p. 494.
23. Williams, *Memoirs*, p. 251.
24. Spoto, *Kindness of Strangers*, pp. 293, 300.
25. Bragg, *Richard Burton*, p. 242; Sheppard, *Elizabeth*, p. 508; Williams, *Memoirs*, pp. 265–266.
26. Bragg, *Richard Burton*, p. 240.
27. Ibid., pp. 278, 280, 289.
28. Kelley, *Elizabeth Taylor*, p. 267; Richard Burton's notebook, November 30, 1971, in Bragg, *Richard Burton*, p. 386; David and Robbins, *Richard and Elizabeth*, p. 165.
29. Dominick Dunne, *The Way We Lived Then* (New York: Crown, 1999), p. 158.
30. *ET*, pp. 84–85; Kelley, *Elizabeth Taylor*, p. 267; Silverman, *Fox That Got Away*, p. 238.
31. Bragg, *Richard Burton*, p. 256.

32. Ibid., pp. 255–256; Kelley, *Elizabeth Taylor*, p. 279.

33. Graham, *Hollywood Revisited*, p. 176; Bragg, *Richard Burton*, p. 257.

Interviews: Robert Burr, Jacqueline Burr, Colin Donnarumma, George J. Stauch, Jerry O'Connell, Brian Hutton, Jack Larson, and notes from conversations as senior editor, William Morrow, with my authors J. Bryan III and Charles J. V. Murphy, *The Windsor Story*, and with Carlo Fiore, whose *Bud*, a memoir about Brando, I handled as editor-in-chief, the Delacorte Press.

Other books consulted: Coward, *Noel Coward Diaries*; Cole Leslie, *Remembered Laughter* (New York: Knopf, 1976); Lawrence Grobel, *The Hustons* (New York: Scribner's, 1989); William Redfield, *Letters from an Actor* (London: Cassell, 1967); Judith Balaban Quine, *The Bridesmaids: Grace Kelly and Six Intimate Friends* (New York: Pocket, 1989).

CHAPTER 9

1. Richard Burton's notebook, in Bragg, *Richard Burton*, pp. 260, 262–263, 270, 275, 277.

2. *People*, June 6, 1994.

3. Bragg, *Richard Burton*, p. 265.

4. Silverman, *Fox That Got Away*, p. 238.

5. Harrison, *Damned Serious Business*, p. 333; Bragg, *Richard Burton*, p. 269.

6. Bragg, *Richard Burton*, p. 272.

7. Kelley, *Elizabeth Taylor*, p. 279.

8. Bragg, *Richard Burton*, p. 275.

9. Ibid., pp. 276–277.

10. Richard Burton's notebook, December 3, 1968 in Bragg, *Richard Burton*, p. 393.

11. Bragg, *Richard Burton*, p. 276.

12. Francis Taylor's and Nicky Hilton's deaths: Richard Burton's notebook, May 17, 1970, in Bragg, *Richard*

Burton, pp. 277, 334.

13. Kelley, *Elizabeth Taylor*, p. 298.
14. Bragg, *Richard Burton*, p. 290.
15. Ibid., p. 287.
16. Richard Burton's notebook, March 20, 1969, in Bragg, *Richard Burton*, p. 290; see also Spoto, *Passion for Life*, p. 254.
17. Bragg, *Richard Burton*, pp. 149, 168, 293.
18. Sheppard, *Elizabeth*, p. 517.
19. Heymann, *Liz*, p. 296.
20. Ibid., p. 293.
21. Bragg, *Richard Burton*, p. 318.
22. Kelley, *Elizabeth Taylor*, p. 311; Richard Burton's notebook, November 18, 1969, in Bragg, *Richard Burton*, p. 319.
23. Bragg, *Richard Burton*, p. 327.
24. Ibid., p. 329; Richard Burton's notebook, July 28, 1971, in Bragg, *Richard Burton,* p. 362.
25. Richard Burton's notebook, May 18, 1970, in Bragg, *Richard Burton*, p. 335; Heymann, *Liz*, p. 299.
26. Richard Burton's notebook, in Bragg, *Richard Burton*, p. 336.
27. Richard Burton's notebook, May 23, 1970, in Bragg, *Richard Burton*, p. 337.
28. Richard Burton's notebook, June 5, 1970, June 8, 1970, and July 3, 1970, in Bragg, *Richard Burton*, pp. 337–339, 344.
29. Richard Burton's notebook, August 2, 1970, in Bragg, *Richard Burton,* pp. 350–351; Peter Manso, *Mailer* (New York: Hyperion, 1994), p. 695.
30. Vermilye and Ricci, *Films of Elizabeth Taylor*, p. 218.
31. Bragg, *Richard Burton*, p. 353.
32. Heymann, *Liz*, p. 300; Bragg, *Richard Burton*, pp. 355–356.

33. Kelley, *Elizabeth Taylor*, p. 283.

34. Ibid., p. 281.

35. Bragg, *Richard Burton*, p. 333.

36. Richard Burton's notebook, October 25, 1971, in Bragg, *Richard Burton*, pp. 378–379.

37. Kelley, *Elizabeth Taylor*, p. 276.

38. Ibid., p. 276.

39. Richard Burton's notebook, June 28, 1971, in Bragg, *Richard Burton*, p. 359.

40. Richard Burton's notebook, September 15, 1971, in Bragg, *Richard Burton*, pp. 373, 380; Spoto, *Passion for Life*, p. 248.

41. Dunne, *Way We Lived Then*, p. 157.

42. Sheppard, *Elizabeth*, p. 528; Richard Burton's notebook, in Bragg, *Richard Burton*, pp. 404, 406.

43. Richard Burton's notebook, November 19, 1971, in Bragg, *Richard Burton*, p. 385.

44. J. Bryan III and Charles J. V. Murphy, *The Windsor Story* (New York: Morrow, 1979), p. 572; Richard Burton's notebook, December 7, 1971, in Bragg, *Richard Burton*, pp. 393, 481.

Interviews: Brian Hutton; Cy Egan; and notes from my conversations with Charles J. V. Murphy, the Duke of Windsor's collaborator on *A King's Story* and coauthor of *The Windsor Story*, which I edited at William Morrow and Company.

Other books consulted: Quine, *Bridesmaids*, p. 339 (Callas and Kelly in *Greatest Story*); Christopher Andersen, *Citizen Jane: The Turbulent Life of Jane Fonda* (New York: Holt, 1990), pp. 216–217.

CHAPTER 10

1. Kelley, Elizabeth Taylor, p. 285.

2. Graham Jenkins with Barry Turner, *Richard Burton*

My Brother (New York: Harper and Row, 1988), pp. 195–196.

3. Sheppard, *Elizabeth*, p. 546.

4. Bragg, *Richard Burton*, p. 340; Waterbury and Arceri, *Elizabeth Taylor*, p. 242; Jenkins and Turner, *Richard Burton My Brother*, p. 195; Richard Burton's notebook in Bragg, *Richard Burton*, p. 410.

5. Waterbury and Arceri, *Elizabeth Taylor*, p. 242.

6. Heymann, *Liz*, p. 307.

7. Spoto, *Passion for Life*, p. 260; Sheppard, *Elizabeth*, pp. 546–547; Waterbury and Arceri, *Elizabeth Taylor*, p. 243.

8. Bragg, *Richard Burton*, p. 415; Fisher and Fisher, *Been There, Done That*, pp. 260, 262.

9. Kitty Kelley, *Jackie O* (New York: Ballentine, 1979), p. 341; Bragg, *Richard Burton*, p. 412; *ET*, p. 137.

10. Interview with Edward Dmytryk; Bragg, *Richard Burton*, pp. 412–413; David and Robbins, *Richard and Elizabeth*, p. 205; Kelley, *Elizabeth Taylor*, p. 288.

11 Vermilye and Ricci, *Films of Elizabeth Taylor*, pp. 231–232; Sheppard, *Elizabeth*, pp. 547, 549; Kelley, *Elizabeth Taylor*, p. 283; Braggs, *Richard Burton*, pp. 362–363.

12. Kelley, *Elizabeth Taylor*, p. 283; Bragg, *Richard Burton*, pp. 362–363.

13. Richard Burton's notebook, July 28, 1970, in Bragg, *Richard Burton*, p. 363; Spoto, *Passion for Life*, p. 264.

14. Heymann, *Liz*, pp. 314–317.

15. Dunne, *Way We Lived Then*, pp. 158–160.

16. Ibid., p. 161.

17. Vermilye and Ricci, *Films of Elizabeth Taylor*, p. 237.

18. Heymann, *Liz*, pp. 313, 317; Richard Burton to Maria Burton, March 28, 1973, in Bragg, *Richard*

Burton, p. 396.

19. Ferris, *Richard Burton*, p. 232.

20. Heymann, *Liz*, pp. 320–321; James Spada, *Peter Lawford* (New York: Bantam, 1991), pp. 421–422.

21. Spada, *Peter Lawford*, pp. 409, 419–421.

22. Ibid., pp. 415, 419.

23. Ibid., p. 422.

24. Heymann, *Liz*, p. 320.

25. Waterbury and Arceri, *Elizabeth Taylor*, p. 248; Kelley, *Elizabeth Taylor*, pp. 299, 305, 307 refers to young women "Henry Wynberg entertained at nude swimming parties when she was away. I remember going to the house once—the one that Elizabeth was paying rent on and sharing with Henry—and finding three different girls there at the same time," said one man. "Two of the girls were waiting in an adjoining room for Henry to finish with the third." "Henry would drive Elizabeth's Rolls-Royce around and pick up girls when she was away," said Don Crider, one of her hairdresser friends, Bragg, *Richard Burton*, p. 419; Jenkins and Turner, *Richard Burton My Brother*, p. 207; Spada, *Peter Lawford,* p. 438.

26. Jenkins and Turner, *Richard Burton My Brother*, p. 207.

27. David and Robbins, *Richard and Elizabeth*, p. 180; Waterbury and Arceri, *Elizabeth Taylor*, p. 247; Kelley, *Elizabeth Taylor*, p. 299; Patricia Seaton Lawford with Ted Schwartz, *The Peter Lawford Story* (New York: Carroll and Graf, 1988), p. 176.

28. Heymann, *Liz*, p. 327; Kelley, *Elizabeth Taylor*, p. 307; Bragg, *Richard Burton*, p. 474.

29. Bragg, *Richard Burton*, p. 422; David and Robbins, *Richard and Elizabeth*, p. 180.

30. Bob Colacello, *Holy Terror: Andy Warhol Close Up* (New York: HarperCollins, 1990), p. 218.

31. Bragg, *Richard Burton*, p. 430; David and Robbins, *Richard and Elizabeth*, pp. 210, 213; Heymann, *Liz*, pp. 328, 332.

32. David and Robbins, *Richard and Elizabeth*, pp. 213, 216; Kelley, *Elizabeth Taylor*, p. 309, source: "one of [Wynberg's] business partners"; Heymann, *Liz*, pp. 327, 335, 417: December 1990, Superior Court of the State of California, County of Los Angeles, "the two sides settled, Elizabeth claiming exoneration and Wynberg claiming victory"; Walker, *Elizabeth*, p. 324.

33. David and Robbins, *Richard and Elizabeth*, pp. 210–211; Heymann, *Liz*, p. 334: "I accepted the situation," continued Wynberg, "but I had given up my automobile business to be with Elizabeth, and I needed a new professional outlet to fill the void"; Kelley, *Elizabeth Taylor*, p. 313.

34. Steven Gaines, *Simply Halston* (New York: Putnam's, 1991), pp. 290–291.

35. Heymann, *Liz*, p. 334; Bragg, *Richard Burton*, p. 433; Walker, *Elizabeth*, p. 327; Kelley, *Elizabeth Taylor*, p. 317; David and Robbins, *Richard and Elizabeth*, p. 219.

36. David and Robbins, *Richard and Elizabeth*, p. 7.

37. Ibid.

38. Walker, *Elizabeth*, p. 328.

39. Heymann, *Liz*, p. 337; Nickens, *Elizabeth Taylor*, p. 156; Bragg, *Richard Burton*, p. 433.

40. Jenkins and Turner, *Richard Burton My Brother*, p. 213; Bragg, *Richard Burton*, p. 434; Kelley, *Elizabeth Taylor*, p. 321.

41. Bodyguard Brian Haynes to Kelley, *Elizabeth Taylor*, pp. 321–322; Bragg, *Richard Burton*, p. 434.

42. Charles Winecoff, *Split Image* (New York: Dutton, 1996) p. 354; Heymann, *Liz*, p. 339; David and

Robbins, *Richard and Elizabeth*, p. 205; Kelley, *Elizabeth Taylor*, pp. 325–327.

43. Heymann, *Liz*, p. 342; E.T. cancels Tony commitment: Andersen, *Citizen Jane*, p. 282.
44. Spoto, *Passion for Life*, p. 281, quotes the L.A. *Herald-Examiner,* February 16–17 and July 25, 1977: "Actress Elizabeth Taylor's ex-boyfriend, Henry C. Wynberg, was scheduled to be arraigned today in Beverly Hills Municipal Court on ten counts of misdemeanor . . . of contributing to the delinquency of four teenaged girls [by] allegedly providing drugs and alcohol, engaging in sexual acts with them and taking lewd pictures of them." Later that year, after admitting sexual misconduct with one sixteen-year-old, he was sent to the county jail for ninety days, fined $1,250, and ordered to a five-year probation thereafter (the longest period allowed by California law).
45. Heymann, *Liz*, p. 344.

Interviews with Ed Ditterline, Brian Hutton, and Edward Dmytryk.

Also consulted: Merv Griffin and Peter Barsocchini, *From Where I Sit* (New York: Pinnacle, 1982), p. 46.

CHAPTER 11

1. Kelley, Elizabeth Taylor, p. 330.
2. Heymann, *Liz*, p. 348; Andy Warhol, *The Andy Warhol Diaries*, edited by Pat Hackett (New York: Warner Books, 1989), p. 29.
3. Walker, *Elizabeth*, p. 332; Heymann, *Liz*, p. 349.
4. Warhol, *Andy Warhol Diaries*, pp. 177–178.
5. Ibid., p. 178.
6. Kelley, *Elizabeth Taylor*, p. 373, 380; Heymann, *Liz*, p. 366.

7. James Prideaux, *Knowing Hepburn* (Boston: Faber and Faber, 1996), pp. 97, 99–100, 102–103, 108–109, 117.

8. Gaines, *Simply Halston*, p. 205; Betty Ford and Chris Chase, *The Times of My Life* (New York: Ballantine, 1979). Ms. Ford's alcohol and drug intervention occurred in April 1978.

9. "Meet the Poolman to the Stars," *National Examiner*, October 26, 1999, pp. 1–2.

10. Waterbury and Arceri, *Elizabeth Taylor*, p. 268; Kelley, *Elizabeth Taylor*, p. 388; Robin-Tani, *New Elizabeth*, p. 145.

11. Spoto, *Passion for Life*, p. 299; Kelley, *Elizabeth Taylor*, pp. 340, 389, 391.

12. Heymann, *Liz*, p. 383; Peter Feibleman, *Lily: Reminiscences of Lillian Hellman* (New York: Morrow, 1988), p. 265.

13. Spoto, *Passion for Life*, p. 299; Walker, *Elizabeth*, p. 349; *ETO*, p. 95.

Interviews with Curtis Harrington, Ray Stricklyn, and notes from conversations with Radie Harris, E.T., Andy Warhol, Joyce Haber, and Halston.

CHAPTER 12

1. Robin-Tani, New Elizabeth, pp. 144, 147; Walker, Elizabeth, p. 367; Bragg, Richard Burton, p. 468.

2. Robin-Tani, *New Elizabeth*, p. 148.

3. Jenkins and Turner, *Richard Burton My Brother*, pp. 232–233; Bragg, *Richard Burton*, pp. 463, 469.

4. *ETO*, p. 95; Robin-Tani, *New Elizabeth*, pp. 147, 150; Spoto, *Passion for Life*, pp. 307–308.

5. Kelley, *Elizabeth Taylor*, pp. 414-415; Jenkins and Turner, *Richard Burton My Brother*, p. 234; Nickens, *Elizabeth Taylor*, p. 183.

6. Jenkins and Turner, *Richard Burton My Brother*, p. 235; Bragg, *Richard Burton*, p. 471.
7. Bragg, *Richard Burton*, p. 473: "On something"; p. 470: "I'm inclined to think it was very clever on Elizabeth's part, unconsciously perhaps."
8. Jenkins and Turner, *Richard Burton My Brother*, pp. 240–242.
9. Heymann, *Liz*, p. 8; "It's time to change": Spada, *Peter Lawford*, p. 462.
10. *ETO*, pp. 99, 100–101; Spada, *Peter Lawford*, p. 462; Heymann, *Liz*, pp. 9–10.
11. Spoto, *Passion for Life*, p. 319; "Hollywood Drug-gies," *Globe*, July 6, 1999, pp. 28–29; Patrice Baldwin, "Brooke Begged Judd Nelson Not to Quit Show," *Globe*, May 25, 1999, p. 47.
12. Nickens, *Elizabeth Taylor*, p. 183; "E.T. resumes alcohol and pills": Heymann, *Liz,* p. 10.
13. Spoto, *Passion for Life*, p. 321.
14. Heymann, *Liz*, p. 400.
15. Ibid., p. 399.
16. Ibid., p. 400.
17. Ibid., p. 432.
18. Sessums, "Elizabeth Taylor Tells the Truth," p. 74.
19. Theroux, "Ms. Taylor Will See You Now," pp. 168–169.
20. Ibid., p. 169.
21. Ibid.
22. Ibid.
23. Ibid.
24. J. Randy Taraborrelli, *Michael Jackson* (New York: Birch Lane, 1991), p. 408.
25. Ibid., p. 390.
26. Theroux, "Ms. Taylor Will See You Now," p. 168.
27. Taraborrelli, *Michael Jackson*, p. 447.
28. Ibid., p. 448.

29. Ibid., p. 427.
30. Robin-Tani, *New Elizabeth*, p. 146.
31. Spoto, *Passion for Life*, p. 321; Bragg, *Richard Burton*, p. 487.
32. Jenkins and Turner, *Richard Burton My Brother*, pp. 2–3.
33. Ibid., p. 11.
34. Ibid., p. 16.
35. Ibid., p. 244
36. Bragg, *Richard Burton*, p. 486.

Interviews: Edward Dmytryk, Jean Porter, and notes from editorial conferences with Lana Wood when I was her editor at G. P. Putnam's Sons for her memoir *Natalie*.

Other books consulted: Quine, *Bridesmaids*, pp. 495, 504; Betty Ford and Chris Chase, *The Times of My Life* (New York: Ballantine, 1978).

CHAPTER 13

1. Nancy Collins, "Liz's AIDS Odyssey," Vanity Fair, November 1992, p. 264.
2. Spoto, *Passion for Life*, p. 321.
3. Heymann, *Liz*, p. 404.
4. Ibid.
5. Walker, *Elizabeth*, p. 365.
6. Heymann, *Liz*, p. 405.
7. Collins, "Liz's AIDS Odyssey," p. 268.
8. Hudson and Davidson, *Rock Hudson*, p. 33.
9. Collins, "Liz's AIDS Odyssey," p. 212.
10. Ibid., p. 264; the doctor later denied having made such a statement.
11. Nancy Reagan and William Novak, *My Turn* (New York: Random House, 1989), p. 280.
12. Hudson and Davidson, *Rock Hudson*, pp. 18, 182; Rock had been lovers with Tom Clark and Jack

Coates Ibid., p. 304; Nader and Miller gay: Ibid., p. 52.

13. Ibid., pp. 252, 253, 288, 304.

14. Ibid., pp. 236, 274–275; aspiring Vegas dancer: Ibid., p. 291.

15. Ibid., p. 306.

16. Collins, "Liz's AIDS Odyssey," p. 264.

17. Marquesa De Varela, "Elizabeth Taylor and Her Beloved Former Daughter in Law Aileen Getty," *Hello!,* August 14, 1993, p. 53; "Elizabeth Taylor: *Advocate* Interview," *Advocate*, October 15, 1996, p. 44; Robin-Tani, *New Elizabeth*, p. 145.

18. Collins, "Liz: AIDS Odyssey," p. 212.

19. Heymann, *Liz*, p. 408.

20. Robin-Tani, *New Elizabeth*, p. 263.

21. Ibid., p. 166–167.

22. Ibid., p. 169.

23. Vermilye and Ricci, *Films of Elizabeth Taylor*, p. 265.

24. Ibid., p. 265; Grover, "Tony Bennett's Ex," *National Enquirer,* November 2, 199, p. 60.

25. Robin-Tani, *New Elizabeth*, p. 167.

26. Ibid., p. 167.

27. Heymann, *Liz*, p. 414.

28. Ibid., p. 417; Calvin Klein: Steven Gaines, *Obsession* (New York, Birch Lane, 1994), p. 330; Gaines, *Simply Halston,* pp. 166–168.

29. Heymann, *Liz,* p. 418; interview with Lisa Rubinstein, Ogilvy & Mather graphics designer.

30. Spoto, *Passion for Life*, p. 328.

31. Waterbury and Arceri, *Elizabeth Taylor*, p. 261; Robin-Tani, *New Elizabeth,* pp. 143–144; Malcolm's pass at ET: Rosenfield, *The Club Rules,* p. 13.

32. Colacello, *Holy Terror*, p. 495.

33. Gaines, *Obsession,* p. 365.

34. Vermilye and Ricci, *Films of Elizabeth Taylor*, p. 34.

35. Taraborrelli, *Michael Jackson*, p. 494.
36. CNN, "People," June 8, 1999.
37. Spoto, *Passion for Life*, p. 335.
38. Ken Harrell, "Liz's Love Secrets" and "My Nightmare with Larry the Violent Doped-Up Boozer," *Globe*, December 8, 1998, p. 24.
39. Collins, "Liz's AIDS Odyssey," p. 262.
40. Spoto, *Passion for Life*, p. 333.
41. Ibid., p. 335.
42. Harrell, "Liz's Love" and "My Nightmare," pp. 24–25.
43. Ibid., p. 25.
44. CNN, "People," June 8, 1999.
45. Harrell, "Liz's Love" and "My Nightmare," p. 24.
46. Spoto, *Passion for Life*, p. 335.
47. Ibid., pp. 335–336.
48. Theroux, "Ms. Taylor Will See You Now," p. 171.
49. Harrell, "Liz's Love" and "My Nightmare," p. 24.
50. Ibid.
51. Ibid.
52. Ibid., p. 25.
53. Collins, "Liz's AIDS Odyssey," p. 262.
54. Heymann, *Liz*, p. 429.
55. Ibid., p. 428.
56. Vermilye and Ricci, *Films of Elizabeth Taylor*, p. 269.
57. Claire Spiegel and Virginia Ellis, "3 Doctors Cited in Taylor Drug Case," *Los Angeles Times*, August 11, 1994.
58. Ibid., the *L.A. Times* story says Skinner gave E.T. drugs from April 1987 through November 1988, and Roth, from March 1988 through December 1989.
59. Heymann, *Liz*, p. 435.
60. "E.T.: *Advocate* Interview," p. 52.
61. Lysa Moskowitz-Mateu and David La Fontaine, *Poi-*

son Pen (Los Angeles: Dove, 1996, p. 44; Martin Gould, "Uncovered! Michael's Great Baby Hoax," *Star,* November 23, 1999, p. 9; Christopher Anderson, *Michael Jackson* (New York: Simon & Schuster, 1994), pp. 316, 320–321; 350.

62. Barbara Walters interview, ABC, March 21, 1999.
63. Collins, "Liz's AIDS Odyssey," p. 262.
64. Spoto, *Passion for Life*, p. 335.
65. Collins, "Liz's AIDS Odyssey," p. 262.
66. "E.T.: *Advocate* Interview," p. 52.
67. Heymann, *Liz*, p. 427.
68. Collins, "Liz's AIDS Odyssey," p. 213.
69. Harrell, "Liz's Love Secrets" and "My Nightmare with Larry the Violent Doped-Up Boozer," p. 24.
70. Theroux, "Ms. Taylor Will See You Now," p. 170.
71. Ibid., p. 213.
72. Harrell, "Liz's Love" and "My Nightmare," p. 32.
73. Ibid.
74. Heymann, *Liz*, p. 439; Harrell, "Liz's Love" and "My Nightmare," p. 32.
75. Collins, "Liz's AIDS Odyssey," p. 212.
76. Gary A. Schreiber, "Liz Fires Chef—For Making Her Fat," *National Enquirer*, November 10, 1992, p. 47.
77. Darrach, "If the Knife," p. 82; "picking fights," *People,* September 18, 1995, p. 66.
78. Harrell, "Liz's Love" and "My Nightmare," p. 32.
79. Theroux, "Ms. Taylor Will See You Now," p. 168.
80. Maureen O'Brien, *Publisher's Weekly*, September 19, 1994; Adam Sandler, *Variety*, September 26, 1994; *Los Angeles Times*, June 29, 1994.
81. Heymann, *Liz*, p. 434.
82. Ibid.
83. Harrell, "Liz's Love" and "My Nightmare," p. 32.
84. *People*, September 18, 1995, p. 66.
85. TV's *Entertainment Tonight,* December 2, 1999; $1.5

reported by Heymann, *Liz*, p. 440, but according to a report in the *New York Times* on April 8, 1997, Elizabeth's lawyer Arlene Colman-Schwimmer said accounts that Fortensky received $1.5 million were "inaccurate."

86. James Spada, "E.T.," *McCall's*, July 1997, p. 44.
87. Darrach, "If the Knife," p. 82; Heymann, *Liz*, p. 438.
88. Dunne, *Way We Lived Then*, pp. 185–186.
89. "What Really Happened at the O.J. Trial?" *Star*, December 2, 1987, pp. 6–7.
90. Sessums, "Elizabeth Taylor Tells the Truth," p. 52.
91. Theroux, "Ms. Taylor Will See You Now," p. 168.
92. *The Donny and Marie Osmond Show*, March 19, 1999.
93. Bloom, *Leaving a Doll's House*, pp. 109–111.
94. Ibid., p. 125.
95. Ibid., p. 123.
96. Ibid., p. 128; "opportunistic": Ibid., p. 123.
97. Holden, *Behind the Oscar*, p. 266; Army Archerd, "Just for Variety," *Variety*, December 23, 1997.
98. *Time*, February 24, 1997; Harrell, "Liz's Love Secrets" and "My Nightmare with Larry the Violent Doped-Up Boozer," p. 32; Ken Harrell, Chris Doherty, and Jack Carter, "Liz Sobs as Larry Murder Charges Fly," *Globe*, February 16, 1999, pp. 24–25.

CHAPTER 14

1. Theroux, "Ms. Taylor Will See You Now," p. 167.
2. Darrach, "If the Knife," *Life,* p. 82.
3. Barbara Walters TV interview, ABC, March 21, 1999; *People*, October 27, 1997.
4. Liz Smith, *Los Angeles Times*, April 4, 1997; *Hollywood Reporter*, February 27, 1997.
5. *People*, September 22, 1997; *New York Times*, Sep-

tember 9, 1997.

6. *The Donny and Marie Osmond Show*, March 19, 1999; "100 Dirtiest Celebrity Divorces: Rod & Paula Steiger," *Star*, April 13, 1999, p. 50; "I'll kill myself": Diane Albright and Joe Mullins, "Drug Relapse Caused Liz's Bloody Collapse," *Globe,* March 17, 1998, p. 5.

7. *Hollywood Reporter*, April 8, 1998; Patricia Towle, "Liz Battles to Stay Out of Wheelchair," *National Enquirer*, March 17, 1998, p. 8.

8. *People*, August 23, 1998.

9. "Yikes! It's Liz the Great Grandma," *Star*, May 5, 1988, p. 22.

10. *People*, March 3, 1998; "Liz Credits Steiger for Survival," *USA Today*, March 16, 1999, p. 2D; Neal Hitchens, "Liz: I'm on My Feet Again," *National Enquirer*, June 16, 1998, p. 3.

11. Delta Burke, *Delta Style* (New York: St. Martin's, 1998), quoted in Laurie Campbell, "How Liz Saved My Life," *National Examiner*, March 31, 1998, pp. 6–7.

12. Hitchens, "Liz: I'm on My Feet Again," p. 3.

13. Michael Glynn, "Sad, Lonely and Pain-Racked Liz Lets Steiger Go," *National Enquirer*, April 21, 1998, p. 24.

14. Laurie Campbell, "Ailing Liz Joins Forbidden Cult," *National Examiner*, May 26, 1998, p. 35.

15. Heymann, *Liz*, p. 436; Andersen, *Michael Jackson*, p. 353.

16. Liz Smith, *Los Angeles Times*, May 28, 1998; Hitchens, "Liz: I'm on My Feet Again," p. 3.

17. Janet Charlton, "Star People," *Star*, May 12, 1998, p. 12; "Larry Begs Liz: Take Me Back," *Globe*, July 14, 1998, p. 12.

18. *Los Angeles Times*, November 12, 1998; "Larry Begs

Liz: Take Me Back," *Globe*, July 14, 1998, p. 12.

19. John Harlow, "Taylor Plans Comeback as Wilde Woman," *Sunday Times* (London).

20. Jasper Gerrard, *Times* (London), November 16, 1998.

21. "Liz & Rod to Marry," *National Examiner*, February 16, 1999, p. 13.

22. John South, Robert Blackmon, Mandy Ridder, Marc Cetner, Alan Smith, and Suzanne Ely, "Liz Agony—Drunken Fall Leaves Larry Brain-Damaged," *National Enquirer*, February 16, 1999, p. 37; Sybil Burton's $50,000 alimony: "He Gave a Lot of Pleasure," *Luxury Lifestyles of the Rich and Famous,* April 1998, p. 12.

23. Theroux, "Ms. Taylor Will See You Now," p. 214.

24. *Access Hollywood*, March 12, 1999.

25. Theroux, "Ms. Taylor Will See You Now," p. 168; Mike Walker, "Behind the Screens," *National Enquirer*, February 21, 1999, p. 12.

26. *Entertainment Tonight*, February 26, 1999.

27. "Star People," *Star*, February 16, 1999, p. 13; Barbara Walters interview, ABC, March 21, 1999; "Prince William's Gal," *Star*, April 6, 1999, p. 12.

28. Arlene Walsh, *Beverly Hills 213*, March 17, 1999, p. 6.

29. Liz Smith on Channel 37 TV, April 11, 1999; Janet Charlton, "Star People: Oprah's $250,000," *Star*, May 11, 1999, p. 12.

30. Theroux, "Ms. Taylor Will See You Now," p. 214.

31. Marc Cetner and Reginald Fitz, "Doc's Fear Liz Will Never Walk Again," *National Enquirer*, Fall 1998, p. 17; David K. Li and Kirsten Danis, "Liz Facing 'Weeks' in Spinal Ward," *New York Post,* August 22, 1999, p. 3; 200 pounds, $8,800 room, and $30,000 earrings: Beverly Williston and Janet

Charlton, "Full Story Behind Liz's New Hospital Crisis," *Star,* September 7, 1999.

32. Theroux, "Ms. Taylor Will See You Now," p. 214.

33. Jackson's children, marriage and divorce from Debbie Rowe: Susan Goldfarb, "Wacko Jacko's Bizarre Divorce Deal," *National Examiner*, October 26, 1999, p. 15; "Michael Jackson and Lisa Marie Presley," *Star*, April 13 1999, p. 37; "Lisa Marie Wins Back Michael Jackson," *National Examiner*, November 4, 1997, pp. 22–23; Bennet Bolton, David Wright, and Jeffrey Rodack, "Jacko and His Little Boys," *National Enquirer*, February 3, 1998, p. 28; "Lisa Marie Shocker," *National Enquirer*, January 13, 1998, p. 28; Debbie's biker: Janet Charlton, "Star People," *Star,* July 13, 1999, and November 30, 1999, p. 14; sperm: Gould, "Uncovered! Michael's Great Baby Hoax," pp. 4–9; David Thompson, "Jackson's Marriage Was a Sham—Say Sources," *Globe*, October 26, 1999, p. 29; break with Dr. Schwartz: Mike Walker, "Hollywood Behind the Screen," *National Enquirer,* November 30, 1999, p. 12.

34. Sessums, "Elizabeth Taylor Tells the Truth," p. 74; "The Gloved One Is Getting Ghoulish," *Miami Herald,* November 19, 1999, p. 4A; Jackson-Talyor baby: Charlton, "Star People," *Star*, January 18, 2000, p. 12.

 Interviews: Jack Larson, Norman Bogner, Bettye McCart, anonymous former patients at BFC.

Bibliography

Andersen, Christopher. *Citizen Jane: The Turbulent Life of Jane Fonda*. New York: Holt, 1990.

Astor, Mary. *A Life on Film*. New York: Dell, 1971.

Baker, Carroll. *Baby Doll*. New York: Arbor House, 1983.

Barrett, Rona. *Miss Rona*. New York: Bantam, 1974.

Bernstein, Matthew. *Walter Wanger, Hollywood Independent*. Berkeley: University of California Press, 1994.

Black, Shirley Temple. *Child Star.* New York: Warner, 1988.

Blondell, Joan. *Center Door Fancy*. New York: Delacorte, 1972.

Bloom, Claire. *Leaving a Doll's House*. Boston: Little, Brown, 1996.

Bosworth, Patricia. *Montgomery Clift.* New York: Harcourt Brace Jovanovich, 1978 (paperback edition, New York: Bantam 1979).

Brady, Frank. *Citizen Welles*. New York: Scribner's, 1989.

Bragg, Melvyn. *Richard Burton*. Boston: Little, Brown, 1988.

Brodsky, Jack, and Nathan Weiss. *The Cleopatra Papers*. New York: Simon and Schuster, 1963.

Brown, Peter Harry, and Patte Barham. *Marilyn: The Last Take*. New York: Dutton, 1992.

Brown, Peter Harry, and Pat H. Broeske. *Howard Hughes*. New York: Dutton, 1996.

Bryan III, J., and Charles J. V. Murphy. *The Windsor Story*. New York: Morrow, 1979.

Burton, Philip. *Early Doors*. New York: Dial, 1969.

Colacello, Bob. *Holy Terror: Andy Warhol Close Up*. New York: HarperCollins, 1990.

Collins, Joan. *Past Imperfect*. New York: Berkley, 1985.

Cooper, Jackie, and Dick Kleiner. *Please Don't Shoot My Dog*. New York: Morrow, 1981.

Cottrell, John, and Fergus Cashin. *Richard Burton: Very Close Up*. Englewood Cliffs, N.J.: Prentice-Hall, 1971.

Coward, Noel. *The Noel Coward Diaries*, edited by Graham Payne and Sheridan Morley. Boston: Little, Brown, 1982.

Dalton, David. *The Mutant King*. New York: St. Martin's, 1974.

David, Lester, and Jhan Robbins. *Richard and Elizabeth*. New York: Funk and Wagnalls, 1977.

De Rosso, Diana. *James Mason*. Oxford, England: Lennard, 1989.

Devillers, Marceau. *James Dean*. Singapore: Chartwell, n.d.

Dunne, Dominick. *The Way We Lived Then*. New York: Crown, 1999.

Edwards, Anne. *Vivien Leigh*. New York: Simon and Schuster, 1977.

Ewing, John A., and Beatrice A. Rouse. *Drinking*. Chicago: Nelson-Hall, 1978.

Feibleman, Peter. *Lily: Reminiscences of Lillian Hellman*. New York: Morrow, 1988.

Ferris, Paul. *Richard Burton*. New York: Coward-McCann, 1981.

Fisher, Eddie, with David Fisher. *Been There, Done That*. New York: St. Martin's, 1999.

Ford, Betty, and Chris Chase. *The Times of My Life*. New York: Ballantine, 1978.

Gabor, Zsa Zsa. *Zsa Zsa Gabor, My Story, Written for Me by Gerold Frank*. Cleveland: World, 1960.

Gaines, Steven. *Simply Halston*. New York: Putnam's, 1991.

Gardner, Ava. *Ava*. Thorndike, Me.: Thorndike, 1990.

Graham, Sheilah. *Hollywood Revisited*. New York: St. Martin's, 1984.

Granger, Stewart. *Sparks Fly Upward*. New York: Putnam's, 1981.

Grobel, Lawrence. *The Hustons*. New York: Scribner's, 1989.

Guilaroff, Sydney, and Cathy Griffin. *Crowning Glory*. Santa Monica: General, 1996.

Guinness, Alec. *Blessings in Disguise*. New York: Knopf, 1986.

Gussow, Mel. *Don't Say Yes Until I Finish Talking: A Biography of Darryl F. Zanuck*. New York: Pocket, 1972.

Hadleigh, Boze. *Hollywood Gays*. New York: Barricade, 1996.

Halliwell, Leslie. *Halliwell's Filmgoer's Companion*. New York: Scribner's, 1988.

Harris, Warren G. *Natalie and R. J.* New York: Doubleday, 1988.

Harrison, Rex. *A Damned Serious Business*. New York: Bantam, 1991.

Heymann, C. David. *Liz*. Secaucus, N.J.: Carol, 1995.

Higham, Charles. *Brando*. New York: NAL, 1987.

Hirsch, Foster. *Elizabeth Taylor*. New York: Pyramid, 1973.

Holden, Anthony. *Behind the Oscar*. New York: Simon and Schuster, 1993.

_____. *Laurence Olivier*. New York: Atheneum, 1988.

Hoskyns, Barney. *Montgomery Clift*. New York: Grove Weidenfeld, 1991.

Hudson, Rock, and Sara Davidson. *Rock Hudson*. New York: Morrow, 1986.

Hyams, Joe, with Jay Hyams. *James Dean*. New York: Warner, 1992.

Jenkins, Graham, with Barry Turner. *Richard Burton My Brother*. New York: Harper and Row, 1988.

Kelley, Kitty. *Elizabeth Taylor: The Last Star*. New York: Dell, 1981.

———. *His Way*. New York: Bantam, 1986.

Lacey, Robert. *Grace*. New York: Putnam's, 1994.

LaGuardia, Robert. *Monty*. New York: Arbor House, 1977 (paperback edition, New York: Avon, 1978).

LaGuardia, Robert, and George Arceri. *Red: Susan Hayward*. New York: Macmillan, 1985.

Lamarr, Hedy. *Ecstasy and Me*. New York: Fawcett, 1966.

Lawford, Patricia Seaton, with Ted Schwartz. *The Peter Lawford Story*. New York: Carroll and Graf, 1988.

Leigh, Janet. *There Really Was a Hollywood*. New York: Jove, 1984.

Leslie, Cole. *Remembered Laughter*. New York: Knopf, 1976.

McGilligan, Patrick. *George Cukor*. New York: St. Martin's, 1991.

Manso, Peter. *Mailer*. New York: Hyperion, 1994.

Minnelli, Vincente, and Hector Arce. *I Remember It Well*. Garden City, N.Y.: 1974.

Morley, Sheridan. *The Other Side of the Moon*. New York: Harper and Row, 1985.

Moskowitz-Mateu, Lysa, and David La Fontaine. *Poison Pen*. Los Angeles: Dove, 1996.

Nickens, Christopher. *Elizabeth Taylor*. New York: Dolphin, 1994.

Prideaux, James. *Knowing Hepburn*. Boston: Faber and Faber, 1996.

Quine, Judith Balaban. *The Bridesmaids: Grace Kelly and Six Intimate Friends*. New York: Pocket, 1989.

Reagan, Nancy, and William Novak. *My Turn*. New York: Random House, 1989.

Redfield, William. *Letters from an Actor*. London: Cassell, 1967.

Debbie Reynolds and David Patrick Columbia. *Debbie*. New York: Pocket, 1988.

Riese, Randall. *Her Name Is Barbra*. New York: Birch Lane, 1993.

Riva, Maria. *Marlene Dietrich*. New York: Knopf, 1993.

Roberts, Monty. *The Man Who Listens to Horses*. New York: Random House, 1996.

Robin-Tani, Marianne. *The New Elizabeth*. New York: St. Martin's, 1988.

Rodriguez, Elena. *Dennis Hopper*. New York: St. Martin's, 1988.

Shale, Richard. *Academy Awards*. New York: Ungar, 1978.

Sheppard, Dick. *Elizabeth*. New York: Warner, 1974.

Silverman, Stephen M. *The Fox That Got Away*. Secaucus, N.J.: Lyle Stuart, 1988.

Spada, James. *Peter Lawford*. New York: Bantam, 1991.

Spoto, Donald. *The Kindness of Strangers*. New York: Ballantine, 1985.

_____. *A Passion for Life*. New York: HarperCollins, 1995.

Strasberg, Susan. *Bittersweet*. New York: Putnam's, 1980.

Stricklyn, Ray. *Angels and Demons*. Los Angeles: Belle, 1999.

Swindell, Larry. *Spencer Tracy*. New York: NAL, 1969.

Taraborrelli, J. Randy. *Michael Jackson*. New York: Birch Lane, 1991.

Taylor, Elizabeth. *Elizabeth Takes Off*. New York: Putnam's, 1987.

_____. *Elizabeth Taylor*. New York: Harper and Row, 1964.

Todd, Mike Jr., and Susan McCarthy Todd. *A Valuable Property: The Life Story of Michael Todd*. New York: Arbor House, 1983.

Troyan, Michael. *A Rose for Ms. Miniver*. Lexington: University Press of Kentucky, 1999.

Vermilye, Jerry, and Mark Ricci. *The Films of Elizabeth Taylor*. New York: Carol, 1993.

Warhol, Andy. *The Andy Warhol Diaries*, edited by Pat Hackett. New York: Warner Books, 1989.

Walker, Alexander. *Elizabeth*. London: Weidenfeld and Nicolson, 1990.

Wallace, Irving; David Wallechinsky; Amy Wallace; and Sylvia Wallace. *The Book of Lists 2*. New York: Morrow, 1980.

Waterbury, Ruth, with Gene Arceri. *Elizabeth Taylor*. New York: Bantam, 1982.

Wilding, Michael. *The Wilding Way: The Story of My Life*. New York: St. Martin's, 1982.

Williams, Emlyn. *Emlyn: An Early Autobiography: 1927–1935*. New York: Viking, 1973.

_____. *George: An Early Autobiography (1905–1927)*. New York: Random House, 1961.

Williams, Tennessee. *Memoirs*. New York: Bantam, 1975.

Winecoff, Charles. *Split Image*. New York: Dutton, 1996.

Wright, William. *Lillian Hellman*. New York: Simon and Schuster, 1986.

Zeffirelli, Franco. *The Autobiography of Franco Zeffirelli*. New York, Weidenfeld and Nicolson, 1986.

Index